The Eye of History

RIC Books

Essentials

The Eye of History

When Images Take Positions

Georges Didi-Huberman

Translated by
Shane B. Lillis

RIC Books
Ryerson Image Centre
Toronto, Canada

The MIT Press
Cambridge, Massachusetts
London, England

Originally published as *Quand les images prennent position. L' Œil de l'histoire, 1*, © Les Editions de Minuit, 2009.

This book was set in Adobe Garamond Pro and Whitney by Studio Ours Inc. and was printed and bound in France.

Library of Congress Control Number: 2017955504

ISBN: 978-0-262-03787-7

10 9 8 7 6 5 4 3 2 1

The English translation of the text was supported by the Centre national du livre, Paris.

Back cover: "An American soldier stands over a dying Jap [*sic*] whom he has just been forced to shoot. The Jap had been hiding in the landing barge, shooting at U.S. troops." *Life,* February 15, 1943, 23. Photograph by George Strock. Ryerson Image Centre, Toronto. © George Strock/The LIFE Picture Collection/Getty Images.

Georges Didi-Huberman, a philosopher and art historian based in Paris, teaches at the École des Hautes Études en Sciences Sociales. Recipient of the 2015 Adorno Prize, he is the author of more than fifty books on the history and theory of images, including *Invention of Hysteria: Charcot and the Photographic Iconography of the Salpêtrière* (MIT Press), *Bark* (MIT Press), *Images in Spite of All: Four Photographs from Auschwitz*, and *The Surviving Image: Phantoms of Time and Time of Phantoms: Aby Warburg's History of Art*.

Dr. Shane B. Lillis is a lecturer in the Department of Literature at the University of Nantes (France).

Now for the thinking soul images take the place of direct perceptions; and when it asserts or denies that they are good or bad, it avoids or pursues them. Hence the soul never thinks without a mental image.

— Aristotle, *On the Soul*, bk. III, ch. 7, trans. W. S. Hett (Cambridge, MA: Harvard University Press, 1957), 177.

The support you had from your senses, the support your senses had from the world, the support you had from your general impression of being. They give way. A vast redistribution of the sensibility takes place, making everything bizarre—a complex, continual redistribution of the sensibility. You feel less here, and more there. Where "here"? Where "there"? In dozens of "heres," in dozens of "theres," that you didn't know, that you didn't recognize. Dark zones that used to be bright. Light zones that used to be heavy. You no longer end up in yourself, and reality, even objects, lose their mass and stiffness and no longer put up any serious resistance to the everpresent transforming mobility.

— Henri Michaux, "Knowledge Through the Abyss," in *Darkness Moves: An Henri Michaux Anthology, 1927–1984*, trans. David Ball (Berkeley: University of California Press, 1997), 211.

The eyes alone are yet able to shout.

— René Char, *Feuillets d'Hypnos* (1943–44), in *Œuvres complètes*, ed. J. Roudaut (Paris: Gallimard, 1983).

Contents

**II The Disposition Towards Things: Observing
 the Uncanny**

V The Interposition of Fields: Revisiting History

"authentic aura" of things return. "Blizzard-like production" of documentary/hallucinatory images. *Knowledge through the abysses.*

Illumination. Benjamin: *"I bush images."* The child and the scholar: from the regressive gesture to the philosophical gesture. The illumination as a utopic instant of the image. Revolutionary energy. Rimbaud, illuminator of the Commune. The position of surrealism: "automatic exactness" of intoxication, of eroticism, and of the document. Photography and "profane illumination."

Imagination. Temporal and documentary construction of the profane illumination. Hitler, the arrow, and the bison. Brecht vs. Benjamin: the position of the imagination in Baudelaire and Kafka. Major engagement vs. minor position. The two meanings of *Beschreibung* and knowledge through images, according to Benjamin. Aesthetic freedom and the position of the uncanny: a politics of the imagination.

Emancipating the Eyes of History

How can we see time? How does time come to be perceptible, or rendered sensible? These are questions that we might never stop asking, given how every answer, every time, is questioned in turn in the specific duration and condition of visibility of every new experience. It would be far too easy to carry this question to a metaphysical level, in which time would be raised to a kind of idealized "transcendental condition" and where seeing would be lowered to an overly concrete down-to-earth experience, that of a merely immanent, even illusory condition of sensibility. We should not create artificial ontological hierarchies, for this is the trap into which generalist philosophers and careless theoreticians fall. We apprehend time only through our experience of the psyche, of the body, and of the space around us; we find our way around in the visible only through a certain perception of duration, of memory, of desire, of the before and the after: a certain "trembling of time." To separate the visible from time might mean to make certain words clearer, more unequivocal, but in reality that would be to make things—and above all relations—incomprehensible and disembodied. We need therefore to understand how *seeing* and *being in time* are inseparable and are even mutually grasped.

Seeing time—an experience that involves all the necessary contributions of images to the knowledge of history, including political history—is in fact redoubling one's own experience of time, if it is true that seeing "takes time." For seeing *is* time, whatever we do: time given rhythm by the reciprocal movements of the visible and the seer. These movements are complex and never stop. The academic separation between the "arts of time" and the "arts of space" (from which pictorial, sculptural, and photographic images proceed) has to do with a naive and even dangerous simplification. Seeing means first seeing *this* and then, suddenly, seeing *that*. Seeing perpetually

changes the nature of what is seen as well as the constitution of the one who sees it. It is to open the eyes but to close them also (for otherwise the eye would become dry and would die), and so it is to produce the jerky rhythm of an opening and closing of the eyelids. It is to approach (because from too far away, you see nothing) but also to take a step backwards (because you can see nothing of what is too close). It is to stand facing something but also to look at it sideways, and from every direction. Do our eyes not constantly point here and there, in a head that never stops turning left and right, upwards and downwards, driven by a body that never stops moving in space? Isn't to see sometimes also to see through tears, and through emotions in general? Doesn't it mean—in the darkness, for example—to be unable to perceive clearly what appears before us, be it a phenomenon (external and objective) or a phosphene (internal and subjective)?

The challenge in this perpetually moving experience of the visible, and in what it can teach us, consists of not reducing its complexity, of not enclosing what we experience in the realm of the sensible, be it facing an event that we may witness or facing a visual document that bears witness to such an event. It is necessary to be capable, on the theoretical as well as on the practical level, of not *immobilizing* images; that is to say, of not isolating them from their own capacity to make a certain instant, duration, memory, or desire felt or sensible—in short, a certain *human time* in which are joined the objective and subjective dimensions of the time in what we call "history." But there is nothing easy about this task of allowing the sensible and time their lability, their movement, even their turbulence. The obstacles are legion.

For history experts, the temptation to immobilize images—which is a way of simplifying them and thus simplifying things for the historian—can be seen when they are reduced to a merely functional status as "visual documents." The image serves as a mere iconographic appendix in history books, as we can see in what is nonetheless one of the masterworks of the Annales School, Marc Bloch's *The Royal Touch: Sacred Monarchy and Scrofula in England and France.*[1] This is a way of reducing images to

1 M. Bloch, Appendix 2, "Notes on the Iconography," in *The Royal Touch: Sacred Monarchy and Scrofula in England and France*, trans. J. E. Anderson (New York: Routledge, 2015), 253–62.

a function by reducing their function to an imitation of factual reality, a *representation*—an approach to the image that the history and the theory of art since Wölfflin, Warburg, and Riegl (not to mention Walter Benjamin and Carl Einstein) has actively deconstructed.[2] The inheritors of the Annales School certainly gave increasing attention to images as "monuments," not only as documents, of history. More often than not, however, they did so while continuing to embrace a notion of representation that required the reduction of images to a comfortable "mirror of mentalities,"[3] without noting the fact that the mirror in images—and by means of images—is often cracked.

For the experts in visual arts, the epistemological temptation to immobilize seeing and the object of seeing—like the entomologist who kills his favourite butterfly in order to pin it to a corkboard and then can look at it calmly, steadily, with a gaze that is just as dead as the animal itself—is equally strong. We immobilize the object of seeing when we consider it to be above all a text to be deciphered or a puzzle to be solved. Did not Erwin Panofsky see iconography as a discipline intended, by facing images, for "solving the riddle of the sphinx"?[4] But does the supposition that the image contains a key to interpretation, a key that might be capable of opening all its doors, not simplify the image? On the other hand, we immobilize the subject of seeing when we reduce it to some "viewer's place," an immovable site assigned to the viewer, whether it be to confirm to the rule of the perspectivist "viewpoint" of humanism[5] or to establish a system of modernist vision, according to which the visual object should be absolutely

2 G. Didi-Huberman, "Imitation, représentation, fonction: Remarques sur un mythe épistémologique" (1992), in *L'image: Fonctions et usages des images dans l'Occident médiéval*, ed. J. Baschet and J.-C. Schmitt, 59–86 (Paris: Léopard d'Or, 1996).

3 R. Chartier, "Le monde comme représentation," *Annales ESC* 44, no. 6 (1989): 1505–20; C. Ginzburg, "Representation: The Word, the Idea, the Thing," in *Wooden Eyes: Nine Reflections on Distance*, trans. M. Ryle and K. Soper (New York: Columbia University Press, 2001), 63–78; F. Hartog, *Évidence de l'histoire: Ce que voient les historiens* (Paris: Gallimard, 2007).

4 E. Panofsky, *Meaning in the Visual Arts* (Oxford: Oxford University Press, 1939–55; repr., Chicago: University of Chicago Press, 1982), 57.

5 E. Panofsky, *Perspective as Symbolic Form*, trans. C. S. Wood (New York: Zone Books, 1991). This point of view was questioned by H. Damisch in *L'origine de la perspective* (Paris: Flammarion, 1993), 23–36.

"specific" so that the act of seeing rids itself of any duration or "psychology"[6] (which, from our own experience of images, soon appears to be a simple matter of opinion, even a meaningless categorical imperative).

Images are entirely different from butterflies that have been pinned onto a corkboard for the pleasure—a scholarly but perverse and deadly pleasure— of the entomologist. They are at the same time movements and times, un- stoppable and unpredictable. They migrate in space and survive in history, as Aby Warburg said. They transform and change their appearance; they fly here and fly there, appear and disappear in turns. They have their own "lives," and it is those very lives that interest us and "look" at us [regarder], far more than the shedding of a dead skin that they can leave at our disposal. The best way to look at images, then, would be to have the ability to observe them without compromising their freedom of movement; so to look at them or to keep looking at them would not amount to keeping them [garder] for oneself but, on the contrary, to allowing them to be, emancipating them from our own fantasies of "integral seeing," of "universal classification," or of "absolute knowledge." It is in this way—by accepting the risk of a principle of perpetual incompleteness regarding our will to know—that the subjects of seeing can emancipate themselves, to borrow an expression from Jacques Rancière.[7]

We can sense through this vocabulary that an *epistemological* deci- sion relative to images is never without an implication that passes very quickly from the *aesthetic* register to *ethical* questioning and to the *political* position of the problem. To answer the request here to evoke, albeit brief- ly, these passages from knowledge to the sensible—or from knowledge *of* the sensible, or even a sensible knowledge—to the political field, I would have to underline how the notion of position mobilizes all the modalities that I have just listed. What had already struck me in the photographs of "hysterics" taken in 1875 at the Salpêtrière hospital by Charcot and his assistants was that, where we are supposed to have at our disposition visual documents reflecting a purely clinical category, I discovered in reality a

6 M. Fried, *Absorption and Theatricality: Painting and Beholder in the Age of Diderot* (Chicago: University of Chicago Press, 1988).

7 J. Rancière, *The Emancipated Spectator*, trans. G. Elliot (London: Verso, 2009), 7–29.

multitude of *sensible* aspects in each image that tore up its own intelligible alibi for epistemic representation.

These images showed *poses*: typical gestures, "attitudes of passion." Pauses in time and movement. As such, they were susceptible to being synthesized in a tableau that became the rule for the "complete and regular" attack of hysteria, as the doctors used to say.[8] However, by looking more carefully at the images, we discover something else: a supplement, sometimes excessive, that turns upside down any rule of meaning or visibility. They were, first of all, *pauses*: durations. For example, a foot stretched out towards the lens showed, because it was blurred, unlike other parts of the body, that it had stretched out and moved. The blurred area then gave thickness to the duration of the shot, as well as motility to the still image. Furthermore, it showed something of a struggle, a struggle with the photographer's desire: a *counter-pose*. The foot thrown forwards was also a kick directed towards the camera itself. With this gesture of defiance or show of aggression, the patient said—even shouted—*no!* to the procedure that was intended to create visual knowledge of her suffering.[9] In this sense, already we can say that she *took a position* when she was merely being asked to *take a pose*.

Against these medical photographs, which attempted under the guise of objective knowledge to take power over her stricken body (according to a typically fetishistic and alienating visual mechanism), the "hysteric" sometimes made her suffering—a woman's suffering, ethically mistreated under the guise of being "treated" medically—a potential for counter-effectuation. She sometimes *took position*, as though the symptom itself was in those moments equivalent to something like an uprising. Since the "distribution of the sensible" between bodies seen and bodies seeing had become dissymmetrical, alienating, dissensual, it suddenly turned towards insurrectional confrontation. This clarified—thanks in particular to the work of Michel Foucault on the joint history of madness and the clinic—the fact that this first "terrain of images" was already a thoroughly political terrain.

8 G. Didi-Huberman, *Invention of Hysteria: Charcot and the Photographic Iconography of the Salpêtrière*, trans. A. Hartz (Cambridge, MA: MIT Press, 2003), 157–63.

9 G. Didi-Huberman, "'L'observation de Célina' (1876–1880): Esthétique et expérimentation chez Charcot," *Revue internationale de psychopathologie* 4 (1991): 267–80.

It appeared, then, that being in front of the image had nothing to do with comfortably facing something, since the object of seeing never stops moving in space and in time—or, better still, through multiple and heterogeneous times—as though the seeing subject himself does not stop experimenting with new postures or viewpoints. Even in front of the innocent frescoes of Fra Angelico, it was necessary to take position and, notably, to go back up, to go back through, to revisit from top to bottom the conventional hierarchies of high and low, of iconographies and of "decor," of resemblance and dissemblance, of the figure and the place.[10] In relation to three terms that play out among an image, its object (from which the view is constructed) and its subject (who constructs his or her vision), we find everywhere this structural necessity of the position. The photographed "hysteric" did not simply *pose*; she attempted (in the best case) to wrest a *position* from her status as woman-object. The image itself does not merely *take place* within a greater collection—in the pages of a medical journal in the case of the Salpêtrière or the cells of the Dominican convent in the case of Fra Angelico—this place comes from a montage in which each figure assumes its position in relation to all the others.

Finally, unless the seeing subject remains purely passive, he or she cannot accept holding a certain *posture* while facing the image. This subject must therefore construct a *position* that is capable of affirming something of the image, not on the basis of some immobility or univocity of the gaze but on the basis of a regulated variation of the gaze. Consequently, it appears that any position is subject to a dialectical movement. Not a school or textbook dialectic, in which everything ends nicely (as in Hollywood films) with a "synthesis" or "reconciliation," but on the contrary an anxious, endless, unfinishable, unreconciled dialectic. It is this movement, which is sometimes a joyful knowledge and sometimes an anxious knowledge, that was undertaken by a whole generation of modern thinkers—readers of Nietzsche as much as of Hegel—for whom a nonstandard dialectic imagination made it possible to develop positions that were both rigorous

10 G. Didi-Huberman, *Fra Angelico: Dissemblance and Figuration*, trans. J. M. Todd (Chicago: University of Chicago Press, 1995) and *Confronting Images: Questioning the Ends of a Certain History of Art*, trans. J. Goodman (University Park: Pennsylvania State University Press, 2005).

and inventive, observing and critical, near and distanced. And this was before the Frankfurt School and the "negative dialectic" dear to Adorno, whose history has been traced by Martin Jay in a work suggestively titled *Dialectical Imagination*.[11] I am thinking of that constellation created in the first decades of the twentieth century by Aby Warburg, Walter Benjamin, Carl Einstein, and Georges Bataille.[12]

It is not incidental that, among these four personalities—to which it would be possible to add others, of course, such as Ernst Bloch and his magnificent political theory of "wishful images"[13]—two committed suicide out of political despair. It was in 1940, on July 5 for Carl Einstein and on September 26 for Walter Benjamin. Both sought to flee the Nazis after having struggled for years against all forms of fascist ideology in Europe. Aby Warburg died in 1929, four years before Hitler's rise to power, but he had had time to sense the arrival of the catastrophe; we can see this in the last plates of his atlas of images titled *Mnemosyne*, in which the designs of theocracy converge with those of fascist dictatorship against the background of a long history of European anti-Semitism.[14] Georges Bataille, for his part, had searched feverishly between Nietzsche and surrealism for a political way that was not that of fascism or of bourgeois liberalism or of Stalinism (a communist and libertarian way, close enough to what Michael Löwy and Robert Sayre called a "revolutionary romanticism"[15]).

What remains striking in this half-sketched tableau is that all of these thinkers made images the privileged operators—the crystals—of the historical and political dimension. They placed time at the heart of the image

11 M. Jay, *The Dialectical Imagination: A History of the Frankfurt School and the Institute of Social Research, 1923–1950* (Berkeley: University of California Press, 1996).

12 G. Didi-Huberman, *La ressemblance informe, ou le gai savoir visuel selon Georges Bataille* (Paris: Macula, 1995); *Devant le temps: Histoire de l'art et anachronisme des images* (Paris: Minuit, 2000); and *The Surviving Image: Phantoms of Time and Time of Phantoms; Aby Warburg's History of Art*, trans. H. Mendelsohn (University Park: Penn State University Press, 2017).

13 E. Bloch, *The Principle of Hope*, vol. 3, trans. N. Plaice, S. Plaice, and P. Knight (Cambridge, MA: MIT Press, 1986).

14 A. Warburg, *Der Bilderatlas Mnemosyne* (1927–1929), *Gesammelte Schriften* II-1, ed. M. Warnke and C. Brink, 2nd ed. (Berlin: Akademie Verlag, 2003).

15 M. Löwy and R. Sayre, *Esprits de feu: Figures du romantisme anti-capitaliste* (Paris: Éditions du Sandre, 2011).

and the image at the heart of time. Having all carefully read Freud, they understood that an image (be it a mental, literary, or plastic one), beyond showing someone or meaning something, also *manifests a desire*. But it is a desire like all desires, that is to say, one that is complicated by memory. Thus images demonstrate: they rise up, and sometimes make us rise up too. They make manifest the fact that politics is first of all a matter of subjectivation and imagination, of desire and of memory. The fact that they do so in a symptomatic way, as so often occurs, does not prevent them from being basically political, for the very reason that—whether intentionally or not—they *take position* among a thousand and one possible things: reminiscence and forgetting, wish and refusal, public place and private space, reasoning and fantasy, solidary emotion and solitary gesture, knowledge and non-knowledge . . .

In the same year that Georges Bataille began to create that formidable atlas of visual anthropology that became the journal *Documents*—while Warburg was working on his own collection, *Mnemosyne*; while Marc Bloch was working on his journal *Les Annales*; while Walter Benjamin was working on his *Arcades Project*—he published his novel *Story of the Eye* (under a pseudonym, however, given the scandalous nature of this work).[16] In it Bataille expressed a demand that he never abandoned until his last book, *Tears of Eros*[17]: that our eyes open to and expose themselves to the impossible. On the one hand there is erotic fascination and on the other is death itself—or, even more radically, a fascination that risks and that touches death. As though the eye had to be at the same time voracious and devoured. As though desire and mourning danced together. As though vision could only be inconsolable for the image to open up to us, even if we lost many of our philosophical certainties and our moral tranquility.[18]

In this way, Bataille sought to give serious attention to a great Hegelian precept, "to rise to the same level as death," even in the domain of images and in the exercising of the gaze. That is why his first reflections on the

16 G. Bataille, *Story of the Eye* (1928), trans. J. Neugroschal (London: Penguin Classics, 2001).

17 G. Bataille, *Tears of Eros*, trans. P. Connor (San Francisco: City Lights, 1989).

18 G. Didi-Huberman, "L'image ouverte" (1986), in *L'image ouverte: Motifs de l'incarnation dans les arts visuels* (Paris: Gallimard, 2007), 323–50.

unbearable history of the Nazi camps—reflections that were contemporaneous with Robert Antelme's *The Human Race* and Primo Levi's *Is This a Man?*—took the notion of one's fellow as its anthropological anchor point.[19] If Bataille had a position regarding the images of the worst, it was no doubt that of a limit at the heart of the movement of transgression that never stopped animating it. As Michel Foucault writes in his homage to Georges Bataille in 1963, "to contest is to go to the empty core where being reaches its limit and in which the limit defines being."[20] In the image of the rolling eyeball during orgasm or in death—a very present image in Bataille's imaginary—the gaze therefore touches death, its own death, from the inside.

The fact that the fate of the gaze is embodied in the symptom of the rolling eyeball shows us that this dialectic nonetheless resembles a kind of *circulus vitiosus*. Consequently it demands—so that the potential of its fundamental intuition can be experienced along with its limit—to be turned upside down, or at least to be lifted up or made to rise up. The eyes in Bataille's work are fascinated or repelled, orgasmic or dying; they fail to find their freedom. How can this dialectic be turned upside down? In other words, how can the freedom of the eyes be found or regained? By inventing a *position* in which the limit and transgression can have a new relationship, so that the gaze becomes free, becomes emancipated, and rises up. From the many things I learned from the simple (but difficult) endeavour of analyzing four images created by members of the *Sonderkommando* of prisoners in Auschwitz-Birkenau in August 1944, one of them—and in no way the least important—was this: to tear something—albeit something tiny (for example, four shreds)—from the "unimaginable" of the Shoah was in a certain way to show how making an image and rising up in front of history can both come from the same gesture of resistance.[21]

Emancipating the eyes of history. How is this possible? The members of the *Sonderkommando*, slave attendants to the extermination of their own people while they too were sentenced to die, had inscribed in their own project of

19 G. Bataille, "Réflexions sur le bourreau et la victime" (1947), in *Œuvres complètes*, vol. 11 (Paris: Gallimard, 1988), 262-67.

20 M. Foucault, "Préface à la transgression" (1963), in *Dits et écrits, 1954-1988*, vol. 1, *1954-1969*, ed. D. Defert, F. Ewald, and J. Lagrange (Paris: Gallimard, 1994), 238.

21 G. Didi-Huberman, *Images in Spite of All: Four Photographs from Auschwitz*, trans. S. Lillis (Chicago: University of Chicago Press, 2008).

insurrection the seemingly meagre project of taking a few photographs. It is because this insurrectional project was desperate that they had to, by means of visual or written testimonies, transgress the very limits of its condition of impossibility. They had to, in short, extract a freedom photographically—a freedom of the gaze, of testimony—from a total absence of viable perspective. Since they were going to die, they might as well transmit to potential survivors a few shreds of images that might bear witness, partially but in an irrefutable way, to a situation that was so difficult to imagine for the outside world. So it was from the most radical servitude that members of the *Sonderkommando* of Birkenau succeeded in rising up, in producing a free gesture that in turn produced that tiny thing—a six-centimetre-high contact print hidden in a toothpaste tube that was to be smuggled out of the camp—that even today, in front of our eyes, has the status of historical testimony— one that is local but crucial—of the destruction of the Jews in Europe in August 1944.

History has eyes just as a hurricane makes its eye. The four images by the *Sonderkommando* were produced in the "very eye of history."[22] We can say also that they were not only for *seeing* with our own eyes but were to be *seers*, as eyes; they were therefore, at that moment, the very eyes of history. The eye of a hurricane is the zone of relative calm that forms in the very centre of a "cyclonic circulation," that is to say, of a violence so overwhelming that the world is turned upside down while everything is carried away by the winds. Meteorologists insist on warning us that, even if the weather is mild and the winds are calm in the eye of the hurricane, the place is no less dangerous. For the zone immediately contiguous to the eye (called the eyewall) can at any moment propagate the most formidable forces, since they are contradictory and thus push against one another—in the sea, notably, producing enormous chaotic and destructive wave crests.

The fact that the "eye of history" in the precise case of these photographs should have been situated in the most improbable "dark room" (camera obscura)—the gas chamber of Crematorium V in Birkenau, only just emptied of corpses that, in the image, we see burning in open-air pits organized by the Nazis—was sometimes difficult to face. But the terrible paradox was indeed there. This gas chamber was, for a precise moment, the

22 Ibid., 30–40.

only place in which the member of the *Sonderkommando* could hide from the SS guards. In the darkness and the provisory calm of this eye of the hurricane, he was able to remove his camera from the bucket in which he had hidden it and lift it to his face to produce an image that was correctly framed, not blurred and disoriented like the photographs for which he had no retreat into such a place. Thus the eyewall protected him for a few seconds before unleashing its mortal violence on a new convoy of Jews who were already on their way to death.

This, in any case (even if presented somewhat briefly), is how the model of the *Story [Histoire] of the Eye*, animated by hypotheses to sketch a historical anthropology of the gaze and of the imagination, continued in a project titled *The Eye of History*, whose heuristic required the examination of a certain variety or multiplicity of cases.[23] Eyes of history therefore, where seeing could both deepen and critique historical knowledge, where examining time would permit us both to historicize and to critique images. Gazes cast here, there, or elsewhere, but certainly not everywhere. Transverse explorations, hypothetical montages, unexpected meetings with unusual objects. Multifaceted and imminent approaches, relearning each time—from each object and each case—the method to be followed in order to do justice to the complexity of images, gazes, and times.

No doubt the eyes of history do not see all. But the visual archive of times past—and even the present—is of such extraordinary fragility and transience. We make a lot of images (too many, even), but we destroy so many too. Just as any archival document is limited to its circumstances, its utterance value, the chances that it has or has not been fully conserved, an image is never more than the remains of a world, even if it is able to create its own world. This encourages humility when facing it and when facing the world. But the eyes of history bear witness, in spite of all. To what do they bear witness? First, to a certain condition of the *place*; for example, the courtyard of the Salpêtrière that we glimpse in the background of one image of a "hysteric" that tells us that, her attack having begun, her bed has been pulled out into the open air for more light for a better photo, and too bad

23 G. Didi-Huberman, *L'œil de l'histoire* (Paris: Minuit, 2009-16).

for the ethics of medical confidentiality or basic decency. It is also a way to bear witness to a certain condition of *time*, as well as a certain condition of the *medium*, with all of this mixed with the body of the woman herself, her gestures, and therefore the relationship that the doctors sought to create with her, a relationship of conflict when the rules of the social game became alienating and even intolerable.

The eyes of history, therefore, reveal something of the space and the time that they see. This implies re-spatializing and re-temporalizing our way of looking. Many things, of course, escape us when we face images; often we can only make hypotheses regarding what is off-camera, for example, or whether a gesture immobilized by a drawing or photograph is beginning or ending (these questions continue, differently, with cinema). We only have to take our time to see the emergence from an image, however enigmatic that image might be, of a kind of *morphology*. I often feel, when facing an image, as though I am in front of some unknown flower at an unknown stage of its transformation. As Walter Benjamin writes, with an intuition worthy of Goethe, the visual world, which is inevitably empirical, brings original phenomena into bloom somewhere—an anachronistic or heterochronistic *somewhere*—between the temporality of a "prehistory" and a "post-history."[24]

It sometimes happens that images are fertile: fertilized by the eyes of history, for only our vision and our thinking bear such potential. Then we find ourselves in front of images as we do in front of those "original phenomena," in which we have to understand, through patience, what Benjamin called "rhythm," stating that he used the word to refer to an authentic "dialectic" configuration.[25] What does this mean, other than that a dual viewpoint regarding every dimension of every visual event has to be found every time: a viewpoint that is sensitive both to the discontinuities of images (their emergence, their character as monads) and to their networks of temporal or spatial contextualities (their eternal return as survivals, their character as migrations or montages)? Decidedly, the eyes of history cannot be reduced to mere organs of perception. They think, they look with words

24 W. Benjamin, *The Origin of German Tragic Drama* (1928), trans J. Osborne (New York: Verso, 2009), 45.

25 Ibid., 46.

and phrases, they note and they compare, they stir and they elaborate; in short, they form—jointly with the "order of discourse" that Michel Foucault spoke of—a genuine medium of knowledge about man and history.

Finally, images *participate in a gesture*. To say this is to recognize their fundamental anthropological tenor, which Aby Warburg continuously examined through the notion of "pathos formulae."[26] When René Char, for his part, writes that "the eyes alone are capable of letting out a cry,"[27] we can understand, above all when we recall the historical context in which this phrase (in *Feuillets d'Hypnos*) was written—while he was with the French Resistance during the Nazi occupation. We might even wish to open this phrase to the idea that the eyes are also capable of resisting and of rising up, of breaking away from the intolerable injustice of the world, even if it is only through image-making.

The photographic image snatched from hell by the member of the *Sonderkommando* (his companions called him "Alex," and while his identity has for a long time been in doubt, he was quite probably a Greek Jew, a soldier and resistance fighter named Alberto Errera) helped in no way on the level of armed resistance against the crushing power of the SS. It did not protect him from death. He knew this from the start, yet he took the risk of doing it. And we cannot claim, therefore, that it was completely useless, or that it ended up as merely a visual document of the incineration pits in that part of the camp in the summer of 1944. This image—or rather this series of four images, which are inseparable—bears within it, upon it, the very conditions of its own gesture; it is enough to see it, to look beyond its mere representative "content." The framing, the blur, the contrast, the sequence, the orientation, and in general all the intrinsic characteristics of an image tell us that to make an image is, fundamentally, to make a gesture that *transforms time*. It is perhaps not to "act" directly, in the sense of action or political activism, but it is nonetheless to act in history and on history, in the humblest or the most resounding way.

If I have taken the liberty to return, in these introductory words, to an almost twenty-year-old study, it is because the photographs by the

26 Didi-Huberman, *Surviving Image*, 115–270.
27 R. Char, *Feuillets d'Hypnos* (1943–44), in *Œuvres complètes*, ed. J. Roudaut (Paris: Gallimard, 1983), 200.

Sonderkommando of Auschwitz-Birkenau represent an extreme example for any notion of visual testimony and its political impact. It is also because it was, for me, a crucial opportunity to examine more explicitly the position that the eyes of an ethical subject (even in the depths of sadness) and then the images themselves (even in their most improbable viability) are capable of adopting, in spite of everything, *in front of history*. In examining this question, Aby Warburg helped us to understand that once images are analyzed in detail, then compared and "reassembled" in an atlas, they allow us to grasp the very dialectic of history; they are like the *seers* of this "tragedy" or "psychomachia" that he felt was alive in the rhythm of a great struggle between the *monstra* of barbarity and the *astra* of emancipation.

The tragedy is not always inevitable. In his films, Sergei Eisenstein exposed magnificently just how the burden of mourning could transform into a revolutionary uprising. Bertolt Brecht showed, in his own "photo-epigrammatic" montages, how it was possible to invent dialectic images capable of making, from the documents of modern barbarity, great subversive and lyrical poems. Agustí Centelles succeeded, by photographing his unlucky companions in the Bram camp in 1939, in transforming humiliation into a process of emancipation. Samuel Fuller, filming the liberation of the Falkenau camp in 1945, crossed from the abjection of the concentration camp system all the way to a certain dignity in front of the dead. Pier Paolo Pasolini was able to make an extraordinary joy rise up among the pariahs of modern society, approached through the mixed youth and antiquity of their gestures. Jean-Luc Godard designed his *Histoire(s) du cinema* as a renewed art of the cinema of history (or histories). Harun Farocki was able to revisit and reassemble (*remonter* in French) the images of war in order to deconstruct within them different aspects of the universal war of images in which our contemporary societies live.[28]

There are, of course, innumerable other cases towards which we can turn, from the largest images (such as Picasso's *Guernica*) to the tiniest among them (such as the tract drawn up quickly during the Warsaw ghetto uprising). Many of these images, in the West at least, "turned their eyes" towards the crucial moment in political iconography that was Francisco

28 Didi-Huberman, *L'œil de l'histoire*, passim.

Goya's *Disasters*, as well as his *Caprichos*. From that moment on, which was both enlightenment (of reason) and chiaroscuro (of the image and of imagination), the eyes of history were more often opened and politically determined—for *making visible* to work with critiquing, for *seeing* to go with railing against injustice—and, inversely, for the desire for emancipation to be made sensible. The emancipated eyes of history, free to see history as it enchains us, free to shout in front of that and to free critique, free to see in that very history the chance to imagine or to *foresee* our freedom.

I

The Position of the Exiled

Exposing the War

Exile

In order to know, we must take position. There is nothing simple about such a gesture. To take position means to situate oneself at least twice and on at least two of the fronts included in any position, for every position is inevitably relative. It is, for example, a question of facing something, but in front of that thing we must also take into account everything we turn away from—that which is outside of the frame, behind us, that which we might refuse but that conditions, for the most part, our very movement and therefore our position. It is also a question of situating oneself in time. To take a position is to desire, to demand something, to situate oneself in the present and to aim for a future. Yet all of this exists only on the basis of a temporality that precedes us, encompasses us, and appeals to our memory and even to our attempts to forget, to break away, and to reach the absolutely new. In order to know, we have to know what we want, but also where our non-knowledge, our latent fears, and our unconscious desires are situated. To know, we must therefore take account of at least two resistances, or two meanings in the word *resistance*: the meaning that expresses our philosophical or political desire to break the barriers of opinion (this is the resistance that says no to this and yes to that) as well as the meaning that expresses our psychological tendency to build other barriers in the always profoundly dangerous access to our desire to know (this is the resistance that no longer really knows what it approves and what it renounces).

In order to know, then, we must occupy two spaces and two temporalities at the same time. We must *become involved* and agree to enter, to face, to go to the heart of it, without weaving, without concluding. We must also violently step back in the conflict, or slightly, like the painter who steps back from the

canvas in order to know better where he stands in his work. Nothing can be known in pure immersion, when one is in oneself, on the grounds of being *too close*. Nothing can be known either in pure abstraction, in lofty transcendence, high up in the skies being *too far away*. To know, we must take a position, which involves moving ourselves and constantly assuming the responsibility of such movement. This movement is an approach as well as a step back; it is a reserved approach, a step back from desire. It implies a contact, but one that is uninterrupted, if not broken, lost, or wholly impossible.

That is the position of the person in exile, somewhere between what Adorno called "mutilated life" (where we suffer a cruel lack of contact) and the very possibility of a life of thought (where, in the gaze itself, distance requires us). "One day, the history of the 20th century will have to be reread through the prism of exile," writes Enzo Traverso in the first pages of his recent wonderful book on "dispersed thought," *La pensée dispersée*.[1] It is, in any case, from their situations in exile that many artists, writers, and thinkers have tried to understand—and even to reply to—the new historical configuration that was harshly imposed upon them from the early 1930s.[2] The case of Bertolt Brecht, from this perspective, appears exemplary: his exile began on February 28, 1933, the day after the fire at the Reichstag. From that moment on he wandered from Prague to Paris and from London to Moscow; settled in Svendborg in Denmark; passed through Stockholm to Finland; travelled on to Leningrad, then Moscow and Vladivostok; settled in Los Angeles and sojourned in New York; left the United States the day after testifying before the House Un-American Activities Committee; and ended up in Zurich again before finally returning, definitively, to Berlin.[3] He did not return to Germany until 1948 and therefore

1 E. Traverso, *La pensée dispersée: Figures de l'exil judéo-allemand* (Paris: Éditions Lignes et Manifeste/Léo Scheer, 2004), 7.

2 See, in particular, H. Möller, *Exodus der Kultur: Schriftsteller, Wissenschaftler und Künstler in der Emigration nach 1933* (Munich: C. H. Beck, 1984); J.-M. Palmier, *Weimar en exil: Le destin de l'émigration intellectuelle allemande antinazie en Europe et aux États-Unis* (Paris: Payot, 1988), vol. 1, 325–91, 437–528; vol. 2, 7–77; E. Böhne and W. Motskau-Valeton, eds., *Die Künste und die Wissenschaften im Exil, 1933–1945* (Gerlingen: Lambert Schneider, 1992).

3 For a precise account of Brecht's exile between 1933 and 1948, cf. W. Hecht, *Brecht Chronik, 1898–1956* (Frankfurt: Suhrkamp, 1997), 347–796. See also K. Schuhmann and J. Räuber, eds., *"Das letzte Wort ist noch gesprochen": Bertolt Brecht im Exil, 1933–1948* (Leipzig: Deitsche Bücherei, 1998). On Brecht's exile in the United States, cf. B. Cook, *Brecht in Exile* (New York: Holt, Rinehart & Winston, 1982); A. Heilbut, *Exiled in Paradise: German Refugee*

spent fifteen years of his life "without a theatre, often without money, living in a country whose language was not his own,"[4] between welcome and hostility (the hostility of the McCarthy trials that he had to endure in America).

Yet, despite these difficulties and despite daily tragedies, Brecht managed to make of his situation in exile a *position*, and to make of his position a work of writing and, above all, of thinking—a heuristics of the history that he was going through, the war, and his uncertainty about any future. Exposed to the war but neither too close (he was not mobilized on the battlefields) nor too far away (he had to suffer, although from afar, the numerous consequences of this situation), Brecht undertook an approach to the war, an *exposition* of the war, that was at the same time a knowledge, a position-taking, and an absolutely decisive collection of aesthetic choices.

It is striking that Brecht in exile is also the mature Brecht: the Brecht of the masterpieces, of *The Threepenny Novel*, *Fear and Misery of the Third Reich*, *The Life of Galileo*, *Buying Brass*, *Mr. Puntila and His Man Matti*, *The Caucasian Chalk Circle*, and others. It is also striking (though quite understandable) that in such a precarious situation the playwright should have turned to producing small lyrical forms: "at present," he wrote in his diary on August 19, 1940, while in Finland, "all I can write is these little epigrams, first eight-liners, and now only four-liners."[5] The writer in exile is obliged to take this position, as he is always ready to pack his bags, to go somewhere else. He can do nothing that will weigh him down or slow him down too much, and must reduce the formats and rhythm of his writing, lighten any collections, and assume the de-territorialized position of a poetry in war, or *war poetry*. Moreover, it is an abundant, exploratory, and prismatic poetry: far from withdrawing into elegy, far from giving in to any notion of nostalgia, the writer multiplied choices of form and viewpoints, ceaselessly calling upon all of lyrical memory—from Dante to Shakespeare, to Kleist, to Schiller—and experimenting continuously with new genres that he called "chronicles," "satires," "studies," "ballads," or "children's songs."[6]

Artists and Intellectuals in America (New York: Viking, 1983), 175–94; Palmier, *Weimar en exil*, vol. 2, 392–99.

4 B. Dort, *Lecture de Brecht* (Paris: Le Seuil, 1972), 106.

5 B. Brecht, *Journals, 1934–1955*, trans. H. Rorrison (New York: Routledge, 1996), 89.

6 Ibid.; see Brecht's poetry collections from 1934 to 1941. On this lyrical turning point in Brecht's writing during his exile, see C. Bohnert, *Brechts Lyrik im Kontext: Zyklen und Exil*

Throughout these passing or cyclical forms, it was a question of taking positions and of knowing what was going on in the surrounding context—a military, political, and historical situation. While Brecht's positions seem today, more than ever, "outmoded,"[7] it is worth remarking on how much they agreed with those of Walter Benjamin, his privileged interlocutor,[8] who saw in Brecht the characteristics of a "writing of exile" capable of keeping within its formal demands while directly intervening in political analyses and positions.[9] Even when it is playful and witty, Brecht's writing of exile always invites reflection on the contemporary world, for example, in this little fragment from *Flüchtlingsgespräche*: "The passport is the most noble part of man. Moreover, a passport is not made as simply as a man is made. One can make a man anywhere at all, as carelessly as possible and without any reasonable excuse; but not a passport."[10]

Journal

To take a position, one must in general avoid a certain number of things. When Brecht, in August 1940, assumed the position of one in exile—to the extent that all he could write was "these little epigrams"—he didn't just bury his head under the pillow. He devoured all the newspapers that he could get his hands on; anywhere in Europe, and even using the German press, he arranged to keep up with

(Königsberg: Athenäum, 1982); G. Banu, "Faut-il partir? Faut-il revenir? Les poèmes de l'exil," in *Avec Brecht*, ed. G. Banu and D. Guénoun (Arles: Actes-sud/Académie expérimentale des théâtres, 1999), 109–22.

7 B. Dort, "La traversée du désert: Brecht en France dans les années quatre-vingt," in *Brecht après la chute: Confessions, mémoires, analyses*, ed. W. Storch (Paris: L'Arche, 1993), 122.

8 Walter Benjamin joined Brecht three times—in 1934, 1936, and 1938—at his houses in exile. On their friendship, see B. Dort, "Walter Benjamin et l'exigence brechtienne" (1969), in *Théâtre réel: Essais de critique, 1967–1970* (Paris: Le Seuil, 1971), 129–34; and above all, E. Wizisla, *Benjamin und Brecht: Die Geschichte einer Freundschaft* (Frankfurt: Suhrkamp, 2004).

9 W. Benjamin, "The Land Where the Proletariat May Not Be Mentioned: The Premiere of Eight One-Act Plays by Brecht" (1938), trans. E. Jephcott, H. Eiland, et al., in *Selected Writings*, vol. 3, *1935–1938*, ed. H. Eiland and M. W. Jennings (Cambridge, MA: Harvard University Press, 2002), 330: "The émigré theater must focus exclusively on political drama. . . . More than anyone else, Brecht was always starting afresh. This, incidentally, is what marks him as a dialectician."

10 B. Brecht, *Dialogues d'exilés* (1940–41), trans. G. Badia and J. Baudrillard (Paris: L'Arche, 1972), 9.

current events. On that day he cut out a map of England that was eloquently titled "Kriegsschauplatz," the "theatre of war." On it we see that after the Battle of France, the Luftwaffe planes identified their military objectives by locating aerodromes, munitions factories, harbours, transport infrastructure, and fuel depots (fig. 1.1).[11] In front of this Brecht writes: "it's like having a cloud of dust blown in one's face . . . this is all *in-between time*"—somewhere between his contemplative solitude and the active multitude on the battlefields, somewhere between "Hitler's current victories" and the hope that England would stand.[12]

Starting in 1939, Brecht wrote a few forceful poems under the title "German War Primer."[13] However, his sometimes ironic, sometimes rebellious tone never avoids considering, quite seriously, the knowledge that must be deployed in order to do a poet's work. "I think God himself stays informed about the world in no other way than by reading the newspapers," he wrote before 1933.[14] He had intended to create an aesthetic and political journal with Walter Benjamin, titled *Krisis und Kritik*.[15] He wrote to Karl Kraus. He had a theory of radio.[16] He had begun, above all, to assume his position as a modern artist, at a time when the Cubists had already used newspapers widely in their works.[17] Following the butchery of the First World War, the Dadaists had had fun deconstructing poetically the very notion of information through the medium of the press, by suggesting cutting it up into a thousand pieces, as Tristan Tzara says in *Pour faire un poème dadaïste*, written in 1920:

11 Brecht, *Journals*, 89.

12 Ibid., 88.

13 B. Brecht, "From *A German War Primer*," trans. H. R. Hays, in *War and the Pity of War*, ed. N. Philip (New York: Clarion, 1998), 19.

14 B. Brecht, "Sur l'art ancien et l'art nouveau" (1920–33), trans. J.-L. Lebrave and J.-P. Lefebvre, in *Écrits sur la littérature et l'art*, vol. 1, *Sur le cinéma* (Paris: L'Arche, 1970), 54.

15 Ibid., 93–95; W. Benjamin, *The Correspondence of Walter Benjamin, 1910–1940*, trans. M. R. Jacobson and E. M. Jacobson (Chicago: University of Chicago Press, 1994), 368; W. Benjamin, *Fragments philosophiques, politiques, critiques, littéraires*, trans. C. Jouanlanne and J.-F. Poirier (Paris: PUF, 2001), 226–27. See Wizisla, *Benjamin und Brecht*, 115–63, 289–327; J.-M. Palmier, *Walter Benjamin: Le chiffonnier, l'Ange et le Petit Bossu; Esthétique et politique chez Walter Benjamin* (Paris: Klincksiek, 2006), 594–604.

16 B. Brecht, "Part II: Texts on Radio Broadcasting (1926–1932)," in *Bertolt Brecht on Film and Radio*, trans. M. Silberman (New York: Bloomsbury, 2000), 33–49. See also the study by H.-C. von Herrmann, *Sang der Maschinen: Brechts Medienästhetik* (Munich: Wilhelm Fink, 1996).

17 See A. Baldassari, *Picasso: Papiers journaux* (Paris: Musée Picasso-Tallandier, 2003).

Figure 1.1

Bertolt Brecht, *Arbeitsjournal*, August 19, 1940: "Theater of War: the island. Attacks by sea and by air." © Berlin: Akademie der Künste, Bertolt-Brecht-Archiv (277/35)/Bertolt-Brecht-Erben/Suhrkamp Verlag 1973.

Take a newspaper.

Take a scissors.

Select an article in this newspaper of the same length that you intend to give to your poem.

Cut out the article.

Then carefully cut out each of the words that make up this article and place them in a bag.

Shake it gently.

Then take out each cutting one after the other.

Carefully write them down in the order that they came out of the bag.

The poem will resemble you.

And there you are, a writer who is endlessly original with a charming sensibility, although misunderstood by the common people![18]

Two years later, Bertolt Brecht sketched the following poem:

Why does nobody print in the newspapers
That life is good! Hail, Mary:
How good it is to piss over piano chords
How divine it is embrace in the reeds blown wild in the wind.[19]

In this way, Brecht took a position in the ongoing debate on literary and artistic modernity. It was a question for him (and for many others) of renouncing the vain pretentions of a literature "for eternity" and of adopting, on the contrary, a more direct relationship with historical and political actuality.[20] His friend Tretyakov spoke of "revolutionary literature" in the cinematographic and counter-informative terms of "new reports," whereby

18 T. Tzara, "Pour faire un poème dadaïste" (1920), in Œuvres complètes, vol. 1, *1912–1924*, ed. H. Béhar (Paris: Flammarion, 1975), 382.

19 B. Brecht, "Pourquoi personne n'imprime dans les journaux . . ." (1922), trans. L.-C. Sirjacq, in *De la seduction des anges: Poèmes et textes érotiques* (Paris: L'Arche, 1996), 27.

20 See J. Jourdheuil, "Le jeune Brecht dans les années vingt: Prendre la mesure de l'époque," in *Le théâtre, l'artiste, l'état,* 91–117 (Paris: Hachette, 1979); M. Vanoosthuyse, "Une littérature dans le siècle," in *Brecht 98: Poétique et politique,* ed. M. Vanoosthuyse, 9–19 (Montpellier: Paul Valéry University, 1999).

the poet was to keep "closer to the newspaper" than he ever had before.[21] Such a position could obviously not avoid critique by a press that, throughout Europe, had already fallen into the hands of financial powers and political corruption. At the time, Karl Kraus's entire oeuvre appeared to be a superb accusation against this "manufacturing of the event" by a journalism enslaved by the interests of the powerful. Newspapers, said Kraus, did not stop "publishing"—that is to say, "marketing" (*bringen*)—their disfigured and poorly conceived merchandise; one therefore had to continually "liquidate" (*umbringen*) that system.[22] In 1929 Joseph Roth wrote the following:

> If the newspaper were as immediate, as sobering, as rich, as easily controllable as reality, then it could no doubt, like reality, communicate genuine experiences. Only it gives a reality that is not sure, that is filtered—and a reality that is given form in an insufficient way, which is to say, consequently that it is a falsified reality. For there is no other objectivity than artistic objectivity. That alone can show a state of things that is compatible with reality.[23]

Against the "slave morality of the newspaper" and its endless capacity to falsify—as Ernst Bloch wrote in 1935 in *Heritage of Our Times*[24]—some artists endeavoured to *decompose* this falsified "shaping" of the newspapers and, in a new composition of montages for their own accounts, to recompose, reassemble, and re-edit the factual elements delivered by the illustrated press or the newsreels. It suffices to recall the photomontages of the Dadaists—which, beyond embracing non-sense, often work like political allegories[25]—before the arrival of John Heartfield, whom Brecht praised in 1951 by speaking of a "social critique" (*Gesellschaftskritik*) administered by

21 S. Tretyakov, "Plus près du journal" and "A travers des lunettes embuées" (1929), trans. D. Konopnicki, in *Dans le front de gauche de l'art*, 124-26, 131-38 (Paris: François Maspero, 1977).
22 See J. Bouveresse, *Schmock ou le triomphe du journalisme: La grande bataille de Karl Kraus* (Paris: Le Seuil, 2001), 9-11 (with a translation into French of Kraus's *Song of the Press*).
23 J. Roth, "Die Tagespresse als Erlebnis: Eine Frage an deutscher Dichter" (1929), cited and translated in ibid., 139.
24 E. Bloch, *Heritage of Our Times* (1962), trans. N. Plaice and S. Plaice (Cambridge: Polity Press, 1991), 70-74.
25 See H. Bergius, *Montage und Metamechanik; Dada Berlin: Artistik von Polaritäten* (Berlin: Mann, 2000), 130-59.

the "medium of art" (*Kunstmittel*).[26] We can think also of that "radical film society" that Siegfried Kracauer spoke of in 1931: it had "made an attempt to use archival material to put together a newsreel that really penetrated into our circumstances. It was subjected to censorship and lived only a short life. In any case, this experiment teaches us that simply by arranging the standard newsreel differently, one can make it more incisive."[27]

Work

The position of the exiled person makes that incisive "power of vision" (*Schaukraft*) as vital and necessary as it is problematic, inasmuch as it is devoted to distance and information gaps. If Brecht wrote in August 1940 that it felt "like having a cloud of dust blown in one's face" upon merely opening his manuscript of aesthetic writings on theatre, it was because the military news—which burned with the smoke of bombs and the dust of ruins—had already shocked his view of everything.[28] The *Arbeitsjournal*, or "working journal," in which he shared his feelings was in effect a private *Kriegsschauplatz*, a theatre of war played out on his desk by the strange history of his own wandering life, the invented stories of his own playwriting, and the political history playing out in the world, far away but touching him so closely through the newspapers he carefully read, cut out, and methodically reassembled day after day.

It is often said that the title *Arbeitsjournal* was chosen by Helene Weigel, Brecht's partner, to accentuate its literary character and to justify the disappearance of some more intimate elements—whether sexual or sentimental—such as the writer's travels with Ruth Berlau between 1942 and 1947.[29] But this is not what is most important. The notion of *Arbeitsjournal* is fully justified indeed if we take account of the actual *work*—in the artisanal, artistic, conceptual, and even psychological and Freudian senses—found

26 B. Brecht, Preface (1951), in *John Heartfield und die Kunst der Fotomontage* (Berlin: Akademie der Künste, 1957), 5.

27 S. Kracauer, "The Weekly Newsreels," trans. A. H. Bush, in *The Promise of Cinema: German Film Theory, 1907-1933*, ed. A. Kaes, N. Baer, and M. Cowan (Oakland: University of California Press, 2016), 72.

28 Brecht, *Journals*, 88.

29 See G. Meyer, *Ruth Berlau: Fotografin an Brechts Seite* (Munich: Propyläen, 2003), 68–129.

in this extraordinary oeuvre. It is a journal in which all the different dimensions of Brecht's thinking are constructed together, even if only to contradict one another. It is a permanent work-in-progress, a *working progress* of reflection and imagination, of research and discovery, of writing and of the image.

All the different notions of *journal* and *diary* are gathered together here, including their competing meanings: on the one hand, the *Tagebuch*, the "book of days" or private journal, and on the other hand, the *Tageblatt*, the *Zeitung*, or the *Anzeiger*—that is to say the daily newspaper—all that gathered perhaps in Brecht's mind.[30] Brecht's construction site of writing deployed between 1938 and 1955—essentially during his years in exile—goes well beyond the limits of the private journal in its romantic and modern sense. Against the traditional interpretation by Ralph-Rainer Wuthenow, for example, Jacques Le Rider saw in Brecht's *Arbeitsjournal* a firm "will to renew the traditional form of the journal."[31]

It is true that Brecht wrote private journals in the strict sense of the term.[32] But the *Arbeitsjournal* brings something quite different into play, for it constantly confronts the stories of a subject (minuscule stories, after all) with the history of the whole world—History itself. Like many of Brecht's works, it immediately poses the problem of historicity over any questions of intimacy and actuality.[33] But it still breaks the strict chronology by means of a network of anachronisms taken from his own montages or constructions of hypotheses. It belongs, therefore, more to that essentially modern genre that we might call the "thinking journal," which we find in Nietzsche, Aby Warburg, Hofmannsthal, Karl Kraus, Franz Kafka, Hermann Broch, Ludwig Wittgenstein, Robert Musil, and Hannah

30 For the German edition of Brecht's "journals," see B. Brecht, *Werke*, vols. 26–27, *Journale, 1913–1955*, ed. W. Hecht, J. Knopf, W. Mittenzwei, and K.-D. Müller (Berlin: Suhrkamp, 1994-95). On the *Arbeitsjournal*, see in particular M. Morley, "Brecht's *Arbeitsjournal*: A Rejoinder," *German Quarterly* 48, no. 2 (1975): 229–33; R. Jost, "Journale," in *Brecht Handbuch*, vol. 4, *Schriften, Journale, Briefe*, ed. J. Knopf (Stuttgart: Metzler, 2003), 424–40.

31 J. Le Rider, "Brecht intime? Retour sur les journaux personnels," in Vanoosthuyse, *Brecht 98*, 317. See R.-R. Wuthenow, *Europäische Tagebücher: Eigenart, Formen, Entwicklung* (Darmstadt: Wissenschaftliche Buchgesellschaft, 1990), 185–88.

32 B. Brecht, *Diaries, 1920–1922*, trans. J. Willett (London: Eyre Methuen, 1979).

33 See F. Jameson, "Modernity–Actuality–Historicity," in *Brecht and Method*, 165–79 (London: Verso, 1998).

Arendt, for example.[34] This type of journal is less a chronicle of the days that pass, with their anecdotes and accompanying sensations, than a temporarily disordered workshop or an editing room in which a writer's entire work takes shape and is thought out.

This is a far cry from the "journal of chatter in which the 'I' pours itself out and consoles itself," or from the trap set so often by the form of the private journal, a form that is seemingly "so easy, so obliging and, sometimes, so displeasing because of the pleasant rumination on oneself" that it enjoys at the expense of the writing or the work.[35] If Kafka's *Diaries*—that montage of notes and thoughts, sketches and images—appeared so exemplary to Maurice Blanchot, it was because it succeeded in being written beyond any factual consignment or anecdotal description, capable as it was of breaking the link between speech and the *I* that expresses itself through speech; in such conditions the true writer "can keep the diary only of the work that he does not write," that he will never write or has not yet written.[36] It is what Michel Foucault would later call the work of *hupomnêmata*—"a collection of things read and heard, and a support for exercises of thought . . . through the appropriation, the unification, and the subjectivation of a fragmentary and selected already-said"—in self-writing.[37] It is what Gilles Deleuze would call a writing of "impersonal singularity":

> To write is not to recount one's memories, one's travels, one's loves and griefs, one's dreams and phantasms . . . Literature takes the opposite path, and exists only by discovering under the apparent people the power of an impersonal which is in no way a generality, but a singularity to the greatest extent: . . .

34 See J. Le Rider, *Journaux intimes viennois* (Paris: PUF, 2000). See in particular R. Musil, *Diaries, 1899-1941*, trans. P. Payne (New York: Basic Books, 1998); H. Arendt, *Denktagebuch* (1950-73) (Munich: Piper, 2002); or the astonishing "collective journal" of the Warburg Library, written in Hamburg between 1926 and 1929: A. Warburg, *Gesammelte Schriften*, vol. 7, *Tagebuch der Kulturwissenschftlichen Bibliothek Warburg* (1926-29), ed. K. Michels and C. Schoell-Glass (Berlin: Akademie, 2001).

35 M. Blanchot, *The Book to Come*, trans. C. Mandell (Stanford, CA: Stanford University Press, 2003), 185, 186.

36 Ibid., 187. See also M. Blanchot, "La solitude essentielle" (1953), in *L'Espace littéraire* (Paris: Gallimard, 1955), 20.

37 M. Foucault, "Self Writing," trans. R. Hurley, ed. P. Rabinow (London: Penguin, 2000), 221.

literature does not begin until a third person is born within us who strips us of the power to say I.[38]

Brecht had already written this in his own way in his *Arbeitsjournal* on April 24, 1941:

> that these jottings contain so little that is personal comes not only from the fact that i myself am not very interested in personal matters (and don't really have at my disposal a satisfactory mode of presenting them) but mainly from the fact that from the beginning i anticipated having to take them across frontiers whose number and quality it was impossible to predict. this last thought prevents me from choosing any other than literary topics.[39]

The *Arbeitsjournal* offers, then, to create passages and to cross frontiers. Was it not vital, to someone who found it so difficult to obtain a passport, to think "outside of any customs duty," as Aby Warburg one day claimed? Brecht's journal of exile is therefore a methodical exercise of *freedom of transit*. While he experienced a worrying "in-between time" in 1940, Brecht gave himself sovereignty over the game, in the linking, in the jump, the link between levels of reality that seem completely opposed. On April 17, 1940, he noted his departure "to finland by ship, leaving behind furniture, books, etc.," but he did not neglect to write a little lyrical quatrain for his friend the painter Hans Tombrock.[40] On June 29 and 30 of the same year, he registered both his difficulty obtaining a visa—since it was "getting hot" for him and his friends—and the impossibility of "finish[ing] a play properly without a stage."[41] In July he noted that "many now envisage an imminent victory for german fascism, and with it a victory for fascism in general in europe (if not further)," while also remarking how, around him, "these light nights are very beautiful."[42] While in London "fires from yesterday's and the day

38 G. Deleuze, *Critique et clinique* (Paris: Minuit, 1993), 12-13.
39 Brecht, *Journals*, 144.
40 Ibid., 53.
41 Ibid., 73.
42 Ibid., 78.

before's bombing [were] still raging," on September 10 and 12, 1940, he reflected on the fact that "nothing is more foreign to art than trying 'to make something out of nothing.'"[43] On the 16th he wrote in his *Arbeitsjournal*:

> it would be unbelievably difficult to express my state of mind as i follow the battle of britain on the wireless and in the awful finnish-swedish papers and then write PUNTILA. this intellectual phenomenon explains both that such wars can exist and that literary works can still be produced. puntila means hardly anything to me, the war everything; about puntila i can write virtually anything, about the war, nothing. and I don't just mean "may," but truly "can."
>
> it is interesting how remote literature as a practical activity is from the centres where decisive events take place.[44]

War

The *Arbeitsjournal* is, then, a war journal indeed, bearing all the difficulties that this entails. It is in no way a "book on nothing," as Gérard Genette says of the "journal" in general.[45] While it constantly requires "self-consciousness," it is not so much the relation of self to self that is the principal aim, as Georges Poulet says regarding the romantic journal.[46] If it expresses intimacy, that is not because it seeks within it its *refuge matriciel*, or protecting womb; on the contrary, it seeks only an "open form" that can burst through the dividing lines between the private and history, fiction and the document, literature and the rest.[47] If there is indeed a "genesis of self" at work,[48] it seeks to "descend into the intimacy of the individual," as Pierre Pachet writes, in order to "separate it from itself, and to link it with itself by means of what is most collective, most universal, most impersonal—that is, language."[49]

43 Ibid., 96.

44 Ibid., 97.

45 G. Genette, "Le journal, l'antijournal" (1981), in *Figures IV* (Paris: Le Seuil, 1999), 344.

46 See G. Poulet, *Entre moi et moi: Essais critiques sur la conscience de soi* (Paris: José Corti, 1977), 9–39. See also A. Girard, *Le journal intime* (Paris: PUF, 1986); J. Rousset, *Le lecteur intime: De Balzac au journal* (Paris: José Corti, 1986), 18–218.

47 See B. Didier, *Le journal intime* (Paris: PUF, 1976), 187–93.

48 See P. Lejeune, *Les brouillons de soi* (Paris: Le Seuil, 1998), 315–418.

49 P. Pachet, *Les baromètres de l'âme: Naissance du journal intime* (Paris: Hatier, 1990), 126.

Brecht, however, also spoke of considerable obstacles facing this kind of undertaking. At this moment in his life, from his position in exile, his literature "concerned him in almost no way at all" where he could "write almost everything" about it, while war, which concerned him "in every way," seemed to escape his vital capacity to write. For a long time Brecht made the war a major aspect of writing and of exposition for artistic activity in general: "Show in your paintings, instead, man's inhumanity to man," he declared, for example, to the abstract painters before the war.[50] Following the words of Georg Simmel on the intrinsic relationships between conflict and modernity—where the "tragedy of culture" found its ultimate form in war[51]—Brecht made the "disorder of the world" in general and of war in particular the principal subject of all artistic activity, whether ancient or contemporary:

> The disorder of the world: that is the subject of art. It is impossible to affirm that, without disorder, there would be no art, nor that there could be one: we know of no world that is not disorder. No matter what the universities whisper to us regarding Greek harmony, the world of Aeschylus was full of combat and terror, and so were those of Shakespeare and Homer, of Dante and Cervantes, Voltaire and Goethe. However pacifistic it was said to be, it speaks of wars, and when art makes peace with the world, it always signed it with a world at war.[52]

It is incredibly difficult to expose clearly that to which one is directly, vitally exposed. How can we write what we have undergone; how can we construct a *logos*—or create a category of species, an idea, an *eidos*—with our own *pathos* of the moment? Faced with the constraints linked to his own situation but confronted with the intellectual, ethical, and political demands to *take position* in spite of all, Brecht spontaneously followed the Wittgensteinian precept according to which what one cannot say or explain, one must show. He renounced the discursive, deductive, and demonstrative value of exposition—when "to expose" meant to explain, elucidate, tell in the correct order—in

50 B. Brecht, "Considérations sur les arts plastiques" (1935–39), trans. A. Gisselbrecht, in *Écrits sur la littérature et l'art*, vol. 2, *Sur le réalisme* (Paris: L'Arche, 1970), 58–59.

51 G. Simmel, *Philosophie de la modernité* (1903–23), trans. J.-L. Vieillard-Baron (Paris: Payot, 1989), 355–426.

52 B. Brecht, "Exercises pour comédiens" (1940), trans. J.-M. Vallentin, in *L'art du comédien: Écrits sur le théâtre* (Paris: L'Arche, 1999), 121.

order to deploy more freely its iconic, tabular, and monstrative value. That is why his *Arbeitsjournal* looks like a gigantic montage of *texts* with more or less diverse status, and a montage of *images*, equally heterogeneous, that he cut out and glued here and there in the body or flow of his associative thinking.

Images of all kinds: reproductions of artworks, photographs of the aerial war, newspaper cuttings, faces of his loved ones, scientific outlines, soldiers' corpses on the battlefields, portraits of political leaders, statistics, cities in ruins, genre scenes, still lifes, economic graphs, landscapes, artworks vandalized by military violence . . . With this very calculated heterogeneity, more often than not taken from the illustrated press of the period, Brecht returned to the art of the photomontage, but within an economy of the book—something between the tabular and the narrative montages of the chronological structure of his journal. We can think, of course, of certain literary works that Brecht had known since the 1920s, such as André Breton's *Nadja*[53] or, closer to him as a German writer, Alfred Döblin's *Berlin Alexanderplatz*, in relation to which Walter Benjamin had studied the "crisis of the novel" in terms leading to a defence of writing the documentary montage—"the stylistic principle governing this book is that of montage"—in which photography was invested with a genuine epic power.[54]

This was done, of course, to serve the epic and realist aspects of Bertolt Brecht's thinking. The "most advanced" art, he said, is not the art of abstract autonomization of formal means but instead one in which the question of the historical referent must be asked again, in processes that he called in his journal "a big step towards making the art of theatre profane and secular and stripping it of religious elements."[55] Hence the displaying, the *exposition*

53 See M.-D. Garnier, ed., *Jardins d'hiver: Littérature et photographie* (Paris: Presses de l'École normale supérieure, 1997); D. Grojnowski, *Photographie et langage: Fictions, illustrations, informations, visions, théories* (Paris: José Corti, 2002), 91–176; D. Grojnowski, "Le roman illustré par la photographie," in *Texte/image: Nouveaux problèmes*, ed. L. Louvel and H. Scepi (Rennes: Presses Universitaires de Rennes, 2005), 171–84.

54 W. Benjamin, "The Crisis of the Novel" (1930), trans. R. Livingstone et al., in *Selected Writings*, vol. 2, *1927–1934*, ed. M. W. Jennings, H. Eiland, and G. Smith (Cambridge: Harvard University Press, 1999), 301. See also M. Pic, "Littérature et 'connaissance par le montage,'" in *Penser par les images: Autour des travaux de Georges Didi-Huberman*, ed. L. Zimmermann (Nantes: Cécile Defaut, 2006), 147–77.

55 Brecht, *Journals*, 115.

of documents within the formal framework of his literary constructions. Pythagoras's theorem is rendered in algorithmic language, but its application—a drawing that Brecht reproduced in his *Arbeitsjournal* on May 16, 1942—exposes it as both pedagogical initiation and concrete implementation.[56] It is worth reading the work *Warum Krieg?*, published in 1933 by Albert Einstein and Sigmund Freud, but it would also be efficient, in a sense, to read the war primer of the German army, whose effect would be "astonishingly strong" and even "aggressively masterful" . . . if read in the United States by Jewish actors and for an audience of people in exile.[57] In 1926, in response to a literary inquiry on "the best books of the year," Brecht had praised (albeit gratingly) a harrowing collection of photographic documents of the Great War, titled *Krieg dem Kriege!* "For the price of a record of Christmas songs, you can buy your children this monstrous book of images which is called *War on War* made up of photographic documents that show the successful portrait of humanity."[58]

Perhaps because a large part of his writing focuses on exposition of the theatrical stage, Brecht shows an astonishing *Schaukraft*, or "power of vision," throughout his work. On his copy of the Bible, translated by Martin Luther, he thought it a good idea to stick surprising photographs, such as that of an East Asian statue or a sports car, for example.[59] He collected a whole iconography around Pieter Brueghel the Elder, a painter whom he particularly admired and who even inspired his stage sets.[60] He collected portraits of Mafia criminals and, in the same vein, images of Nazi dignitaries.[61] He studied Asian art and the gestures of Chinese actors.[62] He could have turned his house in Berlin into a permanent exhibition on a "theatre of poverty," in which the humblest objects would coexist with portraits of Marxist philosophers and ancient masks from the Noh theatre.[63]

56 Ibid., 233.

57 Ibid., 172. Brecht's own copy of *Warum Krieg?* is reproduced in E. Wizisla, ed., *Bertolt Brecht, 1898–1998: ". . . und mein Werk ist der Abgesang des Jahrtausends"; 22 Versuche, eine Arbeit zu beschreiben* (Berlin: Akademie der Künste, 1998), 72.

58 Brecht, "Sur l'art ancien," 60.

59 Cf. Wizisla, *Bertolt Brecht, 1898–1998*, 22.

60 Ibid., 91–96.

61 Ibid., 71, 83–90, 143–46.

62 Ibid., 97–106.

63 E. Wizisla, ed., *Chausseestrasse 125: Die Wohnungen von Bertolt Brecht und Helen Weigel in Berlin-Mitte* (Berlin: Akademie der Künste, 2006).

Brecht created atlases and, therefore, photographic files on contemporary history and on the stage sets for his own plays—for example, the fascinating *Modellbücher* of *Antigone* in 1948 and *Mutter Courage* in 1949—generally with the help of Ruth Berlau, his friend and photographer.[64] He liked to think about the "magical force" of Magdalenian engravings, the multiplication of viewpoints in Chinese painting, the dismantling of forms in Picasso's *Guernica*, the lyrical or experimental nature of press images when we know how to detach them from their discursive or ideological system.[65] In short, if he never worked without taking position, he never took position without seeking to know, and never sought to know without having before his eyes the documents that he thought appropriate. But he saw nothing without deconstructing and then re-assembling or re-editing it into a montage for his own purposes, in order to even better expose the visual material that he had chosen to examine.

Document

The "power of vision" in Bertolt Brecht is strangely accompanied by an anxious, dark, and often pessimistic tone. It is a kind of moral pain that often traverses or even contradicts his protestations, his hopes, and his spirited calls for political struggle. There is something of the *lamento* in his way of envisaging the visual documents of contemporary history that he cuts out and sticks onto the pages of his journals. This is particularly noticeable as soon as the victory of the Allies over Nazi Germany seems certain. On March 10, 1945, he appears downcast when faced with the "terrible newspaper reports from Germany," because he sees in them only "ruins, and no sign of life from the workers."[66] He remains surprisingly silent, as though without words or political explanations, about the discovery of the concentration and extermination camps. On the subject of Hiroshima, on September 10, 1945, he speaks of a victory that has "a bitter taste."[67]

64 See G. Meyer, *Ruth Berlau*. For the German edition of the *Modellbücher*, see B. Brecht, "Antigonemodell" (1948) and "Couragemodell" (1949), in *Werke*, vol. 25, *Schriften*, 5, ed. W. Hecht and M. Conrad (Berlin: Suhrkamp, 1994), 71-168, 169-398.

65 See the excellent clarification by P. Ivernel, "L'Oeil de Brecht: A propos du rapport entre texte et image dans le *Journal de travail* et l'*ABC de la guerre*," in Vanoosthuyse, *Brecht 98*, 217-31.

66 Brecht, *Journals*, 348.

67 Ibid., 358.

On March 20, 1947, he counts the fifteen million dead with a geographical map (fig. 1.2).[68] On January 5, 1948, he re-examines the Nuremberg trials: "again it strikes me forcefully how much such a chunk of reality, simply by its size, defies rational and moral judgment."[69]

Upon his return to Berlin, he notes on October 23, 1948: "the rubble bothers me less than the thought of what people must have gone through while the city was being reduced to this rubble."[70] On November 6 he looks sadly upon the people "in thin coats or patched jackets, colour of faces, grey," and two days later his friend Erich Engel appears to him to have "aged a lot, but the eyes are still recognizable," while "his head look[s] like a skull."[71] He notes on November 25 that he has had eleven teeth taken out at the same time.[72] A rather desperate conclusion appears on December 9: "everywhere in this great city, where everything is always in flux, no matter how little and how provisional that 'everything' happens at the moment to be, the new german misere is apparent, which is that nothing has been eliminated even when almost everything has been destroyed."[73]

The war was won against German fascism but a "new misere" had settled throughout the world. The exploitation of man at the hands of man had been weakened in no way, and everyone seemed too exhausted for any kind of revolution. The great powers sat facing one another in two "blocs" that entered their "Cold War." In 1955, while Edward Steichen's great photo exhibition *The Family of Man* was travelling throughout the Western world—it was a complex montage in which images of war and images of peace confronted one another openly[74]—Bertolt Brecht published in East Berlin, with the help of the publisher Eulenspiegel, a sort of photographic atlas of the war titled *Kriegsfibel*, or *War Primer*.[75]

68 Ibid., 367.
69 Ibid., 386.
70 Ibid., 402.
71 Ibid., 406.
72 Ibid.
73 Ibid., 407.
74 Museum of Modern Art, *The Family of Man* (New York: Museum of Modern Art, 1955). On this exhibition, see J. Back and V. Schmidt-Linsenhoff, eds., *"The Family of Man, 1955-2001," in Humanismus und Postmoderne: Eine Revision von Edward Steichens Fotoausstellung* (Marburg: Jonas, 2004).
75 B. Brecht, *Kriegsfibel* (Berlin: Eulenspiegel, 1955). An augmented edition with twenty

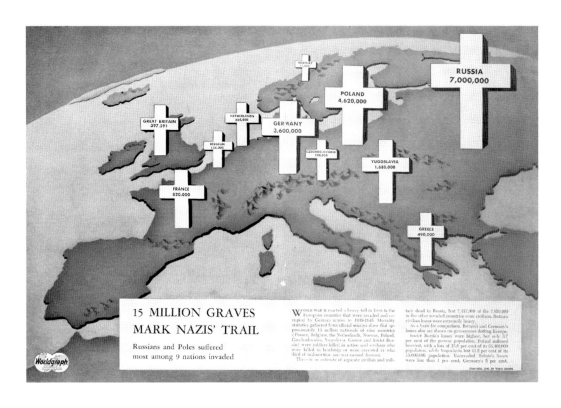

It is a strange and fascinating book, one that is often overlooked in his biographies and bibliographies.[76] It seems to start—or to start over, from A to Z—exactly where in 1955 the *Arbeitsjournal* ended, and for which it might be considered the lyrical and photographic culmination. Its general structure seems to follow the chronology of the Second World War—the Spanish Civil War, the war of conquest in Europe, denunciation of the principal Nazi perpetrators, the imperialist extension of the war, the counteroffensive by the Allies, the return of the prisoners—although the montage is far more complex and subtle. We can say that its composition began in 1940, when Brecht confided to his journals that, in the "in-between time" imposed by exile, he could only cut out newspaper images and compose a few little four-line "epigrams."[77]

A first version was completed in 1944–45, while Brecht was still in the United States. The playwright presented it to his friend Karl Korsch and it can be found today in the archives bequeathed by Korsch to the Houghton Library at Harvard University.[78] Three other versions followed—the third printed in East Berlin, with sixty-nine plates—before the publication in 1985 by Klaus Schuffels and again in 1994 by Eulenspiegel of twenty supplementary plates that had been censored in 1955.[79] Brecht therefore waited ten years—ten years full of travels and obstacles of all kinds—before seeing the publication of his photographic atlas that had been composed in exile. *Kriegsfibel* was refused in 1948 by the editor Kurt Desch. In 1950, Volk und Welt submitted the project for examination, the conclusion being that it was

unpublished plates and an afterword by G. Kunert and J. Knopf was produced by the same publisher in 1994. B. Brecht, *War Primer*, trans. and ed. J. Willett (London: Libris, 1998).

76 It is absent, for example, in G. Berg and W. Jeske, *Bertolt Brecht: L'homme et son oeuvre*, trans. B. Banoun (Paris: L'Arche, 1999).

77 Brecht, *Journals*, 89.

78 This was a little notebook (10.5 by 12.5 cm) whose pages were bound by two metallic attachments. The visual documents as well as the epigrams—which are almost illegible, given their reduced size in the photographs—are stuck onto thick black paper. The frames and the sequences of images differ quite often from the definitive version. The manuscript can be found in the Houghton Library under the reference number bMS Ger 130-27. Three fragments of this work appeared under the title "Und siehe, es war sehr schlecht" in the *Austro-American Tribune* 2, no. 7 (February 1944): 7; no. 8 (March 1944): 9; and no. 11 (June 1944): 7.

79 Cf. K. Schuffels, "Synopsis des différentes versions," in B. Brecht, *ABC de la guerre*, trans. P. Ivernel (Grenoble: Presses Universitaires de Grenoble, 1985), 198–201. See also C. Bohnert, *Brechts Lyrik im Kontext*, 300–309.

"totally unsuitable." Brecht attempted to respond to the ideological critiques being addressed to him, but to no avail.[80]

He had to wait until the autumn of 1954 before he was able to sign a contract with Eulenspiegel. But the Office for Literature of East Berlin refused him an imprimatur, claiming that his work had too many "pacifist tendencies." Having received the Stalin Prize for peace in December 1954, Brecht was in a position to agree with the Office, which was the only way for him to circumvent rejection of his book. He agreed to self-censor a number of plates in the initial project and to follow up with a second, less violent volume, intended to praise Communist society more directly.[81] The book had very mediocre sales, leaving Brecht, a short while before his death, with the painful impression that the German public was developing "a senseless repression of all the facts and judgments concerning the period of Hitler and the war."[82]

Once again the "power of vision" that emanates from this atlas of images—which was to Brecht what *The Disasters of War* was to Goya, who was also misunderstood and censored in his time—was accompanied by the pain of seeing that, in spite of everything, the survivors of the war had conveniently managed to forget quickly the very things to which they owed their survival and their current, albeit relative, state of peace. The *War Primer* is merely a primer, an elementary work of visual memory; we still need to open it and face the images inside for its work of memory to have any chance of reaching us.

Legibility

Like many of Brecht's works, *Kriegsfibel* is also a collective work. The model was entrusted to Peter Palitzsch and the brief commentaries on the photographic documents were written by Günter Kunert and Heinz Seydel. But, above all,

80 K. Schuffels, "Genèse et historique," in Brecht, *ABC de la guerre*, 188–91.

81 We see a trace of this project in the illustration on the back cover, which shows an auditorium full of students in East Germany. The photographic document is accompanied by the following epigram: "Do not forget: many of your brothers fought / So that you might after them sit here. / Do not get buried down, know also how to fight / Learn to learn and never unlearn this." Brecht, *ABC de la guerre*, 234.

82 Cited by Schuffels, "Genèse et historique," 191–97.

it was to Ruth Berlau that the playwright entrusted the majority of the form, as well as the very presentation of the work. Berlau worked closely with Brecht in his iconographical research; she increasingly took on the technical side of reproductions of the atlas. The 1955 edition was therefore, quite naturally, made her responsibility. The two texts that she wrote for it, a short preface in the book and a longer text printed on the inside flaps of the book jacket, evoke first of all Brecht's situation in exile, "working and waiting, until he had to pack his bags again and flee further afield."[83] Then she explains the meaning of this kind of position by affirming that a man in exile is always a wary man, as his mode of observation gives him—when he has the imagination of the writer and thinker—the ability to "foresee so many things" beyond the actuality of the moment that he is currently experiencing.

This foresight is not merely a prophetic voice; it requires a technique, which is that of montage. "I often saw him," she says of Brecht, "with scissors and glue in his hands. What we see here is the result of his 'cuttings': images of war."[84] Why images? Because in order to know, we must know how to see. Because a "document is more difficult to deny" than a discourse or an opinion. Brecht, writes Berlau, "glued the following sentence onto the oak beams of his work room: Truth is concrete [*Die Wahrheit ist konkret*]."[85] But why did he need to cut out those images and reassemble them in another order, that is to say, to move them to another level of intelligibility and legibility? Because a document contains at least two truths, the first of which is always insufficient. For example, when "an American soldier stands close to the corpse of a Japanese soldier [plate 47, fig. 1.3] the viewer sees the triumph over Japan, Hitler's ally. But the photograph encloses another, deeper truth: the American soldier is the instrument of a colonial power fighting against another colonial power."[86] The photograph might *document* a moment of the history of the war in the Pacific, but, once it has been assembled in a montage with the others—and with the accompanying text—it may *induce* a more profound reflection on the deeper stakes of American engagement in the war against the Berlin-Rome-Tokyo axis.

83 R. Berlau, "Préface," in Brecht, *ABC de la guerre*, 231.
84 Ibid., 231–32.
85 Ibid., 232.
86 Ibid.

Ruth Berlau gives another precious clue to the fundamental project of *Kriegsfibel*: if seeing allows us to know and even to foresee something of the historical and political state of the world, it is because the montage of images bases its efficiency on an art of *memory*. As she states in her short preface to the work,

> Why present, only now, these somber images to our workers of state-owned industry, to our cooperative farmers, to our progressive intellectuals, and finally to our young people who enjoy the first rations of happiness?
>
> Whoever forgets the past cannot escape it. This book aims to teach the art of reading images. The novice has as much difficulty deciphering an image as he does a hieroglyph. The vast ignorance of social realities, which capitalism carefully and brutally perpetuates, transforms thousands of photos published in the illustrated press into hieroglyphs which are indecipherable to the unsuspecting reader.[87]

"Whoever forgets the past cannot escape it." This means that a politics of the present, albeit a construction of the future, cannot ignore the past that it repeats or represses (they often go together). The images form, like language, privileged inscription surfaces for those complex memory processes. The *Kriegsfibel* project is therefore related to a double propedeutics for *reading time* and *reading images* where time has some chance of being deciphered. Ruth Berlau was probably mistaken when she made capitalism a political tool capable of darkening time and darkening images (she wrote these lines in the Stalinist period, in a context of political lies and obscurantism). But the importance she gave to *Kriegsfibel* was no less topical, as it repeated a demand—one among others—already expressed by Lászlo Moholy-Nagy, Bertolt Brecht, and Walter Benjamin during the Weimar period.

In 1927, Moholy-Nagy wrote after producing *Malerei, Fotografie, Film* that "the illiterate of the future will not be uneducated in the pen but in the camera."[88] Brecht took up this idea in 1930 with a well-known comment that expressed the complexity of any legibility of images, including any documentary reading: "The situation has become so complicated because the

87 Ibid., 231.

88 L. Moholy-Nagy, "La photographie dans la réclame" (1927), trans. C. Wermester, in *Peinture, photographie, film et autres écrits sur la photographie* (Paris: Gallimard, 2007), 155.

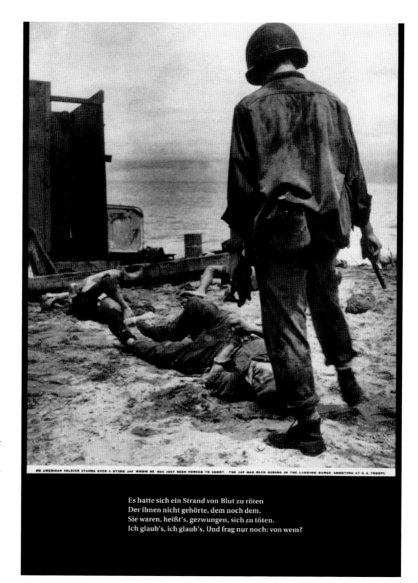

Figure 1.3
Bertolt Brecht, *Kriegsfibel*, 1955, plate 57 [47]: "An American soldier stands over a dying Jap [*sic*] whom he has just been forced to shoot. The Jap had been hiding in the landing barge, shooting at U.S. troops." © Bertolt-Brecht-Erben/Suhrkamp Verlag 1988.

simple 'reproduction of reality' says less than ever about that reality. A photograph of the Krupp works or the AEG reveals almost nothing about these institutions."[89] One year later, Benjamin dialectized in his "Little History of Photography" the "lessons inherent in the authenticity of the photograph. These cannot be forever circumvented by a commentary whose clichés merely establish verbal associations in the viewer."[90] Images tell us nothing; they lie to us or remain obscure like hieroglyphs until we make the effort to *read* them, which means to analyze them, decompose them, reassemble them, interpret them, and distance them from any verbal clichés they arouse as visual clichés.

That is why Bertolt Brecht cut out his visual material, and that is why he joined to the images a commentary that is paradoxical because it is poetic—an epigram of four lines at the bottom of each plate—and that deconstructs the visible obviousness or the stereotype. We cannot, therefore, understand the political position taken by Brecht against the war[91] without analyzing the montage, the formal re-composition, that he based on his mass of documentary materials in an "incomparable initiation to the complex vision" of history, as Philippe Ivernel has said so well.[92] This is how *Kriegsfibel* becomes also that "language in the image of the event" through montage and "re-takings of images" that anticipate strangely, in our own context today, certain historical works of montage such as Jean-Luc Godard's *Histoire(s) du cinema*[93] and Harun Farocki's *Bilder der Welt und Inschrift des Krieges*. In other words, in his illustrated primer, Brecht also examined our own capacity to know how to see, today, the documents of our dark history.

89 B. Brecht, "The Threepenny Lawsuit," trans. M. Silberman, in *Brecht on Film and Radio* (London: Bloomsbury, 2000), 164.

90 W. Benjamin, "Little History of Photography," trans. R. Livingstone et al., in *Selected Writings*, vol. 2, 527.

91 See, in particular, R. Solmi, "Introduzione," in *L'Abicí della guerra: Immagini della seconda guerra mondiale* (Turin: Einaudi, 1975), ix–xxvii; D. Frey, *Brecht, un poète politique: Les images, symboles et métaphores dans l'œuvre de Bertolt Brecht* (Lausanne: Âge d'homme, 1987), 83–91; S. Kebir and T. Hörnigk, eds., *Brecht und der Krieg: Widersprüche damals, Einsprüche heute* (Berlin: Theater der Zeit, 2005).

92 P. Ivernel, "Passage de frontières: Circulation de l'image épique et dialectique chez Brecht et Benjamin," *Hors-cadre* 6 (1987): 153–55, 163; Ivernel, "L'œil de Brecht," 217–18, 220–29. See also Jost, "Journale," 436–40; and, above all, D. Wörthe, *Bertolt Brecht medienästhetische Versuche* (Cologne: Prometh, 1988), 157–89.

93 See M. Poivert, "L'évènement comme expérience," in *L'évènement: Les images comme acteurs de l'histoire* (Paris: Jeu de Paume–Hazan, 2007), 23–26.

II

The Disposition
Towards Things

Observing the Uncanny

Inscription

When we open *Kriegsfibel* and leaf through its dark plates punctured with dreadful images, we are suddenly stunned by the fact that each documented reality, with its cruelty and often its coldness, is accompanied by a small lyrical poem, four lines each time, appearing as though from another world or another time. Thus the plate in which we see the American soldier "standing over a dying Jap whom he has just been forced to shoot" (fig. 1.3)—as the original caption underneath says and which Brecht wished to keep in the cut-out—seems to be underlined, or sub-captioned, by a poem, as follows:

> And with their blood they were to colour red
> A shore that neither owned. I hear it said
> That they were forced to kill each other. True.
> My only question is: who forced them to?[1]

With this poem a voice arises in the desert of the dead shown to us by the image. With it rises, too, a powerful doubt concerning our way of looking at the image. We realize that the plate itself, in its totality, has become the setting for a meeting between three spaces or three heterogeneous temporalities. The first space-time is that of the event that, one day in 1943,

1 B. Brecht, *War Primer*, trans. and ed. J. Willett (London: Libris, 1998), pl. 57 [47]. [Translator's note: Where differences occur in the plate numbers between the English edition of Brecht's *War Primer* used here and the French edition used by Didi-Huberman (B. Brecht, *ABC de la guerre*, trans. P. Ivernel [Grenoble: Presses Universitaires de Grenoble, 1985]), the plate numbers from the English edition appear first, followed by the numbers for the French edition in square brackets.]

placed a Japanese soldier—we can see that there are at least two other corpses on this beautiful beach in the Pacific—at the mercy of the American soldier. The second is that of the magazine for which the photographer worked and in which the treatment of the image goes hand in hand with propaganda, which we can sense in the unverifiable indication that the American soldier killed the Japanese soldier only in self-defence: the Japanese soldier, hidden behind the boat, had been shooting at American troops. The third theatre of operations is that which Brecht organized for his own purposes, which is the dark space on the plate itself from which arises, in counterpoint to the image, like the title cards of silent films, the text of the poem.

A dialectic is therefore at work. It prevents any reading of Brecht's poem without the image that it comments on and to which it even seems to respond.[2] Conversely, it prevents us from thinking we are fully informed about what this photograph represents by reading the original caption. It introduces a healthy doubt concerning the status of the image, without disputing, however, its documentary value. In political terms, Brecht's attitude arises from a *dialectical position*: it was necessary and beneficial for America to counter the expansion of fascism, but it was inevitable that this operation would serve its own strategies of expansion as an imperialist power.

Brecht's approach to his contemporary history, his most burning actuality, on the level of the *medium* is also dialectical: there is apparently nothing more "immediate" than this document of the war in the Pacific taken from the newspapers (the *Journals* at this time brought together images of battles on the Russian front and in North Africa, bombardments of Germany, and the last avatars of Mussolinian power).[3] Yet it is through a very complex *mediation* that Brecht gave shape to all this material, by turning to very precise reminiscences, temporal montages, and stylistic detours. First of all, the images of the war aroused very precise reminiscences of his own experiences during the First World War. Not only did Brecht know

2 It makes little sense, therefore, to read these poems without seeing the images, as is the case in the edition titled "Manuel de guerre" (1940–45), translated from the German into French by J.-P. Barbe, in *Poèmes*, vol. 6 (Paris: L'Arche, 1967), 119–34. The translation into French by Philippe Ivernel, which takes account of the face-to-face encounter between the poem and the image is, by the same token, far more precise.
3 B. Brecht, *Journals, 1934–1955*, trans. H. Rorrison (New York: Routledge, 1996).

the overwhelming iconographies published on this subject—including Ernst Friedrich's *Krieg dem Kriege!* and its warlike antithesis defended by Ernst Jünger, *Das Antlitz des Weltkrieges*[4]—but, like his friend Tretyakov, he had actually experienced in the war how injured men were patched up quickly and sent back into battle:

> I studied medicine. When I was very young, I was mobilized and sent to a hospital. I bandaged injuries, smeared iodine, administered washes and did blood transfusions. If the doctor had said to me "Brecht, cut off that leg," I would have answered: "Yes, sir!," and I would have cut off the leg. If he had said "Brecht, trepan," I would have opened the skull to reach the brain. I saw how men were patched up as quickly as possible to be sent back into combat as quickly as possible.[5]

This experience, followed by profound doubts, revolt, and taking political positions, finally led Brecht to reflect with a sombre irony whose prophetic force touches us even today:

> Germany is the land of poets and thinkers, *Denker und Dichter,* we often say. We should have said for a long time that Germany is the land of thinkers and executioners, *Denker und Henker.* . . . I suggest [moreover] replacing the word *Denker* in the phrase by *Denke*. Germany is the land of *Denke*. Denke is the name for a criminal who killed people to use their corpses. With the fat of the dead, he made soap, and with flesh he made foods, with their bones buttons, and with their skin he made wallets. His work became so perfected that he was astonishingly surprised when he was arrested and condemned to death. Firstly, he did not at all understand why, on the front, one could

4 E. Friedrich, *Krieg dem Kriege!* (Berlin: Freie Jungend, 1924; repr., Munich: Deutsche-Verlag-Anstalt, 2004, based on the 1930 edition); E. Jünger, "Krieg un Lichtbild," in *Das Antlitz des Weltkrieges* (Berlin: Neufeld & Henius, 1930), 9–11. For a translation into French of the prefaces to these works, see O. Lugon, ed., *La Photographie en Allemagne: Anthologie de textes, 1919–1939*, trans. F. Mathieu (Nîmes: Jacqueline Chambon, 1997), 21–22, 26–27. On the photographic iconography of the Great War, see the great work by G. Paul, *Bilder des Krieges, Krieg der Bilder: Die Visualisierung des modernen Krieges* (Paderborn: Ferdinand Schöningh/Wilhelm Fink, 2004), 103–25.

5 Cited by S. Tretyakov, "Bert Brecht" (1936), trans. D. Zaslavsky, in *Dans le front gauche de l'art* (Paris: François Maspero, 1977), 181–82.

sacrifice in such an absurd fashion and without any subsequent use, thousands of human lives Then, why were these men of the court, prosecutors and lawyers, so outraged? He had worked only on second-class people, two-legged waste and dross. He had never made a towel out of a General's skin, nor soap from the fat of a manufacturer, nor buttons from the skulls of journalists. I suppose [then] that the best men in Germany, judging Denke, did not see in his behavior the deep characteristics of German genius.[6]

Brecht's irony is organized to the millimetre. While he reduces the "German genius" of poets and thinkers to the real acts of executioners and criminals, he allows us at the same time to imagine that a political response to this situation would manage to give back the poetic and philosophical sense of a culture made up of *Dichter* and *Denker*. The major uncanniness—and the potential—of his *War Primer* consists in creating, quick as a flash, a link between images of crime and texts of poetry in the way that visible things in the photo suddenly "speak" in the epigrams. From the beginning of his *Journals* in 1939, Brecht considered the question in similar terms: how should one live in a state of terror, and "how can luxury be brought into the parable?" How should one justify the German–Soviet pact and why, at that moment, return to Goethe's *Pandora*? How can one not be immoral in one's poetry "when the morality of a society becomes asocial"?[7]

Epigram

If the images of war in *Kriegsfibel* aroused in Brecht a return to the documented horrors of the first great technological war, with which he was obsessed in his youth, the poems come from a stylistic anamnesis that, finding his sources in classical antiquity, creates on every plate a surprising temporal conflict. Why did Brecht choose the epigram as a form? First of all, because he knew that epigrams were inscriptions engraved by the ancient Greeks on the marble of their tombs. It was therefore a funereal style, in which the dead often sought to offer themselves to the eyes of those who stopped in

6 Ibid., 180.
7 Brecht, *Journals*, 30, 192.

front of their tombs.[8] Then, because the epigram has meaning only in its ethical value, it ended up referring to any short poetry that acted as a "moral" sentence.[9] Furthermore, a special feature of the epigram is its use of simplicity and variation,[10] which corresponds well to the formal questions inherent in the collection of plates imagined by Brecht. Finally, through a reversal of meaning whose secret is found in the surviving elements, the epigram became mixed with laughter and the satirical form, amounting thereupon to a kind of moral or even political *Witz*.[11]

The form of the epigram was all the more suitable for Brecht's project in that it assumed—and has done so since antiquity, after the model of Martial but even more so in the Renaissance and Baroque periods—an acuteness, a "force of concentration," and a "portable character [that made it] a weapon," a genuine poetic weapon against any politics of weapons.[12] Furthermore, Scaliger defines the epigram as a brief dialectic found in a "poem containing a simple indication of a thing, a person, an action, or basing a conclusion on premises, and doing so by the more, the less, the equal, the different, and the contrary."[13] During the Enlightenment, this dialectical value of the epigram

8 U. Ecker, *Grabmal und Epigramm: Studien zu frühgriechischen Sepulkraldichtung* (Stuttgart: Franz Steiner, 1990), 149–67. See also B. Gentili, "Epigramma ed elegia," in *L'épigramme grecque*, ed. O. Reverdin (Geneva: Hardt Foundation, 1968), 37–81; A. Le Bris, *La mort et les conceptions de l'au-delà en Grèce ancienne à travers les épigrammes funéraires* (Paris: Harmattan, 2001).

9 Cf. J. Labarbe, "Les aspects gnomiques de l'épigramme grecque," in Reverdin, *L'épigramme grecque*, 349–83.

10 Cf. W. Ludwig, "Die Kunst der Variation im hellenistischen Liebesepigramm," in Reverdin, *L'épigramme grecque*, 297–334; L. Spina, *La forma breve del dolore: Ricerche sugli epigrammi funerary greci* (Amsterdam: Adolf M. Hakkert, 2000).

11 Cf. L. Robert, "Les épigrammes satiriques de Lucillius sur les athlètes: Parodie et réalité," in Reverdin, *L'épigramme grecque*, 179–291; G. Luck, "Witz und Sentiment in griechischen Epigramm," ibid., 387–408.

12 P. Laurens, "Épigrammme," in *Dictionnaire universel des littératures*, vol. 1, ed. B. Didier (Paris: PUF, 1994), 1107.

13 Cited by P. Laurens, *L'abeille dans l'ambre: Célébration de l'épigramme de l'époque alexandrine à la fin de la Renaissance* (Paris: Belles Lettres, 1989), 10. See also J. Weisz, *Das deutsche Epigramm des 17 Jahrhunderts* (Stuttgart: Metzler, 1979); T. Althaus, *Epigrammatisches Barock* (Berlin: Walter de Gruyter, 1996); T. Schäfer, *The Early Seventeenth-Century Epigram in England, Germany, and Spain: A Comparative Study* (Frankfurt: Peter Lang, 2004). For an anthropological history of the epigram, see J. Dion, ed., *L'épigramme de l'antiquité au XVIIIe siècle, ou du ciseau à la pointe* (Nancy: Association pour la diffusion de la recherche sur l'antiquité, 2002); D. Buisset, *D'estoc et d'intaille: L'épigramme* (Paris: Belles Lettres, 2003).

was further developed by Lessing, who made it a poetic process of expectation and clarification, of suspended signification and joined explanation; and then it was aligned with history itself by Herder.[14]

By eliciting this great poetic tradition and by thinking—like Benjamin and Kracauer—about the photographic conditions of the visibility of history in the twentieth century, in the end Bertolt Brecht constructed these little dialectical machines that are the plates of *Kriegsfibel*, by formulating, in order to define them, a new poetical concept that he quite logically called the *photo-epigram*. This is what he confided to his *Journals* on June 20, 1944, when the collection of plates seemed more or less complete:

> working on a series of photo-epigrams. as i look over the old ones, which in part stem from the beginning of the war, i realise that there is almost nothing i need to cut out (politically nothing at all), proof of the validity of my viewpoint, given the constantly changing face of the war. there are now about 60 quatrains, and . . . the work offers a satisfactory literary report on my years in exile.[15]

As a poetical report of a war "exposed" by a man in exile, *Kriegsfibel* is like a deliberately epic chronological crossing of this whole period. We see the Spanish Civil War first of all, through the detail of a beach in the Basque region and the Plaça de Catalunya in Barcelona, occupied by General Yagüe.[16] We see the columns of armoured vehicles invading Poland, the conflagration in the skies over Norway, German troops entering the Netherlands, Belgium, and France.[17] We see Roubaix destroyed, Paris occupied, a member of the French Resistance shot by the Nazis.[18] We see how the war spreads around the world to London, Liverpool, sub-Saharan

14 G. E. Lessing, "Zerstreute Anmerkungen über das Epigramm und einige der vornehmensten Epigrammatisten" (1771), in *Werke*, vol. 5, ed. J. Schönert (Munich: Carl Hanser, 1973), 420–529; J. G. Herder, "Anmerkungen über das griechische Epigramm" (1785), in *Werke*, vol. 4, ed. J. Brummack and B. Bollacher (Frankfurt: Deutscher Klassiker, 1994), 499–548. On the German epigram in the nineteenth century, see U. Dickenberger, *Der Tod und die Dichter: Scherzgedichte in den Musenalmanachen um 1800* (Hildesheim: Georg Olms, 1991).

15 Brecht, *Journals*, 319.

16 Brecht, *War Primer*, pl. 3-4.

17 Ibid., pl. 5–6, 8.

18 Ibid., pl. 9, 11-12.

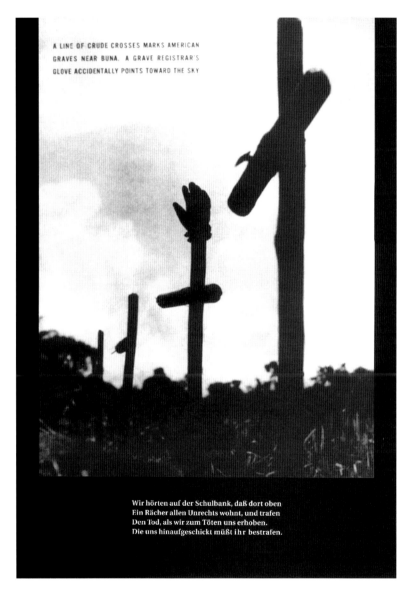

A LINE OF CRUDE CROSSES MARKS AMERICAN
GRAVES NEAR BUNA. A GRAVE REGISTRAR'S
GLOVE ACCIDENTALLY POINTS TOWARD THE SKY

Wir hörten auf der Schulbank, daß dort oben
Ein Rächer allen Unrechts wohnt, und trafen
Den Tod, als wir zum Töten uns erhoben.
Die uns hinaufgeschickt müßt ihr bestrafen.

Figure 2.1
Bertolt Brecht, *Kriegsfibel*, 1955,
plate 54 [45]: "[New Guinea,
1943] A line of crude crosses
marks American graves near
Buna. A grave registrar's glove
accidentally points toward the
sky." © Bertolt-Brecht-Erben/
Suhrkamp Verlag 1988.

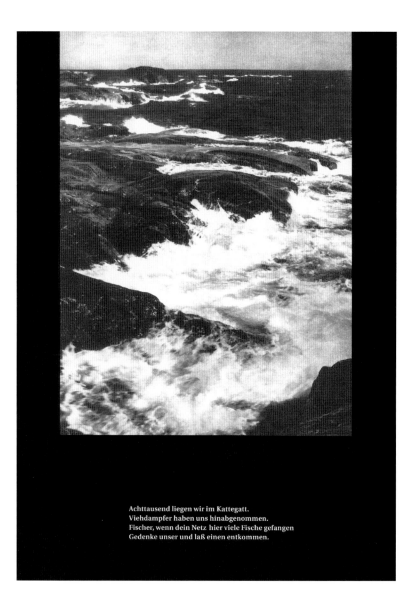

Achttausend liegen wir im Kattegatt.
Viehdampfer haben uns hinabgenommen.
Fischer, wenn dein Netz hier viele Fische gefangen
Gedenke unser und laß einen entkommen.

Figure 2. 2
Bertolt Brecht, *Kriegsfibel*, 1955, plate 7: "Denmark and Norway were occupied by German troops on April 9, 1940." © Bertolt-Brecht-Erben/Suhrkamp Verlag 1988.

Africa, Singapore, Siam, New Guinea and other Pacific islands, Palestine, Sicily, Italy, Normandy, and the eastern front again.[19] And finally we see how, during the Liberation, the survivors find their houses destroyed or experience the joy of finding other survivors; how German prisoners wander about exhausted, beaten, like frozen phantoms; how everything is destroyed and yet the joy of the return to life takes shape.[20]

But many other paradigms traverse this poetical documentary chronicle. First, Brecht ostensibly absorbed the primitive and *funerary* sense of the epigram. Throughout *Kriegsfibel* the dead speak to us, tombs address us—even if it is only through an indication on a military grave: "Unknown"; crosses are planted in the ground while a glove, left there accidentally, points an accusing finger to the sky (fig. 2.1). And one lyrical vision among them all shows the agitated surface of the sea, from which the epigram brings forth the voice of eight thousand dead soldiers swallowed up by the naval battles between Germany and Norway (fig. 2.2).[21] Symmetrically, the *ethical* sense of the epigram lends an accusing tone when it is a question of referring beyond the images of soldiers—German, Russian, American, Japanese[22]—to their war leaders and, beyond them, the all-powerful, the politicians and dictators.[23] It is no coincidence that two photos of Adolf Hitler open and close the 1955 collection, the second one being commented on with the following less-than-triumphant words:

That's how the world was going to be run!
The other nations mastered him, except
(In case you think the battle has been won)—
The womb is fertile still from which that crept.[24]

19 Ibid., pl. 18 [17], 21 [19], 22 [20], 37 [33], 38 [34], 42 [35], 43 [36], 44 [37], 39 [48], 49 [40], 51 [42], 52 [43], 53 [44], 54 [45], 55 [46], 58 [48], 59 [49], 62 [52], 63 [53] and 66 [56], 41 [57], 67 [58], 69 [59].

20 Ibid., pl. 70 [60], 71 [61], 72 [62] and 74 [64], 75 [65], 76 [66], 79 [67].

21 Ibid., pl. 7, 10 and 53 [44], 54 [45].

22 Ibid., pl. 8, 63 [53], 39 [54], 65 [55] and 80 [68].

23 Ibid., pl. 1, 4, 28 [23], 82 [24], 25, 31 [26], 32 [27], 33 [28], 40 [30], 42 [35], 15 [38], 18 [69].

24 Ibid, pl. 81 [69].

In this funerary awareness of political evil there is a third aspect that the reader of Brecht might find strange, and this is an *empathic* aspect to which the choice of documents contributes. It is a form of the epigram that inscribes it in its first fiction, that which places us face to face with the dreadful history of an organized destruction. *Kriegsfibel* exposes all that man can do to man in times of war: bandaging a prisoner's eyes before shooting him; imprisoning a suspect behind the barbed wire of a concentration camp (Brecht chose here an image of his friend Leon Feuchtwanger in the French Camp des Milles); smoking a cigarette in front of an enemy who has just been shot down, finishing off the dying.[25] Brecht was particularly careful to choose images in which we see combatants in the nakedness of their lives, in their distress and fatigue: sleeping in holes that already look like tombs, mixing with the ground from which they shot however they could, injured, mutilated, blinded, collapsing with exhaustion or even madness when faced with the madness going on all around.[26]

Brechtian empathy culminates in the sight of the civilians: the unarmed, those abject souls towards whom it is so easy to be relentless. They are the poor: workers exploited in the arms factories so that others— on the other side—can be better decimated; inhabitants of the bombed cities who wander about, looking haggard, in the smoking ruins or who hole up underground in the tunnels of the metro; farmers to whom the victors distribute some food, on the condition, of course, that they collaborate.[27] They are the women who have lost everything and who desperately mourn over the bodies of their loved ones in Singapore and Palestine and in the East, on the devastated plains of Russia.[28] They are the children to whom *Kriegsfibel* is addressed—children terrorized in London and elsewhere, children whom we see maltreated, starving, injured, sick of the war.[29]

25 Ibid., pl. 12-13, 49 [40] and 57 [47].
26 Ibid., 52 [43], 61 [51], 62 [52], 63 [53], 66 [56], 80 [68], 71 [61] and 74 [64].
27 Ibid., pl. 2, 9, 21 [19], 25 [22] and 59 [49], 60 [50].
28 Ibid., pl. 48 [39], 58 [48] and 69 [59].
29 Ibid., pl. 22 [20], 55 [46], 61 [51] and 72 [62], 73 [63].

Polarity

From such a potentially dialectical author as Bertolt Brecht, one should expect an even more contrasted—or even conflicting—handling of all this historical material. There is lamentation in *Kriegsfibel*, but there is also demonstrated coldness, irony, and a grating wit. It is this aspect that was the object of the most characteristic censorship and self-censorship in the 1955 edition, in which we do not see Hitler eating his stew and smiling kindly at an old woman, or some American starlets allowing their bodies to be covered obscenely with military decorations and stamps to be sold for the war effort.[30] Short of that clearly satirical aspect—which is also inherent in the epigram—Brecht continuously renders visible in *Kriegsfibel* certain structural conflicts whose political meaning is implied by the spatial organization of montage itself.

The most obvious of these polarizations are those that concern the top and the bottom, the built and the destroyed. For example, plates 28 to 36[31] develop an entire sequence on the spatiality of power, captured successively in the images of Hitler making a speech in the arms factory and of Goebbels and Goering confronting their stature as bad (both inadequate and fearsome) sub-leaders. Then we see the three Nazi dignitaries together at the opera, raising their heads as though, as the epigram says, the Wagnerian "fiery magic trick" were dominating them. Then it is the Reich chancellery and its neoclassical architecture, a series of generals and marshals of the Wermacht, a document on the German church in wartime and a Polish factory requisitioned by the Nazis.[32] Here fascist power is shown in the spaces of its political, cultural, cult, military, and industrial functioning. But the plate that closes this series shows an aerial view of bombardments, and the plate that opens it shows a woman, seen from above, wandering in the ruins of her destroyed house.[33] It is a way to expose how certain spaces construct certain powers that are destined to destroy other spaces.

30 Ibid. Plates A1, A11, A12, and A16 in the French edition, *ABC de la guerre*.
31 Plates 23 to 32 in the French and German editions.
32 Ibid., pl. 28 [23], 82 [24], 25, 31 [26], 32 [27], 33 [28], 34 [29], 40 [30], 35 [31], 36 [32].
33 Ibid., pl. 25 [22], 37 [33].

Daß sie da waren, gab ein Rauch zu wissen:
Des Feuers Söhne, aber nicht des Lichts.
Und woher kamen sie? Aus Finsternissen.
Und wohin gingen sie von hier? Ins Nichts.

Figure 2. 3
Bertolt Brecht, *Kriegsfibel*,
1955, plate 23 [21]. © Bertolt-
Brecht-Erben/Suhrkamp
Verlag 1988.

Africa, Singapore, Siam, New Guinea and other Pacific islands, Palestine, Sicily, Italy, Normandy, and the eastern front again.[19] And finally we see how, during the Liberation, the survivors find their houses destroyed or experience the joy of finding other survivors; how German prisoners wander about exhausted, beaten, like frozen phantoms; how everything is destroyed and yet the joy of the return to life takes shape.[20]

But many other paradigms traverse this poetical documentary chronicle. First, Brecht ostensibly absorbed the primitive and *funerary* sense of the epigram. Throughout *Kriegsfibel* the dead speak to us, tombs address us—even if it is only through an indication on a military grave: "Unknown"; crosses are planted in the ground while a glove, left there accidentally, points an accusing finger to the sky (fig. 2.1). And one lyrical vision among them all shows the agitated surface of the sea, from which the epigram brings forth the voice of eight thousand dead soldiers swallowed up by the naval battles between Germany and Norway (fig. 2.2).[21] Symmetrically, the *ethical* sense of the epigram lends an accusing tone when it is a question of referring beyond the images of soldiers—German, Russian, American, Japanese[22]— to their war leaders and, beyond them, the all-powerful, the politicians and dictators.[23] It is no coincidence that two photos of Adolf Hitler open and close the 1955 collection, the second one being commented on with the following less-than-triumphant words:

That's how the world was going to be run!
The other nations mastered him, except
(In case you think the battle has been won)—
The womb is fertile still from which that crept.[24]

19 Ibid., pl. 18 [17], 21 [19], 22 [20], 37 [33], 38 [34], 42 [35], 43 [36], 44 [37], 39 [48], 49 [40], 51 [42], 52 [43], 53 [44], 54 [45], 55 [46], 58 [48], 59 [49], 62 [52], 63 [53] and 66 [56], 41 [57], 67 [58], 69 [59].

20 Ibid., pl. 70 [60], 71 [61], 72 [62] and 74 [64], 75 [65], 76 [66], 79 [67].

21 Ibid., pl. 7, 10 and 53 [44], 54 [45].

22 Ibid., pl. 8, 63 [53], 39 [54], 65 [55] and 80 [68].

23 Ibid., pl. 1, 4, 28 [23], 82 [24], 25, 31 [26], 32 [27], 33 [28], 40 [30], 42 [35], 15 [38], 18 [69].

24 Ibid, pl. 81 [69].

In this funerary awareness of political evil there is a third aspect that the reader of Brecht might find strange, and this is an *empathic* aspect to which the choice of documents contributes. It is a form of the epigram that inscribes it in its first fiction, that which places us face to face with the dreadful history of an organized destruction. *Kriegsfibel* exposes all that man can do to man in times of war: bandaging a prisoner's eyes before shooting him; imprisoning a suspect behind the barbed wire of a concentration camp (Brecht chose here an image of his friend Leon Feuchtwanger in the French Camp des Milles); smoking a cigarette in front of an enemy who has just been shot down, finishing off the dying.[25] Brecht was particularly careful to choose images in which we see combatants in the nakedness of their lives, in their distress and fatigue: sleeping in holes that already look like tombs, mixing with the ground from which they shot however they could, injured, mutilated, blinded, collapsing with exhaustion or even madness when faced with the madness going on all around.[26]

Brechtian empathy culminates in the sight of the civilians: the unarmed, those abject souls towards whom it is so easy to be relentless. They are the poor: workers exploited in the arms factories so that others—on the other side—can be better decimated; inhabitants of the bombed cities who wander about, looking haggard, in the smoking ruins or who hole up underground in the tunnels of the metro; farmers to whom the victors distribute some food, on the condition, of course, that they collaborate.[27] They are the women who have lost everything and who desperately mourn over the bodies of their loved ones in Singapore and Palestine and in the East, on the devastated plains of Russia.[28] They are the children to whom *Kriegsfibel* is addressed—children terrorized in London and elsewhere, children whom we see maltreated, starving, injured, sick of the war.[29]

25 Ibid., pl. 12–13, 49 [40] and 57 [47].
26 Ibid., 52 [43], 61 [51], 62 [52], 63 [53], 66 [56], 80 [68], 71 [61] and 74 [64].
27 Ibid., pl. 2, 9, 21 [19], 25 [22] and 59 [49], 60 [50].
28 Ibid., pl. 48 [39], 58 [48] and 69 [59].
29 Ibid., pl. 22 [20], 55 [46], 61 [51] and 72 [62], 73 [63].

Polarity

From such a potentially dialectical author as Bertolt Brecht, one should expect an even more contrasted—or even conflicting—handling of all this historical material. There is lamentation in *Kriegsfibel*, but there is also demonstrated coldness, irony, and a grating wit. It is this aspect that was the object of the most characteristic censorship and self-censorship in the 1955 edition, in which we do not see Hitler eating his stew and smiling kindly at an old woman, or some American starlets allowing their bodies to be covered obscenely with military decorations and stamps to be sold for the war effort.[30] Short of that clearly satirical aspect—which is also inherent in the epigram—Brecht continuously renders visible in *Kriegsfibel* certain structural conflicts whose political meaning is implied by the spatial organization of montage itself.

The most obvious of these polarizations are those that concern the top and the bottom, the built and the destroyed. For example, plates 28 to 36[31] develop an entire sequence on the spatiality of power, captured successively in the images of Hitler making a speech in the arms factory and of Goebbels and Goering confronting their stature as bad (both inadequate and fearsome) sub-leaders. Then we see the three Nazi dignitaries together at the opera, raising their heads as though, as the epigram says, the Wagnerian "fiery magic trick" were dominating them. Then it is the Reich chancellery and its neoclassical architecture, a series of generals and marshals of the Wermacht, a document on the German church in wartime and a Polish factory requisitioned by the Nazis.[32] Here fascist power is shown in the spaces of its political, cultural, cult, military, and industrial functioning. But the plate that closes this series shows an aerial view of bombardments, and the plate that opens it shows a woman, seen from above, wandering in the ruins of her destroyed house.[33] It is a way to expose how certain spaces construct certain powers that are destined to destroy other spaces.

30 Ibid. Plates A1, A11, A12, and A16 in the French edition, *ABC de la guerre*.
31 Plates 23 to 32 in the French and German editions.
32 Ibid., pl. 28 [23], 82 [24], 25, 31 [26], 32 [27], 33 [28], 34 [29], 40 [30], 35 [31], 36 [32].
33 Ibid., pl. 25 [22], 37 [33].

Daß sie da waren, gab ein Rauch zu wissen:
Des Feuers Söhne, aber nicht des Lichts.
Und woher kamen sie? Aus Finsternissen.
Und wohin gingen sie von hier? Ins Nichts.

Figure 2.3
Bertolt Brecht, *Kriegsfibel*,
1955, plate 23 [21]. © Bertolt-
Brecht-Erben/Suhrkamp
Verlag 1988.

Aerial warfare—perhaps because of its intense technological development between 1939 and 1945, or in any case its unrelenting treatment of civilian populations—has a characteristic place in *Kriegsfibel*. Aerial views show us towns and cities being destroyed, the explosions, the craters, and the clouds of smoke (fig. 2.3). Then we are brought closer to the ruins; from the ground we see, often shot from a low angle, people anxiously looking towards the sky. And finally we see the air-raid shelters, the hiding holes, the basements where everyone tried as much as possible to protect themselves (fig. 2.4):[34]

There was a time of underneath and over
When mankind was master of the air. And so
While some were flying high, the rest took cover
Which didn't stop them dying down below.[35]

Sometimes we see the soldiers themselves holed up, buried, almost crushed—for example, clustered under a train, sleeping in foxholes, or already dead, like Rommel's infantry soldier in Libya, of whom all we can see now are his two legs sticking out of the trench in a sinister, or burlesque, inversion of spatial logic.[36] In his atlas, Brecht arranges symmetrically a series of photos in which we see the cockpits of bombers (fig. 2.5), the surrealist equipment of the pilots at high altitudes, and the fairy-like magical beams of the Direction of Civil Aviation.[37]

Then he shows us the interface of all this process of destruction, which is the industrial production of weapons themselves.[38] We see, for example, workers busy around immense steel plates while the epigram dialectizes in a few words the shell and the armour, the death function and the protection of life (fig. 2.6):

"What's that you're making, brothers?" "Iron waggons."
"And what about those great steel plates you're lifting?"

34 Ibid., pl. 9, 17 [16], 18 [17], 21 [19], 22 [20], 23 [21], 25 [22], 37 [33], 51 [42], 75 [65].
35 Ibid., pl. 21 [19].
36 Ibid., pl. 8, 43 [36], 62 [52].
37 Ibid., pl. 16 [15], 20 [18]. See also plates A6–A8 and A15 in *ABC de la guerre*.
38 Ibid., pl. 2, 36 [32].

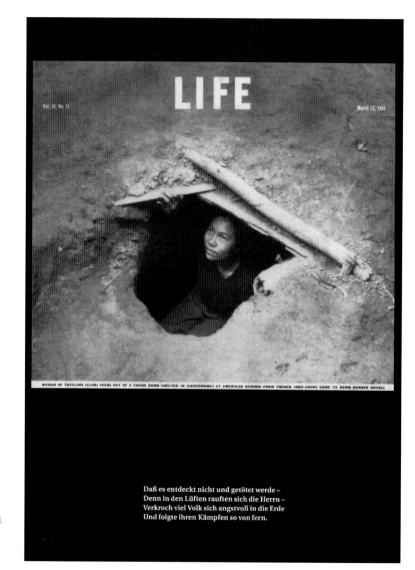

Figure 2.4
Bertolt Brecht, *Kriegsfibel*, 1955, plate 51 [42]: "Woman of Thailand (Siam) peers out of a crude bomb shelter in Sichiengmai at American bomber from French Indo-China come to bomb border hovels." © Bertolt-Brecht-Erben/Suhrkamp Verlag 1988.

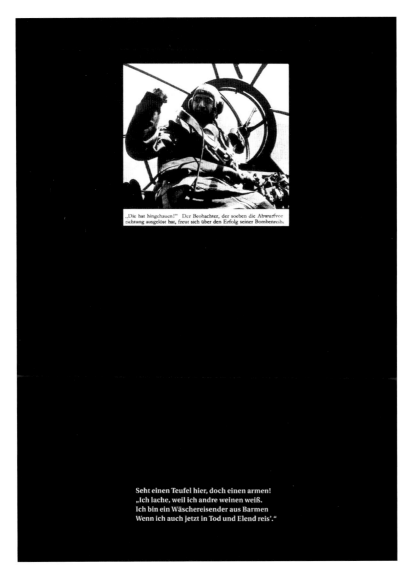

„Die hat hingehauen!" Der Beobachter, der soeben die Abwurfvor
richtung ausgelöst hat, freut sich über den Erfolg seiner Bombenreih.

Seht einen Teufel hier, doch einen armen!
„Ich lache, weil ich andre weinen weiß.
Ich bin ein Wäschereisender aus Barmen
Wenn ich auch jetzt in Tod und Elend reis'."

"They're for the guns that blast the iron to pieces."
"And what's it all for, brothers?" "It's our living."[39]

To live in order to kill, and to kill in order to live, but dying in any case: *Kriegsfibel* is like an image-poem of that infernal, vicious circle. It is no surprise that the *spatial* dimension is accompanied by a *thing-like* dimension that reduces any portrait, any landscape image, any scene in wartime to a still life, even to a funerary still life. These last images were also subjected to censorship in the 1955 edition. But Brecht wishes to show that all these shells and all these weapons built by the workers—and by slave prisoners too—more often than not ended up blowing to pieces these proletarians of the war, the mere soldiers, so that all that was left of them was piles of helmets on the ground (fig. 2.7).[40] The steel sheets that had become weapons or armour become no more than formless waste, useless things, devoid of any meaning. This is why the *War Primer*'s logical conclusion includes a catalogue of absurdity, fully shown in one plate (fig. 2.8, censored in 1955) that acts as a document of non-sense: the meeting on a table of an umbrella and two crutches, a worn tire and a prosthetic leg, a coffee grinder and some grenades[41]—another wartime absurdity, for they are pomegranates (*Granatäpfel* in German), not grenades (*Granaten*).

It is not a question here of *documents* in the way that Georges Bataille and Michel Leiris understood the word in 1929 and 1930. Brecht, in any case, was not a "surrealist" iconographer. It was the war, as he shows, that displaced and surpassed the limits of what our reality normally signifies. This approach to technological objects has nothing to do with any kind of "new objectivity" in the sense of amazement regarding the beauty of the world, even a world at war. What is needed, even in the montages of the most expected images (for example, Hitler in the company of Goebbels and Goering) with the unexpected "documents of non-sense" (the umbrella alongside the prosthesis and used tire), is an epic and lyrical approach to a war that is being played out throughout the world. If Brecht approaches trivial objects much as he does the most technological objects—the airplane

39 Ibid., pl. 2.
40 Ibid., pl. 41 [57]. See also plates A2 and A3 in *ABC de la guerre*.
41 *ABC de la guerre*, pl. A13.

„Was macht ihr, Brüder?" – „Einen Eisenwagen."
„Und was aus diesen Platten dicht daneben?"
„Geschosse, die durch Eisenwände schlagen."
„Und warum all das, Brüder?" – „Um zu leben."

Figure 2.6
Bertolt Brecht, *Kriegsfibel*,
1955, plate 2. © Bertolt-
Brecht-Erben/Suhrkamp
Verlag 1988.

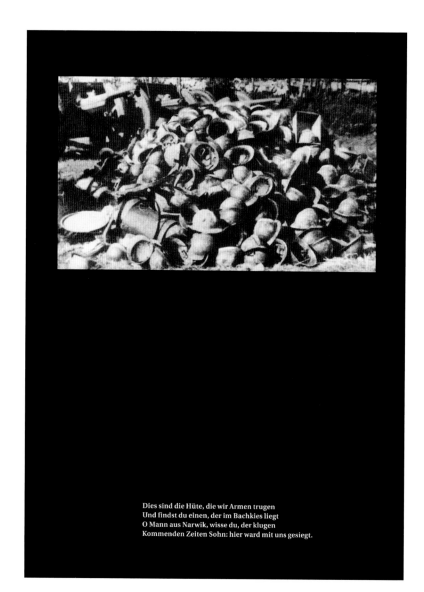

Figure 2.7
Bertolt Brecht, *Kriegsfibel*,
1955, plate A2. © Bertolt-
Brecht-Erben/Suhrkamp
Verlag 1988.

Dies sind die Hüte, die wir Armen trugen
Und findst du einen, der im Bachkies liegt
O Mann aus Narwik, wisse du, der klugen
Kommenden Zeiten Sohn: hier ward mit uns gesiegt.

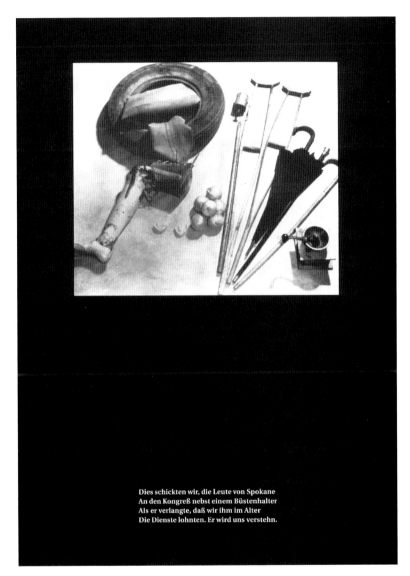

Dies schickten wir, die Leute von Spokane
An den Kongreß nebst einem Büstenhalter
Als er verlangte, daß wir ihm im Alter
Die Dienste lohnten. Er wird uns verstehn.

Figure 2.8
Bertolt Brecht, *Kriegsfibel*,
1955, plate A13. © Bertolt-
Brecht-Erben/Suhrkamp
Verlag 1988.

cockpit, the armoured steel plates, the infantryman's helmet, the prosthetic leg (figs. 2.5 to 2.8)—it is still with a view to returning to the ancient meaning of the epigram itself:

> in ancient greek epigrams man-made utensils are straightforward subjects for lyrical poetry, weapons too. hunters and warriors dedicate their weapons to the gods. whether an arrow enters the breast of a man or a partridge makes no difference. in our day, it is to a great extent moral scruples that prevent the rise of a comparable poetry of objects. the beauty of an airplane has something obscene about it.[42]

Brecht juxtaposed this text from the *Journals*, dated August 28, 1940, with a cold image of a bomber's cockpit control panel (fig. 2.9). The next day he copied out ancient epigrams from the collection by Robert Oehler—elegy of the quiver and the curved bow, elegy of the spear of ash with a bronze blade[43]—both objects of war, that very present and fatal pain. Next to this text he places in counterpoint a German propaganda image showing two hands and three stick grenades, with the following caption: "And finally: bombs and grenades in everyone's hands" (fig. 2.10).[44]

Epic

Brecht's assumption of the epic form (as well as the epigrammatic form) makes sense for him only inasmuch as it acts as a heuristic principle and a historical mode of observation.[45] A heuristic of montage, and observation by means of montage—if the *Journals* bring together an ancient epigram and a photo of hand grenades, and if the *War Primer* juxtaposes portraits of Nazi dignitaries and images of half-destroyed odds and ends, it is because the epic form, in the manner in which Brecht uses it, does not merely follow the

42 Brecht, *Journals*, 93–94.

43 See R. Oehler, *Mythologische Exempla in der älteren griechischen Dichtung* (Aarau: Sauerländer, 1925).

44 Brecht, *Journals*, 95.

45 B. Brecht, "La dramaturgie non aristoélicienne" (1932–51), in *Théâtre épique, théâtre dialectique: Écrits sur le théâtre* (Paris: L'Arche, 1999), 67–68.

events of the war chronologically. Instead it is less attached to the episodes of history—which dramatic form uses as its material—than to the "network of relations that is hidden behind the events," since "whatever happens, there is always another reality behind the one we describe."[46]

However, what is "behind" a factual event is not so much an unfathomable "depth" or "basis," a "root" or an obscure "source" from which history takes its whole appearance. What is behind it is a "network of relations," meaning a virtual expanse that simply asks the viewers (although there is nothing simple about this task) to heuristically multiply their viewpoints. It is therefore a vast moving territory, an open-air labyrinth of detours and thresholds. Brecht referred to this in terms of *curves* and *leaps*: where in the dramatic form "events move in a straight line," the epic form exposes these transformations by moving in curves; where dramatic narration proceeds by continuities ("*natura non facit saltus*"), epic montage reveals the discontinuities at work in every historical event ("*facit saltus*").[47]

Walter Benjamin clarified better than anyone what Brecht is aiming at in this epic form and in his technique of lyrical montage. But he needed two successive writings of the same text, "What Is the Epic Theatre?" in 1931 and in 1939—as well as a short intermediary text titled "Studies for a Theory of Epic Theater"—before being able to achieve this clarification, given how rich the theoretical material of Brecht's project seemed to him.[48] What seems incontestable is that such a project consists in taking position on the level of forms as well as of contents. The epic form for Brecht—into which I would like to pour the photo-epigrammatic form inherent in the *War Primer*—takes position in the history of forms insofar as it explicitly articulates an ancient tradition with the most recent techniques

46 Ibid., 110–12.

47 B. Brecht, "Old versus New Theater," trans. J. Willett, in *Brecht on Theatre*, rev. ed., ed. Marc Silberman (London: Bloomsbury, 2014), 111.

48 W. Benjamin, "What Is Epic Theatre?" (1931), in *Understanding Brecht*, trans. A. Bostock (London: Verso, 1998), 1–15; W. Benjamin, "Studies for a Theory of Epic Theater," ibid., 23–27; W. Benjamin, "What Is the Epic Theatre?" (1939), trans. E. Jephcott et al., in *Selected Writings*, vol. 4, *1938–1940*, ed. H. Eiland and M. W. Jennings (Cambridge, MA: Harvard University Press, 2003), 302–9.

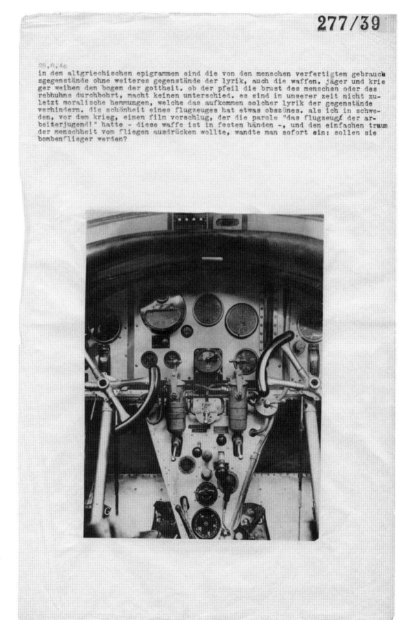

Figure 2.9
Bertolt Brecht, *Arbeitsjournal*,
August 28, 1940. © Berlin:
Akademie der Künste,
Bertolt-Brecht-Archiv
(277/39)/Bertolt-Brecht-
Erben/Suhrkamp Verlag 1973.

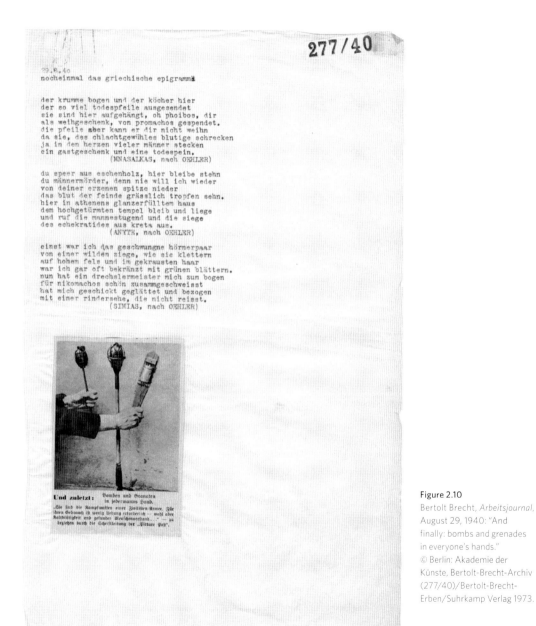

29.8.40
nocheinmal das griechische epigramm

der krumme bogen und der köcher hier
der so viel todespfeile ausgesendet
sie sind hier aufgehängt, oh phoibos, dir
als weihgeschenk, von promachos gespendet.
die pfeile aber kann er dir nicht weihn
da sie, des chlachtgewühles blutige schrecken
ja in den herzen vieler männer stecken
ein gastgeschenk und eine todespein.
 (MNASALKAS, nach OEHLER)

du speer aus eschenholz, hier bleibe stehn
du männermörder, denn nie will ich wieder
von deiner erzenen spitze nieder
das blut der feinde grässlich tropfen sehn.
hier in athenens glanzerfülltem haus
dem hochgetürmten tempel bleib und liege
und ruf die mannestugend und die siege
des echekratides aus kreta aus.
 (ANYTE, nach OEHLER)

einst war ich das geschwungne hörnerpaar
von einer wilden ziege, wie sie klettern
auf hohem fels und im gekrausten haar
war ich gar oft bekränzt mit grünen blättern.
nun hat ein drechslermeister mich zum bogen
für nikomachos schön zusammgeschweisst
hat mich geschickt geglättet und bezogen
mit einer rindersehe, die nicht reisst.
 (SIMIAS, nach OEHLER)

Und zuletzt: Bomben und Granaten
in jedermanns Hand.

„Sie sind die Kampfwaffen einer Zivilisten-Armee. Für
ihren Gebrauch ist wenig Übung erforderlich — wohl aber
Kaltblütigkeit und gesunder Menschenverstand..." — zu
beziehen durch die Schriftleitung der „Picture Post".

Figure 2.10
Bertolt Brecht, *Arbeitsjournal*,
August 29, 1940: "And
finally: bombs and grenades
in everyone's hands."
© Berlin: Akademie der
Künste, Bertolt-Brecht-Archiv
(277/40)/Bertolt-Brecht-
Erben/Suhrkamp Verlag 1973.

of cinematographic, radiophonic, and theatrical montage.[49] It is a question, first and foremost, of "making use of elements of reality in experimental rearrangements," by means of which "Epic Theatre, therefore, does not reproduce situations; rather, it discovers them . . . through the interruptions of the sequences" (*Unterbrechung von Abläufen*).[50]

This interruption consists, quite logically, in creating discontinuities, in "loosening the joints to the greatest possible extent,"[51] in making sure that the situations critique each other dialectically,[52] that is to say, mutually clash: "Its main function is not to illustrate or advance the action but, on the contrary, to interrupt it It is the retarding quality due of these interruptions (*Unterbrechung*) and the episodic quality of this framing (*Umrahmung*) of action which allows gestural theater to become epic theater."[53] Cutting into *episodes, framing, interruption, suspense*: all these terms deploy a vocabulary of montage, allowing Benjamin to make the following conclusion: "Like the images in a film, the epic theater moves in spurts. Its basic form is that of the shock with which the individual, well-defined situations of a play collide This creates intervals which, if anything, undermine the illusion of the audience and paralyze its readiness for empathy."[54]

This is how taking *positions* amounts, in Brecht's heuristics of the exposition of history, to taking *cognizance*. This is how all this exists only by taking *shape* in the rhythmicity of the montage of words, of gestures, of episodes, of images: "In Epic theater the actor's training consists in acting in such a way that he is oriented towards knowledge; and this knowledge, in turn, determines not only the content but also the *tempi*, pauses and stresses of his whole performance."[55] What Brecht talks about in *Man Equals Man*, for example—in which it is once again a question of war—is no less than the disassembling/reassembling—*Demontierung-Unmontierung*—

49 Benjamin, "Epic Theater" (1931).
50 W. Benjamin, "The Author as Producer," trans. R. Livingstone et al., in *Selected Writings*, vol. 2, *1927-1934*, ed. M. W. Jennings, H. Eiland, and G. Smith (Cambridge, MA: Harvard University Press, 1999), 778.
51 Benjamin, "Epic Theatre" (1939), 303.
52 Benjamin, "Epic Theatre" (1931), 10-12.
53 Ibid., 3-4.
54 Benjamin, "Epic Theatre" (1939), 306.
55 Benjamin, "Epic Theater" (1931), 11.

the "reshaping, dismantling, and transforming" that affects both the character Galy Gay and the dramatic description of his metamorphosis as a soldier of the Empire.[56]

If the epic poets invented fables or plots that interrupt and "reassemble" the course of history for their own purposes, it was because they served to create a montage of *immanent historicity* whose elements, taken from reality, induce, through the form they have been given, a new effect of knowledge that is found neither in timeless fiction nor in the chronological facts of reality. Pure fiction—that, for example of Ovid's *Metamorphoses*—disregards all historicity and risks at every moment spilling into myth. But pure documentary narration—that, for example, of a report in *Life* magazine—disregards its immanent historicity just as much, since it falls back entirely on things at the expense of relationships, on facts at the expense of structures. In fact there are neither complete metamorphoses nor absolute facts. It is necessary then to give oneself "experimental conditions" in order to show the non-ideal nature of history, that is to say, its fundamental *impurity*—the incompleteness, the "contradictory," conflicting, incomplete nature—of all historical metamorphosis.[57]

In the theatre in particular, "the unity of the character is in fact formed by the way in which its individual characteristics contradict one another," and as a result each of its gestures shows the conflict, the montage, and the complexity of the relationships.[58] We need to look in the same way at the human gestures of war documented in *Kriegsfibel*. The poet's epic work attains its goal—in the relationship between the cut-out photographic document and the meaning of the quatrain that answers it—if we have access to the complexities at work, or even to the contradictions of the simple gesture of the American soldier who has just felled his Japanese enemy (fig. 1.3), or the several gazes aimed symmetrically by the bomber's gunner and the Thai woman scanning the sky from her shelter (figs. 2.4 and 2.5).

56 W. Benjamin, "Bert Brecht" (1930), in *Selected Writings*, vol. 2, 370.

57 B. Brecht, "Short Organon for the Theatre," trans. M. Silberman and S. Giles, in *Brecht on Theatre*, 3rd ed. (London: Bloomsbury, 2015), 242.

58 Ibid., 245.

Distancing

This montage of complexity in Brecht is called "distancing" (*Verfremdung*). It is a famous concept and a crucial one: Bernard Dort defined its critical value regarding any usual notion of history as well as any traditional notion of the character; Ernst Bloch highlighted its value as a "tableau"; Reinhold Grimm and then Louis Althusser clarified its philosophical value, originating in Hegel and Marx; Bernard Pautrat showed how it constructs something like a "political uncanny" in theatre; Jacques Rancière saw in it a theoretical assumption of the "non-identical to oneself" and of "non-recognition"; Youssef Ishaghpour underlined its cinematographic implications; Jan Knopf widened the field of its theoretical construction from Francis Bacon to Karl Korsch; Philippe Ivernel examined its constitutive paradoxes—to clarify through distance while darkening the form, to multiply the meanings while singularizing each thing; Frederic Jameson noticed in it the emergence of a narrative mode in the "third person"; and Joachim Fiebach recognized in it a very contemporary "potential" for aesthetic deconstruction.[59]

Distancing, therefore, is the ideal position-taking. Yet there is nothing simple in this kind of gesture. To distance does not simply mean to place far away; by moving far away we lose sight of things, while distancing means, on the contrary, that we sharpen our gaze. In the auratic view of things—for example, when a spear is considered by the ancient poet to be a gift from the gods—it is something faraway that appears, however close the apparition. In

59 See B. Dort, *Lecture de Brecht* (Paris : Le Seuil, 1972), 111–50, and, "La 'distanciation,' pour quoi faire?" (1968), in *Théâtre réel: Essais de critique, 1967-1970*, 115–22 (Paris: Le Seuil, 1971); R. Grimm, "Verfremdung: Beiträge zu Wese und Ursprung eines Begriffs," *Revue de littérature comparée* 35 (1961): 207–36; E. Bloch, "Entfremdung, Verfremdung," in *Verfremdungen*, vol. 1 (Frankfurt: Suhrkamp, 1962), 81–90; L. Althusser, "Sur Brecht et Marx" (1968), in *Écrits philosophiques et politiques*, vol. 2, ed. F. Matheron (Paris: Stock-IMEC, 1997), 561–77; B. Pautrat, "Politique en scène: Brecht," in *Mimesis des articulations* (Paris: Aubier-Flammarion, 1975), 339–59; J. Rancière, "The Gay Science of Bertolt Brecht" (1979), in *Politics of Literature*, trans. J. Rose (Cambridge: Polity, 2011), 99–127; Y. Ishaghpour, "D'une nouvelle esthétique théâtrale et de ses implications au cinéma," *Obliques* 20-21 (1979): 163–85; J. Knopf, "Verfremdung," in *Brecht Theorie de Theaters*, ed. W. Hecht (Frankfurt: Suhrkamp, 1986), 93–141; P. Ivernel, "Passages de frontiers: Circulation de l'image épique et dialectique chez Brecht et Benjamin," *Hors-cadre* 6 (1987): 133–63; F. Jameson, *Brecht and Method* (London: Verso, 1998), 51–57; J. Fiebach, "Bilder des Grossen Kapitulation: Brechts Dekonstruktionspotential," *Theater der Zeit: The Brecht Yearbook* 23 (1998): 170–72.

the epic view of things, according to Brecht—for example, when a control panel or three hand grenades are shown to us in the *Journals* (figs. 2.9 and 2.10)—it is the *distance* that demands to be understood in the object, however close its apparition or its photographic framing. Often the faraway element assumes an unreachable *sameness*; distance, on the other hand, appears to give us access only to *alterity*, to the interplay of differences.

Brecht wrote profusely on the distancing effect (*Verfremdungseffekt*) as a revolutionary mark of the kind of theatre that he wished to create.[60] This required, first and foremost, construction of the aesthetic means for a critique of the illusion, opening in the field of drama the same kind of crisis of representation already at work in painting with Picasso, in cinema with Eisenstein, and in literature with James Joyce. To critique the illusion and to create a crisis of representation begin by bringing to the fore the modesty of the very gesture that consists in showing: to *distance* is to *show*, Brecht claimed. It is to make the image appear by informing the spectator that what he sees is only an incomplete aspect and not the entire thing, the thing itself that the image shows. Thus the actor must never take himself to be the character or identify completely with the character in the plot in which he is acting. He must not lie about his position as an interpreter, nor lie about the fact that he is not really Julius Caesar but simply a man from the twentieth century making a living as an actor and acting on a Berlin stage during the Cold War, for example. "At no point must the actor let himself be totally transformed into the character. . . . He must make the act of showing artistic."[61]

> Show that you are showing! Among all the varied attitudes
> Which you show when showing how men play their parts
> The attitude of showing must never be forgotten
> [. . .]
> Never
> Will a thoughtless imitation
> Be a genuine imitation.[62]

60 See B. Brecht, *Brecht on Theatre*, 3rd ed., ed. M. Silberman, S. Giles, and T. Kuhn (London: Bloomsbury, 2015).

61 Brecht, "Short Organon," 243–44.

62 B. Brecht, "Showing Has to be Shown," in *Bertolt Brecht: Poems, 1913–1956*, ed. J. Willett

Showing that we are showing means not lying about the epistemic status of representation: it is to make the image a question of *knowledge* rather than of *illusion*. Moreover, as Brecht wrote, "without knowledge one can show nothing; but how is one to know what is worth knowing?"[63] By foiling the illusion, the showing that is undertaken destroys the unity of the image with the magic of apparition; it is no longer Julius Caesar that I see onstage but the anachronistic composite of a German from the twentieth century speaking about his desire to conquer Gaul. In short, the position-taking that consists in showing, in distancing, in knowing always seems twofold. "This principle—that the actor appears on stage in a double guise . . . ultimately just means that the actual, everyday process is no longer disguised."[64] This is how we can understand a critique of identification, if by that word we mean a process that aims on the one hand to *unify* what we identify with and on the other hand to *unite* without taking the necessary step back from one's observation—for all art, according to Brecht, is an *art of observation*.[65]

Thus, to distance means to show by showing that we are showing and by thus dissociating—in order to show better the complex and dialectical nature—what we show. In this way, therefore, *to distance is to show*, that is to say, to differentiate the evidence in order to better connect the differences both visually and temporally. In distancing, it is the simplicity and unity of things that become faraway things while their complexity and their dissociated nature are brought to the fore. This is what Brecht calls an "art of historicization": an art that breaks the continuity of narrations, takes away their differences, and, compiling these differences together, restores the essentially "critical" value of all historicity. To distance is to know how to handle one's visual or narrative material like a montage

and R. Mannheim (London: Methuen, 1987), 344. [Translator's note: A published English translation of the second part was not available; the last three lines are my own translation.]

63 Brecht, "Short Organon," 246.

64 Ibid., 243-44.

65 B. Brecht, "Notes sur le comédien" (1927-30), in *L'art du comédien: Écrits sur le théâtre* (Paris: L'Arche, 1999), 30-31; B. Brecht, "Critique de l'identification" (1935), ibid., 43-47; B. Brecht, "Observation de l'art et art de l'observation" (1935-39), in "Considérations sur les arts plastiques," *Écrits sur la littérature et l'art,* vol. 2, *Sur le réalisme,* trans. A. Gisselbrecht (Paris: L'Arche, 1970), 63-68.

of citations referring to real history—contemporary history, first and foremost, in which the playwright is himself inscribed, as we see on this "editing table" or "montage table" that the *Journals* were for Brecht. In the theatre, too, "the attitude which he adopts is the socially critical one . . . The object of the A-effect [distancing] is to alienate the social gest underlying every incident. . . . This brings us to a crucial technical device: historicization."[66]

Uncanny

There is something uncanny in distancing: on the one hand, it shows in order to create a *demonstration*; on the other hand, it shows in order to produce a *dismantling* or *de-montage*. First of all, Brecht claims to distance things only to show the historical and political relationships in which they take position at a given moment. In this sense, distancing is an operation of knowledge that aims, through art, at the possibility of a critical gaze on history: "The aim of this technique, known as the alienation effect, was to make the spectator adopt an attitude of inquiry and criticism in his approach to the incident. The means were artistic."[67] This knowledge arises from a perception of the differences that make montage possible. It is not deduced but rather arises within the "surprise that we feel in front of the behavior of our fellows and which, often, takes hold of us in front of our behavior."[68]

This element of *surprise* is fundamental. It opens onto the other face of distancing, where knowing comes with a lack of evidence or obviousness and with the uncanny: "To distance a process or a character means, simply, to take away from that process or that character everything about it that is evident, known, obvious, and to create in its place astonishment and curiosity."[69] Why is there such astonishment, and why is there such unpredictability in the critical effect? It is because distancing creates intervals

66 B. Brecht, "New Technique of Acting," in *Brecht on Theater*, 139–40.
67 Ibid., 136.
68 B. Brecht, "Sur la distanciation" (1936), in *Brecht on Theatre*, 67.
69 Brecht, "La dramaturgie non aristoélicienne," 127.

where hitherto we saw only unity, and because montage creates new connections between orders of reality that are spontaneously thought to be very different. Because all this finally dislocates our usual perception of relationships between things or situations: "We looked for a form of representation that would make what is banal appear unfamiliar, and what we are used to appear astonishing. What we see everywhere was to appear unique, and many things that are apparently natural were to be recognized as the products of artifice."[70] This is a way to open any pre-established rule to the critical power of the exception:

> *The actors:*
> [...]
> Observe the conduct of these people closely:
> Find it estranging even if not very strange
> Hard to explain even if it is the custom
> Hard to understand even if it is the rule
> Observe the smallest action, seeming simple,
> With mistrust
> Inquire if a thing be necessary
> Especially if it is common
> We particularly ask you—
> When a thing continually occurs—
> Not on that account to find it natural
> Let nothing be called natural
> In an age of bloody confusion
> Ordered, disorder, planned caprice,
> And dehumanized humanity, lest all things
> Be held unalterable![71]

To distance is to show by showing the relationships of things shown together and connected according to their differences. There is therefore no distancing without a work of montage, which is a dialectics of de-montage

70 Brecht, "Sur la distanciation," 59–60.
71 B. Brecht, *The Exception and the Rule*, trans. E. Bentley, in *Jewish Wife and Other Short Plays* (New York: Grove Press, 1992), 111.

the epic view of things, according to Brecht—for example, when a control panel or three hand grenades are shown to us in the *Journals* (figs. 2.9 and 2.10)—it is the *distance* that demands to be understood in the object, however close its apparition or its photographic framing. Often the faraway element assumes an unreachable *sameness*; distance, on the other hand, appears to give us access only to *alterity*, to the interplay of differences.

Brecht wrote profusely on the distancing effect (*Verfremdungseffekt*) as a revolutionary mark of the kind of theatre that he wished to create.[60] This required, first and foremost, construction of the aesthetic means for a critique of the illusion, opening in the field of drama the same kind of crisis of representation already at work in painting with Picasso, in cinema with Eisenstein, and in literature with James Joyce. To critique the illusion and to create a crisis of representation begin by bringing to the fore the modesty of the very gesture that consists in showing: to *distance* is to *show*, Brecht claimed. It is to make the image appear by informing the spectator that what he sees is only an incomplete aspect and not the entire thing, the thing itself that the image shows. Thus the actor must never take himself to be the character or identify completely with the character in the plot in which he is acting. He must not lie about his position as an interpreter, nor lie about the fact that he is not really Julius Caesar but simply a man from the twentieth century making a living as an actor and acting on a Berlin stage during the Cold War, for example. "At no point must the actor let himself be totally transformed into the character. . . . He must make the act of showing artistic."[61]

> Show that you are showing! Among all the varied attitudes
> Which you show when showing how men play their parts
> The attitude of showing must never be forgotten
> [. . .]
> Never
> Will a thoughtless imitation
> Be a genuine imitation.[62]

60 See B. Brecht, *Brecht on Theatre*, 3rd ed., ed. M. Silberman, S. Giles, and T. Kuhn (London: Bloomsbury, 2015).

61 Brecht, "Short Organon," 243–44.

62 B. Brecht, "Showing Has to be Shown," in *Bertolt Brecht: Poems, 1913–1956*, ed. J. Willett

Showing that we are showing means not lying about the epistemic status of representation: it is to make the image a question of *knowledge* rather than of *illusion*. Moreover, as Brecht wrote, "without knowledge one can show nothing; but how is one to know what is worth knowing?"[63] By foiling the illusion, the showing that is undertaken destroys the unity of the image with the magic of apparition; it is no longer Julius Caesar that I see onstage but the anachronistic composite of a German from the twentieth century speaking about his desire to conquer Gaul. In short, the position-taking that consists in showing, in distancing, in knowing always seems twofold. "This principle—that the actor appears on stage in a double guise . . . ultimately just means that the actual, everyday process is no longer disguised."[64] This is how we can understand a critique of identification, if by that word we mean a process that aims on the one hand to *unify* what we identify with and on the other hand to *unite* without taking the necessary step back from one's observation—for all art, according to Brecht, is an *art of observation*.[65]

Thus, to distance means to show by showing that we are showing and by thus dissociating—in order to show better the complex and dialectical nature—what we show. In this way, therefore, *to distance is to show*, that is to say, to differentiate the evidence in order to better connect the differences both visually and temporally. In distancing, it is the simplicity and unity of things that become faraway things while their complexity and their dissociated nature are brought to the fore. This is what Brecht calls an "art of historicization": an art that breaks the continuity of narrations, takes away their differences, and, compiling these differences together, restores the essentially "critical" value of all historicity. To distance is to know how to handle one's visual or narrative material like a montage

and R. Mannheim (London: Methuen, 1987), 344. [Translator's note: A published English translation of the second part was not available; the last three lines are my own translation.]

63 Brecht, "Short Organon," 246.

64 Ibid., 243-44.

65 B. Brecht, "Notes sur le comédien" (1927-30), in *L'art du comédien: Écrits sur le théâtre* (Paris: L'Arche, 1999), 30-31; B. Brecht, "Critique de l'identification" (1935), ibid., 43-47; B. Brecht, "Observation de l'art et art de l'observation" (1935-39), in "Considérations sur les arts plastiques," *Écrits sur la littérature et l'art*, vol. 2, *Sur le réalisme*, trans. A. Gisselbrecht (Paris: L'Arche, 1970), 63-68.

of citations referring to real history—contemporary history, first and foremost, in which the playwright is himself inscribed, as we see on this "editing table" or "montage table" that the *Journals* were for Brecht. In the theatre, too, "the attitude which he adopts is the socially critical one . . . The object of the A-effect [distancing] is to alienate the social gest underlying every incident. . . . This brings us to a crucial technical device: historicization."[66]

Uncanny

There is something uncanny in distancing: on the one hand, it shows in order to create a *demonstration*; on the other hand, it shows in order to produce a *dismantling* or *de-montage*. First of all, Brecht claims to distance things only to show the historical and political relationships in which they take position at a given moment. In this sense, distancing is an operation of knowledge that aims, through art, at the possibility of a critical gaze on history: "The aim of this technique, known as the alienation effect, was to make the spectator adopt an attitude of inquiry and criticism in his approach to the incident. The means were artistic."[67] This knowledge arises from a perception of the differences that make montage possible. It is not deduced but rather arises within the "surprise that we feel in front of the behavior of our fellows and which, often, takes hold of us in front of our behavior."[68]

This element of *surprise* is fundamental. It opens onto the other face of distancing, where knowing comes with a lack of evidence or obvious-ness and with the uncanny: "To distance a process or a character means, simply, to take away from that process or that character everything about it that is evident, known, obvious, and to create in its place astonishment and curiosity."[69] Why is there such astonishment, and why is there such unpredictability in the critical effect? It is because distancing creates intervals

66 B. Brecht, "New Technique of Acting," in *Brecht on Theater*, 139–40.
67 Ibid., 136.
68 B. Brecht, "Sur la distanciation" (1936), in *Brecht on Theatre*, 67.
69 Brecht, "La dramaturgie non aristoélicienne," 127.

where hitherto we saw only unity, and because montage creates new connections between orders of reality that are spontaneously thought to be very different. Because all this finally dislocates our usual perception of relationships between things or situations: "We looked for a form of representation that would make what is banal appear unfamiliar, and what we are used to appear astonishing. What we see everywhere was to appear unique, and many things that are apparently natural were to be recognized as the products of artifice."[70] This is a way to open any pre-established rule to the critical power of the exception:

> *The actors:*
> [. . .]
> Observe the conduct of these people closely:
> Find it estranging even if not very strange
> Hard to explain even if it is the custom
> Hard to understand even if it is the rule
> Observe the smallest action, seeming simple,
> With mistrust
> Inquire if a thing be necessary
> Especially if it is common
> We particularly ask you—
> When a thing continually occurs—
> Not on that account to find it natural
> Let nothing be called natural
> In an age of bloody confusion
> Ordered, disorder, planned caprice,
> And dehumanized humanity, lest all things
> Be held unalterable![71]

To distance is to show by showing the relationships of things shown together and connected according to their differences. There is therefore no distancing without a work of montage, which is a dialectics of de-montage

70 Brecht, "Sur la distanciation," 59–60.
71 B. Brecht, *The Exception and the Rule*, trans. E. Bentley, in *Jewish Wife and Other Short Plays* (New York: Grove Press, 1992), 111.

(dismantling) and re-montage (reassembling), of the de-composition and re-composition of everything. Consequently, however, this knowledge through *montage* will be also a knowledge through *uncanniness*. Brecht assumes this by demanding clearly that the use of critical reason should not be confronted but rather incited, revived by such an uncanniness of things:

> In everything that follows, one must never understand "unfamiliar" [*fremd*] to mean "odd" [*seltsam*]. There is no interest whatsoever in presenting processes on the stage as curious, genuinely incomprehensible phenomena; they must, on the contrary, be made understood. . . . Art must not present things as obvious (finding an echo in our feelings), nor as incomprehensible, but as comprehensible albeit not yet understood."[72]

This is to bring us to a *dialectical tableau* that attempts to articulate non-knowledge with comprehension, particularity with generality, contradiction with historical development, discontinuity of the jump with "unity of contradictory terms":

1. *Verfremdung as understanding* (understanding—not understanding—understanding), negation of the negation.
2. *Accumulation of incomprehensible facts until understanding occurs* (the jump from quantity to quality).
3. *The particular in the general* (the event in its singularity, its unicity, yet typical).
4. *The factor of development* (change from a feeling to an opposite feeling, criticism and identification in one).
5. *Contradictory character* (this individual in these circumstances! These consequences of this action!).
6. *Understanding one thing through another* (the scene has at first an independent meaning; once it is placed in relation to other scenes, we discover that it participates in yet another meaning).

72 Brecht, "Sur la distanciation," 61; B. Brecht, "Sur l'art ancien et l'art nouveau," trans. J.-L. Lebrave and J.-P. Lefebvre, in *Écrits sur la littérature et l'art*, vol. 1, *Sur le cinéma* (Paris: L'Arche, 1970), 30.

7. *The jump (saltus naturae*, epic development with jumps).

8. *The unity of opposites* (in unity the opposite is sought, Mother and son—in *Mutter*,—outwardly unified, struggle against each other because of the reward).

9. *Applicability of knowledge* (unity of theory and practice).[73]

Georg Simmel, before Brecht, made a famous analysis of the uncanny, strangeness, or "foreignness" (*Fremdsein*) as a "synthesis between the near and the far," a "special form of reciprocal action" between the subjects of a society.[74] The stranger, the foreigner, is always the strange, the foreign.[75] If the stranger or the foreigner is a fundamental political paradigm—to such an extent that we could almost judge a society on how it treats its foreigners—the strange or foreign would be its fundamental aesthetic corollary, as it appears in the stories of Franz Kafka and in the "uncanny" analyzed by Freud in the same period.[76] It is striking that Brecht's great texts on distancing date from his years in exile, as though his aesthetic position on strangeness/foreignness, on the uncanny, went together with his situation as a foreigner in political exile.[77] The *Journals*, moreover, are saturated with notations on the uncanniness of being a foreigner. He finds himself welcomed to the United States with a kind of comfort that horrifies him both as a VIP and as an "enemy alien," benefiting from the easygoing American ways while also suffering censorship of his texts, here paid by Hollywood and there summoned before the courts for his political ideas.[78]

Both the status of stranger/foreigner and the uncanny cast doubt on any familiar reality. By putting it into question, we can recompose the imagination with other possibilities in the immanence of this reality. To distance

73 B. Brecht, "Le théâtre dialectique—La dialectique au théâtre" (1929-56), in *Théâtre épique, théâtre dialectique*, 167-68.

74 G. Simmel, *Sociologie: Étude sur les formes de la socialisation* (1908), trans. L. Deroche-Gurcel and S. Muller (Paris: PUF, 1999), 663-68. See also A. Loycke, ed., *Der Gast, der bleibt: Dimensionen von Georg Simmels Analyse des Fremdseins* (Frankfurt: Campus/Maison des sciences de l'homme, 1992).

75 Translator's note: The French word *étranger* means both "stranger" and "foreigner." in German, the same is true of the word *Fremde*.

76 S. Freud, "The Uncanny," in *The Uncanny*, trans. D. McLintock (London: Penguin, 2003).

77 Brecht, "Sur la distanciation," 48-73.

78 Brecht, *Journals*, 157-59, 202, 215, 223, 239-40, 372.

means this too: to make everything appear strange or uncanny as well as foreign, and then glean from this a field of new, unseen possibilities. We can easily understand that, for Bertolt Brecht, *Verfremdung* characterized more or less everything interesting that modern art produced—whether popular (Chaplin) or arduous (Joyce), whether formally elaborate (Cézanne) or presented as a documentary, whether geometric (Russian suprematism) or erotic (French surrealism):

> *Distancing effects in Chaplin.*
> Eating a boot (with table manners, by removing the nails like chicken bones, with the little finger raised).
> Technical procedures of cinema:
> Chaplin appears to his starving friend as a chicken.
> Chaplin crushing his rival while trying to appease him.
> [*Distancing effects in other arts.*]
> Joyce uses the distancing effect in *Ulysses*. He distances as much by his way of presenting things (above all by the fact that he frequently and rapidly changes this) as the processes themselves.
> The introduction of cinematographic documents in theatre plays also creates the distancing effect. Since they are confronted by the processes of more general scope presented on the screen, the processes that play out on stage are distanced.
> Painting distances (Cézanne) when it exaggerates the hollow form of a recipient.
> Dadaism and surrealism used the most extreme kinds of distancing effects.[79]

We should not be surprised that the Brechtian theorization of *Verfremdung* is accompanied by "formalist" references (as Georg Lukács said in reproach). Distancing is found in the very principle of revolutionary formalism, which is Russian formalism.[80] The one who expresses this most clearly is undoubtedly Viktor Shklovsky, with his theory of art as a process of "defamiliarization" (*ostranenie*), formulated in 1917. As a materialist theory, it attacked all

79 Brecht, "Sur la distanciation," 73.
80 See A. A. Hansen-Löve, *Der russische Formalismus: Methodologische Rekonstruktion seiner Entwicklung aus dem Prinzip der Verfremdung* (Vienna: Österreichischen Akademie der Wissenschaften, 1978).

Russian symbolist literature and opposed it with a more concrete arrangement of *things*, closer to sensation than to signification: "In order to make us feel objects, to make a stone feel stony, man has been given the tool of art. The purpose of art, then, is to lead us to a knowledge of a thing through the organ of sight instead of recognition."[81] It was at the same time a matter of attacking a whole tradition that made art an eternal image of the world, which was a way of taking a historical position in front of a thing: "Art is a means of experiencing the process of creativity. The artifact itself is quite unimportant."[82]

It is also a way to break with the immobility and the atopy of images: the symbolist artist sees images "marching on without change" and "belonging to 'no one,' except perhaps to 'God'"; the modern poet endeavours to invent "new devices of verbal arrangement and organization," and his work is "far more concerned with the *disposition* than with the creation of imagery."[83] This new disposition is a work of montage: re-disposition of things that make us see them "as though for the first time" but consequently makes them appear unusual. Singling out, or defamiliarization, according to Shklovsky, is what gives access to a new form of observation of things, to a greater acuity in front of reality, but its effect will be one of "darkening" and uncanniness. For in the thing that is singled out (defamiliarized) by art there is a non-coincidence in resemblance, a new knowledge that blurs all recognition.[84]

Those who might be surprised by the analogy between this "anxious resemblance" and the Freudian *Unheimlich* need only observe how Maurice Blanchot situated the "effect of strangeness," that process of generalized defamiliarization, in Brecht:

The image through which the effect of strangeness is realized, says Brecht, the one that, while permitting us to recognize the object, will make it appear

81 V. Shklovsky, "Art as Device," in *Theory of Prose*, trans. B. Sher (Normal, IL: Dalkey Archive Press, 1993), 6.

82 Ibid.

83 Ibid., 2 [emphasis added].

84 Ibid., 3. On the formalist approach to realism, see R. Jakobson, "Du réalisme artistique" (1921), in *Théorie de la littérature: Textes des formalistes russes*, ed. T. Todorov (Paris: Le Seuil, 1965), 98–108; B. Tomashevksy, "Thématique" (1925), ibid., 263–307.

strange and foreign . . . , can designate in everything something else: beneath the familiar the unheard of, and in what is, what may not be. It is a power that sets things apart so as to render them sensible to us and always unknown, from out and by means of this separation that becomes their very space.

Now it is precisely this separation, this distance that Brecht is seeking to produce and maintain through the effect of strangeness. . . . Able to produce the effect of strangeness, the image therefore effects a kind of experiment by showing us that things are perhaps not what they are, that it falls to us to see them otherwise and, by this opening, render them first imaginarily other, then really and entirely other.[85]

85 M. Blanchot, "The Effect of Strangeness," in *The Infinite Conversation*, trans. S. Hanson (Minneapolis: University of Minnesota Press, 2003), 363–64.

III

The Dysposition of Things

Dismantling Order

Division

Like poetry—or as poetry—montage shows us that "things are perhaps not what they are, that it falls to us to see them otherwise," according to the new disposition obtained by the montage. In his essay on Bertolt Brecht, Maurice Blanchot understood how it was necessary, first of all, to question the fundamental relationship between poetry and dispersion:

> Poetry: dispersion that, as such, finds its form. Here a supreme struggle is engaged against the essence of division, and nonetheless from this very basis; language responds to a summons that brings its inherited coherency back into question. It is as though language were torn from itself: everything is broken, shattered, without relation; passage from one sentence to another, one word to another is no longer possible. But once the internal and external ties are broken, there arises in each word as though anew all words; not words, but their very presence that effaces them, their absence that calls them forth—and not words, but the space appearing and disappearing, that they designate as the moving space of their appearance and disappearance.[1]

Everything indeed seems broken, shattered, without relation. Leafing through the *Arbeitsjournal*, we constantly jump from one thing to another: on December 4, 1941, for example, Brecht tells how he offered Fritz Lang a "god of luck" from the Far East, but he sticks a Mexican depiction of

1 M. Blanchot, "The Effect of Strangeness," in *The Infinite Conversation*, trans. S. Hanson (Minneapolis: University of Minnesota Press, 2003), 360.

death on the following page of his journal.[2] On February 25, 1942, he illustrates the collection of war contributions in the United States only to highlight the effect of votive dispersion: a pile of onions with a dead rat in a cardboard box, old shoes with a prosthetic leg (fig. 3.1).[3] On August 19, 1942, Brecht glued into his notebook an image of Ukrainian peasants reduced to slavery by the Nazi occupiers, but next to this he wrote: "breakfast in the office about i o'clock with sandwiches from home and a swig of californian white wine, it is hot but we have fans." Just before— that is, two nights before—he had written the following: "the house is very beautiful. in this garden it becomes possible to read lucretius once more."[4] On April 29, 1944, we find mention of Shakespeare just before a document showing the arrest by German soldiers of Yugoslavian resistance fighters.[5]

Contrasts, ruptures, dispersions. But everything is broken so that the space between things can appear—their shared base, the unperceived relationship that connects them in spite of all, whether it be a relationship of distance, of inversion, of cruelty, or of non-sense. We can certainly find in the *Arbeitsjournal* something of this "iconology of intervals" that Warburg called for. For example, on June 15, 1944, Brecht placed in a montage, side by side, three images: first of all we see Pope Pius XII making a gesture of benediction, then Field Marshal Rommel studying a map with his military staff, and finally a Nazi mass grave in Russia (fig. 3.2).[6] In this montage, the effect of *dispersion* must be thought about from the perspective of cruel coincidence, or even concomitance. These three events, though separate in space, are in fact exactly contemporaneous. They proceed from a shared history. The montage shows us how a religious leader blesses the world only by washing his hands of the injustices that he ignores or passes over in silence; how the Pope's raised hands are echoed in the stick that Rommel points authoritatively at the map, no doubt showing where he wishes to attack; and how these two gestures of power, religious and military, are

2 B. Brecht, *Journals, 1934-1955*, trans. H. Rorrison (New York: Routledge, 1996), 177.
3 Ibid., 200.
4 Ibid., 254-55.
5 Ibid., 309.
6 Ibid., 317-18.

echoed in the gestures of suffering and mourning of those who have nothing left, these Russian women digging up and tragically embracing their dead. We can no longer say then that these images have nothing to do with each other or to see in each other. What we must see, on the contrary, is how, in the midst of such dispersion, human gestures *look at* one another—confront one another, respond to one another—whether over an altar, a military map, or an open mass grave in the countryside.

We have so often reduced Brecht's poetics to pure, simple pedagogy— without accounting for the fact that, like poetry, a pedagogy can ever be "pure" or "simple"—that we have very much misunderstood the decisive role in it of montage as a heuristic procedure of the lyrical text and the theatrical plot. Montage in Brecht appears as a fundamental dramatic gesture inasmuch as it cannot be reduced to the simple status of compositional effect; it is fundamental because it brings up a specific knowledge of history in its own "theatres of operation," the *Kriegsschauplatz* of August 1940, for example (fig. 1.1).[7] Brecht's commentators have often attempted to understand how a "succession of contradictions" conducive to "boiling the traces" could create a carefully elaborated "dialectical creation."[8] Or how the "disorders of the world"—central to art, according to Brecht—could create something like "composed chaos."[9]

Yet the operational value of Brechtian montage remains difficult to discern. Roland Barthes, for example, begins by approaching Brecht's drama from the perspective of an art that is "on the level of its history," accomplishing a "fundamental synthesis between the rigor of political design (in the highest sense of the term) and the total liberty of drama."[10] Then he himself adopts a (rough) approach to montage in order to account for *Mother Courage*. Commenting on a series of seven photographs taken with a telephoto lens by Pic in 1957, he states that "what photography reveals

7 Ibid., 92.

8 B. Dort, *Lecture de Brecht* (Paris: Le Seuil, 1972), 6-10.

9 See J. Fuegi, *Bertolt Brecht: Chaos, According to Plan* (Cambridge: Cambridge University Press, 1987); F. Jameson, *Brecht and Method* (London: Verso, 1998), 66-88.

10 R. Barthes, "Théâtre capital" (1954), in *Œuvres complètes*, vol. 1, *1942-1961*, ed. E. Marty (Paris: Le Seuil, 2002), 503. See also R. Barthes, "Le comédien sans paradoxe" (1954), ibid., 512-14; "Pourquoi Brecht?" (1955), ibid., 575-77; and "Brecht" (1955), ibid., 593.

ITEMS: OLD SHOES, SHIRTS, CORSET, LONG UNDERWEAR, GLOVES, HAT, PURSE AND WIG

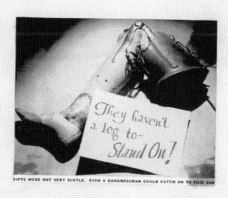

GIFTS WERE NOT VERY SUBTLE. EVEN A CONGRESSMAN COULD CATCH ON TO THIS ONE

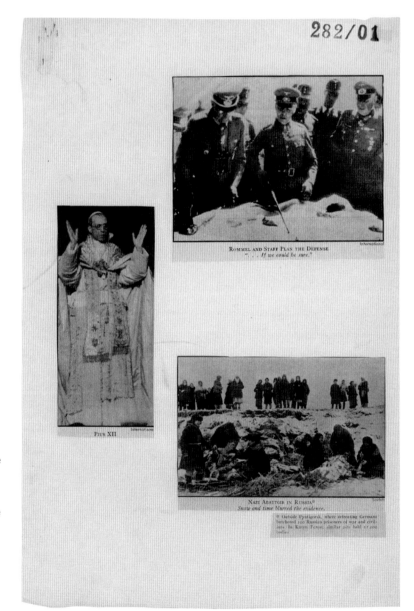

Figure 3.2
Bertolt Brecht, *Arbeitsjournal*, June 15, 1944: "Pius XII. Rommel and staff plan the defence. Nazi abattoir in Russia. Snow and time blurred the evidence. Outside Pyatigorsk, where retreating Germans butchered 200 Russian prisoners of war and civilians." © Berlin: Akademie der Künste, Bertolt-Brecht-Archiv (282/01)/Bertolt-Brecht-Erben/Suhrkamp Verlag 1973.

is precisely . . . the detail. Yet the detail is the very place of signification, and it is because Brecht's theatre is a theatre of signification that the detail is so important in it."[11] At this time, therefore, Barthes admires in every one of Brecht's details the ruptures of continuity and his way of making sure that each image destroyed the "thickening of the tableau," and that each tableau destroyed the linearity of the plot.[12]

Twelve years later, Roland Barthes sees things quite differently. Regarding Eisenstein, he states his rejection of montage as a construction of "obvious meaning," rhetoric of emphasis, refusal of polysemy, and a unilateral position-taking in the epic narration of the Russian Revolution; the "obtuse meaning," however, appears to him only in the *unicum*—or even the *punctum*—of a single isolated photogram in his montage.[13] In 1973 Barthes finally places Diderot, Brecht, and Eisenstein on the same aesthetic level: all three, in his opinion, worked towards "the power of representation" against anything one might expect from an authentic "musical text."[14] From that moment on, the *rupture*, which is essential to montage, would be understood as an authoritative cut-out, and its value as a fragment would be reduced to the "unity of the subject who cuts." In every case, according to Barthes, it is a tableau that is produced, functioning as a "pure cut-out segment, with clearly defined edges, irreversible and incorruptible; everything that surrounds it is banished into nothingness, remains unnamed, while everything that it admits within its field is promoted into essence, into light, into view."[15]

For Barthes, dramatic unity in Diderot, the epic scene in Brecht, and filmic montage in Eisenstein all share that "significant and propaedeutical" aspect of the tableau, with the "ideal meaning" that this supposes—"Good, Progress, the Cause, the triumph of the just History"—and the "fetishized"

11 R. Barthes, "Sept photos modèles de *Mère Courage*" (1959), ibid., 997.

12 R. Barthes, "Préface à *Mère Courage et ses enfants* de Bertolt Brecht (avec des photographies de Pic)" (1960), ibid., 1075.

13 R. Barthes, "Le troisième sens: Notes de recherche sur quelques photogrammes de S. M. Eisenstein" (1970), in *Œuvres complètes*, vol. 3, *1968-1971*, ed. E. Marty (Paris: Le Seuil, 2002), 485-506.

14 R. Barthes, "Diderot, Brecht, Eisenstein" (1973), in *Image, Music, Text*, trans. S. Heath (London: HarperCollins, 1977), 70.

15 Ibid.

composition that follows from it.[16] Everywhere there will be an obsession with "perfect instants" that are "totally concrete and totally abstract" and "what Lessing subsequently calls (in the *Laocoon*) the *pregnant moment*. Brecht's theatre, Eisenstein's cinema are series of pregnant moments . . . in which a whole social situation can be read."[17] The consequence will be philosophical; Eisenstein and Brecht are the embodiments of representation as an "ideal meaning" produced by a transcendent—and even more so political—subject: "Thus all militant art cannot but be representation, legal . . . that is, significant, readable," or, in short, unfit for any polysemy, almost unworthy of the word *art* and, in any case, retrograde and profoundly anti-modern.[18]

Against this analysis, Youssef Ishaghpour sees in Brechtian distancing a fundamental process for dividing the subject and breaking the unity of representation: "Where one might seek to create identity theatrically, Brecht uses theatre to divide. . . . Against the estheticizing of politics and fascist theatrical identification, Brecht politicizes art through distancing."[19] In this way Brecht makes *Verfremdung* a general paradigm for the modernity that cinema will have to take notice of in each of its montage choices. Where Barthes places Brecht and Eisenstein on the (wrong) side of representation, Ishaghpour wishes to draw a line between Brechtian montage (epic; founded on narrative rupture and distancing) and Eisensteinian montage (full of pathos; founded, according to him, on narrative continuity and the empathy of "attractions").[20]

Yet the respective works by Brecht and Eisenstein are far too complex and profuse for us to be able to place all the "rupture" in the one and all "continuity" in the other, or all distancing in the one and all empathy in the other. There are montages full of pathos in Brecht just as there are distancing effects in Eisenstein. We must not forget, on the other hand, the aesthetic complicity shown by the two artists: a photograph by Olga Tretyakova shows them in 1932 practically embracing, caressing

16 Ibid., 71.
17 Ibid., 73-74.
18 Ibid., 77.
19 Y. Ishaghpour, *D'une image à l'autre: La représentation dans le cinéma d'aujourd'hui* (Paris: Denoël-Gonthier, 1982), 22-23.
20 Ibid., 45-59.

each other's cheeks, with an overplayed tenderness and the laughter of the pose.[21]

This aesthetic complicity was more profoundly anchored in a link related to method. The 1920s saw, in both Russia and Germany, the development of a transversal notion of montage among all the arts of representation. That is how Sergei Tretyakov was able to speak of a "theatre of attractions" while Eisenstein was interested in the cinematographic "montage of attractions."[22] Moreover, in his essay on Brecht, Tretyakov insists on the paradigm of montage, whether to describe the playwright's studio as a "living diagram of his literary biography" and his working methods[23] or to evoke the abundance of ideas for staging:

During a sojourn in Moscow in 1932, Brecht explained his project to me: he wanted to construct in Berlin a panoptic theatre in which only the most interesting trials in history of humanity would be played. . . . For example, the trial of Socrates, the trial of a witch, the trial of Karl Marx's *New Rhenish Newspaper: Organ of Democracy*, the trial of George Grosz accused of blasphemy with his cartoon *Christ with a Gas Mask*. Brecht is already far away. He lets his imagination run freely. 'Imagine the trial of Socrates is finished. We assemble the rapid trial of a witch in which the jurors sit, like knights rigid in their armor, condemning the witch to be burned at the stake. Then the trial of Grosz begins, but we forget to remove the knights from the scene. When the outraged prosecutor turns on the painter who offended the good Lord full of grace, a terrible slamming is heard, as though twenty enormous samovars had begun to applaud. They are knights, moved, applauding with their iron hands the defender of the poor abandoned god. We will show, simultaneously,' Brecht continues, 'the trial of the expulsion of the unemployed worker in Germany and your soviet trial in which a worker keeps his dwelling in spite of the owners' claims.'"[24]

21 E. Wizisla, ed., *Bertolt Brecht, 1898-1998: ". . . und mein Werk ist der Abgesang des Jahrtausends." 22 Versuche, eine Arbeit zu beschreiben* (Berlin: Akademie der Künste, 1998), 59.

22 S. Tretyakov, "Le théâtre des attractions" (1924), trans. B. Grinbaum, in *Dans le front de gauche de l'art* (Paris: François Maspero, 1977), 85-92.

23 S. Tretyakov, "Bert Brecht" (1936), trans. D. Zaslavsky, ibid., 195.

24 Ibid., 188-89.

Montage

There is no doubt that montage is a fundamental element in Brechtian poetics.[25] Whether it concerns exposing a theoretical argument in the *Journals* or dramatizing a historical argument in the plays such as *Life of Galileo*, in every case the question of montage is crucial. One only shows and exposes in order to *dispose*, in the sense of "to arrange," not things themselves—for to dispose things is to make a tableau or a catalogue of them—but rather their differences, their mutual shocks, their confrontations, and their conflicts. Brechtian poetics could almost be summarized as an art of *disposing differences*. Such disposition, inasmuch as it considers co-presence or coexistence through the dynamic of conflict, passes inevitably through a work destined to *dys*-pose things, to disorganize their order of appearance. It is a way of showing every disposition as a shock of heterogeneities. That is montage—one shows only to dismember; one disposes only to "dys-pose" first. One places in a montage only to show the gaps that stir every subject facing any other subject.

And it is as though, historically speaking, the trenches opened up in Europe during the Great War had inspired, in the field of aesthetics as well as in the arts (we can think of Georg Simmel, Sigmund Freud, Aby Warburg, Marc Bloch), the decision to *show through montage*, that is to say, through the dismantling and re-composition of everything. Montage was both a method of knowing and a formal process born during the war; it accounted for the "disorder of the world." It has characterized our perception of time since the first conflicts of the twentieth century; it has become the "modern method" par excellence.[26] And it made its appearance at a time when Bertolt Brecht, among other writers, artist, and thinkers, took positions in the debate on aesthetics and politics during the interwar period.

25 See P. Szondi, *Theory of Modern Drama, 1880–1950*, trans. M. Hays (Minneapolis: University of Minnesota Press, 1987); J.-P. Lefebvre, "Brecht et le cinéma," *La Nouvelle Critique* 46 (1971): 42–43; R. Mueller, *Bertolt Brecht and the Theory of Media* (Lincoln: University of Nebraska Press, 1989), 67–95.

26 See P. A. Sitney, *Modernist Montage: The Obscurity of Vision in Cinema and Literature* (New York: Columbia University Press, 1990); M. Teitelbaum, ed., *Montage and Modern Life, 1919–1942* (Boston: Institute of Contemporary Art/MIT Press, 1992); H. Bergius, *Montage und Metamechanik; Dada Berlin: Artistik von Polaritäten* (Berlin: Mann, 2000); H. Möbius, *Montage und Collage: Literatur bildende Künste, Film, Fotografie, Musik, Theater bis 1933* (Munich: Wilhelm Fink, 2000).

Ernst Bloch was one of the privileged witnesses to (and a partisan in) this debate. In *Heritage of Our Times*, published in 1935 and constantly enriched with passages written well into the 1950s, he aimed to refute attacks by Georg Lukács against expressionist art and modern literature in general.[27] Modern art de-composes the order of things; according to this viewpoint, one must place in the same aesthetic sphere such divergent works as those of James Joyce and Franz Kafka, Marcel Proust and Julien Green, André Breton and Alfred Döblin.[28] Bertolt Brecht obviously belonged to this landscape with his literary oeuvre, which he tested out "in the laboratory of the stage by means of Objectivity and montage."[29] As we read *Heritage of Our Times* we can understand that Brecht used montage in drama in the same way that Igor Stravinsky did in music[30] and Walter Benjamin in philosophy.

In his remarkable reading of *One-Way Street* in 1928, Ernst Bloch presents Benjamin's thought as typical of the surrealists, with his characteristic multiplying of viewpoints and his tireless soliciting of forms, "new ones or those known only from despised corners" of bourgeois culture.[31] Montage makes these heterogeneous forms rise to the surface and connect by ignoring any order of grandeur or hierarchy, that is to say, by projecting them onto the same plane of proximity, such as the front of a stage. This is what Bloch wished to call the "form of the revue":

> The indirect impression of the revue came precisely from the sensuous power and liveliness of uncemented scenes, from their changeability and transformation into one another, from their contact with the dream. Thus this form entered as an aid into very different art, from Piscator to the Threepenny Opera; even new aspects of "ad-lib," of feats with the right hand tied behind your back, were not lacking. In Benjamin these feats became philosophical: as a form of interruption, as a form for improvisation and sudden cross-glances, for details and fragments which do not seek any "systematic manner" anyway.

27 E. Bloch, *Heritage of Our Times* (1962), trans. N. Plaice and S. Plaice (Cambridge: Polity Press, 1991), 187–251.

28 Ibid., 221-28.

29 Ibid., 226. See also "On the Threepenny Opera," 211-13, and "A Leninist of the Stage," 229-33.

30 Ibid., 214-20.

31 Ibid., 334.

. . . "Revue" . . . appears as considered improvisation, as a falling away of the broken coherence, as a sequence of dreams, aphorisms, and passwords between which at most a crosswise elective affinity wishes to exist. Thus if "revue," in terms of its methodical possibility, is a journey through the hollowing times, then Benjamin's experiment offers photos of this journey, or rather at once: photomontage.[32]

One-Way Street, in Bloch's opinion, radicalized and rendered philosophical a type of montage that Piscator and Brecht had used in their theatre as an "auxiliary form" of epic narration. Not only did the typographical choices of *One-Way Street*, thanks to its publisher, Ernst Rowohlt, explicitly offer an example of photomontage (created by Sacha Stone), but its literary composition, with its short chapters with such surprising titles, like a catalogue of the improbable, resembled something like photomontage. Bloch saw that this subversive game, which was Dadaist, surrealist, or "anarchist" in nature, accompanied an archaeological work intended to elevate that "optical unconscious" that Benjamin had spoken of so profoundly. The random appearance of the montage of heterogeneities does not preclude an interpretation of underlying relationships: the erratic surface phenomena are not without a questioning of the depths (in the Freudian sense), even if, philosophically speaking, the "substance" has left room for movement, "work," and arrangement. It is thanks to montage that such a method is able to achieve this dual result and, therefore, to place itself as something essentially marginal:

> A thinker tracks down particulars with the utmost precision, mints them sharply, in order nevertheless hardly to say for what the coin is current. He gives script-face values without a bourgeois exchange rate, without even a tangibly different one; what is apparent is anarchic significance and the significance of collecting consternations, wallowing in decay, rescuing, yet substantially unorientated. The same glance which decays causes the diverse flow to freeze at the same time, consolidates it (with the exception of its direction), Eleaticizes even the imagination of the most variant intertwining Benjamin's philosophy causes every intention to die the "death from the truth," and the truth

32 Ibid., 335.

is divided into stilled "ideas" and their court: the "images." Whereas precisely genuine images, the sharp details and exact depths of this literature, its central remoteness and the finds of its cross-drilling do not dwell in snail-shells or caves of Mithras, with a pane of glass in front, but in public process, as dialectical experiment-figures of process. Surrealistic philosophizing is exemplary as polish and montage of fragments, which however very pluralistically and unrelatedly remain such. It is constitutive as montage[33]

This way of thinking certainly influenced Brecht's aesthetic. If Ernst Bloch was right in saying that montage was only an "auxiliary" process in a theatrical work such as *The Threepenny Opera*, it was in 1928—and not by coincidence—that Brecht began to see in montage, and even in photomontage, a fundamental domain of modern literature, beginning with James Joyce's *Ulysses*, which he recognized as having "modified the situation of the novel [to the point of] creating a collection of different methods of observation" arranged in a heterogeneous or multiplying way.[34] Bad novels could even be recognized, Brecht claimed at the time, by the fact that they "contain nothing photographable."[35] On the contrary, artists must work, then, towards "knowing what a document is" by multiplying the processes of confrontation, of comparison, and of documentary montage.[36]

Retrospectively, Brecht saw in the 1920s the crucial moment when a "non-Aristotelian drama" could at last become thinkable or creatable: "The genres became mixed. Cinema erupted into the theatre, and the report into the novel. The viewer was no longer given a comfortable place in the midst of events, and was deprived of the individual character with which he could identify."[37] From there, art's own work consists in questioning singularities rather than individualities (the classical figure of the hero, for example), and then in placing those singularities in conflict with many

33 Ibid., 337. We should note that Bloch vigorously opposed this type of montage with ontologies of fullness and deprivation, illustrated by the works of Scheler and Heidegger.
34 B. Brecht, "Sur l'art ancien et l'art nouveau" (1920–33), in *Écrits sur la littérature et l'art*, vol. 1, *Sur le cinéma*, trans. J.-L. Lebrave and J.-P. Lefebvre (Paris: L'Arche, 1970), 73.
35 Ibid., 57.
36 B. Brecht, "Considérations sur les arts plastiques" (1935–39), in *Écrits sur la littérature et l'art*, vol. 2, *Sur le réalisme*, trans. A. Gisselbrecht (Paris: L'Arche, 1970), 61.
37 B. Brecht, "Sur le réalisme" (1937–41), ibid., 111.

others, in short, creating through montage a whole world of heterogeneities that are joined but confront one another, that are presented together but are different. This is exactly that László Moholy-Nagy called "organized disorder"[38] in 1928, and what Raoul Hausmann outlined, in his article on photomontage in 1931, for the fundamental term that he called "dialectics of forms" (*Formdialektik*):

> If the first form of photomontage consisted of an explosion of viewpoints and a dizzying interpenetration of several levels of images, exceeding futurist painting in complexity, it has since then gone through an evolution that we could call constructive. Everywhere we find the idea that the optical element represents a means of expression with extremely varied aspects; in the particular case of photomontage, it allows, due to its oppositions of structures and dimensions (from the rough to the smooth, from the aerial view to the close-up shot, from the perspective to the flat surface, for example) the greatest technical variety, that is to say the most advanced elaboration of the dialectics of forms.[39]

Dialectic

To dys-pose things is a way to understand them dialectically. Then comes the question of knowing what should be understood by the word *dialectic*. The ancient Greek verb *dialegesthai* means "to converse"—to introduce a difference (*dia*) into a discourse (*logos*). As a confrontation between divergent opinions, with a view to arriving at agreement on a meaning that is mutually accepted as true, dialectics is therefore a way of thinking that is linked to the first manifestations of rational thought in ancient Greece. It was in Plato's work, as we know, that dialectics acquired the fundamental status of a method of truth that related it—and even identified it—with theory (*theoria*) and science (*episteme*) itself. When Bertolt Brecht writes in his *Journals* of his

38 L. Moholy-Nagy, "Photoplastique [photomontage]" (1928), trans. F. Mathieu, in *La photographie en Allemagne: Anthologie de textes, 1919–1939*, ed. O. Lugon (Nîmes: Jacqueline Chambon, 1997), 227.
39 R. Hausmann, "Photomontage" (1931), trans. F. Mathieu, ibid., 232. See also O. Lugon, *Le style documentaire: D'August Sander à Walker Evans, 1920–1945* (Paris: Macula, 2001), 241–93.

literary texts as "a lot theory in dialogue,"[40] he explicitly places himself in the tradition of this initial form of philosophical dialectics. Dialectics, he claims, is "the only possible aid to orientation" in one's thinking, by bringing different points of view into confrontation around the same question.[41]

Brecht often referred to Socrates.[42] He did not merely imagine a theatre that was "a lot of theory in dialogue" but also thought about philosophy as theatre, that is to say, as dialectical theatre, in which every confrontation gives rise to a truth.[43] Then he discovered a new system of dialectics. It was an overwhelming moment in philosophy when dialectics became, through Hegel, the very structure of things and the absolute method for pure thinking, the ultimate system of knowledge, the ultimate knowledge of history, the just way to posit truth in its becoming. And we know that, for Brecht, this new direction reached its culmination in the philosophical and political assumptions of Marxist and Leninist thinking.[44] The *Journals*, alongside other, more dogmatic texts, contain numerous examples of this position: the artist must do much more than invent beautiful forms; he must also fight concepts and substitute them with others.[45] This is why Brecht did not read Hegel's *Aesthetics* without his *Philosophy of History* and refused to separate the history of art from political history, seeing both from the perspective of the great conflicting polarities that can be uncovered only by the dialectical method.[46]

Regarding this reciprocity between thinking of the theatre and political philosophy, Louis Althusser concludes that Brecht transformed the theatre just as Marx transformed philosophy, by introducing politics into thinking about art just as Marx had done for thinking about history.[47] Here, indeed,

40 Brecht, *Journals*, 20.

41 Ibid., 47.

42 See G. Irrlitz, "Philosophiegeschichtliche Quellen Brechts," in *Brechts Theorie des Theaters*, ed. W. Hecht (Frankfurt: Suhrkamp, 1986), 11–31.

43 See C. Subik, *Philosophieren als Theater: Zur Philosophie Bertolt Brechts* (Vienna: Passagen, 2000).

44 See F. Fischbach, *L'évolution politique de Bertolt Brecht de 1913 à 1933* (Lille: Publications de l'Université de Lille III, 1976), 91–130; E. Wizisla, ed., *Bertolt Brecht*, 35–46.

45 Brecht, *Journals*, 10.

46 Ibid., 22–23.

47 L. Althusser, "Sur Brecht et Marx" (1968), in *Écrits philosophiques et politiques*, ed. F. Matheron, vol. 2 (Paris: Stock-IMEC, 1997), 561–77.

dialectics is a fundamental instrument for such a transformation. Theatrical time in Brecht, says Althusser, is more *chronic* than *dramatic*: it is a time that "cannot do without history" (*chronos*), which is imminent with regard to the facts and gestures (*drama*) of the characters: "A time moved from within by an irresistible force, producing its own content. It is a dialectical time *par excellence*."[48] A time that never separates the beginning from the end, the exception from the rule, the crisis from its normal system. And, therefore, a perpetual becoming: "In reality, the processes are never finished. It is observation that cannot do without giving them a deadline. . . . A man who had not seen Mr. K. for a long time greeted him with the following words: 'You haven't changed at all.'—'Oh!' said Mr. K. turning quite pale."[49]

In fact, things are even more complex than is suggested by the simple application of philosophical dialectics to drama and to art. In a text from 1955, "Five Difficulties in Writing the Truth"—initially intended to be published secretly in Hitler's Germany—Brecht states clearly that dialectics is not only a question of method. One needs *courage* to write the truth, *intelligence* to consider the most fruitful situations, *powers of discernment* to know to whom one should impart this truth, *ruse* to distribute it, and finally the *art* of making it possible to wield it like a weapon. Hence, a

> thinking which questions all things and all processes, and is intent on discovering their transient and changeable nature. Our rulers have a great aversion to major changes. They would like everything to stay the same, preferably for a thousand years. It would be best of all if the moon stood still and the sun stopped in its tracks! Then no one would ever get hungry and want to eat their supper. Once they have fired, their enemies should not be allowed to carry on shooting, their shot should be the last. . . . But it is possible, in general, to counter this talk of fate; one can demonstrate that the fate of man is the work of men.[50]

48 L. Althusser, "The 'Piccolo Teatro,' Bertolazzi and Brecht" (1962), in *For Marx*, trans. B. Brewster (New York: Verso, 2005), 137.

49 B. Brecht, "Notes sur la philosophie" (1929–41), trans. P. Dehem and P. Ivernel, in *Écrits sur la politique et la société* (Paris: L'Arche, 1970), 122; B. Brecht, *Histoires d'almanach* (1949), trans. R. Ballangé and M. Regnaut (Paris: L'Arche, 1983), 147.

50 B. Brecht, "Five Difficulties in Writing the Truth," in *Brecht on Art and Politics*, trans. L. Bradley and T. Kuhn (London: Bloomsbury, 2003), 154–55. Text cited and commented on by Dort, *Lecture de Brecht*, 109–11.

Within this concomitance and this complexity, the artist is irresistibly led to transform the textbook dialectical outlines proposed by Hegelian philosophy and Marxist criticism. Althusser saw in Brecht's theatre how the fundamental motif of becoming was accompanied by something like a counter-motif of perpetual suspense, be it in the drama or in the chronicle. Dialectics in Brecht seems to be marked by a strange kind of "delay in self-consciousness" in the face of "sudden appearances in it of a truth as yet hardly defined."[51] It is as though Brechtian drama—and I believe the montage of *Kriegsfibel* shares this strangeness—seeks to expose the interruptions, the contrasts, and the anachronisms of the process more than the process itself as such, as an evolution of a motif towards its "truth." This is what fundamentally distinguishes the artistic use-value of dialectics from its philosophical or doctrinal use-value. Where the neo-Hegelian philosopher builds arguments in order to posit the truth, the artist of montage creates heterogeneities in order to dys-pose truth in an order that is no longer the order of reasons but rather of "correspondences" (to echo Baudelaire), of "elective affinities" (to echo Goethe and Benjamin), of "tearings" (to echo Georges Bataille) or "attractions" (to echo Eisenstein).

This is how to expose the truth by disorganizing, and therefore by complicating while implicating (rather than explicating) things. The playwright's dialectics, like that of artists and non-academic thinkers such as Raoul Hausmann, Sergei Eisenstein, Georges Bataille, Walter Benjamin, and Carl Einstein,[52] is a *dialectics of the montage-maker*, that is to say, the one who dys-poses, separating and then rejoining its elements at the point of their most unlikely relationship. When Hegel, in a text from the *Aesthetics* that Brecht continuously refers to, describes the "dramatic poetry" of antiquity as a process of conflict that always ends up being solved and returning to a state of rest,[53] he describes a dialectics of resolution and of synthesis. But the question in "non-Aristotelian" drama, as well as in the aesthetics of montage in Brecht's work, concerns the infernal relaunching of contradictions and, therefore, the inevitability of non-synthesis.

51 Althusser, "'Piccolo Teatro,'" 141–47.

52 See G. Didi-Huberman, *La ressemblance informe, ou le gai savoir visuel selon Georges Bataille* (Paris: Macula, 1995), 165–383; G. Didi-Huberman, *Devant le temps: Histoire de l'art et anachronisme des images* (Paris: Minuit, 2000), 85–232.

53 G. W. F. Hegel, *Introductory Lectures on Aesthetics* (1835–42), trans. B. Bosanquet (London: Penguin, 1993), ch. 3.

Disorder

This is why, as Jean Jourdheuil remarks, "we cannot learn anything from Brecht that might resemble a constituted knowledge, a collection of rules making up a system. The deliberately fragmentary, punctual, and limited nature of the interventions tends to make any such attempt pointless."[54] As in the surrealist *Documents* of Carl Einstein and Georges Bataille, as in the explosive montages of Eisenstein and Raoul Hausmann, Brechtian dialectic is, first and foremost, *concrete*. We can recall how he wrote on the beams of his workroom: "Truth is concrete"[55]—that is to say, it is unique, partial, incomplete, passing like a shooting star. The viewer of the documents stuck onto the pages of *Kriegsfibel* does not, then, have "truth" at his disposal but rather sees flares, snippets, fragments of truth scattered here and there in the dys-position of images, to the extent that he is only a spectator—inasmuch as he becomes a constant "expectator"—of truth at play: "The *gestus* of the viewer and his attitude [are] those of one that waits."[56]

In front of a meeting of gestures as different from one another as those of Pope Pius XXII with his hands raised, Rommel pointing a baton at a military map, and the Russian women with grief-stricken bodies, grasping cadavers in their arms (fig. 3.2), the viewer has in fact no certainty at all regarding determination of their relationship. Yet he feels—"expecting" as such, for again he has to use his intuition and verify it if possible—that an *over*-determination is at work in this montage of gestures. Walter Benjamin provides a remarkable explanation of the epic and theoretic force of such an approach to the human gesture. First of all, it is *documentary*: "the gestures are found in reality." Second, it is *reframed*: "this strict, frame-like, enclosed nature of each moment of an attitude . . . is one of the basic dialectical characteristics of the gesture." Third, it is *a step back* from the action, the drama,

54 J. Jourdheuil, "Brecht: Par quel bout le prendre ?" (1973), in *L'artiste, la politique, la production* (Paris: Union générale d'éditions, 1976), 185. See also N. Müller-Schöll, "Das 'epische Theater' ist 'uns' (k)eine Hilfe: Brechts Erfindend eines Theaters der Potentialität," in *Brecht 98: Poétique et politique*, ed. M. Vanoosthuyse, 43–54 (Montpellier: Paul Valéry University, 1999).

55 R. Berlau, "Introduction," in B. Brecht, *ABC de la guerre*, trans. P. Ivernel (Grenoble: Presses Universitaires de Grenoble, 1985), 232.

56 Ibid.

the chronology that it breaks with its interruption: "the more frequently we interrupt someone engaged in an action, the more gestures we obtain. Hence, the interrupting of action is one of the principal concerns of epic theatre." Fourth, it is suspensive, *delayed*, even at a standstill: "it is the retarding quality of these interruptions and the episodic quality of this framing of action which allow gestural theatre to become epic theatre."[57]

It is indeed this formal work of montage—reframing, interruption, stepping back, delay—that makes Brechtian poetics, in Benjamin's view, an authentic dialectical work of the image, a work created from within the documented gesture itself in the same way that a photographic montage or an epic sequence can show us its surprise:

> The thing that is revealed as though by lightning in the "condition" represented on the stage—as a copy of human gestures, actions and words—is an immanently dialectical attitude. The conditions which epic theatre reveals is the dialectical attitude at a standstill. For just as, in Hegel, the sequence of time is not the mother of the dialectic but only the medium in which the dialectic manifests itself, so in epic theatre the dialectic is not born of the contradiction between successive statements or ways of behaving, but of the gesture itself. . . . The damming of the stream of real life, the moment when its flow comes to a standstill, makes itself felt as a reflux: this reflux is astonishment. The dialectic at a standstill is its real object. . . . But if the stream of things breaks against this rock of astonishment, then there is no difference between a human life and a word. In epic theatre both are only the crest of the wave. Epic theater makes life spurt up high from the bed of time and, for an instant, hover iridescent in empty space.[58]

To "make life spurt high up from the bed of time"—like the wave, the whirlpool, the tempest, but also the filmic work of montage—is, first of all, to dismantle order, the spatial and temporal order of things. Pius XII, Rommel, and the cadavers of Russian civilians are placed on the montage table and in their contemporaneity only through an initial act of

57 W. Benjamin, "Studies for a Theory of Epic Theatre," in *Understanding Brecht*, trans. A. Bostock (London: Verso, 2003), 23–24.
58 W. Benjamin, "What Is Epic Theatre?" (1931), ibid., 12–13.

dismantling (de-montage) and reassembling (re-montage) that brings them together from a geographical distance and also "outside of the time" of their chronology. We have nothing left to do with the speeches of Hermann Goering and Rudolf Hess, but we can continue to benefit from reading their meticulous dismantling by Bertolt Brecht in his essays on fascism written between 1933 and 1939. Their way of interrupting the manifest arguments, of creating intervals and moments of suspense, of bringing latencies to the surface—in short, of dys-posing discourses—contributes efficiently to the symptomal reading that Brecht wished to call a "restoration of truth."[59]

By making this truth spurt "outside of time," that is, the linear or literal time of the words uttered by Goering (the photographs in *Kriegsfibel* doing the same with the chronological time of the events of the Second World War), the Brechtian dismantling permits us to glimpse everything that symptomatically spans the order of discourses. And, first of all, those contradictions that any thinking about over-determination cannot avoid bringing to light:

> History books and theatre plays generally designate too few justifications for characters' actions. This implies that the action has one justification alone. It is a way to present misguided things, for . . . the whole cluster of justifications, without which an action is generally impossible, must be discovered. In each cluster of justifications, there are contradictions. . . . The transformable character of the world is the result of these contradictions.[60]

What this kind of dismantling of manifest elements loses on the level of chronology, it gains on the level of dynamics. That is why Brecht's form of literary layout—the images stuck into the *Journals* and *War Primer*—aims for a certain rhythm, a certain "speed" in the disposition of things: "the jazzed-up, syncopated iambics that i often use (five feet, but tap-dancing) [aim] to give the epic treatment pace . . . in principle it is possible to use both

59 B. Brecht, "On Restoring the Truth," in *Brecht on Art and Politics*, 133–40.

60 Brecht, "Notes sur la philosophie," 123; Brecht, "Le théâtre dialectique—La dialectique au théâtre," in *Théâtre épique, théâtre dialectique: Écrits sur le théâtre*, ed. J.-M. Valentin (Paris: L'Arche, 1999), 183.

slow motion and high speed in the epic mode."[61] This play on rhythms and tempos often accentuates the strokes and the jolts, the jumps and surges—in other words, the *discontinuities*:

> the jump is constantly being made from the particular to the general, from the individual to the typical, from the now to yesterday and tomorrow, the unity of the incongruous, the discontinuity of the ongoing process. . . .
>
> By jumps, qualities disintegrate, and the image of the whole is modified. . . . Mutations operate with an astonishing rapidity. These days, science allows that the passage from one era to another occurs by leaps; we could even speak of lightning-mutations. For a long time only variations, discordances, tiny aberrations, mere precursory signs occur. But the mutation itself operates with a dramatic suddenness.[62]

We can understand then that the dialectics of the montage-maker radically disorganizes the amount of foreseeability that we might have expected from a "philosophical dialectic" describing the progress of reason in history. The dialectics of the montage-maker (the artist, the one who shows)—inasmuch as this dialectics gives its entire space to symptoms, unresolved contradictions, to speeds of appearance, and to discontinuities—only dys-poses things in order to make their intrinsic tendency for disorder felt. "By applying principles," wrote Brecht, "we do not fear the breaches. It is always useful to remember that if the right reasons were not overlooked in establishing those principles, it means that the right reasons prevailed over the opposite reasons. With these breaches, we bring to light those opposite reasons."[63] Hence, something that sounds like praise for disorder—"Where nothing is in its place, there is disorder. Where, in the intended place, there is nothing, there is order."[64]

A sensation of disorder is therefore required for any dialectics of montage: paradoxical dialectical disorder. On January 21, 1942, Brecht wrote in his *Journals* that his own literary and theoretical work seemed to him a

61 Brecht, *Journals*, 137.
62 Ibid., 121; B. Brecht, *Dialogues d'exilés* (1940–41), trans. G. Badia and J. Baudrillard (Paris: L'Arche, 1972), 24.
63 Brecht, "Notes sur la philosophie," 138.
64 Brecht, *Dialogues d'exilés*, 16.

perpetual transgression of the principles that he had adopted after reading Hegel, Marx, and Lenin. However, "bounds are there to be exceeded," he writes, which implies (as he clarifies the next day) not using dialectics solely in a "relativist" way: "dialectics more or less force you to seek out the conflict in all processes, institutions, and representations."[65] The artist introduces disorder into dialectics, or *as* dialectics, because he handles it by ceaselessly changing the rules or the language games. Hence, for example, the delightful philosophical apologue in the *Book of Interventions in the Flow of Things*, titled "Breaking the Rules":

> The mathematician Ta drew a very irregular figure for his students and set them a test to measure its surface area. They split up the figure into triangles, squares, circles and other figures, whose surfaces were measurable, but nobody could calculate exactly the surface of the irregular figure. Then master Ta took a scissors, cut out the figure, placed it on a pair of scales, weighed it and placed an easily calculable rectangle on the other scale and cut off sections of it until the scales were in balance. Me-Ti called him a dialectician because, unlike his students who only compared one figure with another, he had treated the figure to be calculated as a piece of paper with a weight (and thus solved the test as a real test without bothering about rules).[66]

This apologue contains a mixture of dialectical violence—"breaking the rules" in order to uncover a truth where one did not expect it—and of humour. The two are in fact entwined. In Brecht's opinion, humour has not only a sensual and literary quality but also a theoretical and political one. The dismantling of Goering's speeches is not without humour—albeit a dark humour, coming from a writer in exile whose sufferings were to a certain extent being caused by Goering—such as the montage of a pile of onions with the words "Let's all cry!" (fig. 3.1) and the ridiculously impotent and stiff appearance of the sovereign pontiff facing the atrocities of war (fig. 3.2). In a passage from his "dialogues from exile," Brecht maliciously completes the picture of philosophical order and transgressive disorder,

65 Brecht, *Journals*, 195.
66 B. Brecht, *Me Ti: Book of Interventions in the Flow of Things*, trans. A. Tatlow (London: Bloomsbury, 2016), 85.

of reason and humour, all once again considered from the position of exile, which was, in his mind, the dialectical position par excellence:

> Hegel had the stuff of one of the greatest comics that philosophy has ever known; apart from him, I can see only Socrates, who, moreover, used an analogous method. . . . As far as I can understand, he had a tic: he blinked in one eye, something he did from his birth until his death; without ever having been conscious of it, he continually blinked, like others afflicted with an irresistible Saint-Vitus dance. He was so humorous that he was, for example, incapable of thinking of order without disorder. He clearly understood that extreme disorder is very close to the strictest order. . . . He contested the idea that one and one were identical, not only because everything that exists transforms ineluctably and tirelessly into something else, into its opposite in fact, but also because there is nothing identical to oneself. Like all humorists, he was above all interested in the transformation of things. . . . Until now, I have never met a man without humor who understood Hegel's dialectics. . . . [In the same way] the best school for dialectics is emigration. The most penetrating dialecticians are people in exile. It is changes that forced them into exile, and they are only interested in changes. From the tiniest signs they deduce, so long as they are capable of thinking, the most fantastic events. If their adversaries win, they calculate the price the latter had to pay for their victory, and they have an eye for contradictions. Long live dialectics![67]

67 Brecht, *Dialogues d'exilés*, 84–87.

IV

The Composition
of Forces

Showing Politics Again

Realism

Because of their position of extraterritoriality, political exiles have a special ability or energy according to Brecht: *Schaukraft*, a particularly sharp "power of vision" regarding historical contradictions. "They have an eye for contradictions," Brecht claims (speaking of himself, of course). And he concludes, almost joyously and triumphantly, "Long live dialectics!"[1] But at the heart of this superb dialectical energy, be it violence or humour, ruthless precision of dismantling or a deviation towards disorder— knowledge of contradictions in any case—lies a new knot of *unknown* contradictions with which, I believe, Brecht privately struggled without ever managing to disengage himself fully. "Long live dialectics!" What is that about? What does that implement? Are there not at least two things— two inevitably contradictory things—that Brecht intended when he used the term *dialectic*?

What, then, does Bertolt Brecht want to expose in his plays, his theoretical writings, his montages of images? Is it the rule of history or the rising to the surface of its exceptions? Is it the universal form of becoming (Hegel, Marx) or the singularity of its deformations (Bataille, Hausmann)? Is it law or transgression? Is it a fact of historical determination or a symptom of memorial over-determination? Is it a sovereign flow or a discontinuity in the flow? Is it a necessity of reason in history or a subversive contingency of unconscious desire? Is Brechtian writing important because of its chronistic parameters (as Louis Althusser suggested) or because of its anachronistic paradigm (as, I

1 B. Brecht, *Dialogues d'exilés* (1940–41), trans. G. Badia and J. Baudrillard (Paris: L'Arche, 1972), 87.

believe, Walter Benjamin suggested)? "Non-Aristotelian drama" is, first and foremost, "dialectical," but does this imply the message or the montage? The watchword or the witticism? Social realism or a kind of "surrealization" of all things? Conceptual distancing or association of ideas? Does this drive the fixities and the aporias of "militant art" (as Roland Barthes suggested) or the anarchism of relationships "that engender one another by metamorphosing and that touch on dreams" (as Ernst Bloch suggested)? Can the same gesture document a moment of history and at the same time be dispersed through the anachronisms of the imagination?

It is difficult to decide on these questions, for the simple reason that Brecht himself never really made a definitive choice. That is why the problem brought to the surface here by the notion of dialectics is replicated—or diffracted—each time the author of *Mother Courage* evokes the aesthetic posture to be held in front of historical realities: in short, every time it is a matter of understanding what it means for a literary work or image to be *realist*.

> [The] usual view is that the more easily reality can be recognized in a work or art, the more realistic it is. against this i would like to set up the equation that the more recognizably reality is mastered in the work of art, the more realistic it is. straightforward recognition of reality is often impeded by a presentation which shows how to master it. sugar as described by a chemist loses its recognizability.[2]

It seems to me that Brecht's entire work oscillates around this question. It is clear that an intelligent realism can never be reduced to mere recognition of the reality shown. So what is beyond this mere recognition? There is what Brecht called the "mastering of reality" (*die Realität gemeistert wird*). First, we can understand this mastering to be like the production of *meaning*, above all of the political meaning inherent and immanent in every situation shown. But the extreme invoked—the sugar of chemists—shows us that, for Brecht, it is also a question of wording, or the production of *form*. When it is the meaning that is a criterion, Brecht leans more or less towards a defence of social realism, as when he admires the painter Hans Tombrock's "surprising grasp of the principle of social grouping as a compositional

2 B. Brecht, *Journals, 1934–1955*, trans. H. Rorrison (New York: Routledge, 1996), 84.

category," or when he reproduces in his *Journals* the heroic drawings by Anatoli Yar-Kravchenko without taking into account the fact that they are the exact equivalent of Nazi propaganda comic strips.[3]

Brecht then composes his song for Free German Youth (*Freie Deutsche Jugend*) titled "Construction Song," and another titled "Song of the Future."[4] It is at this time that he subscribes to the Leninist project of "planning in the arts," even if "you have to proceed very carefully."[5] It is at this time that he defends Johannes Becher's "winter battle" by joining every "dialectic" with every "distancing" on the aesthetics of social realism.[6] He seems to return to the position of Georg Lukács on the idea of critical realism, adopting a fundamentally concrete perspective and an active attitude, observing society "from inside," finding "the link between critical realism and socialist realism" against the "bourgeois realism" of James Joyce or Thomas Mann, for example.[7] It is at this time that Brecht sings praises for the "wise attitude of Stalin facing Mayakovsky, the destroyer of forms"[8] . . .

It is not long, however, before he says something totally different. A few lines later, Georg Lukács and the Stalinist censors are suddenly targeted: "If formalism means always looking for new forms for an identical content, then formalism means also to wish to keep old forms for a new content."[9] In the same period (in 1939, to be precise), Brecht is more than ever filled with doubt regarding Stalin's methods when they call for the death of his friend Tretyakov:

My teacher
Tall and kindly
Has been shot, condemned by a people's court

3 Ibid., 77.

4 Ibid., 412.

5 Ibid., 428.

6 B. Brecht, "Le théâtre dialectique—La dialectique au théâtre," in *Théâtre épique, théâtre dialectique: Écrits sur le théâtre*, ed. J.-M. Valentin (Paris: L'Arche, 1999.), 168–78, 236–41.

7 G. Lukács, *La signification présente du réalisme critique* (1957), trans. M. de Gandillac (Paris: Gallimard, 1960), 169–266.

8 B. Brecht, "Sur le réalisme" (1937–41), in *Écrits sur la littérature et l'art*, vol. 2, *Sur le réalisme*, trans. A. Gisselbrecht (Paris: L'Arche, 1970), 171.

9 Ibid.

As a spy. His name is damned.

His books are destroyed. Talk about him

Is suspect and suppressed.

Suppose he is innocent?

The sons of the people have found him guilty

The factories and collective farms of the workers

The world's most heroic institutions

Have identified him as an enemy.

No voice has been raised for him.

Suppose he is innocent?[10]

"One of the severe consequences of Stalinism is the atrophy of the dialectic," Brecht writes following this.[11] In Svendborg in August 1939, in his conversations with Brecht, Walter Benjamin noted this unambiguous comment uttered by the playwright: "In Russia a dictatorship rules over the proletariat," before he added, "So long as this dictatorship is still bringing practical benefits to the proletariat . . . we should not give up on it."[12] A contradiction of all instants would be the price to pay for Brecht's demands on his writing, on his realism, and on his position regarding the political history of his time. In 1957 Roland Barthes situated this both omnipresent and problematic space of history within Brechtian realism:

> In Brecht, History is a general category: it is everywhere, but in a diffuse, non-analytical way; it is spread, glued to human misfortunes, consubstantial with them, like the front and back of a page; but what Brecht puts on show for us to judge is the back, a sensible surface of sufferings, injustices, alienations, impasses. Brecht does not make an object of History, not even a tyrannical one, but rather a general exigency of thought: for him, to found his theatre on History is not only to express the genuine structures of the past, as Marx

10 B. Brecht, "Is the People Infallible?" (1939), in *Bertolt Brecht: Poems, 1913–1956*, ed. J. Willett and R. Mannheim (London: Methuen, 1987), 331.

11 B. Brecht, "On the Criticism of Stalin," in *Brecht on Art and Politics*, trans. L. Bradley and T. Kuhn (London: Bloomsbury, 2003), 341.

12 W. Benjamin, "Diary Entries, 1938," in *Selected Writings*, vol. 3, *1935–1938*, ed. H. Eiland and M. W. Jennings (Cambridge, MA: Harvard University Press, 2002), 340.

demanded of Lassalle. It is also and above all to refuse any essence of man, to deny any reality other than historical in human *nature*, to believe that there is eternal evil, but only redeemable evils; in short, it is to return man's destiny to man himself.[13]

This is why the question of realism was studied by Brecht from a perspective in which it became impossible to distinguish between aesthetic form and ethical content. "At the base of realism, as our own literature has known it, there is a remarkable paradox: the writer's relations with the real have always been, in fact, ethical relations, rather than technical relations: *historically speaking, realism is a moral idea*," writes Roland Barthes.[14] Which means, too, that the intrinsic limits of any realist work are, quite often, moral limits. Where bourgeois realism lifts a taboo—sexuality, social misery—it often stumbles on a political analysis of what is exposed; where socialist realism exposes this political analysis, it stumbles on the moral taboo of desire and transgression. Does this mean that dialectical energy ("Long live dialectics!") is the most difficult thing to sustain on every level when the same situation is exposed in words or in images?

Critique

There is probably no critical realism without a preliminary critique of realism. Because he always followed his tendency to question forms—from the expressionist violence of *Baal* to the experimental montages of the *Arbeitsjournal*—Bertolt Brecht could not subscribe to the dogmatism of Georg Lukács as he tore away at the "anti-realist" tendencies of modern literature, whether it was "subjectivist degrading" in the work of the expressionists, "free association" in Joyce, "dissolution of reality" in Kafka, or

13 R. Barthes, "Brecht, Marx et l'Histoire" (1957), in *Œuvres complètes*, vol. 1, *1942–1961*, ed. E. Marty (Paris: Le Seuil, 2002), 910. See also R. Barthes, "La révolution brechtienne" (1955), in *Œuvres complètes*, vol. 2, *1962–1967*, ed. E. Marty (Paris: Le Seuil, 2002), 314–15 (text included in *Essais critiques* [1964]).
14 R. Barthes, "Nouveaux problèmes du réalisme" (1956), in *Œuvres complètes*, vol. 1, 656.

(later) "vacuity" in Beckett.[15] It is no coincidence that in his violent polemic against Ernst Bloch, Lukács placed montage as a procedure at the centre of the question, to the point of unfairly considering that it involved merely "one-dimensional techniques" or "profound monotony":

> Montage represents the pinnacle of this movement and for this reason we are grateful to Bloch for his decision to set it so firmly in the centre of modernist literature and thoughts. In its original form, as photomontage, it is capable of striking effects, and on occasion it can even become a powerful political weapon. Such effects arise from its technique of juxtaposing heterogeneous, unrelated pieces of reality torn from their context. A good photomontage has the same sort of effect as a good joke. However, as soon as this one-dimensional technique—however legitimate and successful it may be in a joke—claims to give shape to reality (even when this reality is viewed as unreal), to a world of relationships (even when these relationships are held to be specious), or of totality (even when this totality is regarded as chaos), then the final effect must be one of profound monotony. The details may be dazzlingly colourful in their diversity, but the whole will never be more than an unrelieved grey on grey. After all, a puddle can never be more than dirty water, even though it may contain rainbow tints.
>
> This monotony proceeds inexorably from the decision to abandon any attempt to mirror objective reality It goes without saying that such principles are never applied with absolute consistency, even by Joyce. For 100 per cent chaos can only exist in the minds of the deranged, in the same way that Schopenhauer had already observed that a 100 per cent solipsism is only to be found in a lunatic asylum. But since chaos constitutes the intellectual cornerstone of modernist art, any cohesive principles it contains must stem from a subject-matter alien to it. Hence the superimposed commentaries, the theory of simultaneity, and so on. But none of this can be any more than a surrogate, it can only intensify the one-dimensionality, of this form of art.[16]

15 G. Lukács, "Raconter ou décrire? Contribution à la discussion sur le naturalisme et le formalisme" (1936), in *Problèmes du réalisme*, trans. C. Prévost and J. Guégan, 130–75 (Paris: L'Arche, 1975); G. Lukács, "Realism in the Balance," in *Aesthetics and Politics*, trans. and ed. R. Taylor, 28–60 (London: Verso, 2002); Lukács, *La signification présente*, 25–85.
16 Lukács, "Realism in the Balance," 44–45.

What, then, starting from this position of the problem, places the aesthetics of realism in contrast to the aesthetics of montage? The former seeks to understand reality by producing its own "objective mirroring," to use Lukács's term, aiming to restore its intrinsic movement and its historical totality. Its high political value consists in taking advantage of such comprehension in order to take sides on this movement, and on this totality. On the contrary, exposition by montage renounces in advance any overall comprehension, just as it does any "objective mirroring." It dys-poses and re-composes, and therefore it interprets through fragments rather than believing it is explaining the totality. It shows the profound faults rather than the surface coherencies—at the risk of showing the surface faults rather than the profound coherencies—to the extent that its disordering (the "chaos," as Lukács calls it) is its starting formal principle. It does not show things from the viewpoint of their overall movement but from that of their local agitations: it describes the whirlpools in the river rather than the general direction of the flow. It dys-poses and re-composes and therefore exposes by creating new relationships between things, and new situations. Consequently its political value is at the same time more modest and more radical, because it is more experimental. Strictly speaking, it concerns *taking position* on the real by modifying, in a critical way, the respective positions of things, discourses, and images.

This is the whole difference. Brecht disagrees with Lukács when he admits (or claims) that his work consists not in rendering the real—which means exposing its truth—but in rendering the real problematic—which means exposing its critical points, its faults, its aporias, and its disorders.[17] This cannot be achieved with just a watchword. Perhaps it can be accomplished through a joke (an equivocal genre par excellence, regardless of what Lukács says) or, better, in an open series of plays on language or iconic arrangements, as is done so well in the *Arbeitsjournal* and *Kriegsfibel*. Near the beginning of

17 On the debate between Brecht and Lukács, see B. Dort, "Pratique artistique et responsabilité politique" (1970), in *Théâtre réel: Essais de critique, 1967–1970* (Paris: Le Seuil, 1971), 135–40; K. Völker, "Brecht et Lukács: Analyse d'une divergence d'opinions" (1966), trans. D. Letellier and S. Niemetz, *Travail théâtral* 3 (1971): 104–21; J.-M. Lachaud, *Questions sur le réalisme: Bertolt Brecht et Georg Lukács* (Paris: Anthropos, 1988), 87–162. On the debate between Lukács and Bloch, see F. Fischbach, *Lukács, Bloch, Eisler: Contribution à l'histoire d'une controverse* (Villeneuve d'Ascq: Presses Universitaires de Lille, 1979).

his *Journals*, for example, while Brecht was getting over (with difficulty) his urgent flight from the Nazi regime and found himself without theatre work, he reread Lukács, noting that "the talk is once again of realism which they have blithely debased, just as the nazis have debased socialism."[18] He is nastily ironic on "the moscow clique [that] is praising [Julius] hay's play HAVE to the red skies. it is true socialist realism."[19] He attempts then to situate the falseness inherent in the debate between realism and formalism by claiming his own dialectical position, manifested as a literary anachronism in his way of studying ancient forms (loathed, perhaps, under the pretext of their bourgeois obsolescence) in order to invent new ones (loathed, perhaps, under the pretext of their bourgeois obscurity):

> because i am an innovator in my field, there is always somebody or other ready to scream that i am a formalist. they miss the old forms in what i write: worse still, they find new ones; and as a result they think forms are what interests me. but I have come to the conclusion that if anything i underrate the formal aspect. at one time or another i have studied the old forms of poetry, the story, the drama and the theatre, and i only abandoned them when they started getting in the way of what i wanted to say. in poetry i began with songs to the guitar, sketching out the verses at the same time as the music. ballad form was as old as the hills, and in my day nobody who took himself at all seriously wrote ballads. subsequently i went over to other, less ancient forms of poetry, but sometimes i reverted, going so far as to make copies of the old masters and translate villon and kipling. the *song*, which descended on this continent after the first world war as a sort of folksong of the big cities, had already evolved a conventional form by the time when i began using it. i started from that point and subsequently transformed it the realism debate will gum up production if it goes on like this.[20]

Brecht once again evokes Lukács's "simple-mindedness," the latter considering that "the literary avant-garde are bourgeois decadents, end of story" and "the decline of narrative . . . [is] pure decline." In this dogmatic view,

18 Brecht, *Journals*, 6.
19 Ibid., 11.
20 Ibid., 12, 15.

Brecht continues, "montage is viewed as a characteristic feature of decadence. because unity is torn apart by it, and the organic whole dies."[21] It is necessary, then, to redefine the problems of realism and therefore to rethink the question of form, by locating it in a domain that Brecht called a "knowledge" (this is, of course, historical knowledge), which should make it possible, in his opinion, to distinguish authentic realism from mere naturalism.[22] Upon his return to Berlin in 1948, describing in his *Journals* "the silent streets of ruins" under the continuous drone of freight planes, Brecht continued to study the debate on aesthetics by asking, for example, how Picasso had viewed and solved the problems of realism and of formal deconstruction.[23]

There is certainly no critical realism without a crisis of realism and without a form being given to this very crisis. The Brecht of the Berliner Ensemble still felt this contradiction, and he continued to the very end—in the Stalinist context, in which he evolved as both an apparatchik and an irrevocable dissenter—to address these crucial questions. On the one hand, he thinks it ironic that "opponents of formalism often rage against new and stimulating forms, just as certain plain housewives are sometimes quick to denounce beauty or any effort to denounce beauty or any effort to make oneself beautiful as harlotry," and on the other hand, he demands, more than ever, that "literature must commit itself, it must join the fight all over germany, and it must have a revolutionary character and show it, and externally too, in its forms. formalism in this situation is what dissipates its revolutionary content."[24]

Party

It is at the very heart of the most clearly defined certainties that we often find the most fundamental contradiction. In Brecht there is a certainty that his whole life's struggle led to this incandescence: *art shows politics*; it exposes it in every sense of the word—an argument of discourse and an arrangement

21 Ibid., 21.
22 Ibid., 18.
23 Ibid., 401.
24 Ibid., 422, 409.

of images—and it exposes itself within it continuously. Art for Brecht dismantles and reassembles history in order to show its political content, and in order to show it also to political opponents, through documents and their critical montage. The author of *The Decision* therefore situates the artist's activity in comparison to his political position: where it was a matter of showing (a question of form) in order to show again (a question of content, and a question of struggle), and where it was a matter of being partial, of taking sides. "For art," he writes in "Short Organon for the Theatre," "being 'impartial' simply means: belonging to the 'ruling' party."[25] And all the more when totalitarianism reigns: "In these times of decisive choices," writes Brecht in 1933, "art must also choose."[26]

As such, realism must be thought of as a method of struggle[27] in which dialectic is the strategic foundation and the epistemological pivot: "It is the duty of dialecticians to dialectically infuse the different areas of thought, and to infer their political dimension."[28] And Brecht usefully underlines the extent to which art is not unrelated to history, which is something that in turn engages the political responsibility of art historians as much as that of the artists themselves:

> Art historians are people who, away from any politics, live in museums in which are exposed, as well as paintings, sculpted stones and worm-eaten bits and pieces. To these genuinely harmless people, the following thing happens: suddenly, an innocuous and very successful sale of art objects appears like a provocation, and a finger is pointed at the glaring opposition between the fact that people do not have enough money to buy milk for hungry children and the fact that people find enormous sums of money to buy a few meters worth of painted canvas. Astonished, art historians hurry to claim that it is not because they approve of the inordinate prices of the paintings that they approve of the state of affairs which prevents starving children from having milk. They

25 B. Brecht, "Short Organon for the Theatre," in *Brecht on Theatre*, 3rd ed., ed. M. Silberman, S. Giles, and T. Kuhn (London: Bloomsbury, 2015), 246.

26 B. Brecht, "Art et politique," in *Écrits sur la littérature et l'art*, vol. 2, *Sur le réalisme*, trans. A. Gisselbrecht (Paris: L'Arche, 1970), 8.

27 B. Brecht, "Les arts et la révolution" (1948–56), in *Écrits sur la littérature et l'art*, vol. 3, *Les arts et la révolution*, trans. B. Lortholary (Paris: L'Arche, 1970), 177–79.

28 B. Brecht, "Theses on the Theory of Superstructure," in *Brecht on Art and Politics*, 108.

simply believe that the two things had no link. . . . No: neither artists nor their historians can be relieved of their share of responsibility in this situation, nor relieved of the obligation to work towards changing it.[29]

To be party to something, to take sides. How? Brecht promptly made up his mind about this; he had to join the party—the Communist Party, of course. There was his certainty, his way, his courage too, for that is what led to his life being in danger in 1933. There too was his contradiction, unbeknownst to him. He needed, in fact, to follow Lenin in the famous text written in 1905, "Party Organization and Party Literature." After attacking "impartial" bourgeois literature—"accursed period of Aesopian language, literary bondage, slavish speech, and ideological serfdom!"—Lenin supports the idea that literature "must become party literature" and that "literature cannot be a means of enriching individuals or groups"; in this way, "literature must become a component of organized, planned and integrated Social-Democratic Party work."[30] "There is no question that literature is least of all subject to mechanical adjustment or levelling, to the rule of the majority over the minority," Lenin admits, yet "it cannot, in fact, be an individual undertaking, independent of the common cause of the proletariat." As such, therefore, "bookshops and reading-rooms, libraries and similar establishments—must all be under Party control" so as to impose a literature that is "free . . . from careerism, and what is more, free from bourgeois-anarchist individualism."[31] It seems to him that objections arguing for individual freedom can be refuted at once:

> What! some intellectual, an ardent champion of liberty, may shout. What, you want to impose collective control on such a delicate, individual matter as literary work! You want workmen to decide questions of science, philosophy, or aesthetics by a majority of votes! You deny the absolute freedom of absolutely individual ideological work!

29 B. Brecht, "Sur l'art ancien et l'art nouveau" (1920–33), in *Écrits sur la littérature et l'art*, vol. 1, *Sur le cinéma*, trans. J.-L. Lebrave and J.-P. Lefebvre (Paris: L'Arche, 1970), 84–86.
30 V. Lenin, "Party Organisation and Party Literature," in *Lenin on Literature and Art* (Rockville, MD: Wildside, 2008), 21–22.
31 Ibid., 22.

Calm yourselves, gentlemen! First of all, we are discussing party literature and its subordination to party control. Everyone is free to write and say whatever he likes, without any restrictions. But every voluntary association (including the party) is also free to expel members who use the name of the party to advocate anti-party views. . . . Secondly, we must say to you bourgeois individualists that your talk about absolute freedom is sheer hypocrisy. There can be no real and effective "freedom" in a society based on the power of money, in a society in which the masses of working people live in poverty and the handful of rich live like parasites. . . . The freedom of the bourgeois writer, artist or actress is simply masked (or hypocritically masked) dependence [On the contrary,] it will be a free literature, because the idea of socialism and sympathy with the working people, and not greed or careerism, will bring ever new forces to its ranks.

To work, then, comrades! We are faced with a new and difficult task. But it is a noble and grateful one—to organize a broad, multiform and varied literature inseparably linked with the Social-Democratic working-class movement. . . . Only then will "Social-Democratic" literature really become worthy of that name, only then will it be able to fulfil its duty and, even within the framework of bourgeois society, break out of bourgeois slavery and merge with the movement of the really advanced and thoroughly revolutionary class.[32]

Bertolt Brecht wished to be partial to this, in places and at a time—at least until his return to East Berlin—when "the Party" was far from being in power. "Party literature" is intrinsic to a highly political work such as *The Decision*, for example. It is party literature that Louis Althusser admires, in which he sees the Leninist prescription, the "party position," appearing also as the necessary condition in Brecht's work for "displacement of the viewpoint from the speculative to the political."[33] It is party literature that Tretyakov refers to when he calls for a "collectivization of literary work"—which Brecht

32 Ibid., 24–25.
33 L. Althusser, "Sur Brecht et Marx" (1968), in *Écrits philosophiques et politiques*, vol. 2, ed. F. Matheron, 561–77 (Paris: Stock-IMEC, 1997), 569–70. See also F. Fischbach, *L'évolution politique de Bertolt Brecht de 1913 à 1933* (Lille: Publications de l'Université de Lille III, 1976), 21–23.

achieved, albeit in a macho and authoritarian way, under his own name—or when he bundles the surrealists and Freudian psychoanalysts, even if they are Communists, into the bourgeois camp of pure "mystics of the self."[34]

In being party to this, Brecht was nonetheless not completely fooled—and here is the contradiction, his internal struggle—by the fact that such a way of claiming freedom would result in depriving himself of it on another level. "I have become somewhat doctrinaire," he admits once in his notes on literary work (written between 1935 and 1941), "because I had a pressing need to be instructed."[35] It is then that he becomes critical of the "fleeing imagination, that excessive instability in the interplay of images,"[36] an instability and an interplay that he nonetheless deploys at the same time in the erratic pages of his *Journals*. Hence, too, a particular ambivalence—because the case is emblematic—regarding the poetry of Baudelaire, who sings of misery like no other, but without relying on being party to anything: "Poverty, for him, is the poverty of the ragman; despair is that of the parasite, and sarcasm, that of the beggar."[37] In short, the honest worker, the proletarian on the job, is not illustrated enough in that lyricism, which evidently does not correspond with the aesthetics program that can be read in Brecht's speeches given to the writers' congress in the 1950s, while he was enjoying official recognition with the Stalin Prize.[38]

The "pitfalls of commitment" in Brechtian politics have been criticized, sometimes quite severely.[39] In a text from 1962 titled "Commitment," Theodor Adorno puts his finger on Brecht's political limits, even within the dramaturgical textures of plays such as *The Resistible Rise of Arturo Ui*:

> Brecht's comedy of the resistible rise of the great dictator *Arturo Ui* exposes the subjective nullity and pretense of a fascist leader in a harsh and accurate light. However, the deconstruction of leaders, as with all individuals in Brecht, is

34 S. Tretyakov, "A suivre" (1929), trans. B. Grinbaum, in *Dans le front gauche de l'art* (Paris: François Maspero, 1977), 106, and "Les surrealists" (1936), trans. D. Zaslavsky, ibid., 202–3.

35 B. Brecht, "Notes sur le travail littéraire" (1935–41), in *Ecrits sur la littérature et l'art,* vol. 3, 41.

36 Ibid., 16.

37 Ibid., 35.

38 Ibid., 172–74, 177–80.

39 See M. Esslin, *Brecht: A Choice of Evils* (London: Methuen, 1959), 133.

extended into a reconstruction of the social and economic nexus in which the dictator acts. Instead of a conspiracy of the wealthy and powerful, we are given a trivial gangster organization, the cabbage trust. The true horror of fascism is conjured away; it is no longer a slow end-product of the concentration of social power, but mere hazard, like an accident or a crime. This conclusion is dictated by the exigencies of agitation: adversaries must be diminished. The consequence is bad politics, in literature as in practice before 1933. Against every dialectic, the ridicule to which Ui is consigned renders innocuous the fascism that was accurately predicted by Jack London decades before. The anti-ideological artist thus prepared the degradation of his own ideas into ideology.[40]

In short, in Brecht, partisanship—taking sides—opens only onto non-dialectical simplification, that is to say, on an ideological falsification of political analysis:

> Yet the artistic principle of simplification not only purged politics of the illusory distinctions projected by subjective reflection into social objectivity, as Brecht intended, but it also falsified the very objectivity which didactic drama laboured to distil. If we take Brecht at his word and make politics the criterion by which to judge his committed theatre, then politics proves his theatre untrue.[41]

It is by taking Brecht's watchwords literally that we see that, for him, "bad politics becomes bad art, and vice-versa."[42] This is the Brechtian aporia of a political literature, in Adorno's view:

> Aporia of this sort multiply until they affect the Brechtian tone itself, the very fibre of his poetic art. Inimitable though its qualities may be . . . they were poisoned by the untruth of his politics. For what he justified was not simply, as he long sincerely believed, an incomplete socialism, but a coercive domination

40 T. W. Adorno, "Commitment," in T. Adorno et al., *Aesthetics and Politics* (London: Verso, 2007), 184.
41 Ibid., 186.
42 Ibid., 187.

in which blindly irrational social forces returned to work once again. When Brecht became a panegyrist of its harmony, his lyric voice had to swallow chalk, and it started to grate.[43]

Adorno no doubt avoids the difference that separates the *threatened* freedom of the poet in exile—in his journals, Brecht writes of his participation in seminars of the Frankfurt School, exiled in Los Angeles, and his often contradictory interviews with Adorno[44]—and the *comfortable* freedom (although under surveillance) of the official poet of the RDA. As such, the philosopher reunites Brecht where Brecht seems rather dissociated (and therefore more interesting). Hannah Arendt, on her part, saw that these conditions of existence had determined for Brecht two very different systems in his literary work. Exile was his greatness and his creative energy, to the extent that after many years of sterility in Berlin—"Brecht knew of his predicament, knew that he could not write in East Berlin . . . and all he planned for when he lay dying was exile" once again.[45]

In exile, Brecht had the courage to say that it is the poet's ultimate ability to be "someone who must say the unsayable, who must not remain silent on occasion when all are silent, and who must therefore be careful not to talk too much about things that all talk about."[46] After his official recognition upon being awarded the Stalin Prize, however, he had only the facility to keep silent about the contradictions, and no longer offered anything more than a "kind of case history of the uncertain relationship between poetry and politics [because of] the fact of Brecht's doctrinaire and often ludicrous adherence to the Communist ideology."[47] At that moment, moreover, according to Hannah Arendt, his poetry went bad and was compromised: "his ode to Stalin and his praise of Stalin's crimes, written and published while he was in East Berlin but mercifully omitted from the collection of his works," shows not only the extent to which he was capable of writing, alongside the master works, these opportunistic and "indescribably

43 Ibid.

44 Brecht, *Journals*, passim.

45 H. Arendt, "Bertolt Brecht: 1898–1956," trans. H. Zohn, in *Men in Dark Times* (London: Harvest Books, 1995), 216.

46 Ibid., 228.

47 Ibid., 209.

bad" verses, but also the extent to which, in general, "poets have not often made good, reliable citizens."[48] This, Arendt concludes, "may teach us how difficult it is to be a poet in this century."[49] It can tell us, too, about the alternative value of *Kriegsfibel* in those times of official poetry, when Brecht decided to take a poetic and documentary look backwards—a childish one, in the form of an illustrated primer—to a war that he had experienced and observed from exile.

Position

Kriegsfibel never exactly takes sides. It presents things in a certain order—a surprising order, such as the apparent disordering of our accepted opinions about the Second World War—but it establishes no definitive judgment, offers no unequivocal apology, nor does it construct any teleological framework. We see Hitler coming and going in *Kriegsfibel*, and Churchill, Pétain, and representatives of the American Congress, but we do not see Stalin, for example. We see, above all, the different states of people and gestures of urgency in times of war. We see images of politics rather than political icons. We read poems in the ancient style in counterpoint to the factual captions that accompany photographic documents, but we do not read any discourse or speeches on history. Montage makes any authority of message or program equivocal, improbable, and even impossible. This is because, within a montage of this kind, the elements—images and texts—*take position* instead of becoming discourse and *taking sides*.

 Brecht's critique of the "fleeing imagination," with its "excessive instability in the interplay of images," makes room here for an operating imagination that is nonetheless unusually unstable in the interplay of photographic images. However, this instability produces an agitation—a critical movement in which Hannah Arendt no doubt recognized this "ability to imagine" that she extrapolates from Kant and that ends with the "courage to judge": to judge without compromise but with impartiality, without taking sides; to judge without claiming to exclude otherness,

48 Ibid., 210.
49 Ibid., 248.

without ignoring the fact that other combinations are always possible.[50] It is because he has put his imagination to work that Brecht brings his chosen documents into *Kriegsfibel* to "take position." Therefore it is not because he uses his imagination that he remains neutral or maintains a pathic (or even empathic or identifying) perception of the photographed scenes. Montage establishes a position-taking—of each image regarding the others, of all the images regarding history—and this in turn puts the photographic collection itself into the perspective of a new work of *political imagination.*

Even more than Arendt's thinking, it is the thinking of Walter Benjamin that we cannot avoid thinking about here. *Kriegsfibel* is, to a certain extent, and probably unknowingly, the most Benjaminian book Bertolt Brecht ever wrote. First, because it functions—like a children's book, an ABC primer (which is a feminine word in German)—as a critique of violence, and every critique of violence, as Benjamin shows, must be sustained within the sensible element as much as the philosophical element of its history.[51] And then because it addresses with its visual material the question of the relationship between the aestheticizing of politics and the politicizing of the image. We know how much Benjamin in the twenties and thirties thought about the conditions of a possible—and necessary—politics of images. He critiqued the false innocence of the iconographies of the Great War published by the New Objectivity movement.[52] He denounced the bellicose aesthetics of Ernst Jünger, inherent in his collection of images titled *Krieg und Krieger*.[53] Finally, in his famous essay on reproducibility, he suggested that political aestheticizing—characteristic of fascism and realized in war itself—

50 H. Arendt, "Imagination" (1970), in *Lectures on Kant's Political Philosophy* (Chicago: University of Chicago Press, 1992), 79-89. See also the commentary by R. Beiner, "Hannah Arendt on Judging," ibid., 89-157.

51 W. Benjamin, "A Critique of Violence" (1921), in *Selected Writings*, vol. 1, *1913-1926*, ed. M. Bullock and M. W. Jennings (Cambridge, MA: Harvard University Press, 1996), 236.

52 W. Benjamin, "Critique of the New Objectivity," in *Selected Writings*, vol. 2, *1927-1934*, ed. M. W. Jennings, H. Eiland, and G. Smith (Cambridge, MA: Harvard University Press, 1999), 417.

53 W. Benjamin, "Theories of German Fascism: On the Collection of Essays *War and Warriors*, Edited by Ernst Jünger," ibid., 312.

should be answered by a "politicizing of art," something for which, at the time, Bertolt Brecht appeared to be the herald.[54]

Thus Brecht and Benjamin, in their own ways but at the same time and with a shared project in mind—it would have become their journal *Krise und Kritik*—both bore this fundamental mutation in their manner of posing artistic problems, a mutation that Philippe Ivernel quite rightly calls "the political turning point of aesthetics."[55] It is indeed because history is deployed in the sensible element of human gestures and images that this *political-aesthetic* gaze is not only possible but necessary.[56] A great difference, however, separates the two writers. Bertolt Brecht produced his political agitation—even in the fascinating meanderings of his *Arbeitsjournal* and his *Kriegsfibel*—following the doctrinal goal of a partisanship subject to the ideas of Lenin: his watchwords, his considerations of apparatuses, and his disdain for anarchism. But Walter Benjamin succeeded (in his opinion) in constructing a politics of images that appears as a free exercise and a true philosophy of position-taking. Where Brecht saw partisanship as the natural goal of any position-taking, Benjamin understood position-taking as a possible breach of any partisanship.

It is no coincidence that, during the year in which he interpreted Brechtian epic theatre—in order to reveal its most radical originality, albeit at the cost of a certain inflection in his own manifest discourse—Walter Benjamin wrote a short essay on the "destructive character." What he aimed for was a style of critical thinking that would deliver no thesis but rather deconstruct and happily break up existing theses. If the destructive character has a watchword, it is, paradoxically, "make room"; if it constructs something in the end, it is primarily in order to clear, dislocate, dys-pose

54 W. Benjamin, "The Work of Art in the Age of Its Technological Reproducibility, Second Version," in *Selected Writings*, vol. 3, 101-33.

55 P. Ivernel, "Le tournant politique de l'esthétique: Benjamin et le théâtre épique," in *Weimar: Le tournant esthétique*, ed. G. Raulet and J. Fürnkäs (Paris: Anthropos, 1988), 45-68.

56 See S. Moses, "Le paradigme esthétique de l'histoire chez Walter Benjamin," ibid., 103-19; I. Wohlfahrt, "L'esthétique comme préfiguration du matérialisme historique: *La Théorie du roman* et *Origine du drame baroque allemand*," ibid., 121-42; R. Rochlitz, *Le désenchantement de l'art: La philosophie de Walter Benjamin* (Paris: Gallimard, 1992), 134-209; J.-M. Palmier, *Walter Benjamin: Le chiffonnier, l'Ange et le Petit Bossu; Esthétique et politique chez Walter Benjamin* (Paris: Klincksiek, 2006), 561-706.

and re-dispose everything.[57] Benjamin considered dialectical energy from the perspective of childlike elation (in which we see implicitly not only the Nietzschean motif of reversal of values but also the earlier Baudelairian themes of the imagination as a capacity for knowledge and the "morality of toys"):

> The destructive character is young and cheerful. For destroying rejuvenates, because it clears away the traces of our own age; it cheers, because everything cleared away means to the destroyer a complete reduction, indeed a rooting out, of his own condition. . . .
>
> The destructive character sees no image hovering before him. He has few needs, and the least of them is to know what will replace what has been destroyed. First of all, for a moment at least, empty space—the place where the things stood
>
> The destructive character sees nothing permanent. But for this reason he sees ways everywhere. Where others encounter walls or mountains, there, too, he sees a way. But because he sees a way everywhere, he has to clear things from it everywhere. Not always by brute force; sometimes by the most refined. Because he sees ways everywhere, he always stands at a crossroads. No moment can know what the next will bring. What exists he reduces to rubble—not for the sake of the rubble, but for that of the way leading through it.[58]

This text could be considered a praise of montage, for montage does indeed have that "destructive character" by which an initial narrative model—temporality in general—is dislocated in order for the immanent conflictuality to be taken out of it, even its "rooting out," as Benjamin writes. On the other hand, montage starts to clear away, that is to say, to create voids, suspense, intervals that function like so many open ways, paths towards a new manner of thinking about human history and the disposition of things. Where the party imposes the pre-eminent condition of a portion at the others' expense, the position assumes an efficient and conflictual co-presence, a *dialectic of multiplicities* between them. That is why, says Benjamin, we can take position and suggest in an extraordinary way

57 W. Benjamin, "The Destructive Character" (1931), trans. R. Livingstone et al., in *Selected Writings*, vol. 2, 541.
58 Ibid., 541–42.

without seeing beforehand any "image hovering before him." It is the new, reciprocal position of the elements of montage that transforms things, and it is the transformation itself that implements a new thinking. This thinking is decisive, it dislocates and surprises, but it is not definitively partisan in its experimental and temporary nature, to the extent that, born of a topical transformation, it is re-combinable, modifiable, always moving and on a path—"at a crossroad."

The Brechtian montages of the *Arbeitsjournal* and *Kriegsfibel* show this almost unwittingly. In his essay on technological reproducibility, Walter Benjamin begins with a problem that is found at the centre of Brecht's work: the problem of exposition of the political. Man is a political animal, as we have known since Aristotle. But to be political means that it is necessary to *self-expose*: to expose himself to the contradictions of other viewpoints, to expose himself in order to show all his position-takings, to expose himself to the dangers inherent in such an attitude. Photography and cinema—before television—reconfigured this problem entirely, at a time when, on the one hand, Soviet workers played their roles in fiction movies, and when, on the other hand, Hitler became a major phenomenon in the theatre, radio, and cinema (in newsreels) of Weimar Germany: "It tends towards the exhibition of controllable, transferable skills under certain social conditions, just as sports first called for such exhibition under certain natural conditions. This results in a new form of selection—selection before an apparatus—from which the champion, the star, and the dictator emerge as victors."[59]

In such a context, Benjamin and Brecht shared the necessity of thinking about the alternative conditions of a new *politics of exposition*. The well-known "decline of the aura" makes no sense, in Benjamin's view, except where the rituals of political exposition—which, it is worth mentioning, had caught Warburg's attention during the Concordat of Rome in 1929—can make room for a political production of exposition capable of deconstructing the intimidation inherent in the religious parameters of politics and the magical parameters of the artistic image.[60] It is not a matter of saying that art is obsolete, nor that the artist's freedom should be erased in front of the militant's will. It is rather a matter of posing the question of the poet in

59 Benjamin, "The Work of Art," 129.
60 Ibid., 101.

the city, not only as a creator but also as a destroyer, not only as a destroyer but also as a producer, which for Benjamin is a way of posing the "question of the poet's right to exist" politically.[61]

Brecht's oeuvre embodies precisely what Benjamin means by the phrase "author as producer." Even more so, the premises for this problem posed by Benjamin are exactly the same as those that Brecht would soon use for the materials of the collages and montages of the *Arbeitsjournal* and *Kriegsfibel*. The author becomes a producer inasmuch as he not only creates a new work but also makes that work possible counter-information, new thinking, a *new knowledge* that official means of information keep silent, through either censorship or ignorance, through political interest or mere vulgarity. It is a matter, according to Benjamin, of bypassing the sterile alternatives of the propagandist and the artist, in other words, of partisanship and pure creation.[62] Unsurprisingly, the crucial question is to be found at the level of writing and journalistic iconography, in the different media through which our contemporary history is communicated to us:

> the description of the author as producer must extend as far as the press. [But] in Western Europe the newspaper does not constitute a serviceable instrument of production in the hands of the writer. It still belongs to capital. Since, on the one hand, the newspaper, technically speaking, represents the most important literary production, but on the other, this position is controlled by the opposition, it is no wonder that the writer's understanding of his dependent social position, his technical possibilities, and his political task has to grapple with the most enormous difficulties.[63]

And Benjamin then remarks that the technical possibilities of this political task are no better explained than by Bertolt Brecht. "He was the first to make of intellectuals the far-reaching demand not to supply the apparatus of production without, to the utmost extent possible, changing it."[64] In Brecht this transformation is heard in the concept of *Umfunktionierung*, or "functional

61 W. Benjamin, "The Author as Producer" (1934), in *Selected Writings*, vol. 2, 768.

62 Ibid., 771.

63 Ibid., 772.

64 Ibid., 774.

transformation." And the "technical possibility," as Benjamin underlines, is none other than the process of montage inherent in the "revolutionary strength of Dadaism" and the political agitation of John Heartfield's compositions.[65] In the apparatus of traditional production, for example, photographs are placed on one page and poetry on the facing page, beautiful images on one side and beautiful texts on the other. Montage is there, then, to break these barriers between the forces of production:

> What we require of the photographer is the ability to give his picture a caption that wrenches it from modish commerce and gives it a revolutionary use value. But we will make this demand most emphatically when we—the writers— take up photography. Here, too, therefore, technical progress is for the author as producer the foundation of his political progress. In other words, only by transcending the specialization in the process of intellectual production—a specialization that, in the bourgeois view, constitutes its order—can one make this production politically useful; and the barriers imposed by specialization must be breached jointly by the productive forces that they were set up to divide. The author as producer discovers—even as he discovers his solidarity with the proletariat—his solidarity with certain other producers who earlier seemed scarcely to concern him.[66]

The primary political function of montage is therefore to re-compose the forces and domains of production, for example, the domain of the image facing that of the text. In Benjamin's view, Brecht is a perfect model of this re-composition, inasmuch as he widens the "dramatic laboratory" by articulating his epic text with avant-garde visual production (photography, cinema) and, of course, with the musical production of his time (Hanns Eisler, Kurt Weil)[67]—just as the modern novel uses montage and is "based on the document" in order to join the epic dimension;[68] just as modern photography addresses the "fecundity of the document" in order to enlighten

65 Ibid., 774–75.
66 Ibid., 775.
67 Ibid., 775–79.
68 W. Benjamin, "The Crisis of the Novel" (1930), trans. R. Livingstone et al., in *Selected Writings*, vol. 2, 301.

the "trial of history;"[69] just as modern cinema owes its strength to montage as a constantly modifiable and perfectible operating process of fragmenting and re-composition;[70] and just as Brecht's drama re-composes the forces of the political through decomposition and analytical exposition of history.

To take position, then, can only mean—as Benjamin explains by referring to Brecht's dramatic works—to work as a dialectician, as a filmmaker and a photographer at the same time. "In every master there is a dialectician," writes Benjamin.[71] This means too that "epic theater moves forward in a different way—jerkily, like the images of a film strip"; it also means—and we may think of Eisenstein—that "it basically operates through repeated shocks, as the sharply defined situations of the play collide," and that, in such a work of montage, "this creates intervals which undermine the audience's illusion [and that] these intervals are reserved for the audience's critical judgments."[72]

We do not re-compose forces without creating (and this is what the work of art is for) *efficient forms*, and without creating (and this is what montage is for) *efficient shocks*. What these kinds of shocks give up must be called an image: a "dialectics at a standstill." "The dramatic element flares like a magnesium lamp," writes Benjamin, referring to the flash of a camera.[73] The image should then be considered a "spark" (short, a little) of "truth" (much), a latent content "that will one day consume" the established political order (efficient, perhaps).[74] Montage, as topical and political position-taking, as a re-composition of forces, offers us then an *image of time* that explodes the narrative of history and the arrangement of things. In the breach opened by this explosion, it is through this image—from the capture of the visible in the camera to the device of montage—"that we first discover the optical unconscious, just as we discover the instinctual unconscious through psychoanalysis."[75] In other words, it re-exposes history in the light of its most repressed memories, as well as its most unformulated desires.

69 W. Benjamin, *One-Way Street*, in *Selected Writings*, vol. 1, 459; Benjamin, "The Work of Art," 108.

70 Benjamin, "The Work of Art," 101.

71 W. Benjamin, "The Land Where the Proletariat May Not Be Mentioned: The Premiere of Eight One-Act Plays by Brecht" (1938), in *Selected Writings*, vol. 3, 330.

72 Ibid., 331.

73 Ibid.

74 Ibid., 333.

75 Benjamin, "The Work of Art," 117.

V

The Interposition
of Fields

Revisiting History

Anachrony

Politics is exposed only by showing the conflicts, paradoxes, and reciprocal shocks with which all of history is woven. That is why montage appears to be the perfect process for this exposition: things appear in it only to take position, and they show themselves only in order to be dismantled first—just as we speak in French of *une tempête démontée*, meaning a storm that is rough and wild, casting wave against wave, or when we speak of *une horloge démontée*, "an unwound clock"—that is to say, analyzed, explored, and thus scattered by the fury of knowledge implemented by some philosopher or some Baudelairian child.[1] Montage is to forms what politics is to acts: these two meanings of dismantling, or de-montage— which are the excess of energy and the strategy of place, the madness of transgression, and the wisdom of position—are needed together. Walter Benjamin, I believe, never stopped thinking about these two aspects of montage, side by side, as political action. On the one hand, he advises Brecht to learn the ancient Chinese board game *go*, because, he says, the game gives to *positions*—not to the greater or lesser strength of each piece, as in chess—their "proper strategic function."[2] On the other hand, he sees in epic drama the promise of something like a generalized transgression, the art of making each thing come out of its usual place,

1 See C. Baudelaire, "Morale du joujou" (1853), in *Œuvres complètes*, vol. 1, ed. C. Pichois (Paris: Gallimard, 1975), 587.

2 W. Benjamin, "Letter to Bertolt Brecht" (May 21, 1935), trans. M. R. Jacobson and E. M. Jacobson, in *The Correspondence of Walter Benjamin, 1910-1940* (Chicago: University of Chicago Press, 1994), 443.

and consequently the art of "mak[ing] life spurt up high from the bed of time" like the waves of a storm or a whirlpool.

This image of the whirlpool is something familiar to readers of Walter Benjamin. In 1928, when he also published his great theoretical novel on modernity (I mean *One-Way Street*, of course), Benjamin made public his philosophical views on origin (*Ursprung*): the "Epistemo-Critical Prologue" to his great book on German tragic drama. In this work he speaks of the "philosophical style" in history as an "art of interruption in contrast to the chain of deduction"[3] that is generally sought by historians as a bulwark against the essential over-determination of becoming. He calls for use of the idea as configuration rather than concepts, laws, or unequivocal theses: "Ideas are to objects as constellations are to stars. This means, in the first place, that they are neither their concepts nor their laws."[4] Consequently, their meaning comes only from their respective positions: in other words, they arise neither from universality nor from any form of classification,[5] but rather from their stated place in a given montage.

Montage is not, therefore, according to Benjamin (in comparison to what we understand from Ernst Bloch, for example), the stylistic prerogative or exclusive method of our modernity. It comes more generally from every philosophical way of revisiting history—revisiting, re-editing, reassembling into a montage—whether it has to do with going back towards the origins (as in the case of German Baroque drama) or a "reassembly" of the contemporary (as in *One-Way Street*). It is a "philosophical" way— dialectic, in other words, for dialectics and montage are inseparable in this deconstruction of historicism. Dialectics, Benjamin confirms, is the "witness to the origin," inasmuch as every historical event considered beyond mere chronicle demands to be known "as a dual insight . . . , on the one hand it needs to be recognized as a process of restoration and reestablishment, but, on the other hand, and precisely because of this, as something imperfect and incomplete." This is another way of dismantling ("*démonter*") each moment of history by returning through a reassembling ("*en remontant*"),

3 W. Benjamin, *The Origin of German Tragic Drama*, trans. J. Osborne (London: Verso, 2009), 32.

4 Ibid., 34.

5 Ibid., 37.

outside of "actual findings," towards what "is related to their history and their subsequent development."[6]

This dual movement creates intervals and discontinuities, to the extent that historical knowledge—that "philosophical history, the science of the origin," as Benjamin claims—becomes an actual *temporal* montage, "the form which, in the remotest extremes and the apparent excesses of the process of development," or in moments whose secret relationships have not yet been perceived, "reveals the configuration of the idea" and its virtual path.[7] And so there is only a historical "return or upwelling" ("*remontée*") through a re-montage of elements that were previously dissociated from their usual place. In other words, a historical philosophical knowledge worthy of that name will be constructed only by exposing—beyond the narratives and the flows, beyond the singularities of events—the *heterochronies* (using this word to underline their heterogeneity effect) or the *anachronies* (using this word to underline their anamnesis effect) of elements that make up each moment of history.

Montage and anachrony are indeed characteristic of Benjamin's philosophical *gestus* in its totality. There is no reason here to contrast a "modernist" Benjamin, who uses montage in his texts just as Raoul Hausmann does in his images, with a "retrograde" Benjamin, seeking origins and survivals in Baroque drama just as Aby Warburg does with Renaissance painting. The staggering power of Benjamin's gaze on historicity in general has to do with standing constantly on the threshold of the present, in order to "free the present moment from the destructive cycle of repetition and to take from the discontinuity of times the opportunities for a reversal," as Guy Petitdemange writes so aptly.[8] In theological terms—since Benjamin also spoke that language—this means that there is no more future redemption without exegesis of the most ancient texts, no possible Messianism without a rethinking (in particular, a rethinking) of the foundations. In psychological terms, this means that there is no desire without a work of memory, no future without a reconfiguration of the past. In political terms, this means that there is no revolutionary force without

6 Ibid., 40.
7 Ibid., 47.
8 G. Petitdemange, "Le seuil du présent: Défi d'une pratique de l'histoire chez Walter Benjamin," *Recherche de science religieuse* 73, no. 3 (1985): 381–400.

re-montage of the genealogical places, without ruptures and re-engagements of kinship, without re-expositions of all anterior history. That is why the most "avant-garde" element in Benjamin is never without the anachronism of its conjunction with something like an archaeology.[9] Provided, of course, that modernity is not reduced to a mere forgetting of history. Provided that archaeology is not reduced to a mere love of debris. "The theory of the ruins created by time," writes Benjamin in 1930, "should be complemented by the process of deconstruction, which is the task of the critic."[10]

Although Walter Benjamin did not unilaterally agree with every idea in Ernst Bloch's *Heritage of Our Times*, we see today a general convergence of their viewpoints regarding the relationships between position and transgression, montage and anachronism. Bloch sees in montage the historical symptom of a "collapsed context" of bourgeois society, given over to the "process of interruption" characteristic of the avant-garde revolutionaries. Brecht's name then appears:

> For montage breaks off parts from the collapsed context and the various relativisms of the times in order to combine them into new figures. This process is often only decorative, but often already involuntarily experimental or, when used, as in Brecht for example, voluntarily so; it is a process of interruption and thereby one of inter-section of formerly very distant areas. Precisely here the wealth of a cracking age is large, of a conspicuous mixed period of evening and morning in the 1920s. This extends from visual to pictorial connections which have hardly been like this before to Proust, to Joyce, to Brecht, and beyond, it is a kaleidoscopic period, a "revue."[11]

"Richness of a period in agony"—as Aloïs Riegl understands regarding late antiquity and as Walter Benjamin understands regarding mannerism and the Baroque, Ernst Bloch renounces any teleology of historical value.

9 See M. Sagnol, "Walter Benjamin entre une théorie de l'avant-garde et une archéologie de la modernité," in *Weimar ou l'exposition de la modernité*, ed. G. Raulet, 241–54 (Paris: Anthropos, 1984).

10 W. Benjamin, "Criticism as the Fundamental Discipline of Literary History," in *Selected Writings*, vol. 2, *1927-1934*, ed. M. W. Jennings, H. Eiland, and G. Smith (Cambridge, MA: Harvard University Press, 1999), 415.

11 E. Bloch, *Heritage of Our Times* (1962), trans. N. Plaice and S. Plaice (Cambridge: Polity Press, 1991), 3.

There is no more "decadence" than there is "progress" in history; there are only heterochronies or anachronies of processes with multiple directions and speeds. "The New comes in a particularly complex form," writes Bloch.[12] This complexity is something he calls "non-contemporaneity," another way to say *anachronism*. "Not all people exist in the same Now. . . . They carry an earlier element with them; this interferes," and it is a past that is not up-to-date.[13] Montage, with its "catalogue of what has been omitted, of those contents which have no place in the male, bourgeois, ecclesiastical conceptual system,"[14] would then be the best means for making such a non-contemporaneity dialectical, that is, politically fertile.[15]

Montage is an exposition of anachronies inasmuch as it proceeds from an explosion of chronology. Montage contrasts things that are normally combined and connects things that are normally separated. It therefore creates a jolt and a movement: "The jolt: we are beside ourselves. The glance waves, with it, what it held. External things are no longer usual, displace themselves. Something has become too light here, goes to and fro."[16] Once the explosion has occurred, it is a world of dust—shreds, fragments, residues—that surrounds us. But "the dust which the explosion of the non-contemporaneous whirls up is more dialectical than that of diversion; it is itself explosible";[17] in other words, it offers a material, one that is initially very subtle, for the historical movements and revolutions to come.

If the material that comes from montage appears so subtle and volatile, it is because it has been detached from its normal space, because it never stops running, migrating from one temporality to another. That is why montage is fundamentally related to this knowledge of survivals and of symptoms, a knowledge that Aby Warburg insists resembles something like a "history of ghosts for big people" (*Gespenstergeschichte f[ür] ganz Erwachsene*).[18] Ernst Bloch says no less, I believe, when he makes montage a machine for making

12 Ibid., 1.
13 Ibid., 97.
14 Ibid. 355.
15 Ibid., 97-145.
16 Ibid., 189.
17 Ibid., 185.
18 A. Warburg, *Mnemosyne: Grundbegriffe*, vol. 2 (1928-29) (London: Warburg Institute Archive 3, 102-4), 3.

dust in space and wind in time—in short, a machine for releasing the spectres of unconscious memory and desire according to an "eerie intermittence":

> *Montage, direct*: For the first time the wind is definitely here, it blows from everywhere. Parts no longer fit together, have become soluble, can be mounted in a new way. To begin with, only the snipped, newly *stuck* photograph "mounted" was comprehensible for many; the word is of course much older for those handling machines. Even in the human body skin, internal organs are transplanted; but at best the transplanted organ performs in its new place only what is appropriate to that place, nothing else. In *technical* and *cultural* montage, however, the context of the old surface is decomposed, a new one is formed. It can be formed as a new one because the old context increasingly reveals itself as illusory, brittle, as one of surface. If Objectivity distracted with shining veneer, much montage makes the confusion behind it attractive or boldly intertwined. Objectivity served as the highest form of diversion, montage appears culturally as the highest form of eerie intermittence above diversion In this respect montage shows less façade and more background of the times than Objectivity.[19]

It is in the interval created by these displacements that the "background" is revealed. It is in the discontinuity created by these "intermittences" that involuntary memory and unconscious desire are revealed or, rather, rise up. Expressionism, in Ernst Bloch's opinion, had already "mounted its fragments into grotesque caricatures, mounted into the hollow spaces above all excesses and hopes of a substantial kind, archaic and utopian images."[20] Bertolt Brecht's work was necessary then, beyond surrealism and its rebus of cracked consciousness. He used montage "as a force of production . . . , as interruption of the dramatic flow and instructive displacement of its parts, in short, as directorially based politics."[21]

So what did Brecht say about all this? On the one hand, I believe, the position interested him only when it was created in partisanship, and in his mind, transgression could open only onto a political *discipline*. On the other hand, heterochronies are useful only for creating the meaning of history as

19 Bloch, *Heritage of Our Times*, 202-3.
20 Ibid., 205.
21 Ibid., 206.

uttered by Lenin, and anachronies are useful only when they can be resolved in progress or in the revolutionary process as such. That is why Brecht so frequently refuses to understand Benjamin:

> he uses as his point of departure something he calls the *aura*. this is supposed to be in decline of late, along with the cult element in life. b[enjamin] has discovered this while analyzing films, where the aura is decomposed by the reproducibility of the art-work. a load of mysticism, although this attitude is against mysticism. this is the way the materialist understanding of history is adapted. it is abominable.[22]

After these lines, written on July 25, 1938, and two brief mentions in August of the same year and in February 1939, there is not a single mention of Benjamin in the *Arbeitsjournal* until August 1941, when Brecht records, rather coldly, that "walter benjamin has poisoned himself in some little spanish border town."[23] The playwright wrote this with before him the theses of the *Concept of History*, a text that he found "clear" and useful, "despite its metaphors and its judaisms." There is a brief, pessimistic conclusion—"and it is frightening to think how few people there are who are prepared even to misunderstand such a piece"—before he moves on to an almost anachronistic evocation of a rather cruel montage of ideas: "and now to the survivors!" At this point Brecht begins a virulent critique of Horkheimer—that "clown," an academic "millionaire" who discourses on "revolutionary activities" not without going "west, where paradise awaits . . ."[24]

On the other hand, the *Arbeitsjournal* lets partisanship, or position-taking, and movements of transgression fly. In his journals, Brecht eagerly shows the meaning of history—albeit suggested by Hegel, Marx, or Lenin—and spreads all kinds of anachronisms and presumptions, of which the following, I think, seen against the background of the advancing German armies in Europe, seems characteristic:

> 12.6.40. cocteau insists that the idea of tank camouflage came from picasso who suggested it to a French war minister before the great war as a means of

22 B. Brecht, *Journals, 1934-1955*, trans. H. Rorrison (New York: Routledge, 1996), 10.

23 Ibid., 160.

24 Ibid., 160–61.

making soldiers invisible. cocteau also asks himself whether savages don't paint their skins less to make themselves frightening and more to make themselves invisible. that is a good idea. you make things invisible by destroying their form, giving them an unexpected form, making them as it were not inconspicuous, but at once striking and strange. the germans are marching on paris.[25]

Then, towards the end of June 1940, Brecht thinks about Picasso's *Guernica* by underlining the anachronism of this painting, which functions exactly as the "artistic expression of our times," avoiding contradiction by using a "classical form."[26] In October of the same year, the playwright begins to consider "experimental theater" as a "totally antiquated" subject, stating provocatively: "to want the new is old-fashioned, what is new is to want the old."[27] It was at this moment that Brecht considered using the ancient form of the epigram to accompany his photographic documents of military events. Elsewhere we find a few subsequent remarks on Magdalenian art, on the need to follow "popular art" and the need to "go a long way back in time," but also to travel far in space—to China, for example—in order to break the academic hierarchies of our "established arts."[28] The anachronism no doubt reveals its critical necessity at the precise point where it is a matter of redistributing—in other words, of dismantling, reassembling, going back over, and *renewing*—the artistic domains commonly divided according to the old artistic organigram of the "fine arts."

Interposition

If there is a need to agree on the use-value of the anachronism in Brecht, it is first of all because we can see in it something like an operation of temporal distancing: an "effect of strangeness" produced in the texture of the narrative or the historical reflection. Brecht anachronistically

25 Ibid., 57.
26 Ibid., 74.
27 Ibid., 109.
28 Ibid., 50.

sought new principles of dramaturgical montage in Chinese theatre, just as Eisenstein sought his own in Japanese painting.[29] And just as Eisenstein scrutinized the paintings of El Greco, Brecht closely examined those of the elder Brueghel in order to find his own *Verfremdungseffekt* at work in them.[30] He remained fascinated with the exemplary distancing machine that is, in Renaissance painting, the presence of an observer standing back—like the character of Saint John in the *Crucifixion* of Grünewald, pointing his index finger[31]—without knowing that this effect had been strictly theorized in the fifteenth century by Leon Battista Alberti, under the name *ammonitore*.[32]

We might remember that, for Bertolt Brecht, the notion of the plot— from this perspective close to *historia*, according to Alberti—consists in "composing" overall the multiplicity and heterogeneity of the gestures made by the actors: "Everything depends on the 'plot,' it is the core of the theatrical performance. . . . The 'plot' is the theatre's great undertaking, the complete composition of all the gestic incidents."[33] Distancing is revealed to be necessary to the plot "so that the tying together of events can be made visible."[34] From there, Brecht notes that the temporal status of the plot is no more likely to be found in a pure past (that of the rhapsody) than in a pure present (that of mime):

> Schiller's distinction, that the rhapsodist should treat an incident as being
> wholly in the past, while the actor treats it as wholly here and now, is no

29 B. Brecht, "On Chinese Theater," trans. M. Silberman and J. Willett, in *Brecht on Theatre*, 3rd ed., ed. M. Silberman, S. Giles, and T. Kuhn (London: Bloomsbury, 2015), 149.

30 B. Brecht, "*Verfremdung* Techniques in the Narrative Pictures of the Elder Brueghel," ibid., 159.

31 B. Brecht, "Sur la distanciation" (1936), ibid., 71.

32 L. B. Alberti, *On Painting* (1453), trans. R. Sinisgalli (Cambridge: Cambridge University Press, 2013), 63: "It seems opportune then that in the *historia* there is someone who informs the spectators of the things that unfold ; or invites with the hand to show"

33 B. Brecht, "A Short Organon for the Theater," in *Brecht on Theatre*, 250. This text seems to me to echo, almost to paraphrase, Alberti's famous definition of *historia*: "A very great achievement of the painter is the *historia*; parts of the *historia* are the bodies, part of a body a member, part of a member the surface." See also Alberti, *On Painting*, 53.

34 Brecht, "Short Organon," 244.

longer valid in those terms. It must be absolutely apparent when actors perform that "even at the beginning and in the middle they know how it ends."[35]

Whatever you portray you should always portray
As if it were happening now.
[...]
What is happening here is
Happening now and just once. To act in this way
Is habitual with you, and now I am advising you
To ally this habit with yet another.
[...]
Nor should you let the Now blot out the
Previously and Afterwards, nor for that matter whatever
Is even now happening outside the theatre and is similar in kind
Nor even things that have nothing to do with it all—none of this
Should allow you to be entirely forgotten.
So you should simply make the instant
Stand out, without in the process hiding
What you are making it stand out from.[36]

In short, the image obtained is *historicized*—according to Brecht's own vocabulary—only by introducing "detachments" or hiatuses, in other words, in this case, the exposition of conflicts and of montages of time that affect each dramatic action.[37] It is then that each gesture becomes the anachronistic montage of a present capable of exposing both its past and its future, the whys of its memory and the wherefores of its desire. In this kind of montage, the junctures, seams, or links must be quite visible, but the breaks, the discontinuities, and the intervals must also be highlighted.[38] How? Brecht tells us: by changing the lighting or banners or inserting a title.[39]

35 Ibid.
36 B. Brecht, "Portrayal of Past and Present in One," in *Bertolt Brecht: Poems, 1913–1956*, ed. J. Willett and R. Mannheim (London: Methuen, 1987), 307.
37 Brecht, "Short Organon," 229.
38 Ibid., 253.
39 Ibid., 253–55.

Here we have returned to the terrain of the anachronism and of the montage of artistic domains. Indeed, banners recall us to the present of political manifestations, but they also send us to a faraway past; they are for the Brechtian audience what phylacteries were to the paintings of the Middle Ages. And the titles projected on a screen point towards the domain of cinema, evoking the title cards of silent films. *Kriegsfibel* returns to this device in the space of a book of images. Between the phylactery of previous times and the cinematographic projection of texts—a process that was dear to Eisenstein and, later, to Jean-Luc Godard—Brechtian dramaturgical invention accepts the principle according to which any novelty of form, any position-taking, works as an interposition between heterogeneous times or fields. And since it is around the notion of montage that we have examined the *Arbeitsjournal* and *Kriegsfibel*, it seems natural to wonder how Bertolt Brecht might have taken position—or been interposed—regarding the cinema.

It is a long and complex story, one that requires a study in itself. It includes, in particular, a whole body of writings on the art of cinema, written between 1922 and 1933;[40] a tremendous lawsuit against the film adaptation of *The Threepenny Opera*;[41] a collective film, *Kuhle Wampe*, made in 1931–32 and immediately censored because it "depicts the desperate conditions of the unemployed [in a] montage of several relatively self-contained, short pieces";[42] and original scenarios for Fritz Lang (*Hangmen Also Die!*) and for Karl Grune (*Pagliacci*) and poems for the film by Joris Ivens titled *Song of the Rivers*, in 1953. Brecht's sometimes disdainful critical position regarding cinema as a vulgar cultural industry has been examined over and again.[43] But we know also—we can think of Joseph Losey and, above all, Jean-Marie

40 B. Brecht, "Texts and Fragments on the Cinema," in *Brecht on Film and Radio*, ed. and trans. M. Silberman (London: Bloomsbury, 2000), 3-33.

41 Ibid., 131-47. See also the study by L. H. Eisner, "Sur le procès de *L'Opéra de quat-sous*," *Europe* 133-34 (1957): 111-18.

42 B. Brecht, "Short Contribution on the Theme of Realism," in *Brecht on Film and* Radio, 207.

43 See B. Dort, "Pour une critique brechtienne du cinéma," *Cahiers du cinéma* 114 (1960): 33-43; J.-P. Lefebvre, "Brecht et le cinéma," *La Nouvelle Critique* 46 (1971): 40-47; E. Eisler, "Brecht et le cinéma," *Écran* 13 (1973): 5-9; B. Amengual, "Brecht et le réalisme," ibid., 9-14; F. de la Bretèque, "Bertolt Brecht à l'écran," in M. Vanoosthuyse, ed., *Brecht 98: Poétique et politique* (Montpellier: Paul Valéry University, 1999), 305-13; M. Duchardt et al., "Filme und Drehbücher," in *Brecht Handbuch*, vol. 3, *Prosa, Filme, Drehbücher*, ed. J. Knopf (Stuttgart: Metzler, 2002), 417-78.

Straub and Danièle Huillet—how often filmmakers were able to declare their closeness to the Brechtian method and, in particular, their debt towards the concept of distancing.[44]

It is not so much a question of evaluating the debt of Brechtian theatre to the cinematograph or the debt of filmmakers to Brechtian drama. Rather, I believe the question concerns the respective positions—the "interpositions"—of the theatre and cinema in the Brechtian aesthetic machine. Jean-Louis Déotte remarks that "the cinema is that apparatus in which montage is essential, not only as a writing (montage of long takes), but as a montage that integrates other projective apparatuses and their respective temporalities."[45] Even beyond projection—since we can see a film without projecting it, for example, by holding the reel before our eyes or looking at it in an editing room—the modern phenomenon of interposition of artistic fields is described by Adorno as an "erosion of the arts." The inevitable consequence—linked in the aesthetic sphere to the montage of heterogeneous elements, such as the photographic documents of the *Arbeitsjournal* and *Kriegsfibel*—is the aesthetic indetermination of the very notion of art:

> The erosion of the arts is hostile to an ideal of harmony that presupposes, as the guarantee of meaning, what we might call ordered circumstances within the kinds of art. This erosion of the arts wishes to escape from the ideological bias of art, which reaches right down into its constitution as art, as an autarchic sphere of the spirit. It is as if the artistic genres, by denying their own firm boundaries, were gnawing away at the concept of art itself. The original example of the erosion of art was the principle of montage, which appeared before the First World War in the explosion of cubism and, probably independently of that, in experimenters like Schwitters, and after that in dada and

44 See J. Losey, "L'œil du maître" (1960), trans. L. Marcorelles, *Cahiers du cinéma* 114 (1960): 21-32; J.-M. Straub and D. Huillet, "Le chemin passait par Hölderlin," in *Brecht après la chute: Confessions, mémoires, analyses*, ed. W. Storch (Paris: L'Arche, 1993), 94-106. See also Y. Ishaghpour, "D'une nouvelle esthétique théâtrale et de ses implications au cinéma," *Obliques* 20-21 (1979): 163-85.

45 J.-L. Déotte, *Qu'est-ce qu'un appareil? Benjamin, Lyotard, Rancière* (Paris: Harmattan, 2007), 112. I, unlike Déotte, do not deduce from this remark that cinema is the "postmodern apparatus par excellence"; ibid., 101.

surrealism. However, montage amounts to the disruption, and hence the denial, of meaning in works of art through the invasion of fragments of empirical reality that do not abide by the laws of art. The erosion of the arts is almost always accompanied by the attempt by works of art to reach out toward an extra-aesthetic reality. The more an art allows material that is not contained in its own continuum to enter it, the more it participates in alien, thinglike matter, instead of imitating it. It therefore becomes virtually a thing among things, a something we know not what.[46]

By arranging "things among things"—for example, the old tire, two crutches, umbrella, and coffee grinder in a plate of *War Primer* with captions in the form of lyrical epigrams (fig. 2.8)—Brecht makes it hard for us on the aesthetic level, for he made his work a *thing* that is difficult to identify as a work of art. The "erosion of the arts" is therefore characteristic of all photographic montages. When Brecht, in his *Journals*, mentions his doubts about the *Caucasian Chalk Circle* and refers to a painting by Brueghel, we can be reassured with regard to the artistic domains that he brings together.[47] But when we turn the page and we find ourselves face to face with Pope Pius XII, Rommel, and the sight of a mass grave (fig. 3.2), we fall back into the intrinsic difficulty of this "erosion of the arts," for we no longer know exactly what it is. It is neither a political argument in the narrow sense nor a work of art in the narrow sense, but rather a montage in the manner of Warburg's *Bilderatlas*. I am thinking about the very last plates, in which Pope Pius XI can be seen between fascist dignitaries and documents on the anti-Semitic pogroms[48]—three dissimilar images brought together in order to raise a question.

The interposition at work in Warburg's montage does not solely concern the dissimilarity between the three documents. It confronts us with a heterogeneity of the symbolic fields at play. Is it a free artistic association? A reflection on history? An anthropological hypothesis? A dramaturgical

46 T. W. Adorno, "Art and the Arts," trans. R. Livingstone et al., in *Can One Live after Auschwitz? A Philosophical Reader* (Stanford, CA: Stanford University Press, 2003), 385.

47 Brecht, *Journals*, 319.

48 A. Warburg, *Der Bilderatlas Mnemosyne* (1927–29), ed. M. Warnke and C. Brink. 2nd ed. *Gesammelte Schriften*, vol. 2, 1.2 (Berlin: Akademie, 2003), 130–33. See also G. Didi-Huberman, "L'image brûle," in *Penser par les images: Autour des travaux de Georges Didi-Huberman*, ed. L. Zimmerman, 11–52 (Nantes: Cécile Defaut, 2006).

Figure 5.1

Bertolt Brecht, *Arbeitsjournal*, June 17, 1940: "Hitler dances. Führer does jig for victory. Perhaps the most intimate look at Adolf Hitler which the world has ever had is presented in the series of pictures below, taken from a German newsreel. It shows Hitler at precisely the happiest moment of his life. He has just heard the news that France is ready to surrender." © Berlin: Akademie der Künste, Bertolt-Brecht-Archiv (277/12)/Bertolt-Brecht-Erben/Suhrkamp Verlag 1973.

example? A repertory of fundamental gestures? It is all of these things at the same time, and it is all of this that Brecht intended to mount, to assemble—just as in earlier periods one mounted *naturalia* in complex ad hoc frames—in order to obtain usable knowledge. The montages in the *Arbeitsjournal* are more explicitly cinematographic when they offer series of gestural sequences, such as the twenty photograms of the "Hitler jig" on June 17, 1940, when he heard of the surrender of the French troops (fig. 5.1), a series of gestures captured during the Russian campaign, with their reverse angle of villages in flames (fig. 5.2), or the sequence of the Nazi injured by the FFI (Forces françaises de l'intérieur) during the liberation of Paris in September 1944 (fig. 5.3).

Finally, the most disconcerting (and more experimental) apparatus used by Brecht is the bringing together of written lists, for example, in December 1944, an overview of his poems in exile with the contact films of his manuscripts created by Ruth Berlau (fig. 5.4),[49] as though the poems needed not only to be collected graphically but also to be exposed photographically, almost cinematographically. As though literature needed to be given filmic movement by the serial scrolling of a production for which exile was the only unit of time. We know that later Brecht would begin to scatter the iconography of his *Modellbücher*, starting from the unit of time that made up the theatrical performance of *Antigone* or *Mother Courage*. They are long, almost chrono-photographical sequences—94 images for *Antigone* in 1948 and 231 images for *Mother Courage* in 1949[50]—where a dramaturgical model meets a repertory of fundamental gestures and a reflection on the time of performance, everything interposed in the same image in terms of all the others.

Allegory

What type of meaning do we obtain by cutting, interposing, scattering, dismantling, reassembling the element of chronological time in this way? An elementary case that clarifies this can be found in the *Arbeitsjournal*. In the entry for July 25, 1943, we see two photographs of Hitler taken ten years

49 Brecht, *Journals*, 340.

50 B. Brecht, "Antigonemodell" (1948), in *Werke*, vol. 25, *Schriften*, 5, ed. W. Hecht and M. Conrad (Berlin: Suhrkamp, 1994), 71-168; B. Brecht, "Couragemodell," ibid., 169-398.

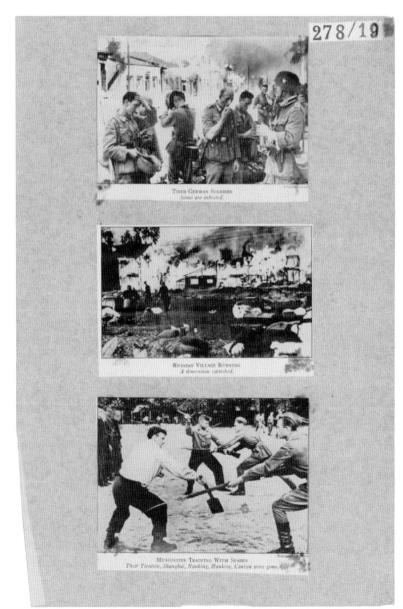

Figure 5.2
Bertolt Brecht, *Arbeitsjournal*,
December 3, 1941: "Tired
German soldiers. Burning
Russian village. Muscovites
training with spades."
© Berlin: Akademie der
Künste, Bertolt-Brecht-Archiv
(278/19)/Bertolt-Brecht-
Erben/Suhrkamp Verlag 1973.

12.9.44
die ungeduld der linken mit den deutschen arbeitern ist begreiflich. da-
bei sollten marxisten wissen, was eine revolutionäre situation ausmacht.
dazu hat das ungarische, italienische, spanische, chinesische beispiel
gezeigt, was ein mit den modernsten waffen und fahrzeugen und polizeisys-
temen ausgestattetes lumpenpack vermag und im deutschen fall handelte es
sich um ein durch illusionen und wirtschaftskrisen geschwächtes proleta-
riat.

On a Paris street, a wounded Nazi . . .

. . . is pounced on by an F.F.I. woman . . .

. . . who disarms him . . .

News of the Day International, Associated Press
. . . then helps carry him off.

Figure 5.3
Bertolt Brecht, *Arbeitsjournal*,
September 12, 1944: "On
a Paris street, a wounded
Nazi is pounced on by an
F.F.I. woman who disarms
him, then helps carry him
off." © Berlin: Akademie der
Künste, Bertolt-Brecht-Archiv
(282/07)/Bertolt-Brecht-
Erben/Suhrkamp Verlag 1973.

apart (fig. 5.5), and in *Kriegsfibel* we see in 1955 two portraits of Hitler, one opening the collection of images and the other closing it.[51] This rudimentary montage shows us that, between the two photos—the one taken in 1933, the other in 1943—time passes, or time will have passed. In 1943 Hitler's features have become more hollowed; he is no longer enjoying the triumphalism and bouquets of flowers of his rise to power, as we see in the document on the left. We see instead the stiffness of his attempt to hide from the Germans the reasons why their army is no longer advancing through the frozen plains of Russia, and why so many soldiers have not come back. Time passes, which means that the wheel of fate is turning; Hitler's crushing victories of 1933 and then 1940 make way for the harbingers of defeat. This means that *death* appears in the interval between these two images, and also in Hitler's own face, subjected to these two states of time.[52]

The historical montage therefore acquires an allegorical value. Leafing through the pages of *Kriegsfibel*, we sometimes find ourselves condensing the portraits in it—political dignitaries, soldiers, ordinary people—with the signs of destruction that the war has caused everywhere. Hitler's mouth, opened to emit its stream of deadly imprecations, begins to rhyme visually with the open mouth of the soldier burned alive, whose death's head is frozen in an eternal cry (fig. 5.6). Between these two states of the face devoted to death (portrait, skull) are then interposed and imposed all the masks whose appearances are multiplied in the *Artbeitsjournal* and *Kriegsfibel*—masks of soldiers subjected to extreme conditions of altitude or cold, gas masks of civilians confronted with a war in which the air itself can be the mortal enemy, bandages covering the disfigured, people burned, shot[53]—until the images of death masks that Brecht collected before asking that a death mask be made from his own dead body.[54]

51 B. Brecht, *War Primer*, trans. and ed. J. Willett (London: Libris, 1988), pl. 1 and 81 [69].

52 On Hitler's face as an over-determined object, see C. Schmölders, *Hitlers Geischt. Eine physiognomische Biographie* (Munich: Beck, 2000).

53 Brecht, *Journals*; Brecht, *War Primer*, pl. 20 [18] and 84 (pilot masks); 12 (blindfolded resistance fighter shot); 52 [43], 61 [51], and 66 [56] (bandages of the injured).

54 Brecht, *Journals*, 435 (death mask of Ernst Barlach). On the death mask of Brecht, see W. Hecht, ed., *Bertolt Brecht: Sein Leben in Bildern und Texten* (Frankfurt: Suhrkamp, 2000), 312–13.

282/15

Ten years have changed Hitler. Left, he is shown addressing his followers shortly after his ascension to power on Jan. 30, 1933. Right (picture taken last November), he is shown trying to explain what has been happening to his armies in Russia. Note, among other things, the difference in waistline.

Photo by Wide World

Figures 5.5 and 5.6
Bertolt Brecht, *Arbeitsjournal*, July 25, 1943: "Ten years have changed Hitler. Left, he is shown addressing his followers shortly after his ascension to power on Jan. 30, 1933. Right (picture taken last November), he is shown trying to explain what has been happening to his armies in Russia. Note, among other things, the difference in waistline." © Berlin: Akademie der Künste, Bertolt-Brecht-Archiv (281/12)/Bertolt-Brecht-Erben/Suhrkamp Verlag 1973.

Bertolt Brecht, *Kriegsfibel*, 1955, plate 53 [44]: "A Japanese soldier's skull is propped up on a burned-out Jap [*sic*] tank by U.S. troops. Fire destroyed the rest of the corpse." © Bertolt-Brecht-Erben/Suhrkamp Verlag 1988.

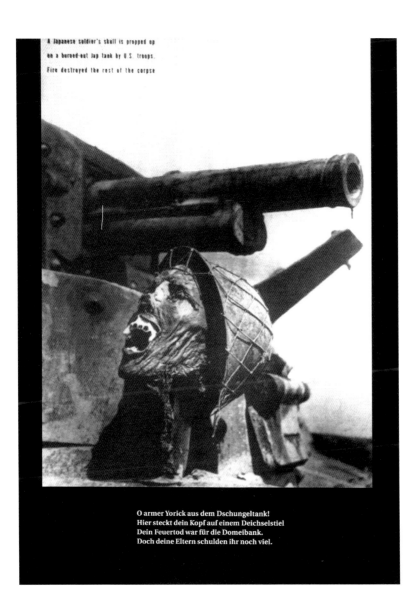

A Japanese soldier's skull is propped up
on a burned-out Jap tank by U.S. troops.
Fire destroyed the rest of the corpse

O armer Yorick aus dem Dschungeltank!
Hier steckt dein Kopf auf einem Deichselstiel
Dein Feuertod war für die Domeibank.
Doch deine Eltern schulden ihr noch viel.

Reinhold Grimm characterized Brecht's *Kriegsfibel* as an "emblematic Marxist" undertaking: Marxist in its content, emblematic in its form. Which is what allowed the exegete to suggest a skull engraved in the sixteenth century, taken from Juan de Horozco's *Emblemas morales*, as a possible "source" for the plate that shows the "screaming" charred soldier,[55] or, more precisely, as a source for Brecht's stylistic choice in composing his own form of *Disasters of War*. Not only does the Brechtian photo-epigram re-examine the relationship between visibility and legibility—a question inherent to any allegorical apparatus[56]—it seems in fact to re-enact the classical structure of the *emblem*, that derivation from the epigram invented by André Alciat in the sixteenth century.[57]

On the black background of his atlas plates, Brecht disposes *three* distinct elements, not two (the photographic image and the poetic epigram), as we might think. In precisely the manner of a classical emblem, almost every plate of *Kriegsfibel* contains a visual representation, an *imago*, joined to two distinct textual modalities; the caption of the photograph, usually cut from a newspaper, acts as what humanist, then Baroque theoreticians called the *inscriptio*, while the epigram itself "moralizes" the whole by acting as a *subscriptio*.[58] This is certainly not to say that in his *War Primer* Brecht was merely undertaking an exercise in past style or a simple game of literary reference. Philippe Ivernel estimates that the comparison between *War*

55 R. Grimm, "Marxistische Emblematik: Zu Bertolt Brechts *Kriegsfibel*," in *Wissenschaft als Dialog: Studien zur Literatur und Kunst seit der Jarhundert-wende*, ed. R. von Heydebrand and K. G. Just (Stuttgart: Metzler, 1969), 351–79, fig. 4–5.

56 See R. Klein, "La théorie de l'expression figurée dans les traités italiens sur les *imprese*, 1555–1612" (1957), in *La forme et l'intelligible: Écrits sur la Renaissance et l'art moderne* (Paris: Gallimard, 1970), 125–50; M. Praz, *Studies in Seventeenth-Century Imagery* (Rome: Edizioni di storia e letteratura, 1964–74); C.-P. Warncke, *Sprechende Bilder— sichtbare Worte: Das Bildversändnis in der frühen Neuzeit* (Wiesbaden: Otto Harrassowitz, 1987), 197–216.

57 A. Alciat, *Les emblèmes* (1551) (Paris: Klincksieck, 1997). See also P. Laurens, "Epigramme," in *Dictionnaire universel des littératures*, ed. B. Didier, vol. 1 (Paris: PUF, 1994), 1108.

58 On this canonical structure of the emblem and its variants, see W. S. Heckscher, "Renaissance Emblems" (1954), in *Art and Literature: Studies in Relationship* (Durham, NC: Duke University Press/Valentin Koerner, 1985), 111–26; A. Schöne, *Emblematik und Drama im Zeitalter des Barock* (Munich: Beck, 1964); C. Balavoie, "Le statut de l'image dans les livres emblématiques en France de 1580 à 1630," in *l'Automne de la Renaissance*, ed. J. Lafond and A. Stegmann (Paris: Vrin, 1981), 163–78; B. F. Scholz, *Emblem und Emblempoetik: Historische und systematische Studien* (Berlin: Erich Schmidt, 2002), 183–213.

Primer and Renaissance or Baroque allegory "is in substance misleading, even if it merits our attention regarding a certain type of relation between the image and writing."[59] "In substance"—that is to say, the content of the montages created by Brecht in his atlas. "The Marxist lesson that Brecht gave," writes Ivernel,

> functions in no way like a baroque lesson that might underscore anything beyond meaning in front of earthly, or sensible, vanities. In the *War Primer*, the written unveils the image but without thinning it; it unveils it, so to speak, by allowing itself to be questioned by it in turn (as already encouraged by the double caption). It does not translate the voice of a transcendent god . . . but at most the viewpoint, a viewpoint that is necessarily historical, of a Marxist wondering about the constraints and demands of collective action.[60]

We must therefore look at and understand the dreadful photograph of the charred skull as being well beyond any universal emblem of the vanity of the human body. "We die every day" (*quotidie morimur*), says the *inscriptio* of the *Emblemas morales*, and the *subscriptio* stitches its poem on earthly life as the constant work of its own death. But Brecht states something quite different, suggesting a questioning of this macabre scene created by the victor who intentionally placed the head of his enemy on the tank's turret. Then Brecht makes *tank* rhyme with *bank* in his epigram, where the bank is the capitalistic nerve of the war: "This sound effect reveals, behind the mythical violence of the war, the regular workings of the economy. The baroque meditation is then brought back brutally to the day-to-day of human societies which are the node of the problem. It turns into anger, and is charged with political energy."[61]

But things are even more complex in this relationship woven by the writer between immemorial traditions—the skull as emblem, the epigrammatic structure—and a political lesson concerning the actuality of the world war. It is no coincidence that in his poem Brecht returns to the present of the

59 P. Ivernel, "Passages de frontières: Circulation de l'image épique et dialectique chez Brecht et Benjamin," *Hors-cadre* 6 (1987): 154.

60 Ibid., 154–55.

61 P. Ivernel, "L'œil de Brecht," in Vanoosthuyse, *Brecht 98*, 228.

cadaver of the Japanese soldier, with its scary, even scarecrow appearance, by addressing it with the words of Shakespeare, when Hamlet meditates in front of the skull of "poor Yorick":

Alas, poor Yorick of the burnt-out tank!
Upon an axle-shaft your head is set.
Your death by fire was for the Domei Bank
To whom your parents still remain in debt.[62]

The tradition of the allegory is certainly called upon here to think about a precise moment in contemporary history. The temporal montage that results from this kind of action, however, enriches and unusually renders more complex the "eye of history," by which I mean Brecht's way of looking at the Japanese-American war in 1943. We can then understand how every montage, whether intentionally or not, brings to a crisis the message that it is supposed to communicate. The tank, visible in the photographic document, allows Brecht to imagine, through an interposed rhyme, the bank that made such mass production possible, by speculating on the debts of those (or the parents of those) who are sent to the slaughter. But the imposing skull in the foreground of the image, with its trivial, un-sublimable details such as the military helmet and the burnt skin still sticking to the bones, is invoked by Brecht in a *figure* through the literary, baroque, almost shocking detour of a quote from Shakespeare. It is enough to read "poor Yorick" to hear Hamlet's famous words in front of the court jester's skull:

That skull had a tongue in it and could sing once. . . . Alas! poor Yorick. I knew him, Horatio; a fancy fellow of infinite jest, of most excellent fancy; he hath borne me on his back a thousand times; and now, how abhorred in my imagination it is! my gorge rises at it. Here hung those lips that I have kissed I know not how oft. Where be your jibes now? your gambols? your songs? your flashes of merriment, that were wont to set the table on a roar? Not one now, to mock your own grinning?[63]

62 Brecht, *War Primer*, pl. 53 [44].
63 W. Shakespeare, *Hamlet*, act 5, scene 1, lines 71-72, 174-182, *Arden Shakespeare* (London: Bloomsbury, 2016), 445, 452.

Even beyond the general thoughts about death and vanity inherent in the viewing of a corpse or a skull—"that skull had a tongue in it . . . Alas! I knew him . . . and now . . . how abhorred [etc.]"—the allegorical approach and the theatrical reference *dialectize* the gaze directed at this macabre document of the American-Japanese war. Brecht allegorizes the document in order to bring us more efficiently face to face with its ambiguity, on the one hand, and its cruelty, on the other. The ambiguity arises in the meeting between the death's head and the evocation of the court jester. If we can speak in front of this skull of an "eternal cry" tied to the irreversible disappearance of the lips, we should then speak also—with the help of the Shakespearian reference proposed by Brecht— of the grimace and the laughter that popular and carnival iconography often create from these two ways of looking at the teeth in a human skull.

Cruelty is not only a result of the macabre object as such. It is highlighted, even reconstructed, in the staging that these human remains have undergone to be made a photographic trophy of American military triumphalism. Brecht's choice, in this sense, joins the political montages proposed in 1924 by Ernst Friedrich in his unbearable book of images *Krieg dem Kriege!* In it we see, for example, under the title "a little joke by the French" (*ein kleiner Franzosenscherz*), a skull mounted on a wooden cross, the image placed opposite men's heads stuck onto bayonets, above the very ironic *subscriptio* "Men's most noble virtues blossom in war"(figs. 5.7 and 5.8).[64] When Brecht introduced the allegorical vision of an idealized America in his *Arbeitsjournal* in July 1941, it was just to show it cruelly, with a photo in which we see his friend Leon Feuchtwanger behind the barbed wire of a French concentration camp.[65]

In light of Philippe Ivernel's reflections, we can nevertheless justifiably question the allegorical (or not) content of these Brechtian processes of historical montage. Is it not obvious that the terms *allegory* and *history* are mutually exclusive? Isn't the allegory just as timeless and general as history is unique and dated? Walter Benjamin's work is very fruitful here with regard to this question, on at least two levels. On the one hand, Benjamin

64 E. Friedrich, *Krieg dem Kriege!* (Berlin: Freie Jungend, 1924; repr., Munich: Deutsche-Verlag-Anstalt, 2004), 226–27. A similar image is seen in Brecht, *War Primer*, pl. 54 [45] (fig. 2.1).

65 Brecht, *Journals*, 156.

Figures 5.7 and 5.8
Ernst Friedrich, *Krieg dem Kriege!*, 1924, p. 226: "The Mesnil cemetery. A little joke by the French."

Ernst Friedrich, *Krieg dem Kriege!*, 1924, p. 227: "Man's most noble qualities blossom in war (words by Count Moltke)."

himself offered an interpretation of Brecht's poems of exile as they were being written. It is an essentially dialectical interpretation, since it makes this war poetry a work of *words for survival*—that is to say, a work of the pure historical present—as well as a work of *surviving words*, that is to say, a work of the impure present and of a reminiscent present. Brecht wrote his *War Primer* by using, according to Benjamin, "words which through their poetic form will conceivably survive the coming apocalypse,"[66] words uttered in the present with a view to a better future, if possible. But they are also "primitive words," Benjamin adds, referring to the epigrammatic style, "lapidary" words, as short as they are perennial (as we see on ancient tombs), which allows us to see in Horace somewhat a potential style of response to the Gestapo's agents.[67]

It was regarding Brecht's entire work, in fact, that Walter Benjamin developed this kind of reasoning. Thus "the forms of epic theatre correspond to new technical forms—cinema and radio" while embodying "the legacy of medieval and baroque drama."[68] It is a paradox, therefore, for in this "new theatre [it] will be noticed, not without surprise, that its origins reach back a very long time."[69] It is important to note also how, empowered by his work on Baroque drama and allegory, Benjamin was able to enlighten Brecht himself regarding this historical origin, for example, by introducing him to the writings of Baltasar Gracián.[70]

It is therefore around a history of language and of forms, to be understood as a *history of survivals*, that we should today reread Walter Benjamin's pages on Baroque allegory in order to examine the question of modern allegory in Brecht.

Allegory, like many other old forms of expression, has not simply lost its meaning by "becoming antiquated." What takes place here, as so often, is a

66 W. Benjamin, "Commentary on Poems by Brecht," (1938–39), in *Selected Writings*, vol. 4, *1938–1940*, ed. H. Eiland and M. W. Jennings (Cambridge, MA: Harvard University Press, 1999), 240.

67 Ibid.

68 W. Benjamin, "What Is Epic Theater?" (1931), trans. A. Bostock, in *Understanding Brecht* (London: Verso, 1998), 6.

69 Ibid., 5.

70 See H. Lethen and E. Wizisla, "'Das Schwierigste beim Gehen ist das Stillesten': Benjamin schenkt Brecht Gracián; Ein Hinweis," *Theater der Zeit: The Brecht Yearbook* 23 (1998): 142–46.

conflict between the earlier and the later form which was all the more inclined to a silent settlement in that it was non-conceptual, profound, and bitter.[71]

What else could this mean in this context, except that the metaphysical timelessness of sacred allegories "survives" in Brecht solely in the form of a non-conceptual conflict of allegory with its implementation that is entirely devoted to historical and profane temporality? This conflict already existed in the Baroque era; the entire question addressed by Benjamin is about knowing *what allegory does with history* (or to history), even in its most fanciful and enigmatic signifying games.

First of all, it is important to see within allegory something like the modern successor to a relationship to history whose "classical" formula had been embodied since antiquity by the epic poem—another great Brechtian paradigm. "The epic poem is in fact a history of signifying nature in its classical form, just as allegory is its baroque form,"[72] to the extent that we might see "history as the content of the *Trauerspiel*."[73] In what form? In the form of an "interweaving" or an entanglement that condenses the allegory.[74] As such, the allegory interrupts and suspends the chronological progress of the action. It is seen in the interludes of Baroque drama, in which arises something Benjamin calls an "exegetic" value but which "secularizes" history through its presentation: "For where it is a question of a realization in terms of space—and what else is meant by its secularization other than its transformation into the strictly present—then the most radical procedure is to make events simultaneous."[75]

Second, allegory replicates this interruption of the chronological continuum on the spatial level. It divides up its nature by exposing partial objects, "amorphous details," by proceeding with the "overbearing ostentation [of] the banal object" that is also an inanimate object.[76] It is the montage of these "still lifes" that makes the object an emblem in which "the moment of expression coincides with a veritable eruption of images"

71 Benjamin, *Origin of German Tragic Drama*, 161.
72 Ibid., 162.
73 Ibid., 56.
74 Ibid., 163.
75 Ibid., 194.
76 Ibid., 185.

scattered in a "chaotic mass."[77] It is a consequence of this dividing up that we experience as we leaf through the collages of the *Arbeitsjournal* and the plates of *Kriegsfibel*—a glove on a cross, scattered helmets, crutches with an umbrella, onions with a prosthetic limb, a skull on a tank's turret (figs. 2.1, 2.7, 2.8, 3.1, and 5.6). "History becomes part of the setting," but as *ruins,* remains, gaps, displaced or archaeological objects.[78] That is, beyond any metaphysical thoughts on the vanity of earthly things, the allegory's fundamental *gestus* is to be found in "sorrow," affliction, mourning (*Trauer*) in the face of the history of man.[79] That is why the emblem becomes the corpse (*die Leiche als Emblem*)[80] and, above all, the death's head: "in allegory the observer is confronted with the *facies hippocratica* of history as a petrified, primordial landscape. Everything about history that, from the very beginning, has been untimely, sorrowful, unsuccessful, is expressed in a face—or rather in a death's head."[81] That is why, finally, imagining the war cannot be separated from the production of such allegories.

It is a historical fact that the fundamental subjects of the figurative expression of emblems, at the very beginning of European modernity, were war and politics. The first collection of this kind appears to be by Claude Paradin in 1551, titled *Devises héroïques*.[82] In his magnificent study on the *imprese* of the Renaissance, Robert Klein reminds the reader from the beginning:

> Giovio tells us in a famous passage from his *Dialogo dell'imprese militari et amorose*, written around 1550, that the fashion had been introduced in Italy by the captains of Charles VIII, and imitated initially by Italian men of war, who drew *imprese* on the weapons and banners, and gave them to their men to be recognizable in the melee and to give them courage.[83]

77 Ibid., 173.
78 Ibid., 177.
79 Ibid., 187.
80 Ibid., 217.
81 Ibid., 166.
82 C. Paradin, *Devises héroïques* (Lyon: Jean de Tournes and Guillaume Gazeau, 1551).
83 R. Klein, "La théorie de l'expression," 125. On humanist and baroque emblematics, see A. Henkel and A. Schöne, eds. *Emblemata: Handbuch zur Sinnbildkunst des XVI und XVII Jahrhunderts* (Stuttgart: Metzler, 1996), col. 1967-96; J. Manning, *The Emblem* (London: Reaktion, 2002), 37-39, 275-320.

Bertolt Brecht's *Kriegsfibel* appears from this viewpoint to be an enterprise or *impresa*, a modern design or motto to make us recognize who is who in the melee, who is good and who does not know that they are bad, who is presumptuous and who is genuinely brave.

The representation of war did not cease, in the nineteenth and twentieth centuries, to avail itself of allegory. There are innumerable appearances of skulls or skeletons in particular—whether frightening or satirical—in the foreground of this iconography.[84] In Brecht's time, Dadaist montages became political allegories until John Heartfield gave the genre its full polemical force in the fight against the Nazis.[85] A work as openly polemical as *Deutschland, Deutschland über alles*, written in 1929 by Kurt Tucholsky, with photomontages by John Heartfield, did not hesitate to consider certain photographic documents as allegories for thinking about war.[86] When Brecht published his *Kriegsfibel* in 1955, Picasso's *Dove of Peace* had already (in 1949) been sewn onto the stage curtain of the Deutsches Theater as a "permanent emblem."[87]

Pathos

In his study of Baroque drama, Walter Benjamin profoundly challenges two prejudices regarding the notion of allegory. On the one hand, allegorical timelessness and transcendence are undermined when Benjamin manages to

84 See S. Holsten, *Allegorische Darstellungen des Krieges, 1870-1918: Ikonologische und ideologiekritische Studien* (Munich: Prestel, 1976), 76-86, 102-14, and figs. 234-83 and 362-429.

85 See H. Bergius, *Montage und Metamechanik: Dada Berlin; Artistik von Polaritäten* (Berlin: Mann, 2000), 130-59; P. Pachnicke and K. Honnef, eds., *John Heartfield* (Berlin: Akademie der Kunste/DuMont, 1991).

86 K. Tucholsky and J. Heartfield, *Deutschland, Deutschland über alles* (1929) (Hamburg: Rowohlt, 1973), 43. On the relationship between this book and Brecht's *Kriegsfibel*, see H. Frank, "Blick auf Brechts *Kriegsfibel*: Zur Ästhetik der Beziehung von Bild und Wort," in *Kunst und Kunstkritik der dreissiger Jarh. 29: Standpunkte zu künstlerischen und ästhetischen Prozessen und Kontroversen*, ed. M. Rüger (Dresden: Verlag der Kunst, 1990), 205-22.

87 Brecht, *Journals*, 424.

show the political immanence of allegories in the most cryptic, hieroglyphic, or "numismatic" aspects of their signifying games: "where nature bears the imprint of history, that is to say where it is a setting, does it not have a numismatic quality?"[88] This allows us to understand both the enigmatic nature of allegory and its historical content engaged in the public and political sphere. When, in his *War Primer*, Brecht makes the sea of buried voices resonate enigmatically (fig. 2.2), he is not far from this paradoxical articulation that makes his iconographic, documentary, and allegorical montage possible.

On the other hand, Benjamin manages to disengage allegory from its ancient and unsympathetically cold reputation. The darkness of the exegesis and, therefore, the signifying complexity of the allegories—in which "any person, any object, any relationship can mean absolutely anything else"[89]— must be understood in reality, in the expressive immanence from which the imprint of the affect is never put out of action:

> The allegory of the seventeenth century is not convention of expression, but expression of convention. At the same time expression of authority, which is secret in accordance with the dignity of its origin, but public in accordance with the extent of its validity. And the very same antinomies take plastic form in the conflict between the cold, facile technique and the eruptive expression of allegorical interpretation. Here too the solution is a dialectical one [that is, against any "non-dialectical" aesthetic thinking of the Neo-Kantian school].[90]

That is why Benjamin promptly dares to compare Baroque allegory, from an age of "unremitting artistic will," with expressionist creations—Dadaist or surrealist—of the 1920s.[91] History and pathos are linked, then, decidedly in a way of seeing the world, and with a note of melancholy, as a great "history of sufferings," or *Leidensgeschichte*: "This the heart of the allegorical way of seeing, of the baroque (*der Kern der*

88 Benjamin, *Origin of German Tragic Drama*, 173.
89 Ibid., 174
90 Ibid., 175.
91 Ibid., 55.

allegorischen Betrachtung), secular explanation of history as the *history of the sufferings* of the world (*weltlichen Exposition der Geschichte als Leidensgeschichte der Welt*)."[92]

This vision of history through pathos is answered directly by Bertolt Brecht's injunction in 1952, highlighted by Klaus Schuffels and Philippe Ivernel in their French edition of *Kriegsfibel*:

> The memory of sufferings endured is astonishingly short in humans. Their imagination of sufferings to come is even weaker. The person from New York has read numerous descriptions of the horrors caused by the atomic bomb, without showing any evident fear. The person from Hamburg is still surrounded by ruins, and yet he hesitates to raise an arm against a new danger of war. The worldwide horror of the forties seems to have been forgotten. Many say that the rain of yesterday can no longer get us wet. It is against this apathy that we must fight. . . . Let us endlessly repeat what has been said ten thousand times already, so as not to have said it too little! Let us renew our warnings, even if they leave the bitter taste of ashes! For humanity is threatened with wars next to which the preceding wars look like awkward attempts, and these wars will most certainly break out if we do not break the hands of those who are openly preparing them.[93]

Just as, according to Walter Benjamin, the primary political function of the thinker and the historian is to use their memories as warnings against the conflagrations to come, according to Brecht, the poet and playwright must replay "the sufferings to come" in their imaginations, on the basis of "memory of the sufferings endured."[94] That is how the question of poetry can be re-examined in the contexts of its lyrical gesture, its content of pathos, as well as its epic and political functions. On April 5, 1942, for example, Brecht

92 Ibid., 166 [translation modified].

93 B. Brecht, *ABC de la guerre*, trans. P. Ivernel (Grenoble: Presses Universitaires de Grenoble, 1985), 7. The text comes from B. Brecht "Propositions pour la paix," cited in G. Didi-Huberman, *L'œil de l'histoire*, vol. 1, *Quand les images prennent position* (Paris: Minuit, 2009), 251–52.

94 W. Benjamin, "On the Concept of History," in *Selected Writings*, vol. 4, *1938–1940*, ed. H. Eiland and M. W. Jennings (Cambridge, MA: Harvard University Press, 1999), 389. See also M. Löwy, *Walter Benjamin: Avertissement d'incendie; Une lecture des thèses "Sur le concept d'histoire"* (Paris: PUF, 2001).

wrote in his *Journals* about the powerlessness he felt, as a producer of lyrical words, facing the ongoing war—"it is like putting a message in a bottle"—but this refers to nothing less than the poet's political responsibility when facing the realities of *Leidensgeschichte*: "the battle for smolensk is a battle for poetry too."[95]

Just below this sentence, Brecht sticks a shattering photograph of two women, screaming their pain, in front of the corpses of their young children in the rubble of bombed Singapore on December 7, 1941. This document was so dear to him, it seems, that he makes it a central plate of *Kriegsfibel* (fig. 5.9), significantly inscribed in a network of *Pietà* situations in which we find prams threatened by German bombs in London, the pain of Jewish women sent out to sea in Palestine, and the pain of the Russian women upon finding the corpses of their murdered young sons in Kerch (fig. 5.11).[96] It is no coincidence that the lamentation of the mothers in Singapore also takes position in a sequence of extreme contrast, since the following plate in *Kriegsfibel* shows the arrogant and sickening indifference of the American soldier posing in front of the corpse of a dead Japanese soldier (fig. 1.3).[97] And it is no surprise that Brecht constructs a key moment of his staging of *Mother Courage* around this kind of prolonged cry, this lament turned into an imprecation whose great, pathetic *gestus* was constructed so well by Helene Weigel (fig. 5.10).[98]

We can see, then, how Bertolt Brecht had to bring his attention to the anthropological, aesthetic, and political problem of the *memory of gestures*. Just as he invented a "non-Aristotelian dramaturgy" with the help of the epic—a more ancient Greek genre than tragedy—Brecht uses his iconographic documentation of the present war as a montage table, an atlas within which to identify and reconstruct the geographical and historical movements of human gesture and affect triggered politically in the body of each. Without knowing anything, it seems, of the ideas introduced into art history by Aby

95 Brecht, *Journals*, 219.

96 Brecht, *War Primer*, pl. 22, 58 [48], 69 [59].

97 Ibid., pl. 48 [39], 49 [40].

98 Brecht, "Couragemodell," 318–19. See M. Pic, "*Mère Courage et ses enfants*: La représentation; Spectacle du Berliner Ensemble au Théâtre des Nations, Paris, 8 et 9 avril 1957," in *Mère Courage et ses enfants* (Paris: L'Arche, 1957), fig. 48–49. See also the photographs of G. Goedhart in E. Wizisla, ed., *Bertolt Brecht, 1898–1998*: ". . . und mein Werk ist der Abgesang des Jahrtausends"; 22 Versuche, eine Arbeit zu beschreiben (Berlin: Akademie der Künste, 1998), 155–69.

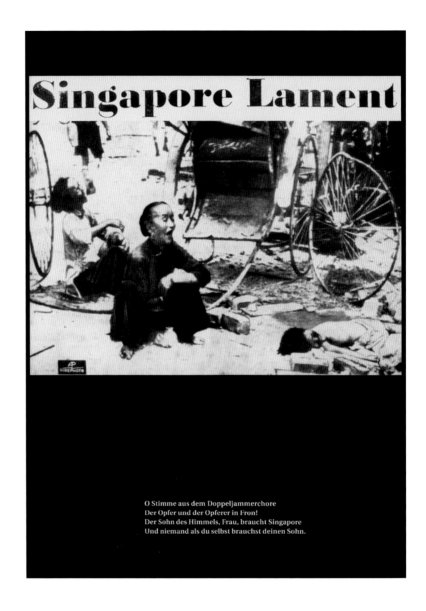

O Stimme aus dem Doppeljammerchore
Der Opfer und der Opferer in Fron!
Der Sohn des Himmels, Frau, braucht Singapore
Und niemand als du selbst brauchst deinen Sohn.

Figures 5.9 and 5.10
Bertolt Brecht, *Kriegsfibel*,
1955, plate 48 [39]:
"Singapore Lament."
© Bertolt-Brecht-Erben/
Suhrkamp Verlag 1988.

Bertolt Brecht, *Couragemodell*,
1949, plate 120a. © Berlin:
Akademie der Künste, Bertolt-
Brecht-Archiv/Bertolt-Brecht-
Erben/Suhrkamp Verlag 1994.

Warburg, Brecht appears to have traced, in his *Arbeitsjournal* and *Kriegsfibel* and the dramaturgical *Modellbücher*, a whole network of "formulae of pathos" (*Pathosformeln*), in which the pain of an Asian woman in 1941 can elicit the physical *gestus* of Mother Courage by means of an anachronistic detour through a reflection on the relationships between tragedy and epic—thoughts that are central to a play such as *Antigone* and to a poem like *Die Medea von Lodz*:

> Between the tramways, the cars, the aerial metros,
> The old cry resounds
> In 1934
> In our city of Berlin.[99]

We would need a whole study to unravel in Bertolt Brecht the tensions or contradictions between *pathos* and *formula*. Or, to put it differently, the constant difficulty of dismissing the tragic gesture in favour of the epic gesture. Brechtian orthodoxy, as we know, seeks to contrast vigorously the empathy of the tragic—how, indeed, to escape empathy in front of a gesture so filled with pathos as that of a mother lamenting over the corpse of her dead child?—and epic distancing. In the staging of *Mother Courage*, the execution of Swiss Cheese takes place offstage so as to create a distance, to deconstruct the empathy between the mother and the child, on the one hand, and between that pain represented and the audience on the other. "*In the distance, a roll of drums* [for the execution]," writes Brecht in the stage directions. "*The* Chaplain *stands up and walks toward the rear.* Mother Courage *remains seated. It grows dark. It gets light again.* Mother Courage *has not moved.*"[100]

Does this mean that the *pathos* of the *Pietà* is dismissed by such distancing? In any case, this is what Philippe Ivernel believes, like Roland Barthes, when he relies on the "Chaplain's back as he walks away, out of modesty, and powerlessness; that curved back, as it leaves, gathers all the

99 B. Brecht, "La Médée de Lodz" (1934), trans. B. Lortholary, in *Poèmes*, vol. 8 (Paris: L'Arche, 1967), 130. See also "Les mères des disparus," ibid., 18-19; B. Brecht, *Sophocles' Antigone: In a Version by Bertolt Brecht* (1948), adapted by Brecht from the German translation of Sophocles by Friedrich Hölderlin; trans. J. Malina (New York: Applause, 1990); Brecht, "Antigonemodell," 71-168.

100 B. Brecht, *Mother Courage and Her Children* (1939), trans. E. Bentley (New York: Grove, 1966), 64.

"AFTER THE LIBERATION OF KERCH BY OUR UNITS, THERE CAME TO LIGHT THE SHOCKING DETAILS OF ONE OF THE MOST FIENDISH CRIMES THAT THE GERMAN ARMY PERPETRATED ON SOVIET TERRITORY—THE SHOOTING OF OVER 7,000 CIVILIANS. THE GERMAN COMMANDANT'S OFFICE ASSEMBLED THE POPULATION BY RUSE, HAVING POSTED ORDER NO. 4 DIRECTING THAT CITIZENS WERE TO APPEAR IN SENNAYA SQUARE. AFTER THEY ASSEMBLED THEY WERE SEIZED, DRIVEN OUTSIDE THE CITY AND MOWED DOWN BY MACHINE GUN FIRE." —FROM THE NOTE ON GERMAN ATROCITIES ISSUED BY PEOPLE'S COMMISSAR OF FOREIGN AFFAIRS VYACHESLAV MOLOTOV ON APRIL 27, 1942. THIS PICTURE WAS TAKEN AS TWO PARENTS, RETURNING TO KERCH AFTER ITS RECAPTURE BY THE RED ARMY IN FEBRUARY 1942, IDENTIFIED THE BODY OF THEIR SON.

Und alles Mitleid, Frau, nenn ich gelogen
Das sich nicht wandelt in den roten Zorn
Der nicht mehr ruht, bis endlich ausgezogen
Dem Fleisch der Menschheit dieser alte Dorn.

Figure 5.11
Bertolt Brecht, *Kriegsfibel*, 1955, plate 69 [59]: "This picture was taken as two parents, returning to Kerch after its recapture by the Red Army in February 1942, identified the body of their son." © Bertolt-Brecht-Erben/ Suhrkamp Verlag 1988.

pain of the mother, which is insignificant in itself."[101] If this were true—how can we say that the pain of a mother who hears, in the distance, her child die is "insignificant in itself"?—then we would have to accept that the bodies remain silent so that some political message can be uttered. We would have to suggest that history is pure transcendence, and that our affective immanences have no effect at all on the course of truth. It would be necessary, "out of modesty," as Barthes says, that the pain itself (*Leid*) no longer have a place in the representation of *Leidensgeschichte*.

However, this categorical choice is not only impossible but precisely contradicted by the aesthetic choices of Brecht and Helene Weigel. The immobile and mute cry of Mother Courage is no less significant than a harrowing clamour and is no less full of *pathos* and *pietà* than the cries of Medea and the protestations of Antigone. It may be immobile, but it is also silent. It appears exactly like a photographed cry or the cry of a statue, that is, as a cry shown in its "dialectics at a standstill"; it is a cry that is deliberately exposed in its *image*. And that is why the documentary iconographical collections created by Bertolt Brecht assume, beyond their historical function, a heuristic aspect destined to resume a theatrical and lyrical approach to the pain of the world.

This content full of pathos is found in the plates of *Kriegsfibel*. The images actually singularize, cruelly, the suffering of wartime: in the fatigue of the workers and the prisoners reduced to slavery, in the anxiety of civilian populations, in the visible terror on the faces of the soldiers themselves, in the exhaustion of the wounded, in the glazed eyes of the children and the imploring of the women. All of this is not only put in perspective but also personified by the lyrical epigrams, as we can see in the poems below the images of lamentation (figs. 5.9 and 5.11):

O voice of sorrow from the double choir
Of gunmen and the victims of the gun!

101 R. Barthes, "Préface à *Mère Courage et ses enfants* de Bertolt Brecht," in *Œuvres complètes*, vol. 1, *1942-1961*, ed. E. Marty (Paris: Le Seuil, 2002), 1070. Cited and commented on by P. Ivernel, "L'œil de Brecht: A propos du rapport entre texte et image dans le *Journal de travail* et l'*ABC de la guerre*," in M. Vanoosthuyse, ed., *Brecht 98: Poétique et politique*, 217-31 (Montpellier: Paul Valéry University, 1999), 230-31.

The Son of Heaven needed Singapore
And no one but yourself needed your son.

I say all pity, woman, is a fraud
Unless that pity turns into red rage
Which will not rest until this ancient thorn
Is drawn at last from deep in mankind's flesh.[102]

All pity is indeed "a fraud" if it is unable to turn into "red rage." In other words, the *pathos* and the feeling of pity never suffice from the point of view of real action in its political necessity. But to say that the *pathos* must turn into and be extended as an *ethos* does not mean that it is outside the political game—quite the contrary. Nicole Loraux has shown, in the context of Greek tragedy, how the cry of the mother in mourning, however "anti-political" it may appear in its pure Dionysian manifestation, nonetheless assumed an essential function in the economy of the *polis*.[103] Is it any coincidence that the two authors who best understand the constituent role of *pathos* and even of pity in Brecht's work are two women who are very attentive to the corporeal dimension of political manifestations? In 1955 Ruth Berlau sees in Brecht's fundamental *gestus* a link between "truth, friendship [and] philanthropy": if there is pity in the author of *Mother Courage*, it is a *hard pity*, for "his love for humans or—as he prefers to say—for people, that love is not unconditional, but hard, bound with conditions; stupidity must be eradicated."[104]

Hannah Arendt recognizes that in the foundations of Brechtian lyricism—and even in his epic pedagogy—there is a very profound movement, the *gestus* of compassion:

What brought Brecht back to reality, and almost killed his poetry, was compassion. When hunger ruled, he rebelled along with those who were starving: "I am told: You eat and drink—be glad you do! But how can I eat and drink when I steal my food from the man who is hungry, and when my glass of water is needed by someone who is dying of thirst?" Compassion

102 Brecht, *War Primer*, pl. 48 [39] and 69 [59].
103 See N. Loraux, *La voix endeuillée: Essai sur la tragédie grecque* (Paris: Gallimard, 1999).
104 R. Berlau, "Introduction," in Brecht, *ABC de la guerre*, 232.

was doubtless the fiercest and most fundamental of Brecht's passions, hence the one he was most anxious to hide and also was least successful in hiding; it shines through almost every play he wrote.[105]

Compassion (*Mitleid* in German): a painful dialectics, a dialectical effect on each of the sufferings (*Leid*) of another. It is that which any political history understood as a *Leidensgeschichte* makes us confront. Even a writer of epic and didactic plays cannot escape this intimate tragedy: "The leitmotiv was the fierce temptation to be good in a world and under circumstances that make goodness impossible and self-defeating. The dramatic conflict in Brecht's plays is almost always the same: Those who, compelled by compassion, set out to change the world cannot afford to be good."[106]

Isn't compassion just an unfortunate form of political impotence or a torn consciousness, as Hegel might have said? Hannah Arendt thinks, on the contrary, that Brecht's intimate conflict brings into play a paradigm that is fundamental to any revolutionary political thinking:

> Brecht discovered by instinct what the historians of revolution have persistently failed to see: namely, that the modern revolutionists from Robespierre to Lenin were driven by the passion of compassion—*le zèle compatissant* of Robespierre [for example. As for] Marx, Engels, and Lenin, in Brecht's coded language, [they] "were the most compassionate of all men," and what distinguished them from "ignorant people" was that they knew how to "transform" the emotion of compassion into the emotion of "anger." . . . There have been many among the revolutionists who, like Brecht, acted out of compassion and concealed their compassion, under the cover of scientific theories and hardboiled rhetoric.[107]

We could say, too, that compassion transformed into anger makes us *take position*, but that too often a contradiction arises when the necessary

105　H. Arendt, "Bertolt Brecht: 1898-1956," trans. H. Zohn, in *Men in Dark Times* (London: Harvest Books, 1995), 235.

106　Ibid., 236.

107　Ibid., 236-38.

organization of anger ends up only *taking sides,* to the point of acting against any elementary goodness. For example,

> when the Party—in 1929, after Stalin, at the Sixteenth Party Congress, had announced the liquidation of the right and left opposition—began to liquidate its own members, Brecht felt what the Party needed right then was a defense of killing one's own comrades and innocent people. In *Measure Taken* he shows how and for what reasons the innocent, the good, the humane, those who are outraged at injustice and come running to help are being killed. For the measure taken is the killing of a Party member by his comrades, and the play leaves no doubt that he was the best of them, humanly speaking. Precisely because of his goodness, it turns out, he had become an obstacle to the revolution. When this play was first performed, in the early thirties, in Berlin, it aroused much indignation. Today we realize that what Brecht said in his play was only the smallest part of the terrible truth, but at the time—years before the Moscow Trials—this was not known. Those who even then were bitter opponents of Stalin, both inside and outside the Party, were outraged that Brecht had written a play defending Moscow, while the Stalinists denied vehemently that anything seen by this "intellectual" corresponded to the realities of Communism in Russia."[108]

Brecht's impossible posture—though *impossible* is what the artist and the thinker are held to—could not be better described than as above: somewhere between taking sides and taking positions. If the side-taking, the partisanship, can function as a safeguard against the pure emotions that eventually bog down political action with a tearful and impotent gaze, then taking position makes it possible to contradict the doctrinaire movement of the Party, where *pathos* no longer prevails and is no longer seen as anything but an obstacle. Such is the intrinsic limit of Brechtian distancing when frozen in dogma. Distancing is obviously necessary, but in its incessant play, in its dialectic with the proximity of *pathos*. This is what allows Jean-Marie Straub and Danièle Huillet to declare their debt to Brechtian distancing on the condition that Hölderlin and his *pathos*, his tragic lyricism, are not unilaterally forced out.[109]

108 Ibid., 240–41.
109 J.-M. Straub and D. Huillet, "Le chemin passait par Hölderlin," in *Brecht après la chute: Confessions, mémoires, analyses,* ed. W. Storch, 94–106 (Paris: L'Arche, 1993), 98–99.

In a series of texts on art and politics written between 1933 and 1938, Brecht states that emotions as such—for example, the cries of those women whose documentary images he stuck onto the white pages of his *Arbeitsjournal* or the black plates of his *Kriegsfibel*—have to be integrated into the experimental construction of any modern drama: "emotions, which are not ordered by the intelligence, must nonetheless be integrated and used as such, in their disordered state, . . . by the artist. To integrate and use them means that the intelligence makes all kinds of things of them, provisory things, experimental things."[110] What Brecht claims, then, with great relevance, is that emotion's only source and fate are not empathy with another person. We do not need to imagine that we are mothers or that we are in the streets of Singapore on December 7, 1942, or in the Russian village of Kerch on April 27, 1942, to be moved by the cries of the women in mourning documented by Brecht (figs. 5.9 and 5.11).

> The rejection of empathy is not the result of a rejection of the emotions, nor does it lead to such. The crude aesthetic that these emotions can only be stimulated by means of empathy is wrong. Nonetheless a non-Aristotelian dramaturgy has to apply a cautious criticism to the emotions that it aims at and incorporates.

It is indeed the most rational form, whether the documentary image or the didactic play, that creates the most emotional reactions.[111]

And what the dialectician must not ignore in all of this is the historical and political immanence of *pathos*, whatever it may be: "The emotions have a quite definite class basis; the form they take at any time is historical, restricted and limited in specific ways. The emotions are in no sense universally human and timeless."[112] These are the words of a materialist somewhere between Marx and Mauss—the Mauss who speaks of "obligatory expression of the feelings" in particular—but also somewhere between Nietzsche and Warburg—the Nietzsche of genealogy, the Warburg of *Pathosformeln*.

110 B. Brecht, "Art et politique," in *Écrits sur la littérature et l'art*, vol. 2, *Sur le réalisme*, trans. A. Gisselbrecht (Paris: L'Arche, 1970), 52.

111 B. Brecht, "Short Description of a New Technique of Acting That Produces a *Verfremdung* Effect," in *Brecht on Theater*, 3rd ed., ed. M. Silberman, S. Giles, and T. Kuhn (London: Bloomsbury, 2015), 194.

112 Ibid.

Memory

Emotions are therefore "historical" for Brecht—they are in no way "universal" or "timeless." But to be in history is also to be crossed through by a memory. That is why we can speak, along with Aby Warburg, of "survivals" without sacrificing to the universality and timelessness of archetypes.[113] Sigrid Weigel, for example, identifies the biblical *Pathosformeln* at work in a piece that was as "contemporary" as *Mahagonny* could be.[114] This speaks against any notion of the "modernist decadence" of epic and allegorical literary genres.[115] The Russian woman with her arms open in the shape of a cross in front of the corpse of her son riddled with bullets (fig. 5.11) is crossed through, consciously or not, by the gestural, cultural, or cult memory of the *Pietà*, whether the rite was Catholic or Orthodox. This is so true that the man who keeps her from collapsing—her husband, according to the factual caption under the photograph—assumes exactly the same gestural role as the masculine figures in the iconography of the Passion, as well as the rituals of lamentation.[116]

It is because it is crossed through by memory—and itself a vehicle of memory—that the photographic image allows here, by means of the supplementary trick of the epigram that underlines its virtual antiquity, an epic, allegorical, and lyrical function, as though transgressing its immediate nature as a document of history. We can say that the temporal complexity and plasticity of the photographic medium—well beyond, therefore, Barthes's famous "*ça a été*"—are found to be constitutionally capable of such crossing through or transpiring of memory in history. Hence the possibility of *documentary lyricism* inherent in the most notable literary uses of photography, from Georges Rodenbach's *Bruges-la-Morte* to W. G. Sebald's

113 See G. Didi-Huberman, *The Surviving Image: Phantoms of Time and Time of Phantoms; Aby Warburg's History of Art*, trans. H. Mendelsohn (University Park: Penn State University Press, 2017).

114 S. Ziegel, "'Gott in *Mahagonny*': Walter Benjamin liest Brecht," *Das Brecht-Jahrbuch* 29 (2004): 253–67.

115 As we see, for example, in M. Murrin, *The Allegorical Epic: Essays in Its Rise and Decline* (Chicago: University of Chicago Press, 1980), 173–96.

116 See E. De Martino, *Morte e pianto rituale: Dal lamento fúnebre antico al pianto di Maria* (1958) (Turin: Boringhieri, 1977); G. Didi-Huberman, *Ninfa dolorosa: Essai sur la mémoire des gestes* (forthcoming).

Austerlitz, including Breton's *Nadja* and Georges Bataille's *Documents*.[117] Even the purely photographic documentation by Walker Evans of American misery in the 1930s was quickly understood—in 1938 by Thomas Mabry, then executive director of the Museum of Modern Art in New York—and, finally, taken on by its own author, as a genuine "documentary lyricism."[118]

The profound necessity for documentary lyricism is found in attempts to not leave silent the extraordinary in history, that which so many photographic "reports" return to us daily. The extraordinary in history—that is to say, images of its unimaginable events—leaves us speechless as long as we remain powerless, unable to speak up in front of it. *Kriegsfibel* informs us that it is not enough to stick a caption chosen by the photographer or the newsmagazine, or the archival centre from which it came, under an image of history. Every image of history needs not only an inscription—as Walter Benjamin insists vigorously in his essay on photography[119]—but a *dialectized* inscription, one that is more or less redoubled. Lyricism gives a name, perhaps, to this polyphony.

It is not enough to remark that modern history no longer exists without the documentary value—or both "realist" and "formative" value, as Siegfried Kracauer says[120]—of the medium of photography. It is necessary to address the stylistic and political questions of understanding what words might be capable of responding to the new visibility of historical events. What words might constitute the extraordinary in history as recountable, transmissible,

117 See D. Grojnowski, *Photographie et langage: Fictions, illustrations, informations, visions, théories* (Paris: José Corti, 2002), 91–176, and "Le roman illustré par la photographie," in *Texte/image: Nouveaux problèmes*, ed. L. Louvel and H. Scepi, 171–84 (Rennes: Presses Universitaires de Rennes, 2005); J. Thélôt, *Les inventions littéraires de la photographie* (Paris: PUF, 2003). On W. G. Sebald, see M. Pic, "Les yeux écarquillés: W. G. Sebald face à la polémique du souvenir," *Critique* 703 (2005): 938–50, and "Image-papillon et ralenti: W. G. Sebald ou le regard capturé," *Infra-Mince* 2 (2006): 90–104.

118 See O. Lugon, *Le style documentaire: D'August Sander à Walker Evans, 1920–1945* (Paris: Macula, 2001), 74–100; J. T. Hill, "Comments on Walker Evans' Lecture 'Lyric Documentary—My Aesthetic Autobiography,'" in *Walker Evans: Lyric Documentary* (Göttingen: Steidl, 2006), 12–26.

119 W. Benjamin, "Little History of Photography," in *Selected Writings*, vol. 2, 527: "This is where inscription must come into play, which includes the photography of literarization of the conditions of life, and without which all photographic construction must remain arrested in the approximate."

120 S. Kracauer, *History: The Last Things Before the Last* (1966), completed by P. O. Kristeller (Princeton, NJ: Markus Wiener, 1995).

memorial experiences? Walter Benjamin poses the problem in "Experience and Poverty" by musing about the fact that in 1918, "people returned from the front in silence."[121]

It is no small matter that such a radically "modern" author, as Brecht was in the thirties, should have chosen at the beginning of the war the ancient form of the epigram so as not to be silent in horror in front of the world *Leidensgeschichte*, and in order to dialectize—lyrically—the inscriptions of photographs collected from the newspapers. It is no small matter either that the poet René Char, during the most dangerous moments of his military operations in the Resistance, brought together (documented) acts and (lyrical) poems in collections titled *Pauvreté et privilege* and—the most famous—*Feuillets d'Hypnos*.[122] "Some days one must be afraid to give names to things that are impossible to describe";[123] that is to say, to raise the imagination of language to a level where "man is capable of doing what he is incapable of imagining."[124] The same can be said, no doubt, for poetry and for any words: their use-value includes the worst and the best, the act of *speaking in order to say nothing* (the fleeting, frivolous, decorative side of lyricism), but also that of *having the courage to name* (the confronted, vital, political side of lyricism). This courage to name is that of confronting the real as an image—like Perseus, who confronted the Gorgon Medusa by using his reflective shield—that is also to say, to confront the present as a memory.[125]

And this is how poets revisit and reassemble, rather than tell, history. They swim against the current of history—without denying its immanence, without drifting away, without walking on the banks—then rearrange everything to suit their own reminiscent montages. They invent, in this way, an *art of memory* that is neither commemoration subservient to official discourses nor the misanthropic distancing of the ivory-tower artist. Such is, undoubtedly, the distance that Brecht sought in the epic style that appears in each of his literary productions, whether his works of theory, his plays,

121 W. Benjamin, "Experience and Poverty," in *Selected Writings*, vol. 2, 731.

122 R. Char, *Pauvreté et privilège* (1941–79), in *Œuvres complètes*, ed. J. Roudaut (Paris: Gallimard, 1995), 627–70, and *Feuillets d'Hypnos* (1943–44), ibid., 171–233.

123 Char, *Pauvreté et privilège*, 631.

124 Char, *Feuillet d'Hypnos*, 230.

125 Ibid., 178 ("Le temps vu à travers l'image").

or his poems. Furthermore, the iconographic montages—iconopoetic, we might say—of the *Arbeitsjournal* and *Kriegsfibel* can be likened to actual epic stagings of visual material taken from the Second World War. The avant-gardist analysis of Brechtian epic style by Walter Benjamin should be completed by a more retrospective viewpoint on the *Vorgeschichte* of this style.

The epic is not an autonomous poetic genre in Brecht, but rather a fundamental tone in his style of writing. The canonical separation of the three genres of poetry—lyrical, epic, and tragic—as Hölderlin, among others, explains,[126] did not interest him particularly. Yet given the poet's remarks on the naive appearance of the *epos*, its "visible, sensuous unity" tied to the real, its way of making sure that "surrounding objects appear from this standpoint with that same exactitude,"[127] all these aspects probably directed Brecht's syntactic choices as well as his iconographic arrangements (figs. 2.10 and 3.1). As though, in the epic language itself, to *name* and to *place before the eyes* are players in the same poetic gesture. "Epic language represents," writes Emil Staiger. "It makes signs towards something. It shows. . . . Consequently, the epic is akin to plastic arts."[128]

But this does not mean to say that placing before the eyes is equivalent, in this context, to placing in the present. The epic indeed seeks something from the image, but we should not fall into the trap of imitation, and we should remember that the image itself is never in the present. The remarks of Gilles Deleuze prove valuable here:

> It seems obvious to me that the image is not in the present. . . . The image itself is a bunch of temporal relations from which the present unfolds, either as a common multiplier, or a common denominator. Temporal relations are never seen in ordinary perception, but they can be seen in the image, provided the image is creative. The image renders visible, and creative, the temporal relations which cannot be reduced to the present.[129]

126 F. Hölderlin, "On the Different Modes of Poetic Composition," in *Essays and Letters*, ed. J. Adler and C. Louth (London: Penguin, 2009), 254.

127 Ibid., 256–57.

128 E. Staiger, *Les concepts fondamentaux de la poétique* (1946), trans. R. Célis, M. Gennart, and R. Jongen (Brussels: Lebeer-Hossmann, 1990), 73, 79.

129 G. Deleuze, "The Brain Is the Screen," in *Two Regimes of Madness: Texts and Interviews, 1975–1995*, rev. ed., trans. A. Hodges and M. Taormina (New York: Semiotext(e), 2007), 295.

If, on the other hand, the poem's function is to avoid leaving silent what first left us silent in front of history, if the poem is that *speech in spite of all* that the writer seeks to extricate from experience, then we must understand the complexity, the anachrony, the heterogeneity—in short, the construction of time required by such a speech.

In his magisterial study of the Greek verbal system—included in a book titled *Aîtres de la langue et demeures de la pensée*, which could just as easily have been called "Being and Language," like Heidegger's *Being and Time*—Henri Maldiney precisely characterizes the temporal mode of epic poetry in ancient Greece: it has to do, he says, with the verbal time called *aorist*. In treatises on the grammar of Indo-European languages, we read that "the present indicated a proceeding considered in its development [while] the aorist indicated a pure proceeding, excluding any consideration of duration,"[130] a little like our own use of the imperfect tense when we recount our dreams ("I was walking along endlessly, and then the ground was opening in front of me . . ."). "Pure proceedings": this means only procedures exposed in their *becoming*, not in their chronology. This also means that memory is "placed before our eyes" as independent of a subject that would be the owner or manipulator of its recalling: "The aorist . . . shows a certain and remarkable independence regarding the present of the speaker. . . . The action rises in itself and its absolute emergence is the event of a time . . . that does not stop occurring . . . , always at incidence."[131] As, in Brecht's work, Pope Pius XII's raised arms and, on the contrary, those of the woman collapsing in Kerch (figs 3.2 and 5.11).

The incidence of memory—which can be its raising or its crossing, but also its accident, its sudden fall, its symptom—requires the shock of images, the discontinuity of times, the dispersion of language (which Maurice Blanchot considers the primary matter of all poetry). That is why Homer promoted the spoken word as *epos* and not as *logos*: "Every verb that is part of the vocabulary of speech appears in the *Iliad* and the *Odyssey*—except

130 A. Meillet and J. Vendryes, *Traité de grammaire comparée des langues classiques* (Paris: Librairie ancienne Honoré Champion, 1927), 167.

131 H. Maldiney, *Aîtres de la langue et demeures de la pensée* (Lausanne: L'Age d'homme, 1975), 83.

legein. . . . These different dimensions [of speech] come together in *epein*," writes Henri Maldiney.[132] Where *logos* promotes the noun as a simple part of discourse, *epos* makes it rise in intensity as a "center of language"; where the principle of the unveiling of *logos* is found in dialectics—in Plato's sense of the term—the unveiling of *epos* is found in reminiscence; where *logos* manipulates its elements like signs, *epos* constructs them as forms in perpetual formation.[133] And this is why the speech act in the epic narrative is inseparable from the "make-image" (*Bilden*), the "make-poem"—that *Dichten* "which points to the eminent act of the poet [in the] sense of creating by compressing"[134]—and the "make-think" (*Denken*).

Everything in this incidence of memory refers to aorist time, when an action is "experienced, enunciated, and thought as a happening action, as absolute emergence whose event is pure incidence."[135] Gustave Guillaume, whose work inspired Henri Maldiney, describes the aorist as "an act that is developed *in the past* in the form of a *happening* thing."[136] It is a temporal paradox, even an anachronism—as opposed to the perfect tense as action that is developed in the past in the form of a *happened* thing—which explains both the strangeness, the uncanniness, and the intensity, the "over-actualization," as Guillaume describes it,[137] of images taken from any epic reminiscence. Here *epos* contrasts with *chronos* as well as *logos*: it liberates a narrative "whose diachrony is not chronothetic (separating eras) but essentially aspectual."[138] Here the past is presented outside of the present, outside of *presence* as well as chronological, contemporary history, but also outside mere actuality as well as teleology, in an enigmatic "there is" that juxtaposes its heterogeneous elements as though on a montage table, or in a free association that swirls around an inaccessible knot of *real*—the eye of history, like the eye of the hurricane.

132 Ibid., 145–46.
133 Ibid., 149, 152, 155.
134 Ibid., 153.
135 Ibid., 83.
136 G. Guillaume, *Temps et verbe: Théorie des aspects, des modes et des temps* (Paris: Librairie ancienne Honoré Champion, 1929; repr., 1984), 93 [emphasis added].
137 Ibid., 92–93.
138 Maldiney, *Aîtres de la langue*, 146.

That is why *epos* is memory in action, gathering of the origin (*arche*) as opposed to determination of the cause (*aitia*).[139] In *epos*, the "having been" is not left in the background and it has not really passed, nor has it passed away, and it is certainly not "no longer being." It persists. It *survives*, it persists in the dimension of the *memorable as having seen*:

> Epic temporality is that past-present which is called *the memorable*. An-historic, a-chronic with regard to chrono-genesis, it does not precede the present, but rather is absolutely contemporary with it according to a vertical rather than a horizontal order of time. . . . *Epos* brings to light what is latent, hidden, and what is buried in the unconscious of a people under the sort of incomplete pre-language made up of misunderstood nouns and gestures, epithets and myths floating between the sky and the earth, unexplainable alliances and interdictions, magical limits, "signs deprived of meaning" . . . as Hölderlin said—and, unsurprisingly, in *Mnemosyne*. [Thus] *epos* is ana-chronic: it revisits the *time implicated* in the diachronic distribution of the constructed states of human language.[140]

It was with the help of the Freudian notion of *Darstellbarkeit*—a theatrical word if ever there was one, since it indicates the "presentability" of a word on stage as much as the "figurability" of a body in speech—that Pierre Fédida returns to this analysis in order to deploy its meta-psychological fecundity. *Mnemosyne* is at the psychological crossing of the image and the word, as Warburg shows us, and this crossing could be called *Darstellbarkeit*. *Epos* would then refer to that "reminiscent present" that, being reminiscent, overshoots any chronological separation between past and present, but also any possibility of removing images from words or words from images. In *epos*, writes Fédida, the image is not seen but is rather "seeing, visually made to see clearly the memorable in words and language. The clairvoyance of the image is the time of its memorability. *The image has seen*."[141] We understand

139 Ibid., 148.
140 Ibid., 148–49, 152.
141 P. Fédida, "Passé anachronique et présent reminiscent: *Epos* et puissance mémorial du langage," *L'écrit du temps* 10 (1985), 27.

then that it is the image as such that is deployed in aorist time.[142] We understand that memory visualizes here only in order to name, and names only in order to better reach the image: "The interest of *naming* and of the name is precisely that of removing the word from any category of representation and of making it contain both the *dynamis* and the *energeia* of the image, insofar as the image is sensorially—aesthetically—reminiscent of the thing."[143]

Is this not exactly what animates the epic tone of Brecht's words, between poetry and photography, between the written and the stage, between the simplicity of the object shown and the complexity of the montage of objects (figs. 2.7–2.10 and 3.1)? Is there not at the same time in Brecht this will to give back to language its imagination (as we can see clearly in the montages in the *Arbeitsjournal*), but also to give back to images their (poetic) speech, their capacity for political address and invocation (as we see in every plate of *Kriegsfibel*)? Can we not see here the double necessity—a psychological and a scenic necessity, a necessity specific to the *Darstellung*—of the montages of photographs created by Brecht outside of his poems and plays, which, in this period of exile and war, could not be presented on a visible stage?

Lyricism

Bertolt Brecht, as we have seen, was not immune to contradictions. "I've never been able to endure anything but contradiction," he says somewhere.[144] Written by him, this sentence means first that there is only a confronted writing of art and thinking in general. As a poet in wartime, Brecht was also a poet at war. Lyricism made no sense for him except for introducing protest, contradiction, confrontation, and conflict. In particular, it was to introduce history into aesthetic emotion, memory into

142 Ibid., 34.
143 Ibid., 39-40. See also P. Fédida, *Le site de l'étranger: La situation psychanalytique* (Paris: PUF, 1995), 81-92.
144 B. Brecht, "Notes sur le travail littéraire," in *Écrits sur la littérature et l'art*, vol. 3, *Les arts et la révolution*, trans. B. Lortholary (Paris: L'Arche, 1970), 41.

recent history, revolutionary desire into memory itself. But contradiction is everywhere; it multiplies and spreads to every order of magnitude and to the very heart of writing itself, even of the political project that it wishes to express. Perhaps confronted writing should appear as a writing of partisanship, enunciated in a firm, simple, and shareable form? But this is not the case at all. As a poet, Brecht knew very well that confronted writing exists only by producing open forms, forms in which the questioning outlives the affirmation and the exclamation: "Poems become flat, empty, bland, when they remove the contradictions from the subject, when the things they speak of are not presented in their living form, that is to say as multiple, not definitive, excluding any definitive formulation."[145]

Brecht called upon a *critical lyricism*—"the critical stance is the only productive one," he says in the same pages, "the only one worthy stance for a man Without a critical stance, real artistic pleasure is impossible"[146]—which suggests, of course, the demand for an internal confrontation of lyricism as effusion, empathy, emotion, with itself. Brecht no doubt dreamed of a possible Hegelian overshooting of contradiction, particularly when he formulated (lyrically) the project of implementing a real *logical lyricism*: "If the lyrical design is a happy one, feeling and reasons work fully with it, and it is they that shout at one another in elation: you decide."[147] There is even a *revolutionary lyricism* that Brecht not only hoped for but also verified upon examining photographs of the Russian Revolution, as though material history had been, at one point, invested with an irresistible poetic force:

The photographs of the Russian revolution, not only those of 1917, but also those of 1905, show a curious literarization of the street. The towns and even the villages are dotted with formulae as well as symbols. The class that seizes power writes, with powerful strokes, its opinions and its watchwords on the buildings that it seized. On the churches it writes: "Religion is the opium of the people"; on other buildings instructions for how to use them

145 Ibid., 19.
146 Ibid., 18.
147 Ibid., 17.

are sprawled. In demonstrations, placards covered in writing are carried; at night, films are projected onto the walls of houses. This literarization has entered into the values of the Soviet Union. From one end of the year to the other, the demonstrations, be they regular or exceptional, have established a tradition. The working masses showed an unusual sense of forms in the choice of their emblems. During the great demonstration of May 1, 1935, I saw beautiful emblems belonging to textile manufacturers (in white wool), little flags with a new shape floating gently in the wind, and, on transparencies, fanciful portraits of political adversaries and numerous slogans, making it possible to see at the same time several of these portraits and slogans. Professional lyricism, in the Soviet Union, did not keep the same pace as this art of the masses.[148]

Is there not a harsh contradiction between this revolutionary lyricism, on the one hand—and it in turn is stretched between traditional lyrical images, such as the sheets "floating gently in the wind," and the avant-garde images, such as the projections of films on the walls of houses—and, on the other hand, the "professional lyricism" of socialist realism? Is there not a cruel contradiction between the poetic "literarization" of the street that Brecht speaks of and the showcasing of watchwords and slogans? Just how far does lyricism allow contradiction without disappearing as such? To speak of "professional lyricism" surely amounts to speaking of a dead lyricism. Was Brecht himself not a "professional lyricist"? Did not the musician Paul Dessau include in his great *Deutsches Miserere* some twenty lyrical arrangements of quatrains from *Kriegsfibel*?[149] It is necessary, therefore, facing these difficulties, to remember that *epos* cannot be fully subject to the laws of *logos*; an internal contradiction in the poetic narrative does not have the same status as an internal contradiction in a logical statement. Where doctrine is blocked, images eventually become free. Where the philosopher's dialectic is exhausted, the dialectic

148 Ibid., 11–12.
149 See F. Hennenberg, *Dessau-Brecht: Musikalische Arbeiten* (Berlin: Henschelverlag, 1963), 471–72. See also the recent recording titled *Kriegsfibel* (Berlin: Polyphenia, 2003), sung by Kathrin Angerer, based on the photo-epigrammatic texts by Brecht and the musical compositions of Hanns Eisler.

of the lyrical montage-maker can begin.[150] Where the side-taking becomes bogged down, the positions can branch off and proliferate.

These branchings—at work everywhere where Brecht becomes interesting to us—are neither hesitations regarding form nor renunciations of content. Where the doctrinaire sees a dead end, a block, the poet enables himself to open a way and to create a rhythm. And that is it: the positions are taken only by taking the rhythm. And again, everything is accomplished by going through a memory, notably that of Hölderlin's finding in the Greeks, the situation of the Enlightenment; that is to say, the question of "human reason passing through the midst of the unthinkable," as he writes in his "Notes on the *Antigone*."[151] We know, first of all, that Hölderlin claims the political wisdom of Sophocles in the "republican" confrontation—as he says in reference to the French Revolution—between the characters of Creon and Antigone;[152] and that, second, he formulated the principle of rhythmic transgression proper to any poetic language in the process of caesura—"interruption" giving a kind of "pure speech" torn from the world of conceptual representation.[153]

This clearly marks once more the distinction between taking position and taking sides. The latter has a speculative certainty about it capable of stopping the question and commanding the action, while the former implements the "caesura of the speculative," whose fundamental stakes (poetic, philosophical, and political) in Hölderlin were clarified by Philippe Lacoue-Labarthe.[154] Philippe Marty carefully analyzes the poetic work of caesura in Bertolt Brecht—cuts in the lines, cut-outs in the motifs, reframing, re-montage—and what is interesting in such an analysis, beyond its prosodic technicity, appears where the poetic and

150 On the relationship between lyrics and dialectics in Brecht, see C. Bohnert, *Brechts Lyrik im Kontext: Zyklen und Exil* (Königsberg: Athenäum, 1982), 35–41.

151 F. Hölderlin, *"Notes on the* Antigone," in *Essays and Letters*, 327.

152 Ibid., 332.

153 Ibid., 325–27.

154 See P. Lacoue-Labarthe, "La césure du spéculatif," in F. Hölderlin, *L'Antigone de Sophocle*, trans. P. Lacoue-Labarthe (Paris: Christian Bourgois, 1978), 183–223; repr. in *L'imitation des Modernes: Typographies II* (Paris: Galilée, 1986), 39–69. The two sides, the poetic and the political, of this analysis are examined further in P. Lacoue-Labarthe, *Métaphrasis, suivi de: Le théâtre de Hölderlin* (Paris: PUF, 1998) and *Poétique de l'histoire* (Paris: Galilée, 2002).

political registers work together. We understand then why a war poem had to be, at the height of the references to Horace and Hölderlin, a poem of the sound shock, the historical cut, the counter-rejection and the apostrophe . . .[155]

> Out of the libraries
> Emerge the butchers.
> Pressing their children closer
> Mothers stand and humbly search
> The skies for the inventions of learned men.
> [. . .]
> Fog envelops
> The road
> The poplars
> The farms and
> The artillery.[156]

What Brecht demands of lyricism, moreover, is not that it be rhymed harmoniously but rather that it be intensely rhythmed. Rhythm in this instance means neither the beat nor regularity. Brecht demands rather that rhythm itself be "shifting, syncopated, gestic," as we read in his short theoretical essay on "rhymeless verse with irregular rhythms":

> Many of my most recent works in verse have had neither rhyme nor any regular solid rhythm. The reason I give for labelling them verse is that they display a kind of (shifting, syncopated, gestic) rhythm, even if not a regular one. . . . The problem was simple: I needed elevated language, but was quite put off by the oily smoothness of the usual five-foot iambic metre. I needed rhythm, but not the usual jingle. [Using caesuras] gave the jerky breath of a man running and such syncopation did more to show the speaker's conflicting feelings. [So] there I gave up iambics entirely and applied strong but irregular rhythms.[157]

155 See P. Marty, "Brecht: La coupe du vers; Mètre et dialectique," in Vanoosthuyse, *Brecht 98*, 157–76.

156 B. Brecht, "1940," in *Poems, 1913–1956*, 347.

157 B. Brecht, "On Rhymeless Verse with Irregular Rhythms," in *Brecht on Theatre*, 170–71.

This war lyricism—we should note that these lines were written in 1939, in exile, and might be considered a manifesto for the poems in *Kriegsfibel*—consists in going back through, reviewing, revisiting, reassembling history: going back through in the sense of swimming back up the river against the current of current political history; rearranging or reassembling all things by working on the divides in time, by deconstructing them like a filmmaker who constructs a plot by rearranging the rushes. This requires inventing rhythms, writing by constant cuts and re-montages, but it also requires seeing history unwind differently from a factual chronicle with a meaning or even a *telos*.

War cannot, in the poet's view, be the "reason in history." It is "literally 'meaningless,'" writes Brecht in his *Journals*, but it is in this way that it "displays a remarkably epic character" by giving us its painful and paradoxical lesson: "it teaches mankind about itself as it were, reads a lesson, a text to which the thunder of gunfire and the exploding bombs merely provide the accompaniment."[158] We should not be surprised that, in this context, Brecht was struck in 1940 by the fact that "speed has become a new characteristic in warfare. the german blitzkrieg has nullified all calculations, in that preconceived moves are implemented with such speed that their consequences are unforeseen," literally dismantling the constructions of any deterministic history.[159] In other words, war either devours and dazes us or makes us children, if it is true that childhood is the time when we are stirred by both fear and play in the same movement.

158 Brecht, *Journals*, 38.
159 Ibid., 57.

VI

The Position of the Child

Being Exposed to Images

Pedagogy

The most moving aspect of *Kriegsfibel* is fully indicated in its title—a title in the form of a montage. It joins the term for the worst thing, *Krieg* ("war"), to a word that initially addresses children: *Fibel* ("primer"). Just as Bertolt Brecht was able to compose songs, his calendar stories (*Kalendergeschichten*), and, in the midst of a world war, his children's songs,[1] here he works to offer to future generations—or to the souls of his contemporaries' children, if still possible—a book of images that is yet in no way innocent. In the economy of its illustrated plates, it is a book in which the worst can be leafed through from A to Z, that is to say, from Hitler back to Hitler, through the pain of so many mothers whose children were killed by fascism (fig. 5.11).

As soon as the project of "poetic documentation" of the war came to light in Brecht's mind—from the depths of his exile and as the German army was taking hold of Europe with terrifying rapidity—the question arose of imagining what such an enterprise was capable of transmitting to future generations. In wartime the same applies both to pedagogy and to poetry: one wonders inevitably what purpose and for whom all this can serve. Is it not both laughable and desperate to learn history or to recite poems while urgency holds minds in its grasp, while the future is compromised, when bodies are in the grip of hunger, and when one must be ready at every moment to pack one's belongings and leave before the

1 B. Brecht, *Liederbuch*, ed. F. Hennenberg (Frankfurt: Suhrkamp, 1984). See also the children's song "Alphabet," in B. Brecht, *Bertolt Brecht: Poems, 1913-1956*, ed. J. Willett and R. Mannheim (London: Methuen, 1987), 239.

menacing enemy invades? It was as a father and a pedagogue that Brecht initially posed the question:

> My young son asks me: Should I learn mathematics?
> What for, I'm inclined to say. That two bits of bread are more than one
> You'll notice anyway.
> My young son asks me: Should I learn French?
> What for, I'm inclined to say. That empire is going under.
> Just rub your hand across your belly and groan
> And you'll be understood alright.
> My young son asks me: Should I learn history?
> What for, I'm inclined to say. Learn to stick your head in the ground
> Then maybe you'll come through.
> Yes, learn mathematics, I tell him
> Learn French, learn history![2]

Kriegsfibel can be leafed through as a book of historical images, but it can also be read as a collection of lyrical poems, some very easy to understand, others more enigmatic. For Brecht, poetry is linked with pedagogy, first of all because its material can in no way be reduced to the egoistic *I* of the Romantic but rather has to find its source in the historical and politic *we*; second, because its very expression has no other purpose than to open up to the social world, to come to fruition through a process of *transmission*. Why, for example, does Brecht make the formal choice of a "rhymeless lyricism with irregular rhythms"? Because regular rhymes and rhythms, in his mind, create a sort of poetic hypnosis, a "dreamlike state" in which everything is closed in on itself and nothing offers itself; everything is felt but nothing is learned. "If we wanted to think," writes Brecht regarding his poetic choices,

> we would first have needed to tear ourselves away from a state of mind that leveled, blurred, and integrated all things. With the irregular rhythms, ideas adopted more easily their corresponding emotional forms. In so doing, I did not have the

2 B. Brecht, "1940," in *Poems, 1913-1956*, 348.

VI

The Position of the Child

Being Exposed to Images

Pedagogy

The most moving aspect of *Kriegsfibel* is fully indicated in its title—a title in the form of a montage. It joins the term for the worst thing, *Krieg* ("war"), to a word that initially addresses children: *Fibel* ("primer"). Just as Bertolt Brecht was able to compose songs, his calendar stories (*Kalendergeschichten*), and, in the midst of a world war, his children's songs,[1] here he works to offer to future generations—or to the souls of his contemporaries' children, if still possible—a book of images that is yet in no way innocent. In the economy of its illustrated plates, it is a book in which the worst can be leafed through from A to Z, that is to say, from Hitler back to Hitler, through the pain of so many mothers whose children were killed by fascism (fig. 5.11).

As soon as the project of "poetic documentation" of the war came to light in Brecht's mind—from the depths of his exile and as the German army was taking hold of Europe with terrifying rapidity—the question arose of imagining what such an enterprise was capable of transmitting to future generations. In wartime the same applies both to pedagogy and to poetry: one wonders inevitably what purpose and for whom all this can serve. Is it not both laughable and desperate to learn history or to recite poems while urgency holds minds in its grasp, while the future is compromised, when bodies are in the grip of hunger, and when one must be ready at every moment to pack one's belongings and leave before the

1 B. Brecht, *Liederbuch*, ed. F. Hennenberg (Frankfurt: Suhrkamp, 1984). See also the children's song "Alphabet," in B. Brecht, *Bertolt Brecht: Poems, 1913–1956*, ed. J. Willett and R. Mannheim (London: Methuen, 1987), 239.

menacing enemy invades? It was as a father and a pedagogue that Brecht initially posed the question:

My young son asks me: Should I learn mathematics?
What for, I'm inclined to say. That two bits of bread are more than one
You'll notice anyway.
My young son asks me: Should I learn French?
What for, I'm inclined to say. That empire is going under.
Just rub your hand across your belly and groan
And you'll be understood alright.
My young son asks me: Should I learn history?
What for, I'm inclined to say. Learn to stick your head in the ground
Then maybe you'll come through.
Yes, learn mathematics, I tell him
Learn French, learn history![2]

Kriegsfibel can be leafed through as a book of historical images, but it can also be read as a collection of lyrical poems, some very easy to understand, others more enigmatic. For Brecht, poetry is linked with pedagogy, first of all because its material can in no way be reduced to the egoistic *I* of the Romantic but rather has to find its source in the historical and politic *we*; second, because its very expression has no other purpose than to open up to the social world, to come to fruition through a process of *transmission*. Why, for example, does Brecht make the formal choice of a "rhymeless lyricism with irregular rhythms"? Because regular rhymes and rhythms, in his mind, create a sort of poetic hypnosis, a "dreamlike state" in which everything is closed in on itself and nothing offers itself; everything is felt but nothing is learned. "If we wanted to think," writes Brecht regarding his poetic choices,

we would first have needed to tear ourselves away from a state of mind that leveled, blurred, and integrated all things. With the irregular rhythms, ideas adopted more easily their corresponding emotional forms. In so doing, I did not have the

2 B. Brecht, "1940," in *Poems, 1913-1956*, 348.

impression that I was distancing myself from lyricism [because,] for certain social functions of lyrical poetry, we could become engaged in new directions.[3]

Poetry, according to Brecht, therefore transmits emotions to make one think, or even to make one act, rather than to make one dream, or sleep, or fold in on oneself outside of the historical world. Poetry, for this, has to renounce the "usual jingle" in order to awaken its reader, as we awaken a child by opening the child up to the world and by teaching that child something. This would be a first pedagogical task. In other words, this would be its political content, given that children, because they embody the future, are in fact the stakes of all conflicts and all historical transformations. What Brecht's poems (and plays, of course) seek to respond to politically is in fact an adverse pedagogy, the "pedagogy of death" by which fascism can be summarized and of which the poet in exile (along with Fritz Lang) sadly recognizes the philosophical source:

6 jan 42

lang disconsolately shows me a book by an american educationalist on the education of young people in nazi germany ("education for death"). it turns out to be the wildest aberration of german idealism. everything that is done derives from the "spirit." by the rules of the old school, according to which the spirit cannot perish, this bunkum could go on for 1000 years [but] terrible as it is that children are being perverted like this by the million, the practical effect will be nil. this is another germ that can only survive in the medium it was raised in.[4]

Could we thus make the pedagogy of war—the pedagogy of death—fail? Brecht's relative optimism is founded here on the inanity of the "social foundations" of everything that the Nazi doctrine proposed, that usurpation of the word *socialism*. Nonetheless, five months later in his *Journals* and in the context of a discussion with Herbert Kline, a documentary film director, Bertolt Brecht recognizes the power of subjugation of Nazism, which he characterizes as a power squared, so to speak: "fascism is a form of government

3 B. Brecht, "Notes sur le travail littéraire," in *Écrits sur la littérature et l'art*, vol. 3, *Les arts et la révolution*, trans. B. Lortholary (Paris: L'Arche, 1970), 30–31.

4 B. Brecht, *Journals, 1934–1955*, trans. H. Rorrison (New York: Routledge, 1996), 187.

Figure 6.1
Kurt Tucholsky and John
Heartfield, *Deutschland,
Deutschland über alles*,
1929, p. 219.

which enables peoples to be subjugated to such an extent that they can be misused or subjugate other peoples."[5] Elsewhere in the *Journals*—more precisely, a few lines away from the images showing Hitler giving a speech in the posture of a "pedagogue" of the people (fig. 5.5)—Brecht recognizes again that the Germans of his time are "guilty of servility."[6]

Pedagogy is apparently the art of forging the souls of our children, the art of developing their knowledge, their discourses, their values, and their very feelings. It is therefore, inevitably, a battlefield in which powers of subjugation and powers of liberation are constantly in conflict. Although it was published in 1955, *Kriegsfibel* carries the profound marks of attempts that had preceded it since the end of the First World War. In his political pamphlet from 1929, "photo-mounted" by John Heartfield, for example, Kurt Tucholsky arranges for his reader the terrible impression of a group of children rushing joyously towards . . . the bottom of a trench in which their future adult takes on the appearance of a future soldier devoted solely to a future as a cadaver (fig. 6.1).[7] In 1924 Ernst Friedrich devotes the entire beginning of his photographic atlas *Krieg dem Kriege!* to the question of children subjected to the pedagogies of war in order—via "military toys" and the exaltation of nationalistic values—to enlist them and therefore to subjugate them to the point of turning them into cannon fodder (fig. 6.2).[8] It is important to remember that in front of these pacifistic demonstrations stood, firm in its militarist ideals, the culture of war exalted by Ernst Jünger, among others, to whom, in fact, Walter Benjamin immediately gave the most scathing and just reply.[9]

5 Ibid., 241.

6 Ibid., 293.

7 K. Tucholsky and J. Heartfield, *Deutschland, Deutschland über alles* (Hamburg: Rowohlt, 1973), 219.

8 E. Friedrich, *Krieg dem Kriege!* (Berlin: Freie Jungend, 1924; repr., Munich: Deutsche-Verlag-Anstalt, 2004), 37–51.

9 E. Jünger, ed., *Krieg und Krieger* (Berlin: Junker and Dünnhaupt, 1930) and *Das Antlitz des Weltkrieges: Fronterlebnisse deutscher Soldaten* (Berlin: Neufeld and Henius, 1930). For his critique of these military texts, see W. Benjamin, "Theories of German Fascism: On the Collection of Essays *War and Warriors*, Edited by Ernst Jünger," in *Selected Writings*, vol. 2, *1927–1934*, ed. M. W. Jennings, H. Eiland, and G. Smith (Cambridge, MA: Harvard University Press, 1999), 312–21. For a translation of some of these theses, see O. Lugon, ed., *La Photographie en Allemagne: Anthologie de textes, 1919–1939* (Nîmes: Jacqueline Chambon, 1997), 20–29 (Ernst Friedrich, Kurt Tucholsky, Ernst Jünger), 321–26 (Paul

Figure 6.2
Ernst Friedrich, *Krieg dem Kriege!*, 1924, p. 38: "Don't give such toys to children anymore."

Pedagogy? The art of "learning to see depths where there are commonplaces," as Karl Kraus puts it.[10] It is to learn to see everything from the perspective of conflict, transformation, the gap, and the alteration. It is also, in Brecht's view, the art of transforming and of multiplying one's own means to know something of the world and to act upon it—even if it only has to do with learning the ABCs:

Comrades, your work was successful.
You've helped to disseminate
Marxism's teachings and the
ABC of Communism—
For the ignorant . . .
[If] our world is to be altered:
Rage and stubbornness, knowledge and rebellion
Quick reactions, profound meditation
Icy patience, endless repetition
Awareness of little things and awareness of big ones:
Only studying reality's going to
Help us alter reality.[11]

But when *Kriegsfibel* appeared in 1955, the times had changed. The photomontage of the demonstration made way in the socialist regime for the photomontage of glorification. Russian constructivism, the art of position-taking, disappeared behind Stalinist images and a unilateral taking of sides.[12] The state of "peace" being that of the Cold War, the illustrated

Groblelen, Hans Ammann). On the writing and the iconography of the war in Ernst Jünger, see J. King, "Wann hat dieser Scheisskrieg ein Ende?" Writing and Rewriting the First World War, (Schnellroda: Antaios, 2003); M. Vanoosthuyse, *Fascisme et littérature pure: La fabrique d'Ernst Jünger* (Marseille: Agone, 2005); M. Guerri, *Ernst Jünger: Terrore e libertà* (Milan: Agencia X, 2007). On the motif of war in German writers of this period, see H. H. Müller, *Der Krieg und die Schriftsteller: Der Kriegsroman der Weimarer Republik* (Stuttgart: Metzler, 1986).

10 Commented on by J. Bouveresse, "Apprendre à voir des abîmes là où sont des lieux communs": Le satiriste et la pédagogie de la nation," *Agone* 35-36 (2006): 107-31.

11 B. Brecht, *The Decision* (1929-30), in *Brecht: Collected Plays*, vol. 3, ed. J. Willett (London: Bloomsbury, 2013), 89.

12 See Lugon, *Photographie en Allemagne*, 235-41; M. Tupitsyn, *Gustav Klutsis and Valentina Kulagina: Photography and Montage after Constructivism* (New York: International

press, both in the West and in the East, continued to adopt the propagandist character of the preceding years. The atlases and photographic exhibitions extolled a bizarre heroism of peace—but a terribly monitored peace, a peace of the atomic threat—which can be seen, for example, in the exhibition *The Family of Man*, conceived by Edward Steichen, to which Brecht's *Kriegsfibel* might be considered an implicit reply.[13]

That is why *Kriegsfibel* opens and closes on two poems by Brecht: the one cited by Ruth Berlau on the inside flap of the French edition, the other appearing on the back cover and accompanying a photograph that shows students listening to a lesson in their amphitheatre (fig. 6.3)—poems on the *necessity of learning.*

> Learn the basics! For those
> For whom the time has come,
> It is never too late!
> Learn your ABC, it is not enough, but
> Learn it! Don't be put off!
> Start! You must know everything!
> [. . .]
> Don't forget: many of your brothers fought
> So that, after them, you could sit here.
> Don't bury your heads, know how to fight
> Learn to learn and never unlearn it.[14]

Center of Photography, 2004); O. Sviblova, ed., *Une arme visuelle: Le photomontage soviétique, 1917–1953*, trans. E. Mouravieva (Moscow: Maison de la photographie de Moscou, 2005–06); A. Lavrentiev, *Rodtchenko et le groupe Octobre*, trans. J. Bonnet (Paris: Hazan, 2006); A. Lavrentiev, ed., *Rodtchenko photographe: La révolution dans l'œil*, trans. V. Dariot and I. Imart (Paris: Musée d'art moderne de la ville de Paris, 2007).

13 On the illustrated press of that period, see B. von Dewitz and R. Lebeck, eds., *Kiosk: Eine Geschichte der Fotoreportage, 1839–1973* (Cologne: Museum Ludwig-Steidl, 2001), 188–248. On nationalist ideologies after 1945, see M. Flacke, ed., *Mythen der Nationen: 1945, Arena der Erinnerungen* (Berlin: Deutsches Historisches Museum, 2004), 173–202 (on the RDA). On the exhibition *The Family of Man,* see Museum of Modern Art, *The Family of Man* (New York: Museum of Modern Art, 1955); J. Back and V. Schmidt-Lisenhoff, eds., "*The Family of Man,* 1955–2001," in *Humanismus und Postmoderne: Eine Revision von Edward Steichens Fotoausstellung* (Marburg: Jonas, 2004).

14 B. Brecht, *ABC de la guerre*, trans. P. Ivernel (Grenoble: Presses universitaires de Grenoble, 1985), 233–34.

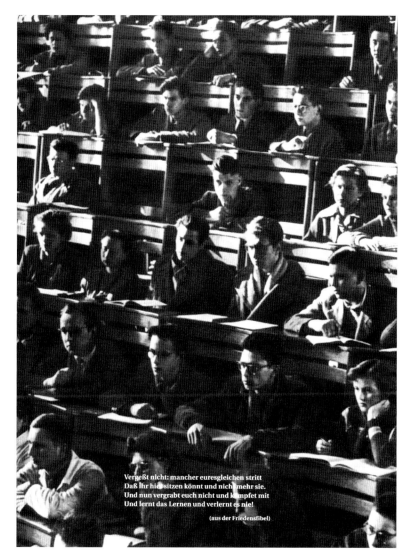

Vergeßt nicht: mancher euresgleichen stritt
Daß Ihr hier sitzen könnt und nicht mehr sie.
Und nun vergrabt euch nicht und kämpfet mit
Und lernt das Lernen und verlernt es nie!

(aus der Friedensfibel)

Figure 6.3
Bertolt Brecht, *Kriegsfibel*, 1955, back cover of the German edition: "Learn to learn and never unlearn it!" © Bertolt-Brecht-Erben/ Suhrkamp Verlag 1988.

This is a heavy knowledge and a light knowledge at the same time. On the one hand, *Kriegsfibel* demands an effort of memory from its reader, an effort founded on this considerable historical debt: we, who today are comfortably seated in front of our book of images of the past, owe this comfort and our freedom of thought to all the pain that these images document and that Brecht insisted on—desperately—so that we not repress it in our contemporary world. On the other hand, this sequence of images and the poems that accompany it make up, after all, only a manageable primer, a ludic arrangement more than a genuine tool of erudition. As Roland Barthes's analysis of this shows, the "great critical tasks" that Brecht set himself ("liquidation, theorization, bringing into crisis") are never without pleasure, for pleasure comes from every discovery—whether impertinent, unintentional, or destructive—of truth, which determines in his plays a form of rejoicing rather than a distraction.[15]

"Learn to learn and never unlearn it!" (*Und lernt das Lernen und verlernt es nie!*): in this central precept of Brechtian pedagogy, there are therefore the incessant pleasure of questioning and the perspective of what Peter Szondi calls "dialectical consent."[16] There is that strangely Nietzschean joyful knowledge that Brecht claims in his *Journals*—"These remarks are written with the feeling of being at the start of a new era, like little samples of a gay knowledge, with the pleasure of learning and trying"—and that Jacques Rancière writes about from the perspective of disorder, humour, and the image as fundamental dialectical detours for any political knowledge of history.[17] Walter Benjamin had already

15 R. Barthes, "Brecht et le discours: Contribution à l'étude de la discursivité" (1975), in *Œuvres complètes*, vol. 4, *1971–1976*, ed. E. Marty (Paris: Le Seuil, 2002), 786, 791. See also R. Barthes, "Brecht," in *Œuvres complètes*, vol. 1, *1942–1961*, ed. E. Marty (Paris: Le Seuil, 2002), 593: "Brecht's drama accomplishes an authentic synthesis between the rigor of the political design (in the highest sense of the term) and the freedom of dramaturgy. It is a drama that is both moral and overwhelming: it brings the spectator into a more active consciousness of History and its struggle. . . . This moral theater is at the same time a theater of pleasure: there is, at work in Brecht, a delight of theater, all the resources of a minutely edified art, not intended to 'entertain' but to delight."

16 P. Szondi, "Celui qui dit oui et celui qui dit non" (1966), trans. M. Bollack, in *Poésies et poétiques de la modernité* (Lille: Presses universitaires de Lille, 1981), 63–69.

17 J. Rancière, "Le gai savoir de Bertolt Brecht" (1979), in *Politique de la littérature* (Paris: Galilée, 2007), 113–43.

underlined, in his own reflections on didactic theatre, that with the Brechtian *Lehrstück* the audience becomes at the same time a "collective" moved by "political will," and therefore directly interested in the "lesson" transmitted and a sort of "play partner" in the unintentional montage and de-montage proposed by the epic construction.[18]

When Benjamin, in his conversations with Brecht, noted once again that the great playwright's epic drama was crossed through with something like a memory—or a desire—for a theatre for children, or even a children's theatre (*Kindertheater*) made for and by children themselves,[19] he opened a fundamental path to an understanding of Brecht and, more generally, I think, to any reflection on the relationship between history and imagination. Even before *Kriegsfibel*, the *Arbeitsjournal* placed children at the centre of its *Kriegsschauplatz*, or "theatre of war." On September 21, 1940, for example, Brecht conjoined an aerial view of a working-class town's architecture imagined by Hermann Goering and the face of a child (who was none other than Stefan, his own son).[20] Elsewhere, Brecht collected the image of a little girl frozen in front of the tomb of her father in a military cemetery.[21] Elsewhere, a joyful ring of children appears to have survived the destruction, though covered in ashes, amidst bombed-out ruins, but when we look more closely, we see that it is in fact a sculpture, not real children, still standing in the rubble of Stalingrad.[22]

On October 15, 1943, Bertolt Brecht stuck a photograph into his *Journals*, one that he must have found overwhelming. In it we see a theatre play for children in London, but it is taking place in a building already destroyed by the bombing[23] (fig. 6.4), like a well-known image from the same time in which we see a functioning library, with its readers concentrating on their books, while the whole space has been torn apart by German bombs.

18 W. Benjamin, "What Is the Epic Theatre?" (1939), trans. E. Jephcott et al., in *Selected Writings*, vol. 4, *1938-1940*, ed. H. Eiland and M. W. Jennings (Cambridge, MA: Harvard University Press, 2003), 302-9.

19 W. Benjamin, "Diary Entries," in *Selected Writings*, vol. 3, *1935-1938*, ed. H. Eiland and M. W. Jennings (Cambridge, MA: Harvard University Press, 2002), 336.

20 The photo appears in the French edition of Brecht's *Journals*; B. Brecht, *Journal de travail*, trans. P. Ivernel (Paris: L'Arche, 1976), 131.

21 Brecht, *Journals*, 40.

22 Brecht, *Journal de travail*, 324-25.

23 Brecht, *Journals*, 304.

Children's vaudeville is presented in a natural theater in London's Aldgate. Irene Yasheim, who used to live in it, is putting across *As Time Goes By*. Notice curtain.

Pedagogy in wartime—or in exile—might that then be another name for resistance? The decision to learn in spite of everything, the effort to never, whatever the cost, "unlearn to learn"?

Primer

The primer is as paradoxical a form of literature as it is childish or "elementary." It is a book for learning to read, as though it were possible to invent a particular kind of water for learning to swim. It is a work in which reading is thought about not in its will to understand the message contained in the text, but rather in its fundamental gesture of apprehending letters. It is therefore a book for creating movements, affects; a book not for reading something that might be hidden in the folds of its pages but for *desiring to read* everything that is disseminated and that can be browsed elsewhere. There is nothing innocent in such a device. History shows us that the pedagogy of reading—which goes hand in hand, as Brecht explicitly indicates, with the pedagogy of images—is itself in a battlefield in which powers of subjugation meet powers of liberation, moral constraints and playful arrangements, the chains of the lesson and the unchained outbursts of the game.

Kriegsfibel looks first of all like a *lesson*. Or, rather, like a manual intended for not "unlearning to learn" our history, present in that of the Second World War. The tone of the lyrical epigrams makes its resolute scansion of warnings, cautions, incitements, and moral aphorisms resonate throughout. We see that the ABC of politics generally, in Brecht's view, is to be found in the ethical choices and in the accession of every individual to the knowledge of his fellows. This is what allowed Bernard Dort to say that Communism was, for Brecht, "essentially ethical" and even a litigant for a kind of "mystical education" or, better still, a genuine "materialist asceticism."[24] This also explains the formal and stylistic rooting of Brechtian pedagogy in history itself—the long history of religious pedagogy. According to Tretyakov, Brecht admired in Luther, for example, the fact that "all the

24 B. Dort, *Lecture de Brecht*, (Paris: Le Seuil, 1972), 83-84.

expressivity of his language [was] due to its extreme alignment with the gesture."[25] Can we not perhaps see in *Kriegsfibel*—and without fear of going from a model taken from the Protestant Reformation to a paradigmatic genre taken from the Catholic Counter-Reformation—a survival of the "spiritual exercises" and other didactic compositions of the Baroque era?

One would have to consider the entire history of visual alphabets. Frances Yates showed, in her magisterial study on the art of memory as well as in an examination of their prolonged use in Elizabethan drama, how learning and memorizing were always accompanied by the systematic dramatization of knowledge and history.[26] This dramatization implies a certain regard for the means of staging, an arrangement of figurability that Freud, in Brecht's time, would have called *Darstellbarkeit*. What does this mean? That to learn (and to teach) and to memorize knowledge demand a certain articulation of the imagination and of symbolization. We see that, in the art of memory and in the works of ancient pedagogy, letters begin to make gestures and become organized around a structure of *visibility* of bodies or objects; conversely, bodies and objects try to fan out in combinatory elements, in concatenations, in alphabetic sequences—in short, in layouts of *legibility* (figs. 6.5 and 6.6).[27]

It seems that Brecht had some ideological difficulty—despite what Walter Benjamin attempted to transmit to him regarding the *Nachleben* of epistemo-mystical structures in the Baroque era—in admitting that there might be any Jesuitical character to his own political pedagogy. It was far smarter, funnier, and more comfortable to go far away—to

25 S. Tretyakov, "Bert Brecht," in *Dans le front de gauche de l'art* (Paris: François Maspero, 1977), 83–84.

26 F. A. Yates, *The Art of Memory* (1966), in *Selected Works*, vol. 3 (London: Routledge, 2007), 129–59, 342–67, and *Theatre of the World* (London: Routledge and Kegan Paul, 1969).

27 Yates, *Art of Memory*. On visual alphabets and figurative poems, see G. Pozzi, *La parola dipinta* (Milan: Adelphi, 1981) and *Sull'orlo del visibile parlare* (Milan: Adelphi, 1993); C. Parmiggiani, ed., *Alfabeto in sogno: Dal carme figurato alla poesia concreta* (Milan: Mazzotta, 2002). On the theoretical problems linked to this conjunction of the visible and the legible, see (in an obviously considerable library, including every author interested in iconography) M. Schapiro, *Words, Script, and Pictures: Semiotics of Visual Language* (New York: George Braziller, 1996); B. Vouilloux, *La peinture dans le texte, XVIIIe–XXe siècles* (Paris: CNRS, 1994); B. Erdle and S. Weigel, eds., *Mimesis, Bild und Schrift: Ähnlichkeit und Entstellung im Verhältnis der Künste* (Cologne: Böhlau, 1996).

China, for example, where the religious content is indifferent because it is indecipherable. Thus we see Brecht inventing a little "social writing" (*eine soziale Schrift*) on the explicit model of Chinese ideograms:

1 feb 42
ruth finds chinese characters very good and suggests a poem about a few of them. *peace* is a woman with a roof over her; *home* is a pig under a roof; *harmony* is a mouth close to rice, etc. maybe i ought to draw up a *catalogue of characters* myself [fig. 6.7] . . . by asking many people you could devise a social script.[28]

This ideogrammatic coalescence between reading and gesture is integral to the fundamental precepts of Baroque pedagogy. It is fully achieved in the dramatic productions in which allegories and history—political actuality itself—were in Jesuit schools the highlights of an "education through playing."[29] And this *legibility of the gesture* was not without a theory of the image capable of taking back for itself the great tradition of *ars memoriae*. There would certainly not have been any dramatized pedagogy without philosophical presuppositions regarding the place of the image—that famous "composition of the place" analyzed in Ignatius de Loyola by Pierre-Antoine Fabre, in relation to the very notion of "spiritual exercises"—a place thought of as the theatre of a meeting between lessons to be retained (*docere*) and affective movements (*movere*) and the pleasure (*delectare*) that makes them unforgettable for us because they are performed both corporeally and spatially.[30]

There existed in France, beginning in the 1560s, an elementary method of reading published under the title *Rôti-cochon* and illustrated with wood engravings.[31] But it was in 1658 that the illustrated primer really began,

28 Brecht, *Journals*, 197.

29 F. de Dainville, *L'éducation des jésuites, XVIe–XVIIIe siècles* (Paris: Minuit, 1978), 471–533.

30 See P.-A. Fabre, *Ignace de Loyola: Le lieu de l'image; Le problème de la composition de lieu dans les pratiques spirituelles et artistiques jésuites de la seconde moitié du XVIe siècle* (Paris: EHESS-Vrin, 1992); R. Dekoninck, *Ad imaginem: Statuts, fonctions et usages de l'image dans la littérature spirituelle jésuite du XVIIe siècle* (Geneva: Librairie Droz, 2005).

31 The first edition of this children's book is extremely rare today. The Bibliothèque de l'Arsenal in Paris has a later edition: *Rôti-cochon ou méthode très-facile pour bien apprendre les enfants à lire en latin et en français* (Dijon: Michard, n.d. [1689–1704]).

Figures 6.5 and 6.6
Johannes Rombrech,
*Congestiorum artificiose
memorie*, 1533: visual
alphabet.

Giovan Battista della Porta,
Ars reminiscendi, 1602:
visual alphabet.

with Comenius's *Orbis sensualium pictus*, an illustrated work with 150 figures, which was so popular that it was constantly republished until the beginning of the nineteenth century.[32] During the Enlightenment—after Jean-Jacques Rousseau's reflections in 1762 in *Emile, ou de l'éducation*— there was considerable development of children's literature and of pedagogy through images. In particular, the French revolutionaries undertook a "civic education" through their illustrated primers and their "collections of historical tableaux" addressed to the young, and the German pedagogues did the same.[33]

Everywhere, in fact, one saw the circulation of primers: Karl Petermann attempted to create an "analytico-synthetic" theory about them in 1893 and Karl Hobrecker wrote a short history of them in 1924— which was admired at once by Walter Benjamin, who had not missed the crucial importance of these problems—before the very complete work by Ségolène Le Men on French primers in the nineteenth century.[34] In Brecht's time there appeared many kinds of popular works called *Kalender-Bilder*

32 J. A. Comenius, *Orbus sensualium pictus* (Nuremberg: Endterus, 1658; repr., Dortmund: Harenberg, 1991). On this work, see J. Adhémar, "L'enseignement par l'image," pt. 1, *Gazette des Beaux-Arts*, 6th ser., 97 (1981): 53–60; E. Kushner, "Le rôle de la vision dans l'œuvre pédagogique de Comenius," in *La visualisation des choses et la conception philosophique du monde dans l'œuvre de Comenius*, ed. H. Voisine-Jechova (Paris: Presses de l'Université de Paris-Sorbonne, 1994), 53–62. On Comenius's dramaturgical activity and his notion of *Lehrstück*, see M. Cesnaková-Michalcová, "L'éducation par le jeu théâtral: Comenius auteur dramatique et théoricien du théâtre," ibid., 153–60.

33 For France, see J. Adhémar, "L'enseignement par l'image," pt. 2, *Gazette des Beaux-Arts*, 6th ser., 98 (1981): 53–60. For Germany, see H.-H. Ewers, "La littérature moderne pour enfants: Son évolution historique à travers l'exemple allemand du XVIIIe au XIXe siècle," trans. A. Burkardt and C. Gepner, in *Histoire de l'enfance en occident*, vol. 2, *Du XVIIIe siècle à nos jours*, ed. E. Brecchi and D. Julia (Paris: Le Seuil, 1998), 434–60. On the history of pedagogy through games, see M.-M. Rabecq-Maillard, *Histoire des jeux éducatifs* (Paris: Nathan, 1969).

34 K. Petermann, *Lebensbilder: Lese- und Schreib-Fibel für Elementar-Klassen nach der analytisch-synthetischen Lesemethode* (Leipzig: Klinkhardt, 1893); K. Hobrecker, *Alte vergessene Kinderbücher* (Berlin: Mauritius, 1924; repr., Dortmund: Harenberg, 1981); W. Benjamin, "Old Forgotten Children's Books" (1924), in *Selected Writings*, vol. 1, *1913-1926*, ed. M. Bullock and M. W. Jennings (Cambridge, MA: Harvard University Press, 1996), 410; S. Le Men, "Les abécédaires d'histoire naturelle et leur illustration au XIXe siècle," in *Écritures, systèmes idéographiques, pratiques expressives*, ed. A.-M. Christin (Paris: Le Sycomore, 1982), 307-20, and *Les Abécédaires français illustrés du XIXe siècle* (Paris: Promodis, 1984).

Figure 6.7
Bertolt Brecht, *Arbeitsjournal*, January 1, 1942: "Catalogue of characters (or) social writing." © Berlin: Akademie der Künste, Bertolt-Brecht-Archiv/Bertolt-Brecht-Erben/Suhrkamp Verlag 1973.

(which mixed anecdotes and political history), *Bilder-Fibel*, or *Spielfibel* (the most famous of these having been composed by Tom Seidmann-Freud in 1930).[35]

Brecht's *Kriegsfibel*—as the *Lehrstück* genre itself and as a "pedagogical play"—necessarily extends the tension inherent in any attempted "education game" or "education through images." On the one hand, the game and the image set in motion a particular *delectation* that is intended to pass into the reader's body the very meaning of the *lectio*—the language organized as a message, the discourse of knowledge; on the other hand, image, gesture, and *delectatio* will always be susceptible to bursting the *lectio* with that voracity of imagination that in Plato had already brought to the surface all the pedagogue's mistrust. This tension is at work throughout the history of primers: tools of the *lectio* and of the constraint, when the ABCs rhyme with "Christian education"—that is, the obligation to learn to read by beginning with the Credo—or even, in post-revolutionary France, when the ABCs rhyme with "moral education" (figs. 6.8 and 6.9).[36] Arrangement of the *delectatio* and the game—when ABC supposes ACB or CBA, that is to say, it allows the player to throw into the air, to dismantle, disassemble all the particles of organized language.

Yet by delighting too much in the rhythmic of the signifiers—"fa fe fi fo fu phé pho phi phe pha" (fig. 6.10)—doesn't the child risk losing the doctrine of the philosophers? By playing too much on the sound material—"vou lez-vous fai re da da tout de suite . . . sa ta ga va za ja na ra ma" (fig. 6.11)—doesn't the education tool risk turning into a Dadaist game? Unsurprisingly, the collages of Max Ernst, Raoul Hausmann (figs. 6.12 and 6.13), and Kurt Schwitters and the photographic montages of Man Ray and Vitezslav Nezval in the 1920s often took up, sometimes nonsensically, the

35 On the *Kalender-Bilder*, see I. Wiedemann, *"Der Hinkende Bote" und seine Vettern: Familien-, Haus- und Volkskalender von 1757 bis 1929* (Berlin: Museum für Deutsche Volkskunde, 1984); R. Reichardt and C. Vogel, "Kalender-Bilder: Zur visuellen Dimension populärer Almanache im 18. und 19. Jahrhundert," in *Der Kalender als Fibel des Alltagswissens*, ed. Y.-G. Mix (Tübingen: Max Niemeyer, 2005), 85–136. On the *Bilder-Fibel* and *Spielfibel*, see *Erste neue Bilder-Fibel für ganz kleine Kinder* (Berlin: Winckelmann, n.d.; R. Reinick, *ABC-Buch für kleine und grosse Kinder* (Leipzig: Dürr, 1876); T. Seidmann-Freud, *Hurra, wir lessen! Hurra, wir schreiben! Spielfibel no. 1* (Baden-Baden: Herbert Stuffer, 1930) and *Spielfibel no. 2* (Berlin: Herbert Stuffer, 1931).

36 See Le Men, *Abécédaires français*, 141–99.

Figures 6.8 and 6.9
Anonymous (French), *ABC ou Instruction chrétienne, divisé par syllabes, pour la facilité des petits enfans*, 1812: title page and frontispiece.

Anonymous (French), *Abécédaire moral, instructif et amusant à l'usage des enfans et des adolescens*, 1811: title page and frontispiece.

FE‑NÈTRE.

fa fe fi fo fu
phé pho phi phe pha
Ca-fé, fa-de, dé-fi, fée,
fils, fille, frère.

M. MÉ DOR

VOU LEZ-VOUS

FAI RE DA DA

TOUT DE SUITE

a e é è i o u

â ê î ô û

ab eb ib ob ub

ar er ir or ur

sa ta ga va za ja na ra ma

Figures 6.10 and 6.11

Anonymous (French), *Nouvel alphabet de l'enfance orné d'un grand nombre de dessins et de textes explicatifs*, 1867: unnumbered plate.

Anonymous (French), *Le livre des enfants sage, no. 9: ABC du rêve de Marguerite*, 1873: unnumbered plate.

form of this initiation into signs, the primer, which in French is called an *abécédaire*.[37] Brecht brings together, therefore, both the long duration of a tradition and the recent avant-gardist rout. He obviously refused to see in the primer the nostalgic sense that Stefan George sought to give it, by giving the title *Die Fibel* to one of his early poetry collections.[38] But he certainly adopted the ironic content of Jean-Paul, who with his *Life of Fibel* (published in 1812) made the primer a form that could be defined as a "book of books," basically an aberrant form:

> This work [which], with its elements from science in general, namely the alphabet, contains a succinct catechism, varied poems, colored images of men and animals and little still lifes, an abridged natural history, a brief manual on different trades [is] the book of books, containing all the *patres et matres lectionis*, the book that the greatest genius must study even before the age of five—in a word, the most perfect work We call this, by abbreviation, the *ABC*, when we could call it the *Aybeeceedeeffgeeaytchijayka yelemenopeequeworessteeyuveewexyzee*. . . . I had read it before reading Homer and the Bible.[39]

Here, then, the primer (*Fibel*) is claimed as an alternative to any Credo, that is to say, to any Bible (*Bibel*). The world—particularly the world of language—is shown less within it in its fundamental principles than it is dismantled into scored elements, into pieces that it will always be permissible to reorganize according to the plot (*Fabel*) that our imagination, each time differently, will direct towards new bifurcations. On this point, Walter Benjamin seems the most profound thinker with regard to this "childish knowledge." He collected toys and made

37 See H. Bergius, *Montage und Metamechanik: Dada Berlin; Artistik von Polaritäten* (Berlin: Mann, 2000), 22–27; J. Bordes, *La infancia de la vanguardias: Sus profesores desde Rousseau a la Bauhaus* (Madrid: Cátedra, 2007); S. de Puineuf, "Au commencement était l'alphabet: L'avant-garde internationale en quête de la langue universelle, 1909–1919," *Cahiers du Musée national d'art moderne* 102 (2007–08): 37–63.

38 S. George, *Die Fibel* (Berlin: Bondi, 1927).

39 Jean-Paul [Johann Paul Friedrich Richter], *Vie de Fibel* (1812), trans. C. Pichois and R. Kopp (Paris: Union générale d'éditions, 1967), 47, 49, 133.

atlases of them.[40] From 1918 he was interested in the great odds and ends—no less than ten volumes in quarto—of Friedrich Justin and Karl Bertuch, titled *Bilder buch für Kinder*.[41] His own collection from 1928, titled *One-Way Street*, stops at postage stamps ("There is, it is known, a stamp-language that is to flower-language what the Morse alphabet is to the written one"), toys, and all kinds of experiences and childish situations: "Child reading," "Belated child," "Child on the carousel," "Untidy child," Child hiding."[42] Mainly the "untidy child" appears to be the prototype of the dreamer, the creator of montages, and the scholar, the one who does not accept closure, who remains suspended on any meeting, observes every trace, and "knows nothing lasting" facing the open catalogue of the visible world:

> *Untidy child.*—Each stone he finds, each flower he picks, and each butterfly he catches is already the start of a collection, and every single thing he owns makes one great collection. In him this passion shows its true face, the stern Indian expression that lingers on, but with a dimmed and manic glow, in antiquarians, researchers, bibliomaniacs. Scarcely has he entered life than he is a hunter. He hunts the spirits whose trace he scents in things; between spirits and things, years pass in which his field of vision remains free of people. His life is like a dream: he knows nothing lasting; everything seemingly happens to him by chance. His nomad-years are hours in the forest of dream. To this forest he drags home his booty, to purify it, secure it, cast out its spell. His dresser drawers must become arsenal and zoo, crime museum and crypt. "To tidy up" would be to demolish an edifice full of prickly chestnuts that are spiky clubs, tinfoil that is hoarded silver, bricks that are coffins, cacti that are totem poles, and copper pennies that are shields.[43]

40 See *Walter Benjamins Archive: Bilder, Texte und Zeichen* (Berlin: Akademie der Künste/ Suhrkamp, 2006), 56-75.

41 F. J. Bertuch and K. Bertuch, *Bilderbuch für Kinde: Porte-feuille des enfants, mélange intéressant d'animaux [. . .] et autres objets instructifs et amusants pour la jeunesse, avec de courtes explications scientifiques proportionnées à l'entendement d'un enfant* (Weimar: Bureau d'industrie, 1796-1821).

42 W. Benjamin, *One-Way Street*, in *Selected Writings*, vol. 1, 480, 463-65.

43 Ibid., 465.

A little later, in "Berlin Childhood," Benjamin speaks about learning to read—reading without understanding, playing with letters—and heterogeneous montages by taking up, almost word for word, the above lines on the untidy child.[44] The question then arises of knowing how to formulate, philosophically, the purpose of a *memory primer*, if not a history primer. Is it just to once more provide a few "primitive" images, a few "alphabetical elements" of the past? Certainly not. The primer is like memory itself, in the sense that "what is forgotten seems to us laden with all the lived life it promises us."[45] It is therefore an anachronistic object par excellence, returning to the *formerly* in light of the *soon* that constantly reconfigures our desires. Did Brecht, as he got older, understand that his *Kriegsfibel* engaged not only his entire actual relationship with political history but also his desire, his entire writing project, and perhaps his theatre project too? Walter Benjamin, in any case, regulated the Proustian reminiscence of his old "reading box" (*Lesekasten*, fig. 6.14) on the most contemporary issues—issues of writing, of the image, of thought—in the midst of political catastrophe in 1933:

> none of the things that surrounded me in my early years arouses greater longing than the reading box. It contained, on little tablets, the various letters of the alphabet inscribed in cursive, which made them seem younger and more virginal than they would have been in roman style. Those slender figures reposed on their slanting bed, each one perfect, and were unified in their succession through the rule of their order—the word—to which they were wedded like nuns. I marveled at the sight of so much modesty allied to so much splendor. It was a state of grace. Yet my right hand, which sought obediently to reproduce this word, could never find the way. It had to remain on the outside, like a gatekeeper whose job was to admit only the elect. Hence, its commerce with the letters was full of renunciation. The longing which the reading box arouses in me proves how thoroughly bound up it was with my childhood. Indeed, what I seek in it is just that: my entire childhood, as concentrated in the movement [*Griff*] by which my hand slid the letters into the groove, where they would be arranged to form words.

44 W. Benjamin, "Berlin Childhood around 1900," in *Selected Writings*, vol. 3, 356.

45 Ibid., 395.

My hand can still dream of this movement, but it can no longer awaken so as actually to perform it. By the same token, I can dream of the way I once learned to walk. But that doesn't help. I now know how to walk; there is no more learning to walk.[46]

The primer is indeed, in the hands of a child, that paradoxical device—both an open game and a required course—where the *gesture of learning* is invited and made operational. The adult seems to have unlearned this gesture of learning. *Kriegsfibel*, a primer for adults, thus sets up a supplementary paradox whose intent is for us "not to unlearn to learn," in spite of everything. How so? By the montage of gestures (photographed on each plate) and of words (printed in white on black on each plate), as though the linking of the document (the *lectio* of this pedagogy) with the poem (the lyrical and even musical *delectatio*) allows us to return somewhat to this "state of grace" that Benjamin speaks of with regard to his entry as a child—his gestural entry—into the forest of language.

Naïveté

Whatever we gain in gestures and images, however, we risk waiting a long time for it in precise discourse and established certainties. The status of the subject that the *Fibel* supposes, a status of non-knowledge inherent in the gesture of learning, could then be called naïveté—on the condition that one remembers that the word has nothing to do with stupidity and that it refers to a *native* status, the very status supplied symbolically by the lesson in the *Lesekasten* or primers. It has been said, correctly, that Bertolt Brecht could be understood fully in light of an "aesthetics of naïveté."[47] No *Fabel*—no epic or dialectical "plot"—without the exordium of the *Fibel*, that language game that wishes to take everything from the beginning. No political knowledge without prior orientation of the body, and without stumbling, without trial and error in language.

46 Ibid., 395-96. On the issue of the game in Walter Benjamin, see the important study by H. Brüggemann, *Walter Benjamin über Spiel, Farbe und Phantasie* (Würzburg: Königshausen & Neumann, 2007), 47-125.

47 D. Schöttker, *Bertolt Brecht Ästhetik des Naiven* (Stuttgart: Metzler, 1989).

Stein **Deutſch** (Schwabacher)

Nr. 57.

Nr. 65.
Buchstaben zu Vetters Lesekasten.

Nr. 36d. Lesebrett für die Hirtschen Alphabete Nr. 71/72.

Figure 6.14
Anonymous (German),
Reading Box, 1929.
Catalogue of the Kölner
Lehrmittelanstalt, 188.

Brecht worked a lot with the simplest stylistic forms, so-called popular or ancient forms capable of the greatest resistance to time, as well as the greatest formal plasticity with regard to the demands of the present. The ballads, for example: immemorial popular songs that are reconfigured in Brecht through a more recent tradition—that of protest or revolutionary songs—as *Lieder* of a new genre.[48] Another example: the satirical plots or calendar stories (*Kalendergeschichten*), of which Brecht took from Johann Peter Hebel the concept of a modern reutilization of them as an "epic-ethical" literary form, as Walter Benjamin notes in 1929 in his study of Hebel: "Morality, which is foreign to the mediocre narrator, is for Hebel the continuation of the epic by other means. And since it reduces the *ethos* to a question of tact, the concrete achieves here the greatest force."[49] It appears to be a matter, once again, of placing the accent on the gesture, without which any language loses its poetic density and dries up into immutable discourses, and thus becomes immobile and dead.

The naïveté inherent in the "gesture of learning" is not without a certain rhythmic of the body facing language. This has to do with the dramatic arts, of course, but Brecht seems to have in mind more generally something like an anthropology of the gesture and speech. He calls upon them to show "movements of people (also shifts of the emotions) organized as simple models for study purposes."[50] For example, in his *Journals* he mentions the vital necessity of the festival and the specific importance of the carnival in this, as profanation or inversion of social values by means of a certain usage of the body and of language: "day of disguises and mockery. day of penitence for the most cherished traditions and most elevated persons."[51]

48 Brecht, *Liederbuch*. On the relationship between scholarly music—that of Schönberg first of all—and popular songs, see Brecht, *Journals*, 224-25, 250-51. On ballads and protest songs, see W. Hinck, ed., *Geschichte im Gedicht: Texte und Interpretationen; Protestlied, Bänkelsang, Ballade, Chronik* (Frankfurt: Suhrkamp, 1979).

49 W. Benjamin, "Johann Peter Hebel" (1929), trans. R. Rochlitz, in *Oeuvres*, vol. 2 (Paris: Gallimard, 2000), 169. See J. P. Hebel, *Kalendergeschichten, mit Lithographien von Josef Jakob Dambacher* (1829-33) (Berlin: Aufbau, 1971); B. Brecht, *Tales from the Calendar*, trans. Y. Kapp and M. Hamburger (London: Methuen, 1966). See also the study by J. Knopf, *Geschichten zur Geschichte: Kritische Tradition des "Volkstümlichen" in den Kalendergeschichten Hebels und Brechts* (Stuttgart: Metzler, 1973).

50 Brecht, *Journals*, 20.

51 Ibid., 147.

Brecht finds himself even bemoaning the fact that the materialism of the German philosophers—which he loved so much and of which, to a certain extent, he himself was a part—lacks the style and sensuality necessary for touching with the finger or, better still, "touching with the body" what *material* but also *language* means:

> we germans have materialism without sensuality. with us the "mind" is constantly cogitating on the mind. body and objects remain mindless. in german drinking songs all you hear about are effects on the mind, even in the most vulgar songs. the smell of wine-barrels never occurs. we don't like the taste of the world. we have brought a cosiness to love, sexual pleasure has something banal about it. when we talk of taste, we again mean something purely intellectual, the tongue has long since ceased to function, taste is something like having a feeling for harmonisation. think of the combination "purely spiritual." with us the spirit sullies itself as soon as it touches matter. matter for us germans is crap, to all intents and purposes. in our literature this distrust of the vitality of the body is to be felt everywhere. our heroes cultivate sociability, but they don't eat; our women have feelings, but no backsides, to compensate for which our old men talk as if they still had all their teeth.[52]

And this is how Brecht underlines the sensorial meaning of the word *aesthetic*, bemoaning—on June 10, 1950, in his *Journals*—the fact that the Communist literary critic keeps every ideological discourse but nothing of the aesthetic body given to the rhythms and pleasures of the text:

> read a work on gorki and me, written by a working-class student in leipzig. ideology, ideology, ideology, nowhere an aesthetic concept; the whole thing is like a description of a dish in which nothing is said about the taste. the first thing we have to do is institute exhibitions and courses to develop taste, ie for the enjoyment of life.[53]

To those who are able to wonder if psychoanalysis is not a "bourgeois science" (as a "science of the individual") comes a symmetrical doubt

52 Ibid., 12.
53 Ibid., 433.

concerning historical materialism in its capacity to say something about the body of politics: "from [Max] PLANCK'S DETERMINISM OR INDETERMINISM (1938) . . . : 'it is impossible to sound out the interior of a body if the sounding instrument is bigger than the entire body.' historical materialism also shows this 'imprecision' in relation to the individual."[54]

Claiming naïveté, then, should be understood positively, generously, and no longer as a state resulting from some kind of privation in an individual "who does not yet know." Naïveté is found at the precise point where the phenomenon of emergence links with the "pleasure of learning," and whose correlative would be, for Brecht, the "enjoyment in learning and inquiry . . . , in such a way that the audience can 'enjoy' the sensations, insights and motivations that the wisest, most passionate and most active among us derive from the events of the day and the century."[55] And Brecht clarifies this for the spectator: "the theatre can provide weak (simple) and strong (composite) pleasures. The latter, which are what we are dealing with in great drama, reach their climaxes rather as intercourse does in the case of love; they are more intricate, more richly mediated, more contradictory and more momentous."[56]

Naïveté therefore has nothing to do with an idiotic simplification of things. Rather, it is a particularly trusting opening into the voluptuous complexity—relationships, ramifications, contradictions, contacts—of the world around us. It is the gesture of accepting such a complexity, questioningly. It is the pleasure of wanting to play with it. In this sense, naïveté is as creative as it is receptive. The one who invents something, Brecht affirms, always becomes sensual: "invention makes one fall in love" (*Erfindung macht verliebt*).[57] And love makes one exquisitely naive—which does not mean stupid or ignorant. The scholar, the thinker, and the artist are capable of playing in spite of everything while working, creating. Capable of rediscovering the gesture of learning, of constantly reopening to the pleasure

54 Ibid., 213.

55 B. Brecht, "A Short Organon for the Theatre," in *Brecht on Theatre*, ed. M. Silberman, S. Giles, and T. Kuhn (London: Bloomsbury, 2015), 236.

56 Ibid., 231.

57 B. Brecht, "Des opportunités: L'invention rend amoureux" (1940), in *De la séduction des anges* (Paris: L'Arche, 1997), 72.

of the *Fibel*, they make, through invention or discovery, a very fruitful and powerful use of naïveté. For example, "After reading a new article by Niels Bohr on physics, Einstein shouted: 'This is the highest form of musicality, in the sphere of thought!' He could also have said of this article that it was an *insurrection*, perfectly conceived and powerfully executed!"[58]

To see in a physico-mathematical proposition something like music, and even a well-orchestrated insurrection, shows the heuristic (and theoretical) power of naïveté. "The main idea is to learn to think crudely [*die Hauptsache ist, plump denken lernen*]. Crude thinking is the thinking of the greats," writes Brecht. And it is Walter Benjamin who once again cites and comments most correctly on what is at stake—which is nothing less than dialectics itself:

> There are many who consider the dialectician a lover of subtleties. So it is uncommonly useful when Brecht puts his finger on the "crude thinking" that dialectics produces as its antithesis, includes within itself, and needs. Crude thoughts have a special place in dialectical thinking because their sole function is to direct theory toward practice. They are directives *toward* practice, not *for* it; action can, of course, be as subtle as thought. But a thought must be crude to find its way into action.[59]

How can naïveté, or "crude thinking," manage to elicit the contrary, that is, dialectical thinking? If we retain the Brechtian definition of *Verfremdungseffekt* as a process capable of the "reproduction of real-life incidents on the stage in such a way as to underline their causality and bring it to the spectator's attention,"[60] how then can we say of the naive gaze that it might be able to make a causality appear across the moving surface of sensible things? Yet this is indeed what happens sometimes when naïveté becomes the phenomenological capacity to *not avoid evidence*. That is why Brecht constantly states the importance of distancing effects in the so-called popular arts, from puppet shows and children's theatre to Brueghel's

58 B. Brecht, "Propositions pour la paix," trans. P. Dehem and P. Ivernel, in *Écrits sur la politique et la société* (Paris: L'Arche, 1970), 261.

59 W. Benjamin, "Brecht's *Threepenny Novel*," in *Selected Writings*, vol. 3, 7.

60 Brecht, *Journals*, 83.

Proverbs and the great actors capable of making their bodies "a walking a[lienation]-effect."[61] That is why he aims in his plays "to entrust the acting of the sage to the children."[62]

It is best to take another example: to observe concretely how the point of view of the naive person can contribute to the subtlety of the dialectical point of view. Let us look at Adolf Hitler through the documents collected by Bertolt Brecht, and let us look at him naively. Here Hitler dances with joy, doing a jig on the spot upon learning that he has "won," as do so many children and athletes (fig. 5.1); there Hitler addresses the people and poses as a sort of supreme educator (fig. 5.5). As children we learned—from a very violent pedagogy, necessitated by the events for a certain generation, and for the following generations a long and difficult initiation based on history books and the testimonies of parents, a pedagogy whose path is remade in a way by *Kriegsfibel*—that Hitler embodied an absolute political evil. What counts at the bottom of this is not Hitler as a dancer or an orator, but this "political evil" that he embodied at a moment in history.

The naive person never begins by addressing such fundamental questions. Instead he or she looks at how bodies move, and that is all. If need be, this person will be surprised by the disguise—by which I mean the military uniform with its characteristic logo, the familiar swastika. This person will wonder what kind of energy commands these kinds of gestures. And this is why Brecht in his *Journals* endeavours to reproduce Hitler's jig *in extenso* before asking "Is Hitler a dummy?"; he returns repeatedly, even in his *War Primer*, to images of the dictator as public orator.[63] This is why he also writes, right next to his photo-essay on the meeting between Benito Mussolini and Marshal von Ribbentrop in 1940, "what a wealth of material for the theater there is in these fascist illustrated weeklies," which contemporary epic drama could no longer do without.[64] But let us not be mistaken; Brecht was interested in the photographs of the fascist body

61 Ibid., 464.
62 Ibid., 122.
63 Ibid., 60–70, 106–7, 164, 204, 233, 286; B. Brecht, *War Primer,* trans. and ed. J. Willett (London: Libris, 1998), pl. 1, 28 [23], 33 [28], 81 [69]. See also Brecht, *ABC de la guerre,* A1, A16.
64 Brecht, *Journals,* 104.

only insofar as the intent of his drama was—albeit naively, with interposed "plots"—to show bodies, gestures struggling with history and politics, power and subjugation.

This is when the naive gaze makes us shift from an apparent a-causality (bodies shown for themselves, without directly indicating the historical, political or economic motivation that animates them) towards something of a different order that I might call "anthropological over-determination" (in the sense by which Aby Warburg examined the long duration of the "pathos formulae" throughout the history of Western representation). There is a certain way, then, of looking at bodies in order to say something else about the memory and desire that animate them. Can we find any better example, in Brecht's time, of this brilliant naïveté, this genial inventiveness at the same time, this *operational naïveté*, than the staging of his own dancing body by Charlie Chaplin?[65]

Chaplin's character seems to be the paradigmatic figure of naïveté. But Chaplin shows it to us in such a way that, from the naive person's viewpoint, a dialectical thought can genuinely be born. Furthermore, the naive person's gesture can find its meaning and its efficiency in an authentic position-taking, one that is both ethical and political. In *The Dictator*, for example, naïveté is constructed, even over-signified, by the character's amnesic condition. The little Jew has forgotten that he was a great hero of the First World War, but this forgetting drives him to the greatest political courage—despite his constant fear, despite his childish panic—in the context of anti-Semitism and the premises of the Second World War. In *Modern Times*, from 1936—that is, at the time of the Popular Front and the Spanish Civil War—Chaplin appears like a lost child, an orphan of society whose destiny seems to be an impossible relationship with the social world and the world of work in particular.

At the beginning he is a worker who is so little adapted that he is incapable of keeping his job, or even his class. He cannot even register as a proletarian who may join a union, he causes every possible malfunction on the factory's assembly line, and he ends up, via a psychiatric hospital and prison, destitute, a tramp, a *lumpenproletarian*, permanently hungry. A whole study on its own would be required to completely describe Chaplin's

65 Ibid., 347–48.

gestures in this film, as so many position-takings, in spite of everything and in spite of himself, evoked by this naive character at every step. I am thinking, for example, of the moment when he finds himself with a red rag in his hand, an innocent but suddenly galvanizing interface between a demonstration by the unemployed workers—"Liberty or Death" we read on the banners—and the police, who charge them and then take him away as a Communist leader. A few prison sojourns later, Chaplin finds himself once again in the position of launching (more naively than ever) a brick at the head of one of the policemen who have come to quell the workers' strike. All this is shown—as though in a montage—through his irresistible choreography, his childish tenderness, his gallantry even in the police van, his sensuality, his irrepressible passion for roller skating during the night among the toy shelves of a department store . . .

Intoxication

Bringing the figure of the naive person into the political *gestus* of de-subjugation amounts to accepting something like a moment of anarchy in any position-taking that is not undertaken inside an overall project—a taking of sides. The question raised by Chaplin's gestures in *Modern Times* can then be understood from a more dialectical perspective: by what means did the naive person become capable of appearing so cunning, so skilled, so political? How does child's play turn into social tactics, even small guerrilla tactics, at every moment, in every gesture? How does the weakest acquire that sovereignty and sometimes even that efficiency in protest? Hunger (a dominant theme in every Chaplin film) and immediate ethical sentiments (his spontaneous refusal of the injustice that unfolds in front of his eyes, when the young girl is threatened by the police) contribute strongly to this power of conversion that transforms initial weakness into unexpected potential.

There is something else, however, something that perfectly links naïveté with a certain capacity for decision, and weakness with a certain capacity for resistance, and that is *intoxication*—or at least the way in which a subject goes about playing with the world, provided that the latter is de-realized beforehand, displaced in the imagination, envisaged from the viewpoint of a play of local forms rather than overall content. In *Modern Times*, Chaplin

begins, of course, by going mad: the repetitive gestures of the industrial assembly line make his body prey to a rhythmic chorea, a symptomatic form that idly repeats the alienating form of the work; he sees rivets everywhere, even on the secretary's lower back and the bosom of a bourgeois lady passing by at that moment. It is with such a hallucinatory state that Chaplin brings into play an extraordinary physical potential and a complete psychological freedom; in short, a capacity to disrupt everything in the functional reality of the factory. A little later, in prison, it is after involuntarily absorbing a dangerous quantity of cocaine that the naive character—naive because he thinks it is simply salt—becomes foolhardy enough to face the blows and pistols of the bad guys. It is as though what society calls "alienation" displays an energy capable of liberating us from this society that is organized entirely for the subjugation of its subjects.

This is a long way from any kind of partisanship, and Bertolt Brecht, in spite of his admiration for Chaplin, would certainly not have agreed (at least, on the theoretical level) with such hypotheses. Brecht is, as we know, a sober author. He likes neither intoxication nor madness. He worries about the symptom when the latter disassembles the organized parts of our body or our mind:

> in distraught moments the components of the mind break up like parts of a mortally stricken empire. communication between the parts ceases (it suddenly becomes apparent that the whole thing consists of separate parts), they now only have the meaning they have for themselves, which is not much. it can happen that all of a sudden i can see no sense in institutions like music or politics, see my nearest and dearest as strangers etc. health consists of equilibrium.[66]

Far from Chaplin, then, Brecht would evoke once again, in a Berlin occupied by the Red Army, the dangerous antics of "a very young, drunk Russian officer aiming his revolver [at civilians]. he has the pale, desperate expression drunks have and is sunk deep in the realm of inarticulate gestures, incapable of making himself understood."[67]

66 Ibid., 329.
67 Ibid., 413.

For Brecht, however, there are different kinds of drunkenness. The danced drunkenness in art forms is not the gesticulated drunkenness of the soldier, absurdly waving his weapon and threatening to kill anything around him that moves, in a pitiful simulacrum of omnipotence. There are, therefore, an intoxication that is merely pathetic, suffered, pitiful, destructive, and a *poetic* intoxication: active, creative, sovereign, far from— or, rather, benefiting from—the first. Brecht, for example, was one day surprised at the poetic pleasure he found in reading Federico García Lorca: a pure intoxication of words, he notes. But he interrupts his own pleasure in order to ask "how this pleasure might be made available to our workers, and whether it ought to be available to them." The man of the Party (which he is) then objects: "our situation, the phase we are at, doesn't permit it. no drunken orgies on mountaineering tours!" To which responds the man of letters (which he is too): "but mountaineering tours cause their own type of intoxication, as does literature, and few other arts." The note ends abruptly on these words, as though to better signify the conflict in which Brecht never ceased to struggle.[68]

Poetic intoxication? It would be a way to push as far as possible the territory—the field of bifurcations—opened by the imagination. We can think of the Surrealists' experiments with drugs and psychical automatism. But Ernst Bloch was right to widen the viewpoint by considering montage, that complex formal procedure, from the perspective of an intoxication of images in the time of their dislocation: "montage appears culturally as the highest form of eerie intermittence above diversion, indeed possibly as a contemporaneous form of intoxication and irrationality."[69] Even in the political pedagogy of Eisenstein's films these moments of intoxication emerge powerfully, these explosive moments in which movements seem to shatter into fragments, features explode into fireworks, and images dance the drunken dance of Dionysus.[70]

68 Ibid., 432.

69 E. Bloch, *Heritage of Our Times* (1962), trans. N. Plaice and S. Plaice (Cambridge: Polity Press, 1991), 203.

70 See S. M. Eisenstein, *Teoria generale del montaggio* (1935–37), ed. P. Montani, trans. C. De Coro and F. Lamperini (Venice: Marsilio, 1985), 226–31 ("Naissance du montage = Dionysos"). See also G. Didi-Huberman, *Le danseur des solitudes* (Paris: Minuit, 2006), 177–78, for a brief commentary on this text.

In his fine article on the relationships between epic images in Brecht and the dialectic image in Benjamin, Philippe Ivernel recalls the discussions of Brecht and Benjamin on the question of how to live in the world.[71] Or, to put it another way, the question of *how to doubt reality*. How do we, alienated by too much habit, manage to doubt in a useful way what surrounds us and where we live? Brecht, as we know, provides distancing (*Verfremdung*) as a tool to know the world around us from the viewpoint of singularization, uncanniness, disappropriation, a way of "apprehending the habitual in its un-thought aspects, to understand it as an historical reality" that is always capable of changing or improving, of metamorphosing.[72] Which leaves the world around us with the possibility of seeing itself reframed and reassembled in other ways; in short, the possibility of eliciting a new experience and an *other* knowledge.

Benjamin arrives at this same unframing and this same re-montage or reassembling through a reflection on the "authentic" or "secularized" aura, which is strongly opposed to the cultic aura of religious stagings and theosophies. This reintroduces dialectically what the *Verfremdung* believes it holds at a distance, which is empathy for the world around us, the *Einfühlung*.[73] It is, however, neither the cult of mysteries nor transcendence that Benjamin seeks to reintroduce here, but rather *experience*, and even *experiment*. What is the risk of offering oneself to intoxication, other than experiencing the limits within which our own reason, our own sensations, and our own relationships with others are held? Philippe Ivernel is right to call on the "smuggling route" that is, in Benjamin's "epistemo-critical" work, his experience with drugs.[74] "The dialectical image seeks to polarize the opposition between the dreamlike and the scientific in order to better found the demands of praxis."[75]

We should recall the last lines of *One-Way Street* and the manner in which Benjamin dialectizes science and intoxication, then intoxication and the fundamental political questions of community and revolution. First, scientific astronomy is said to have introduced a relationship with the world

71 P. Ivernel, "Passages de frontières: Circulation de l'image épique et dialectique chez Brecht et Benjamin," *Hors-cadre* 6 (1987): 133–35.

72 Ibid., 137.

73 Ibid., 139–40.

74 Ibid., 141–47.

75 Ibid., 146.

of pure optical and instrumental knowledge that destroys the relationship of Dionysian drunkenness that the ancients fostered communally with the cosmos. Then the political situation of 1918 is described as a process of annihilation whose negative vertigo can be overcome only by a revolutionary drunkenness, that is to say, a drunkenness *in community*:

> Nothing distinguishes the ancient from the modern man so much as the former's absorption in a cosmic experience scarcely known to later periods. Its waning is marked by the flowering of astronomy at the beginning of the modern age. Kepler, Copernicus, and Tycho Brahe were certainly not driven by scientific impulses alone. All the same, the exclusive emphasis on an optical connection to the universe, to which astronomy very quickly led, contained a portent of what was to come. The ancients' intercourse with the cosmos had been different: the ecstatic trance [*im Rausch*]. For it is in this experience alone that we gain certain knowledge of what is nearest to us and what is remotest from us, and never of one without the other [*Ist doch Rausch die Erfahrung, in welcher wir allein des Allernächsten und des Allerfernsten, und nie des einen ohne des andern, uns versichern*]. This means, however, that man can be in ecstatic contact with the cosmos only communally [*in der Gemeinschaft*]. . . . In the nights of annihilation of the last war, the frame of mankind was shaken by a feeling that resembled the bliss of the epileptic. And the revolts that followed it were the first attempt of mankind to bring the new body under its control. . . . Living substance conquers the frenzy of destruction [*Taumel der Vernichtung*] only in the ecstasy of procreation [*Rausche der Zeugung*].[76]

This is what he tried to experience (*erfahren*) in his moments of experimental intoxication between 1927 and 1934, through different drugs.[77] It was a question of producing an experience of the world that was genuinely beyond empathy and distancing. As we read in *One-Way Street*, "it is in this experience alone that we gain certain knowledge of what is nearest to us and what is remotest from us, and never of one without the other." There is first an uncanniness due to the incomplete metamorphosis of all things,

76 Benjamin, *One-Way Street*, 487.
77 W. Benjamin, *On Hashish*, trans. H. Eiland et al. (Cambridge, MA: Harvard University Press, 2006).

which, we will remember, gave Brecht the very characteristic of distancing: "The people I'm with . . . are very much disposed to transform themselves to some degree. They do not, I would say, become strange, nor do they remain familiar; rather, they simulate strangers."[78]

Could the hand that lights a candle become, in the intoxication of hashish, "waxy"? The identity and the fixedness of things leave room for an alteration and a transformation in which the subject finds himself as though induced, drowned, empathetically submerged[79]—to the extent that the strangeness effect makes the aura return, paradoxically, to the foreground, to the comic tone that the experience can take:

> All those present take on hues of the comic. At the same time, one steeps oneself in their aura. . . . First, genuine aura appears in all things, not just in certain kinds of things, as people imagine. Second, the aura undergoes changes, which can be quite fundamental, with every movement the aura-wreathed object makes. Third, genuine aura can in no sense be thought of as the spruced-up magic rays beloved of spiritualists which we find depicted and described in vulgar works of mysticism.[80]

These are fundamental remarks: the aura is at the same time demystified, "secularized," and somewhat constricted in its *Urphänomen*. On the one hand, it is "genuine," says Benjamin, only when it concerns all things, and not only that unique and grandiose screen referred to at the end of the church by the sacred relic or icon. On the other hand, it is never without movement and a transformation of its qualities that is almost cinematographic, when the icon and the relic find their auratic potential in their absolute immobility and their continuity. Then Benjamin, after his experience of intoxication with hashish, comes to a radically modern, materialist, and formalist conclusion (which is therefore radically anti-spiritualist):

> the characteristic feature of genuine aura is ornament, an ornamental halo, in which the object or being is enclosed as in a case. Perhaps nothing gives such a

78 Ibid., 21.
79 Ibid., 64.
80 Ibid., 19, 58.

clear idea of aura as Van Gogh's late paintings, in which one could say that the aura appears to have been painted together with the various objects.[81]

This mode of thinking might allow us to re-link the *epic* dimension dear to Bertolt Brecht with an *auratic* dimension that implies a certain potential of the object, whether it has to do with a leather glove pointing to the sky (fig. 2.1) or a pile of abandoned helmets on the ground (fig. 2.7) or a used tire next to a coffee grinder (fig. 2.8), a bomber's control panel (fig. 2.9), a hand grenade (fig. 2.10), or a pile of onions photographed beside a prosthetic leg (fig. 3.1). What is at stake in this notion of aura reimagined by Benjamin through the prism of his experience with the drug is nothing less, in any case, than a new conception of the aesthetic articulated on the phenomenon of an intoxication of forms, drunkenness that is experimented within things, the most concrete and banal things in our surroundings.

An intoxication of forms. First, this means a hyperaesthesia, a hyper-acuteness in the subject with regard to the visible world and the sensible world in general: "One becomes so tender, fears that a shadow falling on the page might hurt it."[82] This means, second, that objective forms proliferate:

> There can be an absolutely blizzard-like production of images, independently of whether our attention is directed toward anyone or anything else. . . . Of course, this process may result in the production of images that are so extraordinary, so fleeting, and so rapidly generated that we can do nothing but gaze at them simply because of their beauty and singularity.[83]

Everything in this intoxication of forms seems to pass between dimensions or movements that are associated in a typically cinematographic mode: a centripetal, voracious, and focalizing movement of *mass* from the close-up, considered as an abyss of the gaze ("the mask of one's own face, that is, the displayer's face The death that stands between me and

81 Ibid., 58.
82 Ibid., 48.
83 Ibid., 60.

my intoxication"[84]); the trenchant movement of *division*, of the frame, of the cut ("The idea itself comes apart and opens the way to new stores of images"[85]); and finally, *multiplication*, rapid digression, or incessant passage—all things that are characteristic (which is no surprise) of a genuine experience of knowledge through montages.[86] Things that Henri Michaux would later describe in his own, admirable way, in *Connaissance par les gouffres*, between the mass of "suction-pad images," the cutting of "meaning holes," the aura of "visions of ornaments," and the multiplied creation of "unexpected relationships" between each element of perceived reality.[87] We should remember, however, that Michaux himself, in an experience with psilocybin in 1958, attempted to polarize but not exclude the documentary and hallucinatory dimensions that the same photograph could arouse in a viewer absorbed in the intoxication—with de-realization and hyper-acuteness mixed—of images:

> The first surprising thing . . . was the photo of one, then two people, who I thought were particularly arrested in their appearance. One of them was Macmillan. It should not have seemed surprising to me, given that photographs naturally impose a form of standstill. But this standstill was a prodigious one, one that never finished, being constantly renewed as an obstruction to movement. It was a possible sign that I was beginning, without knowing it, to be overcome by little interior movements, while another part of me entered into a proportional immobility. . . . Whatever the case regarding him and his immobility, I got rid of him by turning the page of the magazine that contained him. This was not done without a certain effort. And there, first or second in a row marching in honor of this same Macmillan, was a Soviet soldier looking as stiff as required for such an occasion, his mouth determined, which with age would begin to look contemptuous, looking now almost like a canopy, a mouth at attention. Every time I turned my eyes

84 Ibid., 19, 32.
85 Ibid., 75.
86 Ibid., 20, 23, 32-34. See also W. Benjamin, "Hashish in Marseilles," in *Selected Writings*, vol. 2, 673-79. These experiences are close to what I attempted to analyze in Georges Bataille as "dialectic of forms" in *La ressemblance informe, ou le gai savoir visuel selon Georges Bataille* (Paris: Macula, 1995), 165-383.
87 H. Michaux, *Connaissance par les gouffres* (Paris: Gallimard, 1988), 11-12, 18, 163, 192.

towards this mouth, it performed a kind of repetition of immobilization which, even for the army, was something abnormal in its constraints. Thus, the Soviet and the Englishman were exceptionally united, although without knowing it.[88]

In this experience, in which the most banal gesture for a photograph—turning the page of an illustrated magazine that includes a news report on the visit of Harold Macmillan to Moscow—takes on the exaggerated proportions of a spell cast on the transfixed bodies in the image, we can understand the art of what Michaux calls the "instructive" character of the psychotropic: "He sees more quickly than we do, identifying what we have not yet understood."[89] Such would be the "epistemo-critical" value of intoxication: two immobile images (as are all photographs) suddenly give the feeling of a "prodigious standstill . . . constantly renewed." Instead of the image being seen as a stable unit, it is looked upon as a "repetition of immobilization," which is a way of singularizing it, of putting it into movement, of making its appearance strange or multiplying its effects. The hallucination would be instructive if it succeeded in addressing, in front of these images, the fundamental questions that our habitual familiarity with the photographic illustration generally affronts: movement, duration, pause, pose, gesture, montage, metamorphosis . . . Don't we need a momentary blacking out of our habits in order to show all things in a new light?

Illumination

Intoxication is therefore "instructive," provided, of course, that it is thought, written, poeticized—*reassembled*, in short. Walter Benjamin's experiments with drugs take on their full literary and philosophical aspects when we remember that they repeat an earlier attempt by Charles Baudelaire in *Les paradis artificiels*, in which intoxication—like the question of poetic imagination, different from the mere personal "fantasy"—is referred to as

88 Ibid., 35–36.
89 Ibid., 171.

a genuine epistemo-critical position, a position of knowledge.[90] Although it is set on a "primitive passion" for the image, such an experience is no less dialectical. In an undated memorandum on hashish, Walter Benjamin writes in German that "images already *live* everywhere" (*überall* wohnen *schon Bilder*), and in French, "Je brousse [*sic*] les images,"[91] which means "I bush images." In other words, images arouse an extraordinary language in me; they are a kind of bushland, a jungle even, in which I can only get lost, become submerged, relinquish myself, condemned to ingurgitate those images, to "graze" them, as Paul Klee wrote somewhere regarding his own relationship to images.

This experience is dialectic in that it brings into contact the tightest instant with the most expansive duration, the short alphabet-primer of childhood with the long science of ultimate things. On the one hand, through drugs (I am thinking of an experience with mescaline that took place on May 22, 1934, and was recorded by Fritz Fränkel), Benjamin finds himself like a child in front of his "reading box"; he draws and writes according to the regressive gesture of the most simply defined fairytale that can be copied down in handwriting (fig. 6.15):

Sheep my sleepy sheep
Sheep my sleepy sheep
Sheep
My sleepy sheep
Sleep my little child sleep
Go to sleep sleep well
You need to sleep.[92]

On the other hand, the childish gesture is extended in a more worrying manner, a more elaborated manner, in a philosophical gesture very close to Hamlet's questioning of all existence. This is expressed by Benjamin in a

90 C. Baudelaire, *Les Paradis artificiels* (1860), in *Œuvres complètes*, vol. 1, ed. C. Pichois (Paris: Gallimard, 1975), 399–517.

91 W. Benjamin, *Sur le haschich et autres écrits sur la drogue* (1927-34) (Paris: Christian Bourgeois, 1993), 102.

92 W. Benjamin, *Sur le haschich*, trans. J.-F. Poirier (Paris: Christian Bourgois 2011), 93.

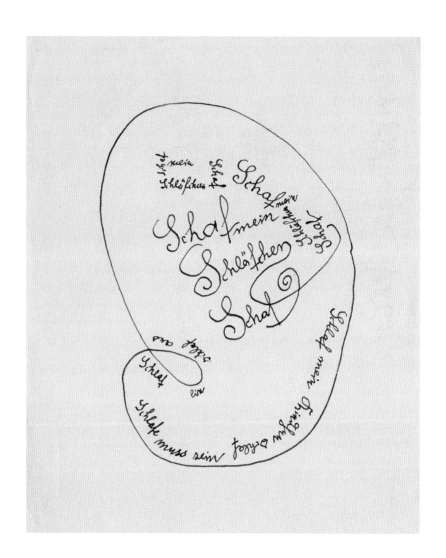

movement of his body; in a shuddering instant, he imagines himself covered by a kind of net, as Fränkel notes:

> A particular action performed by the test subject [Walter Benjamin] catches F[ränkel]'s attention. The subject lets his raised hands, which are not touching, very slowly glide at a great distance from his face. . . . B[enjamin] explains it to him in the following manner: The hands were gathering a net, but it was not only a net over his head; it was a net over the whole of space. . . . Elaborating on the net, B proposes a variation on Hamlet's rather anodyne question, "To be or not to be": Net or mantle—that is the question. He explains that the net stands for the nocturnal side of existence and for everything that makes us shudder in horror. "Horror," he remarks, "is the shadow of the net on the body. In shuddering, the skin imitates the meshwork of a net. This explanation comes after a shudder has traveled over the test subject's body.[93]

This experience could be called an *illumination*. Something that comes from almost nothing—a mere shudder of the skin, a passing sensation—becomes the sign of almost everything. A hypochondriac shudder is a net around the body; a hyperbolic net is the structure of the universe. Elsewhere it is in a single word that time becomes capable of suddenly being illuminated:

> Poetic evidence in the phonetic: at one point I maintain that, in answering a question a little earlier, I had used the expression "for a long time" purely as a result (so to speak) of my perception of a long time in the sounding of the words of the question and answer. I experience this as a poetic evidence.[94]

Is it not indeed luminous to perceive all of a sudden, thanks to a furtive interval caused by a certain drunken state, how the words "a long time" can be experienced, not only in the duration of their pronunciation but also as a duration that is implied in the words, a duration that the words signify but also, more than that, put into action poetically, make imaginable, audible, and tangible?

Figure 6.15
Walter Benjamin, "Lullaby Drawing, May 22, 1934."
© Akademie der Künste, Berlin, Walter Benjamin Archiv 423/3.

93 Benjamin, *On Hashish*, 93–94.
94 Ibid., 20.

It is by locating such "fecund moments" during his experiences with drugs that Walter Benjamin touches upon this "dialectic at a standstill" in the image that marks, in the flow of our habits, the "utopic instant" that Jean-François Poirier notices:

> There is a standstill in the image. The image achieved in drunkenness—because it is an interruption in the continuum of life, a cancellation of the event at the very instant that it occurs—could well be the paradigm of that dialectic at a standstill, of that utopic instant that persists in its immaterial form and that mediatizes the knowledge of possibilities that have remained buried in the past.[95]

It is therefore through a reflection on the temporal incidence of images that Benjamin philosophically disengages this squaring of the circle from political thinking: how the subjective and solitary conditions of capture by the image (alienation) can be transformed into objective and collective conditions of a capacity for dis-alienation or empowerment, uttered as the power to "procure the forces of drunkenness for the revolution."

The illumination suggested by Benjamin is not at all anchored exclusively in the experience of drugs. In fact we can see it at work, for example, in the gentle intoxications he offered in his radio broadcasts between 1929 and 1932, collected in *Aufklärung für Kinder* (*Enlightenment for Children*).[96] These stories and reflections, narratives and arguments, were offered to children like so many "lights" or "illuminations" born of the childlike capacity to think while playing, to take position by dysposing, dismantling or disassembling, by reassembling every element in the face of the others. It had to do with using speech by asking once again the practical question—that of "language games," as Wittgenstein said in the same period—on the basis of a situation that one could call the ABCs or a primer.

This position consists less in simplifying things with a movement of regredience, or regression, than in questioning them once again on another level, a level at which childhood and history think about each other, think

95 J.-F. Poirier, "Le monde dans une image," afterword to Benjamin, *On Hashish*, 108.
96 W. Benjamin, "Radio Stories for Children," in *Radio Benjamin*, trans. J. Lutes with L. H. Schumann and D. K. Reese (New York: Verso, 2014).

with each other. Working with these same Benjaminian paradigms, Giorgio Agamben suggests that "a theory of experience could in this sense only be a theory of in-fancy, and its central question would have to be formulated thus: *is there such a thing as human in-fancy?*"[97] In this way Agamben is able to see infancy as a "transcendental experience of the difference between language and speech, which first opens the space of history"[98]—where, for example, image and poem give us access to historicity through the illumination of a return through time, a re-montage, a *reassembling of time.*

The experience of the image is somewhere, then, in speech, at the point of its difference in the order of discourse, at the point where that difference "opens the space of history." Isn't this basically what Arthur Rimbaud demanded from poetic illumination? Against the "insipid . . . subjective poetry" of the Romantics, he sought instead (in 1871, at the same time as the "battle of Paris—where so many workers are dying") to create an "objective poetry" that would be like a "psalm about current events," like the "Parisian war song" that Rimbaud wrote in tribute to the Communards.[99] For this, it was a matter of "working to make [him] self a seer" and, inseparably, a matter of critiquing the poet's subjectivist position, by assuming his role as an illuminator of history: "It's false to say: I think; one ought to say I am thought.—Forgive the play on words. I is somebody else."[100]

That is to say, then, that seeing and thinking are moved first by an otherness, and it is to assert clearly that poetry is infancy and science, game and action, intoxication and position-taking all at the same time—*infancy*, through Rimbaud's insatiable propensity to play on words ("ithyphallic and squaddy"; "I puked up your pomaded hair"); *science* of the "supreme Scholar," in spite of the drunkenness of the "disordering of all the senses"; and *action*, finally, since poetry must chant the demand for something like a revolution ("poetry and lyres give rhythm to the action"; and beyond,

97 G. Agamben, *Infancy and History: On the Destruction of Experience*, trans. L. Heron (London: Verso, 2007), 54.

98 Ibid., 60.

99 A. Rimbaud, *Selected Poems and Letters*, trans. J. Harding (London: Penguin, 2004), 237. In French, "Lettres dites du Voyant" (1871), in *Poésies: Une saison en enfer; Illuminations*, ed. L. Forestier (Paris: Gallimard, 1999), 83–87.

100 Rimbaud, *Selected Poems*, 236.

that sentence in which Rimbaud hammers home the idea that poetry must be ahead of history itself[101]).

It is perhaps for this reason that the *Illuminations* revolve greatly around a certain relationship of childhood to war.[102] In this relationship, the child is no longer merely terrorized but, rather, active; no longer just the receiver of a pedagogy but an actual professor of utopic instants and revolutionary intoxications, as well as, later, the aura as described by René Char in his beautiful series of "Interrogative responses to a question by Martin Heidegger":

> Poetry is a "song of departure." Poetry and action, stubbornly communi-cating vessels. . . . Poetry, because of speech itself, is always brought by thinking to the fore of the action whose imperfect content it brings on a perpetual life-death-life race. Action is blind, and it is poetry that sees. . . . From the viewpoint of Rimbaud and the Commune, poetry will no longer serve nor rhythm the bourgeoisie. It will be ahead, . . . it will be its own master, being master of its revolution; once the departure signal has been given, the action towards turning constantly into *seeing* action. . . . In light of recent political actions . . . , all action that is justified must be a counter-action whose revolutionary content awaits its own decommitment, a proposable action of refusal and resistance, inspired by a poetry ahead and often in disagreement with it.[103]

René Char's evocation—addressed to Martin Heidegger, we should note—of the "communicating vessels" between poetry and action clearly marks a cer-tain position of Surrealism, notably its antifascist position, in the question here inspired by Rimbaud and the Commune. If Walter Benjamin experimented with the "disordering of all the senses" by taking drugs and, even more so, by the multiplication of theoretical viewpoints, of mediations of knowledge, it is because Baudelaire and then Rimbaud had already laid down these poetic and

101 Ibid., 237.
102 A. Rimbaud, "Childhood" (Enfance), from *Illuminations* (1872–75), in *Selected Poems*, 190–93. See also "Guerre," also from *Illuminations*, in *Poésie*.
103 R. Char, "Réponses interrogatives à une question de Martin Heidegger" (1966), in *Œuvres complètes*, ed. J. Roudaut (Paris: Gallimard, 1995), 734–36.

political demands for a sort of *knowledge through illumination*. But it is also, and above all, because the Surrealists, his contemporaries, exercised a similar demand, armed as they were with those "clairvoyant" apparatuses that are photography, film, collage, and montage.

It is just before writing about Bertolt Brecht—and on the fragile and decisive relationship between poetics and politics—that Walter Benjamin mentions Surrealism as the "last snapshot of the European intelligentsia."[104] From the outset, the question in his argument appears as that of the relationship between an "anarchistic Fronde and a revolutionary discipline," a poetic freedom inherited from Rimbaud (from whose *Illuminations* he cites a passage) and constraints inherent to any joint political action.[105] The vulnerability of this connection is in the difference, which can be tiny or radical, between *taking a position* and *taking sides*. Thus it is not certain that Aragon is taking sides in *Une vague de rêves* (*A Wave of Dreams*), published in 1924. But the "dialectical nucleus" of his work, as Benjamin writes, is evident in his experimental position-taking, "where the threshold between waking and sleeping was worn away in everyone as by the steps of multitudinous images flooding back and forth; language seemed itself only where sound and image, image and sound, interpenetrated with automatic precision and such felicity that no chink was left for the penny-in-the-slot called 'meaning.'"[106]

By describing this experimental poetic situation and discovering that it is agitated by "multitudinous images flooding back and forth," Benjamin uses a surprising vocabulary for someone who might link such a "flow of images" with some personal "fantasy" of the inspired creator. It is not a question of fantasy but rather of "automatic exactness," an objective quality with which every ebb and flow of images is invested. Here, therefore, the illumination is *automatic*. By simplifying somewhat—for in each work, in each concrete experience, everything is of course intermingled and complicated—we can say that Surrealism, in Benjamin's view, is significant in that it associates, combines, and assembles in a montage two symmetrical

104 W. Benjamin, "Surrealism: The Last Snapshot of the European Intelligentsia," in *Selected Writings*, vol. 2, 207.

105 Ibid.

106 Ibid., 208.

automatisms: on the one hand, the automatic ebb of "interior" images and, on the other, the automatic flow of "exterior" images.

The first automatism is psychical. This is what, in its free use by the Surrealists, ranges from the "mental automatism" of Pierre Janet to the "repetition compulsion" according to Sigmund Freud—automatism of repetition and intoxication about, according to Benjamin, a "creative overcoming of religious illumination."[107] The introductory lesson of this religious illumination is no longer the Credo or the Jesuit spiritual exercise (which Georges Bataille also rejected, in his own way, from "inner experience") but, eventually, the use of drugs: a "materialist" introductory lesson, says Benjamin, "but a dangerous one."[108] In *Nadja*, by André Breton—who on this level replicated a "dialectics of intoxication" already present in Dante (the "Dante poet of the terrestrial world," according to Erich Auerbach, cited here by Benjamin)—it is love, not drugs, that leads to illumination.[109] Just as in Bataille's *Histoire de l'oeil*, this function is granted to erotic experience.

What Benjamin discovers in these Surrealist experiences is no less than a conjunction of "revolutionary energies," a "political view" of the world in general.[110] Psychic experience is intended to transform into position-taking; there is a "transformation of a highly contemplative attitude into revolutionary opposition."[111] And this proceeds from a double conversion, a double detour: inner intoxication is transformed into reminiscent thinking (a detour through duration), and the latter elicits a new view of the exterior world (a detour through things).

> Breton and Nadja are the lovers who convert everything that we have experienced on mournful railway journeys (railways are beginning to age), on godforsaken Sunday afternoons in the proletarian neighbourhoods of great cities, in the first glance through the rain-blurred window of a new apartment, into revolutionary experience, if not action. They bring the immense forces of "atmosphere" concealed in these things to the point of explosion.[112]

107 Ibid., 209.
108 Ibid.
109 Ibid., 210.
110 Ibid.
111 Ibid., 213.
112 Ibid., 210.

It is here that "photography intervenes in a very strange way," says Benjamin. With its technical possibilities for framing (or unframing), series connections and fragmentations (disassembling and reassembling, editing and re-editing), photography makes visible—or, rather, *illuminates*—a whole world where "inconceivable analogies and connections between events are the order of the day."[113] Benjamin calls this a capacity for lyricism—provided one sees how this lyricism and this illumination relate to a possibility opened up by the medium of photography, that automatism of reproduction and objectivity. Hence the both fantastic and documentary aspects, the memorial and the revolutionary aspects in the photographic production of images as a paradigm that is decidedly central to literary and artistic Surrealism in general.[114]

Benjamin calls this (although the well-known expression has nonetheless been little explained) a "profane illumination." Its "inspiration," he explains, is "materialistic" and "anthropological."[115] It is consequently, as an experience of illumination, on the level of *objects* themselves, the most ordinary objects, and, above all, on the level of *bodies*, that Surrealism, before Brechtian drama, recognized as the first place of any revolutionary energy. To make poetics political, one would start by forking, by converting—without denying, of course—this *surprise* in which any artistic gesture begins:

> The esthetic of the painter, the poet, *en état de surprise*, of art as the reaction of one surprised, is enmeshed in a number of pernicious romantic prejudices. . . . For histrionic or fanatical stress on the mysterious side of the mysterious takes us no further; we penetrate the mystery only to the degree that we recognize it in the everyday world, by virtue of a dialectical optic that perceives the everyday as impenetrable, the impenetrable as everyday. . . . The long-sought image space is opened, the world of universal and integral actualities, where the "best room" is missing . . . Nevertheless . . . this will still be an image space and, more concretely, a body space . . . that image space to which profane illumination initiates us. Only when in technology body and image space so

113 Ibid., 211.

114 See R. Krauss and J. Livingstone, *L'amour fou: Photography and Surrealism* (New York: Abbeville Press, 1985). See also the recent study by M. Poivert, *L'image au service de la révolution: Photographie, surréalisme, politique* (Cherbourg: Point du jour, 2006).

115 Benjamin, "Surrealism," 209.

interpenetrate that all revolutionary tension becomes bodily collective inner-vation, and all the bodily innervations of the collective become revolutionary discharge, has reality transcended itself to the extent demanded by the *Communist Manifesto*. For the moment, only the Surrealists have understood its present commands.[116]

And this is how we might "win the energies of drunkenness for the revolution."[117] This is how we poets might know not only how to claim but also how to implement, albeit against the aims of the *Communist Manifesto*, an untimely "experience of freedom." I see this as *taking position*—which cannot be reduced to *taking sides*, defined by Benjamin as "the constructive, dictatorial side of revolution."[118] In short, it has to do with recognizing the political limits in any "intoxication component," as well as seeing in the profane illumination of poets the chance not to lose the *revolt* in *revolution*.[119]

On this point, Benjamin fully admits how much he finds himself, like the Surrealists, confronted with reason—cruel reason—in the history of the 1920s and '30s: "And that means pessimism all along the line" therefore, "mistrust in all reconciliation."[120] And if Benjamin wished to push the profane illumination of the artist to the point of suggesting—remembering, perhaps, Arthur Rimbaud—abandonment of any "artist career,"[121] it would be less from a feeling of revolt than from a logic within the illumination. The "enormous flow of images" is less an issue of artistic expression than a specific historical and philosophical knowledge[122]—a *knowledge through montages* that anyone can experience by simply looking at the whirlwinds that this "flow of images" constantly produces.

116 Ibid., 216–18.
117 Ibid., 216.
118 Ibid., 215.
119 Ibid.
120 Ibid., 216–17.
121 Ibid., 217: "In reality, it is far less a matter of making the artist of bourgeois origin into a master of 'proletarian art' than of deploying him, even at the expense of his artistic activity, at important points in this image space. Indeed, mightn't the interruption of his 'artistic career' perhaps be an essential part of his new function?"
122 See J. Fürnkäs, *Surrealismus als Erkenntnis; Walter Benjamin: Weimarer Einbahnstrasse uns Pariser Passagen* (Stuttgart: Metzler, 1988).

Imagination

The link that Walter Benjamin made between the "profane illumination" and photography as a technique shows us that the "flow" of intoxication would be nothing—would be worth nothing, would not last, would not have any critical value—without the construction of these images *in time*: construction of duration that would not be possible without some kind of technical mediation. What intoxication brings to the surface as an illumination or a "utopic instant" of the image, imagination—imagination envisaged as the "utopic duration" of the image—must make into an experience for thinking, an "image of thought."[123] Because it is a game, because it never stops disassembling things, the imagination is an unpredictable and infinite construction, a perpetual revival of movements that are engaged, contradicted, surprised by new branchings. And it is for this reason that the primer is a form that suits it so well: the imaginative must always throw into the air the letters of discourse, joyfully scatter the signposts of the pre-existing doctrine, before starting over from A to Z.

This construction plays well dialectically on two tableaux at the same time: it *dys-poses* things only to better *expose* their links. It creates relationships with differences; it creates bridges over abysses that it opened itself. It is therefore a montage, an activity in which imagination becomes a technique—a craft, an activity that uses the hands and apparatuses—for producing thought in the incessant rhythms of *differences* and *links*. The technical or artisanal aspect of this imaginative construction—its "construction game" character, similar to those that children play today with cubes or the aptly named Lego bricks—appears throughout the *Journals*. Brecht describes himself as engaging in a constant activity of cutting, of collage, of considerations of the page itself as a tabular "workspace," that is to say, like an operating field:

remarkable how the manuscript becomes a fetish, even as you work at it! i am utterly at the mercy of my manuscripts which I constantly paste up and keep up to aesthetic scratch [*un das ich ästhetisch auf der Höhe halte*]. i constantly

123 See the French edition of a collection of essays by Walter Benjamin, *Images de pensée* (1925–35), trans. J.-F. Poirier and J. Lacoste (Paris: Christian Bourgois, 1998).

catch myself trying to make do with a quite definite number of lines for an alteration, just so that there will be enough room on the page.[124]

Every page of the *Journals* is like a mobile plate from a primer, a field of disjointed vignettes, just as each of Brecht's plays is more or less organized as a montage of distinct planes—the "11 images"[125] of *Mother Courage*, for example, which our classical heritage wishes to translate into tableaux. In December 1944, Brecht confided his passion for "photographic experiments with r[uth Berlau], with a view to setting up an archive of my work on film." He explains that "innumerable experiments" are needed: "it is amusing to discover what sources of error there are in the kinds of papers, the types of film, the lighting equipment, the lenses etc. first result POEMS IN EXILE [fig. 5.4]. then I go through the STUDIES again to the same end."[126] The end in question is, over and above the "fraying of the arts" dear to Adorno, to give every page of writing the photographic and visual opportunity to create a whole field of imaginative links. This is, moreover, according to Brecht, the technical possibility opened by the "little photographic editions which . . . promise critical correspondence" (*kritische Korrespondenz*).[127]

This "critical correspondence," generated by the co-presence of unexpected images in the course of a written argument, blossoms throughout the *Arbeitsjournal*, giving it its singular aesthetic—but also critical—potential. On May 16, 1942, for example, while reading a short history of science, Brecht wonders about the links between Pythagoras's theorem and its illustrative and operational diagram drawing (fig. 6.16).[128] But the page that follows creates a perplexing connection: we see Hitler speaking seriously with a member of his staff (regarding the Russian front, of course) and, just above, a view of the oil wells of Baku, on the Caspian Sea (fig. 6.17).[129] This linking of images is not commented upon. Worse

124 Brecht, *Journals*, 141.
125 Ibid., 145.
126 Ibid., 342.
127 Ibid., 343.
128 Ibid., 232. But, in fact, it concerns a theorem by Thales, as explained in the work to which Brecht refers: C. Singer, *A Short History of Science to the Nineteenth Century* (Oxford: Clarendon Press, 1941), 9.
129 Brecht, *Journals*, 233.

16.5.42
singers SHORT HISTORY OF SCIENCE lesend, entdecke ich, dass ich in der schule
niemals bei der einführung des pythagoräischen satzes diese

zeichnung gesehen habe. man hat ihn uns einfach zum büffeln gegeben.

Figure 6.16
Bertolt Brecht, *Arbeitsjournal*,
May 16, 1942: "Short History
of Science." © Berlin,
Akademie der Künste,
Bertolt-Brecht-Archiv
(280/11)/Bertolt-Brecht-
Erben/Suhrkamp Verlag 1973.

280/12

Hitler, photographed in conversation with Col. Engel on the Russian Front, seems agitated. He should be—he's not winning.

THESE WELLS ARE AT BAKU ON THE CASPIAN

Figures 6.17 and 6.18
Bertolt Brecht, *Arbeitsjournal*, May 16, 1942: "Hitler, photographed in conversation with Col. Engel on the Russian Front, seems agitated. . . . These wells are at Baku on the Caspian." © Berlin, Akademie der Künste, Bertolt-Brecht-Archiv (281/20)/Bertolt-Brecht-Erben/Suhrkamp Verlag 1973.

Bertolt Brecht, *Arbeitsjournal*, May 16, 1942: "Magdalenian drawings of bison." © Berlin, Akademie der Künste, Bertolt-Brecht-Archiv (280/13)/Bertolt-Brecht-Erben/Suhrkamp Verlag 1973.

still, it is directly (and anachronistically) followed by an archaeological statement: a Magdalenian engraving found in the caves of Niaux in the Ariège department of France (fig. 6.18).[130]

It seems, then, that thought scatters or disperses, that the tabular exposition of images destroys or tackles the logical exposition of an argument that would account for their links. However, this is not the case if we understand that the argument is to be established in a regredient manner. It suffices to look first at the prehistoric drawing of the bison, in which an arrow points to—and is embedded in—its heart. Brecht writes here that "knowing, however, where the heart of the buffalo was located, gave the hunter magical powers."[131] This in turn shows the "epistemo-desiring" potential of the image: On the one hand, it demonstrates a *knowledge* that goes well beyond its visible aspects; the bison is drawn remarkably well, but what matters remains in the area indicated by the arrow, the invisible organ of the heart, which the arrow must reach in order to conquer the animal. On the other hand, it shows a magically perpetuated *desire* on the wall of a cave, expressed by the drawing of the arrow, which is first and foremost a design (in the senses of *plan* and *intention*) to reach its vital end.

It suffices, then, to look anew at the document from 1942 in order to understand through the interposed images that, in order to reach Hitler's heart, to strike him down, one would have to point the arrow at the oil industry, which was the nerve centre of the war. "The association is not missed," writes Philippe Ivernel, "between the heart of the bison, that vulnerable point, and the fuel that the Nazi army needed to go farther and farther."[132] This is where montage operates: in this link that is constantly stretched between memory (the prehistoric bison) and the present (the Russian campaign), between the present (Hitler advances still) and desire (Hitler must be beaten), between descriptive knowledge and prospective magic. We know how Aby Warburg tried, during the First World War,

130 Ibid., 234 (the drawing itself is from Singer, *A Short History of Science*, 3).
131 Ibid.
132 P. Ivernel, "L'œil de Brecht: À propos du rapport entre texte et image dans le *Journal de travail* et l'*ABC de la guerre*," in M. Vanoosthuyse, ed., *Brecht 98: Poétique et politique* (Montpellier: Paul Valéry University, 1999), 225.

to clarify these epistemo-magical aspects of political imagery.[133] Close to this form of thinking, Walter Benjamin writes in 1936 that the mimetic power should be understood anthropologically as a dialectic that produces a certain form of *knowledge* (showing where the vital organ is located) and that indicates a certain form of *action* (in order to kill the animal, or the enemy), all in the same aesthetic form constituted by the graphic—or choreographic—movement invented for the occasion:

> The knowledge that the first material on which the mimetic faculty tested itself was the human body should be used more fruitfully than hitherto to throw light on the primal history [*Urgeschichte*] of the arts. We should ask whether the earliest mimesis of objects through dance and sculpture was not largely based on imitation of the performances through which primitive man established relations with these objects. Perhaps Stone Age man produced such incomparable drawings of the elk only because the hand guiding the implement still remembered the bow with which it had felled the beast.[134]

Brecht at work on and playing on associations, Brecht manipulating in exile these images of Adolf Hitler and of wild beasts felled—this Brecht is therefore imaginative, an assembler of montages and even, to a certain extent, a caster of historical spells. A "seer" in any case, who gives images the task of creating "critical correspondence" between knowledge and action. Often there is naïveté in this gesture, but "naïveté is a particular feature of old men as well as children, and it is the mature man who contains in him both the child and the old man."[135] The *Arbeitsjournal* is in no way the work of a child or an old man, but rather the work of a mature man. By playing with images, however, Brecht constantly composes effects of interpretation and heterogeneous temporalities, so that he fears neither abyssal regressions towards prehistory nor the dizzying projections into the most unverifiable

133 See A. Warburg, "La divination païenne et antique dans les écrits et les images à l'époque de Luther" (1920), trans. S. Muller, in *Essais Florentins* (Paris: Klincksieck, 1990), 245-94.

134 W. Benjamin, "The Knowledge That the First Material on Which the Mimetic Faculty Tested Itself," trans. E. Jephcott, in *Selected Writings*, vol. 3, 253.

135 Brecht, "Notes sur le travail littéraire," 40.

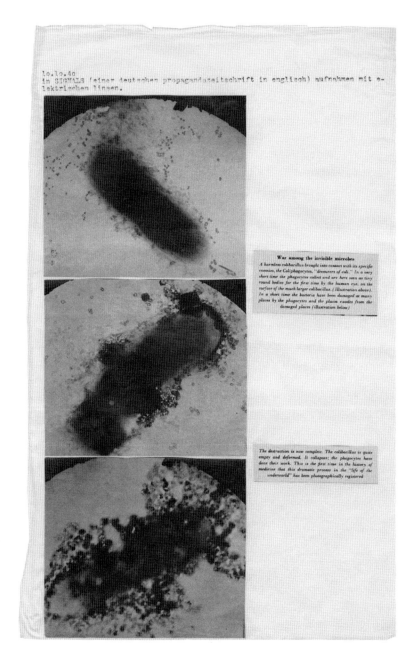

future. His experimentation with images is the only other way to express his experimentation with current history—his principal object of anxiety—like a sort of game with fate from a position of exile.

A final example. Between an attitude of Mussolini and two gestures of Hitler, Brecht shows us—interposes, assembles in a montage—three moments set under an electronic microscope, of a bacillus being attacked and destroyed by phagocytes (fig. 6.19).[136] Is it the scholar looking thus at the battlefield under the microscope, the same person who elsewhere saw "how war emerges as a vast field akin to the fields of modern physics"?[137] Or is it the child who, in the intoxication of images—real soldiers, tin soldiers, wooden cubes, microbes, whatever—"checks what is closest and what is farthest, and never the one without the other," by looking at all this, for example, in the real crushing of destroyed cities (fig. 6.20)?[138] It is no accident that in the *Journals* there appear, in 1941 but two months apart, a description of the aerial war, "cut off from life," and the shocking tale of the death of Grete Steffin, a remote story in which nonetheless every detail, including the lobes of the woman's lungs, is made strangely accessible to us.[139]

The *Journals* and *War Primer*, as imaginative montages—documentary elements and lyrical movements mixed together—respond exactly to this double dimension, to this perpetually coming and going rhythm: the systole, or contraction, of *seeing* (this is the necessarily historical and focalized aspect of Brecht's work), and the diastole, or dilation, of *clairvoyance* (this is the anachronistic and dispersed aspect). Charles Baudelaire—before Walter Benjamin analyzed it and followed in his tracks—gives the term *imagination* to this double faculty of observation and extrapolation:

Imagination is not fantasy, nor is it sensibility, difficult though it would be to conceive of an imaginative man who was not sensitive. Imagination is a virtually divine faculty that apprehends immediately, by means lying outside philosophical methods, the intimate and secret relation of things, the correspondences and analogies. The honours and functions Poe confers on this

136 Brecht, *Journals*, 39.
137 Ibid., 123.
138 Ibid., 100, 40, 297.
139 Ibid., 149–51.

faculty give it such value (at least when one has thoroughly grasped the author's thought) that a scholar without imagination seems no more than a false scholar, or at least an incomplete one.[140]

Goethe characterizes the condition of artistic work as a paradox: "There is no way of more surely avoiding the world than by art, and it is by art that you form the surest link with it."[141] And it seems significant to me, insofar as "the world" reaches us first of all as our political history, that Hannah Arendt should transcribe for her own purposes this thought by Goethe in the context of her "thinking diary."[142] But to what extent does Bertolt Brecht make this his own paradox? Well, not to the very end. The diastole of the imagination is for him simply a moment to get over, not a rhythm that must always be reset. There is no reason, thinks Brecht, to continue indefinitely to play like children with the chaos of the world. The *Journals* is only a journal, after all, that is to say, a private arrangement (deprived of its collective value, which was for Brecht the most important). *War Primer* is only a primer, an ABC, a tool for finishing with childhood (at least in the eyes of the pedagogue). Which amounts to saying that for Brecht, in the context of Leninist materialism, any position-taking must end up—and disappear, and cease to scatter—in a better organization of social reality.

This explains Brecht's violent hostility towards Baudelaire and his refusal of Surrealism, for example, when he sought to distinguish at all costs, through distancing, the "strange" from the "bizarre."[143] This is what makes him refuse the dreamlike aspect of montage that Ernst Bloch highlighted,[144] and finally accept, without worrying too much, the propagandistic organization of Soviet montages after the liquidation of "formalist" tendencies by Lenin and Stalin. Brecht detests the misery

140 C. Baudelaire, "Further Notes on Edgar Poe," in *Selected Writings on Art and Literature,* trans. P. E. Charvet (London: Penguin, 1992), 199.

141 J. W. von Goethe, *Maxims and Reflections* (1810), trans. E. Stopp (London: Penguin, 1998), 7.

142 H. Arendt, *Denktagebuch* (1950-73) (Munich: Piper, 2002).

143 Brecht, "Short Organon," 242.

144 See Bloch, *Heritage of Our Times*, 335 (regarding the "sensuous power and liveliness of uncemented scenes, from their changeability and transformation into one another, from their contact with the dream").

that Baudelaire looks at so eloquently, because it is not a misery organized by class and party organization, a plebeian decidedly incapable of taking power from the hands of the bourgeoisie.[145] It is a *poetic* consequence that concerns *politics*, as we can see clearly from the unpredictable and infinite, even anarchistic, character of the imagination: "As we speak of fleeting thoughts [*Gedankenflucht*], we could call fleeting imagination [*Bilderflucht*] that excessive instability in the alternation of images [*allzu labiles Auswechseln von Bildern*]. The images in question are for the most part extremely superficial."[146] This is how the pedagogue intends to place the limits of any imaginative position and of any *delectatio* in the utterance—the last word, the watchword, the Party—of its *lectio*.

But this is also what makes up the very contradiction of Brecht as a poet, a contradiction that Benjamin, who endeavoured at one time to conjugate the *lectio* of epic drama with the *delectatio* of "profane illumination," must have noticed. This is what appears crudely in the polemical discussions—and also in the uncomfortable silences—between the two men when together for a few weeks in Lavandou in 1931 and then in Svendborg in 1934, 1936, and 1938.[147] Their little quarrel on literary depth, in 1934, is characteristic in this respect: "'It's nonsense [says Brecht]. You have to ignore it. Depth doesn't get you anywhere at all. Depth is a separate dimension, it's just depth—and there's nothing whatsoever to be seen in it.' To conclude the discussion I tell B. that penetrating into depth is my way of travelling to the antipodes."[148]

It is no surprise that this exchange on depth—poetic depth, but also psychical depth—takes place in the context of a larger discussion on the work of Franz Kafka. Stéphane Mosès analyzes remarkably the meanderings and the issues at stake that appear fundamental, since they touch on not only the status of the literary image but also its ethical and temporal situation, between memory and history.[149] "I reject Kafka" says

145 Brecht, *Brecht on Theater*, 286.
146 Brecht, "Notes sur le travail littéraire," 35.
147 See W. Benjamin, *Understanding Brecht*, trans. A. Bostock (London: Verso, 1998), 105.
148 Ibid., 110.
149 S. Mosès, "'Le prochain village': Brecht et Benjamin interprètes de Kafka," in *Mélanges offerts à Claude David pour son 70ᵉ anniversaire*, ed. J.-L. Bandet (Berne: Peter Lang, 1986), 276–90.

Brecht to Benjamin.[150] But what exactly does he reject in Kafka? Simply his capacity as a *seer*, which Brecht considers an obstacle to Kafka's capacity to *see*: "As a visionary, Kafka saw what was to come, without seeing what exists now."[151] To which Benjamin responds—the text written for the journal *Jüdische Rundschau* gives this answer all its argumentative power—that the revolutionary gesture is found perhaps in a reminiscent present: everything that Brecht detests in Benjaminian references to the Jewish tradition rather than a present of partisanship that is forgetful of its own profound genealogies.[152]

The major engagement of Brechtian literature and drama is answered by the minor position of Kafka's writings—regarding which Gilles Deleuze and Félix Guatarri remark later that "everything in them is political"[153]—and of Benjaminian thinking. In 1916, in the midst of the world war, Benjamin submitted to Martin Buber the necessity to rethink entirely the link between literature and politics: "The opinion is widespread, and prevails almost everywhere as axiomatic, that writing can influence the moral world and human behavior, in that it places the motives behind the actions at our disposal." Yet this is a serious philosophical error, for it considers language a mere means for action, a "weak action and whose origin does not reside within itself."[154] The paradox of any poetic position-taking is therefore that its efficiency does not reside within a "transmission of content" or a doctrine of actions to be carried out, but rather in a return to its own inner "crystal" that refers to the accursed share, the "un-mediated" part, as Benjamin writes, of its deployment.[155]

Stuck between Martin Buber and Bertolt Brecht, Benjamin was probably not understood by either of them. His dialectic is too daring, too demanding, just as his relationship with both tradition and revolution

150 W. Benjamin, "Notes from Svendborg," in *Selected Writings*, vol. 2, 786.

151 Ibid., 785.

152 Ibid., 785–90.

153 G. Deleuze and F. Guatarri, *Kafka Toward a Minor Literature*, trans. D. Polan (Minneapolis: University of Minnesota Press, 2003), 17. See also the texts by F. Guatarri recently published by Stéphane Nadaud, *Soixante-cinq rêves de Franz Kafka et autres textes* (Paris: Lignes, 2007).

154 W. Benjamin, "Letter to Martin Buber," July 1916, in *The Correspondence of Walter Benjamin, 1910–1940*, trans. M. R. Jacobson and E. M. Jacobson (Chicago: University of Chicago Press, 1994), 79–80.

155 Ibid., 80.

is too anachronistic, and apparently doomed to be impossible. But Benjamin touches the heart of the question that concerns us here, which is that of the relationship between imagination and history. The imagination of the *seer*—be it Rimbaud, Kafka, or Benjamin himself—necessarily relies on the documents of the *observer*, but it also allows itself to go against all this historical material, disorganizing (happily or cruelly) what the surface causal evidence suggests. Images are needed in order to make history, above all during the eras of photography and of cinema. But imagination is needed too, in order to see images again and, therefore, to rethink history.

All this contained a risk that Walter Benjamin knew was necessary, while Brecht did everything—except in his *Journals*, and except in his books of images and here and there in his poems—to ward it off. This risk appears in the image when the doctrine begins to crumble, when the pedagogy fails, when the distancing opens up too great a realm of strangeness. What happens, in fact, when strangeness reigns? Maurice Blanchot explains it clearly in his commentary on Brecht:

> How can he keep the effect of strangeness from stupefying the mind rather than waking it, from making it passive rather than active and free? Although he does not reveal it directly, his thought is clear. There is a "good" strangeness and a "bad" strangeness. This first is the distance that the image places between ourselves and the object, freeing us from the object in its presence, making it available to us in its absence; permitting us to name it, to make it signify, and to modify it: a mighty and a reasonable power, the great driving force of human progress. But the second strangeness to which all the arts owe their effects is the reversal of the first one, which, moreover, is its origin; it arises when the image is no longer what allows us to have the object as absent but is rather what takes hold of us by absence itself: there where the image, always at a distance, always absolutely close and absolutely inaccessible, steals away from us, opens onto a neutral space where we can no longer act, and also opens us upon a sort of neutrality where we cease being ourselves and oscillate strangely between I, He, and no one.[156]

156 M. Blanchot, "The Effect of Strangeness," in *The Infinite Conversation*, trans. S. Hanson (Minneapolis: University of Minnesota Press, 2003), 366.

There is no "good" or "bad" strangeness; there is only that evidence which is difficult to support. The strangeness of images exposes us to an *excess of knowledge* that can be alternately revelation (clairvoyance) and confusion (delirium). To handle images is to accept walking the tightrope and risking the fall. The contradiction in Brecht regarding images is therefore in the very place that Benjamin calls the dialectic of the image and what Blanchot calls the "duplicity of the imaginary."[157] This duplicity is not a lie—far from it—but rather something like a reversal of distance in itself, when *distance looks at us*, touches us, and comes to reach us in our depths. It is what Blanchot calls neither "identification" (for the ego is no longer in the centre) nor "empathy" (for affect goes along with the neutral), but rather *fascination*.[158] This is a fascination that we need to know how to wake up from when we look at the images of history in order to gain some new knowledge. But also a fascination that must not be repressed, that we must accept, even though it be "regressive," as psychoanalysts say—bringing our own body into play and into question[159]—when we are put back into a situation of non-knowledge, that of contemplating an image like a child in front of his ABC book or primer: between the gravity of the *lectio* and the lightness of the *delectatio*.

That is no doubt what Brecht could not bear in the stories of Kafka (and worse, if he had read it, in the *Journals*): that childish fascination constantly in suspense between lightness and gravity, play and fear, always held to the instant, to the *aion*, always impertinent with the meaning of history, with *chronos*, with progress, and even the idea of the project. Georges Bataille, who rigorously highlights the hostility of the Communists towards Kafka, merges perfectly with the analysis that Benjamin attempts, in his discussions of 1934, to argue against Brecht:

> A goal is always, without hope, *in time*, like a fish in the water, a mere dot in the movement of the universe. . . . Is anything more contrary to the communist position than [that of Kafka]? We could say that communism is action

157 Ibid.

158 Ibid., 366-67.

159 See P. Fédida, *Par où commence le corps humain? Retour sur la régression* (Paris: PUF, 2000).

itself, the action that changes the world. In it the goal, the changed world, situated in time to come, subordinates existence, present activity [to the constraints of its great historical project].[160]

This notion of the project finds resistance in Kafka's "perfect childishness."[161] From this party escapes—but never victoriously, always in its "minor form," as Bataille wrote too[162]—the position of impertinence and even irresponsibility, suggested at one moment in playing with images.

Georges Bataille often describes children playing in the middle of the rubble of war, whether in the setting of "La maison brûlée" ("the burned house") or in the reflections on the "attraction of the game" in *Le coupable* ("the guilty one") and on "the will to chance" in the book *Sur Nietzsche*, all texts written between 1944 and 1945.[163] We can easily imagine that Bataille, in the mindset of *Documents*, might have put on the same level—through montage and a ninety-degree imaginary rotation of the gaze—the fields of rubble of bombarded Hamburg (fig. 6.20) and the "décor rubble" in front of which, perhaps, the little spectators laughed and cried with fear at the children's theatre in London (fig. 6.4).

But what does this game of imagination with the worst of reality speak to us about? Perhaps it speaks of that "aesthetic freedom" that Schiller, during the French Revolution, said was necessary for any genuine political freedom.[164] If Benjamin is the heir of such a tradition, it is at the cost of, as we know, a particular pessimism in a time when "the enemy . . . is victorious" and when the thinker himself, a permanent exile, feels he is part of the "generations of the downtrodden."[165] Yet Walter Benjamin's position-takings, even if they are desperate from the

160 G. Bataille, *La Littérature et le mal* (1957), in *Œuvres complètes*, vol. 9 (Paris: Gallimard, 1979), 272.

161 Ibid., 273–79.

162 Ibid., 285.

163 G. Bataille, "La maison brûlée" (1944–45), in *Œuvres complètes*, vol. 4 (Paris: Gallimard, 1971), 120–21, 124; *Le Coupable* (1944), in *Œuvres complètes*, vol. 5 (Paris: Gallimard, 1973), 310–29; *Sur Nietzsche: Volonté de chance* (1945), in *Œuvres complètes*, vol. 6 (Paris: Gallimard, 1973), 139–44, 174, etc.

164 F. Schiller, *On the Aesthetic Education of Man: In a Series of Letters*, trans. E. M. Wilkinson (Oxford: Clarendon Press, 1982), letter XXIII, 163.

165 W. Benjamin, "On the Concept of History," in *Selected Writings*, vol. 4, 391, 394.

viewpoint of organization of political progress, masterfully survive beyond the *side-takings* of Bertolt Brecht. It as though it were necessary to reverse the school hierarchies and to understand, today more than ever, the possible teaching of the *childish position*—naive, anxious, excessive, moving, playful, non-doctrinal—in front of images:

> The typical picture book that was used or that is still used for lessons on things in German schools are good examples of this. We think these books are useful, either because they teach the child to recognize real things in the things shown, or because the things shown allow us to introduce them into the world of real things and to become familiar with them. There is no need to say just how wrong this explanation is.
>
> [. . .]
>
> The child inhabits them. Their surface, unlike that of colored pictures, is not a *Noli me tangere*—either in itself or in the mind of the child. On the contrary, it seems incomplete and so can readily be filled out. Children fill them with a poetry of their own. This is how it comes about that children *in*scribe the pictures with their ideas in a more literal sense: they scribble on them.[166]

This, therefore, is the dialectic and, furthermore, the *politics of the imagination* that this attitude—envisaged as an epistemo-critical paradigm—fundamentally arouses: the child (at least the paradigm that this term refers to) fears neither being fascinated by images, since she "inhabits" them, nor handling them, since she feels "free" to do so. She allows herself to be grasped by the aura and the profane in the moment. She allows herself to be carried by the *lectio* of the picture book and recognizes in this way the inscription that accompanies every plate. But her *delectatio* makes her even more voracious: she discovers multiplicities at work in every image that is looked at with the others. She sees everywhere "allusive virtualities." Then she allows herself to be overcome by the joy of a writing supplement (*Beschreibung*): she covers in signs, "over-inscribes" every inscription and

166 W. Benjamin, *Fragments philosophiques, politiques, critiques, littéraires*, trans. C. Jouanlanne and J-F. Poirier (Paris: PUF, 2001), 144–45, and "Old Forgotten Children's Books," in *Selected Writings*, vol. 1, 411.

thus produces her own condensation (*Verdichtung*) of virtualities—which is called, quite simply, poetry (*Dichtung*).

"For no other pictures can introduce children to both language and writing as these can—" writes Benjamin in his essay from 1919, "—a truth that was exposed in the old primers when they first provided a picture to illustrate the words." And Benjamin concludes by claiming that, in front of these picture-book primers, children "awaken" to visible reality "just as they dream their dreams" in the clairvoyant universe of their imagination.[167] This is why the obsolete illustrations of the old primers continued to fascinate the avant-garde artists (Max Ernst in particular) at the very time that Benjamin wrote these lines[168]—as though "children swiftly came to an understanding over the heads of the pedagogues."[169] An understanding about what? About a politics of the imagination that is entirely different from an illustrated politics or a side-taking, a partisanship, using images to communicate more clearly the watchwords of its doctrine.

Walter Benjamin's "philosophical fragments" are full of the leitmotif of the imagination as a form of knowledge. It concerns a certain epistemo-critical status specific to the visual arts.[170] But it also concerns, more fundamentally, a global intuition and a project that had been important to him for a very long time, which was to create a "documentary work" (*Dokumentarwerk*) whose object would have been imagination or fantasy (*Phantasie*).[171] Which is what Georges Bataille attempted later in his own iconographic montages, from *Documents* to *Tears of Eros*. Documents of the imagination, emanating from it and expressing it. Documents regarding a

167 Benjamin, "Old Forgotten Children's Books," 412.

168 See W. Herzogenrath, ed., *Max Ernst in Köln: Die Rheinische Kunstszene bis 1922* (Cologne: Rheinland/Rudolf Habelt, 1980), 224–29.

169 Benjamin, "Old Forgotten Children's Books," 409. For other fragments on this theme, see Benjamin, *Fragments philosophiques*, 73–74, 156–58. On Benjamin's passion for children's books, see G. Scholem, *Walter Benjamin: The Story of a Friendship*, trans. H. Zohn (New York: New York Review of Books, 2012). See also Brüggemann, *Walter Benjamin über Spiel, Farbe und Phantasie*, 47–125.

170 See D. Schöttker, ed., *Schrift-Bilder-Denken: Walter Benjamin und die Künste* (Berlin: Hausam Waldsee/Suhrkamp, 2004); S. Weigel, "Die unbekannten Meisterwerke in Benjamins Bildergalerie," *Trajekte: Zeitschrift des Zentrums für Literatur- und Kulturforschung Berlin* 7, no. 13 (2006): 15–22.

171 W. Benjamin, *Moscow Diary* (1926–27), trans. R. Sieburth (Cambridge, MA: Harvard University Press, 1986), 101.

knowledge through images in which Benjamin—Bataille would later extend his intuitions—saw a scansion at work, the rhythm of an emerging apparition or "manifestation" (*Erscheinung*) and of a "deformation" (*Entstaltung*): "We might rather describe the manifestations of the imagination as the deformation [*Entstaltung*] of what has been formed. It is characteristic of all imagination that it plays a game of dissolution with its forms."[172]

Benjamin then gives this important dialectical nuance: "while imagination de-forms, it never destroys" (*die Phantasie, wo sie entstaltet, dennoch niemals zerstört*).[173] Indeed it does not destroy, for instead it disassembles or dismantles. It disassembles only to reform and to reassemble in a montage everything in its own economy of clairvoyance. We must then understand the crucial position of montage in this economy of the imagination. The famous critique of the aura, "The Work of Art in the Age of Its Technological Reproducibility," finds a new meaning: "the unique apparition of a distance, however near it may be," writes Benjamin regarding the cultic aura.[174] What must be displaced in this sentence is not the apparition or appearance (*Erscheinung*) as such. That "distance," *Ferne*, should perhaps be turned into another German word for distance: *Entfernung*, or perhaps even "distancing," *Verfremdung*. And finally, the word "unique" (*einmalig*) is indeed that from which the image must be freed. This is what must be renounced: the notion that the image is "one," or even that it is "whole." Rather, we should recognize the potential of the image as that which determines that it will never be the "one-image" or the "all-image"—what destines it to multiplicities, to intervals, to differences, to connections, to relations, to bifurcations, to alterations, to constellations, and to transformations. In other words, to *montages*. To montages capable of punctuating for us the apparitions and deformations and that are capable of showing us, in images, *how the world appears* and *how it is deformed*. It is in this way, by taking position in a given montage, that the different images that make it up—by composing its chronology—can teach us something about our own history—by which I mean something *else*.

172 W. Benjamin, "Imagination," trans. R. Livingstone, in *Selected Writings*, vol. 1, 280.

173 Ibid.

174 W. Benjamin, "The Work of Art in the Age of Its Technological Reproducibility (Third Version)," trans. H. Zohn and E. Jephcott, in *Selected Writings*, vol. 4, 255.

List of Illustrations

off." © Berlin: Akademie der Künste, Bertolt-Brecht-Archiv (282/07)/Bertolt-Brecht-Erben/Suhrkamp Verlag 1973.

Index